The Renaissance Englishwoman in Print

The Renaissance Englishwoman in Print ❦ Counterbalancing the Canon

Edited by ANNE M. HASELKORN
and BETTY S. TRAVITSKY

The University of Massachusetts Press • Amherst

Copyright © 1990 by The University of Massachusetts Press
All rights reserved
Printed in the United States of America
LC 89-32870
ISBN 0-87023-690-3 (cloth); 691-1 (pbk.)
Designed by Susan Bishop
Set in Garamond Type
Printed and bound by Thomson-Shore, Inc.

Library of Congress Cataloging-in-Publication Data
The Renaissance Englishwoman in print : counterbalancing
the canon / edited by Anne M. Haselkorn and Betty S. Travitsky.

p. cm.
Includes bibliographies and index.
ISBN 0-87023-690-3 (alk. paper). —
ISBN 0-87023-691-1 (pbk. : alk. paper)
 1. English literature—Early modern, 1500-1700—
History and criticism. 2. English literature—Women
authors—History and criticism. 3. Women and literature—
England—History—16th century. 4. Women and
literature—England—History—17th century. 5. Women—
England—History—Renaissance, 1450-1600. 6. Women in
literature. 7. Renaissance—England. 8. Canon (Literature)
I. Haselkorn, Anne M. II. Travitsky, Betty (date).
PR418.W65R46 1990
820.9'352042—dc20 89-32870

British Library Cataloguing in Publication data are available.

In memory of William W. Brickman,
honorary mentor par excellence,
to whose encouragement I owe all my efforts
B S T

In memory of my mother,
Fannie Chasman Milker
A M H

Contents

Acknowledgments ix

BETTY S. TRAVITSKY
Introduction: Placing Women in the English Renaissance 3

I. The Outspoken Woman

ANN ROSALIND JONES
Counterattacks on "the Bayter of Women": Three Pamphleteers of the Early Seventeenth Century 45

IRA CLARK
The Power of Integrity in Massinger's Women 63

GAIL REITENBACH
"Maydes are simple, some men say": Thomas Campion's Female Persona Poems 80

II. Woman on the Renaissance Stage

ABBE BLUM
"Strike all that look upon with mar[b]le": Monumentalizing Women in Shakespeare's Plays 99

ANNE M. HASELKORN
Sin and the Politics of Penitence: Three Jacobean Adulteresses 119

TINA KRONTIRIS
Style and Gender in Elizabeth Cary's *Edward II* 137

III. The Woman Ruler

CONSTANCE JORDAN
Representing Political Androgyny: More on the Siena Portrait of Queen Elizabeth I 157

CLARE KINNEY
The Queen's Two Bodies and the Divided Emperor: Some Problems of Identity in *Antony and Cleopatra* 177

CONTENTS

JOSEPHINE A. ROBERTS
Radigund Revisited: Perspectives on Women Rulers in
Lady Mary Wroth's *Urania* 187

IV. The Private Woman

JUDITH BRONFMAN
Griselda, Renaissance Woman 211

R. VALERIE LUCAS
Puritan Preaching and the Politics of the Family 224

BETTY S. TRAVITSKY
"His wife's prayers and meditations": MS Egerton 607 241

V. Women and the Sidneian Tradition

BETH WYNNE FISKEN
"To the Angell Spirit . . .": Mary Sidney's Entry into the
"World of Words" 263

MARGARET ANNE MCLAREN
An Unknown Continent: Lady Mary Wroth's Forgotten Pastoral
Drama, "Loves Victorie" 276

NAOMI J. MILLER
Rewriting Lyric Fictions: The Role of the Lady in Lady Mary
Wroth's *Pamphilia to Amphilanthus* 295

MAUREEN QUILLIGAN
Feminine Endings: The Sexual Politics of Sidney's and Spenser's
Rhyming 311

GARY F. WALLER
The Countess of Pembroke and Gendered Reading 327

ELAINE V. BEILIN
Current Bibliography of English Women Writers, 1500–1640 347

Notes on Contributors 361

Acknowledgments

We thank

Margaret W. Ferguson for unflagging help and interest in this project.

Patrick Cullen for valuable suggestions.

Jean Howard and Arthur Kinney who read the book for the press and suggested many valuable improvements.

Josephine A. Roberts for her help with the illustrations.

Robert A. Machalow of the York College Library/CUNY; and William C. Parise, Jr., and Rita Coleman of the Brooklyn College Library/CUNY for their generous assistance with interlibrary loan requests.

Our families:
Avraham, Moshe, Malky, Miriam, Aviella, Baruch, Tzirel Leah, and Aharon David;
Howard, Danny, and Martha

The Renaissance Englishwoman in Print

BETTY S. TRAVITSKY

Introduction

Placing Women in the English Renaissance

MANY distinctive features of the English Renaissance—its lateness relative to the Renaissance in southern Europe, its adaptations to the wide swings of the Tudor and Stuart political, economic, cultural, and religious programs, its generally sober, religious tone, its governance for a stretch of approximately fifty years by a woman—are widely recognized. But the consequences of these peculiarities for English women are less familiar.

The Renaissance Englishwoman in Print attempts to investigate these consequences by examining cultural products of Tudor and Stuart England. Focusing chiefly on literary texts, the essays in this collection correlate writings by men that have traditionally been contained within the literary canon with writings by women that have traditionally been marginalized. Of course, the intertwining of power relations—gendered, economic, political, and religious—with the preservation of texts, a process that Barbara Herrnstein Smith has aptly termed "a complex evaluative feedback loop,"[1] is the (usually silent) factor that shapes a literary canon. And the essays in this collection treat cultural documents in ways that necessarily raise and address questions about English Renaissance politics, religion, and economics. Many of the gendered assumptions of the English Renaissance are highlighted by this counterbalancing of representations of Renaissance women by contemporary men with writings (on related topics) by Renaissance women.

To attempt such a counterbalance is to deal, as contributors to this volume do, with such topics as the differences between writing by men and writing by women, the standardization of genres, and the inclusion of some "kinds" within the canon along with the exclusion of others. It is to propose a consciously, sympathetically gendered reading of texts written by men and women and a gendered approach to the writing process. (See particularly the essays by Beth Wynne Fisken, Maureen Quilligan, and Gary F. Waller.) It is to approach Renaissance texts with

IN OLD-SPELLING texts throughout this volume, *i–j* and *u–v* have been regularized. Any further changes in the texts are noted within individual essays.

INTRODUCTION

a receptivity to their intertextuality and contextuality, to employ the range of current, revisionist approaches—new historicist, cultural materialist, Lacanian, performative, and new textual—in aid of the feminist enterprise. But it is less to expand our concept of the boundaries of literature than to be faithful to the expansive, experimental, uncanonical nature of the enterprise of letters during the Renaissance—to what Rosalie L. Colie called the "inclusionism: uncanonical forms, mixed kinds, and nova reperta"[2] of Renaissance writings. It is to propose, in this spirit, an opening of the Renaissance canon to recently recovered writings and to the potential treasury of still-unknown writings. No one volume could possibly bring the entire corpus of the traditional canon into such focus, and no volume questioning the very notion of a generically pure and closed canon could logically attempt to establish a new canon by doing so. In fact, one of the most exciting aspects of the deliberate study of neglected and unknown materials is the constant possibility that something could turn up that would change the "look" or "significance" of the field. This collection, which brings together many diverse materials on the Renaissance English woman for the interested student of the period, is a pioneering effort to bring the traditional literary canon and hitherto excluded and neglected women's writings into momentary counterpoint.

I

Collectively, the essays in this collection move us toward a placing of women in the English Renaissance. For one thing, their very juxtaposition demonstrates how severely our understanding of this phase of European history has been limited by our lack of access to the thinking of past women. A reading of these interrelated studies highlights some of the gendered assumptions that Renaissance men and women shared and disagreed about with a force that no one-sided view of the period could achieve. In combination, these essays challenge our simpler, past readings of Renaissance representations and thereby enrich our understanding of them. To see the threat of woman's rule, for example, first expressed by male dogma about "monstrous women" and then undercut by a woman ruler's efforts to personate masculinity is to gain a fuller understanding of the workings of the gender system in Renaissance England. (See Part III, "The Woman Ruler," below.)

These essays also demonstrate that the Renaissance gender system was unlike that of the twentieth-century West, and, therefore, that we cannot "place" women in the English Renaissance without making a conscious effort to re-create that system. We must make a conscious effort to understand the thinking of and about women in a period when

women (as a whole) were forced by political and familial circumstances into life-styles over which they exerted no control. Their de facto position of dependence within a family—which was considered their unique, biologically determined position—sustained a uniform Renaissance perspective on "the place of women" that could not be resisted easily. We would probably be startled, today, by entries in the journal of a contemporary woman who had internalized the propriety of absolute submission to her husband. But we would be less startled by the voicing of such sentiments by a Renaissance Englishwoman, or by the expectation of such submission on the part of a Renaissance Englishman. The voicing of such sentiments, however, throws additional light on frequent Puritan preaching at domineering wives and on multiple Renaissance retellings of the tale of Griselda. Thus, interrelating the writings by Renaissance men and women illuminates English Renaissance social history, while a knowledge of the history of the period illuminates Renaissance texts and establishes their significance. (See Part IV, "The Private Woman.")

The intertwining of these essays highlights correlations between Renaissance efforts to suppress and empower women and contemporaneous literary constructs of women. It is most significant that women writers were actually protesting male mistreatment of women and were re-signifying traditional constructs of women at a time when few men depicted even exceptional situations in which some women were allowed to break silence. It is significant that the protests by women were not printed more than once, while commonplace male attacks on women went through multiple editions. (See Part I, "The Outspoken Woman.") We move toward a historicizing of male dread of women when we read plays by Renaissance men in which stage adulteresses are harshly punished and even innocent wives are monumentalized, side-by-side with a play by a woman writer who passes gentler judgment on a historical adulteress. (See Part II, "Woman on the Renaissance Stage.")

Finally, we learn a great deal about the gender system of the English Renaissance by recovering and studying the long-neglected writings of Renaissance women. These writings support the contention that some English women did experience a Renaissance, although it was an uneven one. They demonstrate that the Renaissance Englishwoman's experience of the Renaissance was not a carbon copy of the experience of Renaissance Englishmen. The essays in this collection illustrate the partial, often painful emergence of some Renaissance Englishwomen from cultural marginality as they developed a voice of their own. They show us some of the ways in which writings expressing approved values were enshrined and newer, less reverential writings were shunted aside as the canon developed. It is to be hoped that their arguments and the ques-

INTRODUCTION

tions they raise will provide a springboard for further reconsideration of the traditional Renaissance literary canon.

2

All scholars who work in the field of Renaissance women's studies owe an incalculable debt to two brilliant historians, Natalie Zemon Davis and the late Joan Kelly. In her early reassessment of the Italian Renaissance from a feminist perspective, Kelly concluded that a period previously considered crucial to the evolution of modern Western man was a time of restriction for Western women. It is no exaggeration to state that her revolutionary question, "Did Women Have a Renaissance?" and her reply, "there was no renaissance for women—at least not during the Renaissance,"[3] have become a rallying cry and even, alas, a truism for many of her colleagues and followers. We now treat as givens Kelly's cautionary reminders—originally startling in their freshness—that society had become fixedly patriarchal and hierarchical by the end of the Middle Ages, and that women's status and power were greatly reduced during the Italian Renaissance. Natalie Davis's trenchant early (and continuing) analyses of the nature of women's history, as well as her meticulous individual studies of the early modern woman, have also enabled us to conceptualize and direct our work in terms of the larger theoretical framework of historical research in the period. She, too, has helped us to recognize fundamental ground rules, for instance, that "we should be interested in the history of both women and men, that we should not be working only on the subjected sex any more than an historian of class can focus exclusively on peasants."[4]

Since Kelly first re-viewed the Renaissance in Italy with "the doubled vision of feminist theory,"[5] our knowledge about and our attitudes toward many aspects of female identity in the English Renaissance have been increased in quantity and in subtlety. Scholarly perspectives on the position of women in English Renaissance society—on the power, for example, of the female monarch; on the effects of the humanist educational plan on the lives of "ordinary" and "extraordinary" women; on the participation of English women in the economic and religious life of their time; on the absence or proliferation of "Judith Shakespeares" in English Renaissance society; on the exclusion of these women and their contributions from the record of the period—have been immensely refined by the work of many scholars who have followed in Kelly's footsteps.[6]

In particular, several superb collections of essays have raised theoretical questions about Renaissance women of great interest to readers of this volume. *Rewriting the Renaissance* ranges over the whole of Renais-

sance Europe and deals with women's activities in a variety of spheres. *Women in the Middle Ages and the Renaissance* deals not only with a broad geographic and interdisciplinary span, but also covers a much wider period of time. *Ambiguous Realities* focuses on texts, dealing with writings from the whole of Europe during both the medieval and the Renaissance periods. *Silent But for the Word* concentrates on the religious writings of (mainly) Tudor women. And Katharina Wilson's two fine anthologies of writings by medieval and early modern women introduce many texts by women in both periods on the Continent and in England.[7] This present volume attempts to further the work of these earlier collections.

Still further study is essential to reevaluate and rework traditional approaches to the period and to avoid truisms. For the most part, the earlier Burckhardtian assertions "that [Italian Renaissance] women were regarded as equal to men [, that] . . . the education of the women in the upper classes was essentially the same as that of the men [, and that] . . . with education, the individuality of women in the upper classes was developed in the same way as that of men" have been discarded. Our consciousness has been alerted to the patronizing attitudes that coupled these evaluations with such assertions as "These women had no thought of the public; their function was to influence distinguished men, and to moderate male impulse and caprice."[8] But occasionally scholars still question the entire re-viewing of women's history in the Renaissance, denigrate the findings of feminist Renaissance scholars, and/or do not apply feminist insights and methodologies in their own work.[9] Others perhaps accept Kelly's statements too facilely, for the Renaissance is not without great significance for women: we should not ignore the realities of female impact and achievement—despite and around formidable obstacles—during the period.[10] Without denying the broad originality and significance of Kelly's contribution, we may today question whether some of her ideas require occasional moderation. As a student of Renaissance Englishwomen's writings, I find myself in agreement with Elaine Beilin, who answers Kelly's famous question with "a literary critic's much qualified 'yes' " (*RE,* 290 n. 13). Yes, an examination of the writings of Renaissance Englishwomen suggests that at least some of these women did "have" a Renaissance and that the experience of the Renaissance for women has not yet been as fully evaluated as possible.[11]

3

Reconstructing and accounting for all the facets of any period is, however, probably impossible, and highlighting only those areas that

INTRODUCTION

seem most significant to the individual researcher is patently unsatisfactory. "History," in Catherine Belsey's words, "is always in practice a reading of the past," and "criticism . . . always in practice a reading of texts." Both, moreover, are essentially doomed efforts, for any "interpretation is in a sense an anachronism,"[12] and the past is necessarily larger than the sum of even its entire output of documentation. While arduous efforts are being made at reconstructing the Renaissance, the reality of dealing with partial and sometimes inaccessible primary evidence and the problematic of transforming literary and prescriptive sources into a mirror of reality may, finally, be insoluble tasks. The heroic efforts of historical reconstructionists, working for years to reconstitute tiny Renaissance villages, suggest the magnitude and inherent frustration of the task of learning about the historically nondescript, a category that has fitted a perhaps disproportionate number of privatized women.[13] This factor is particularly handicapping when we recognize that, in a sense, there were as many Renaissance Englands as there were individual inhabitants of England during the Renaissance. As Herrnstein Smith notes, "Not only is an entity always experienced under more or less different conditions, but the various experiences do not yield a simple cumulative . . . knowledge of the entity because they are not additive."[14] To analyze the expressed (or inferred) experience of even a group of "known" Renaissance Englishwomen is therefore to understand "their" Renaissance inadequately.

Despite handicaps such as these that beset the would-be student of early modern women, we should persevere. And an analysis of the Renaissance Englishwoman provides a particularly apt subject for scholars in the English-speaking world. For the writings of these women, produced against that often-bleak background which empowered Kelly's famous question, indicate that at least some women in Renaissance England did experience at least a partial Renaissance. And even a minimal degree of historical imagination suggests that this experience played an important role in the subsequent history of Western women.

While the Tudor victory at Bosworth Field in 1487 is one convenient starting point for the Renaissance in England, the more rounded figure 1500 is somewhat neater and perhaps more appropriate. It brings us closer to the rule of Henry VIII (1491–1547), that quintessential Renaissance prince, and to the Renaissance glitter he brought in 1509 to an English throne that was more settled than that his father had occupied. And the year 1660 is a convenient one for closure of the period, since it was the dawn of a restoration, under Charles II, of a monarchy but not of the England of the Tudors and early Stuarts. As the following sketch indicates, events between these dates had profound, if

often unintended, consequences for Renaissance Englishwomen and for the family in Renaissance England.

In sometimes bizarre and unlikely ways, women and the "notion of woman" gained importance under Henry VIII. The stable, early years following Henry's marriage (in 1509) to Catherine of Aragon (1485–1536), exposed the English to the presence of a royal consort who was the pious and educated product of the Spanish Renaissance, a strong, capable, and sophisticated woman who surrounded herself with courtiers imbued with Renaissance learning and piety. The significance of her presence in England can be measured by the fact that the years from 1523 to 1538, a period that includes Catherine's separation from the court and the two years following her death, have been dubbed the "Age of Queen Catherine of Aragon."[15] If the progressiveness on the "woman question" of the group of humanist-courtiers often known as the Sir Thomas More Circle is somewhat debatable, the fact that Catherine inspired and sustained these men is not. Equally certain is the fact that these theorists actually produced a number of works bearing on the nature, education, and treatment of women. In Dorothy Gardiner's striking formulation, "The Cinderella of social problems has become a subject of interest, even of personal enthusiasm to a group of scholars of the first rank; . . . its tutelary spirit is a queen." Recent scholarship has supported Foster Watson's assessment of Catherine's enduring influence on this circle of scholars with the suggestion that at least one of the works of Sir Thomas Elyot was a politically inspired effort to rally around the standard of the deceased queen.[16]

To note Catherine's significance for Renaissance women's history is not to gloss over the significance of her removal from the English court by Henry in 1532. Nor is it to forget that her grave difficulties with her husband were, both during her lifetime and after her death, commonly called the "king's great matter," though they were undoubtedly as great, and much more tragic, a matter for her. And it is not to contradict Ruth Kelso's assessment of the spheres of action of men and women in that time: "The perfect man, . . . was the courtier, resplendent with all the highest human powers and graces, to which only a court could give full scope. The perfect woman, in general renaissance theory, was the wife, married to a man well born and virtuous, and shining in her restricted realm with her own qualities, but only like the moon, with reflected light."[17] Rather, it is to suggest that Catherine's powerlessness in the face of Henry's determination to produce a male heir is perhaps less significant, historically, than the perception of modern scholars that her mistreatment at his hands made her into a public hero, and increased public sympathy for a woman's point of view.[18]

INTRODUCTION

Such events as Henry's long struggle to repudiate and divorce Catherine in order to marry Anne Boleyn, his other notorious marital difficulties, and his succession of replacement queens sensitized the English to questions concerning marriage. They partially account for the enormous amount of writing on this subject which characterizes the period; they led the king—and England—to break with the Roman Catholic church and to an effort, later validated by a commission Henry called for the purpose, to promulgate an authorized Anglican position on questions of marriage and divorce. The consequences of this debate for Englishwomen, who, under an Anglican dispensation, lost the opportunity for even an enclosed career within the convent and were therefore destined for either spinsterhood or wifehood, cannot be overstated. Scholars debate the relative gains and losses for wives within the Roman Catholic and Protestant camps, but most agree that the attention paid by theorists from both sides to the functions of women within the family and to other aspects of family life affected woman's position in what had become virtually her only acceptable roles.[19]

The visibility of the four successor-queens who, with varying degrees of success, followed Anne Boleyn as Henry's consorts was not commensurate with their power. The exhausting public appearances of Jane Seymour following the birth of (the future) Edward VI apparently cost her her life; Anne of Cleves was easily set aside by Henry; the vivacious Catherine Howard was beheaded by him; and Catherine Parr, for all that she restored order to the royal household and ruled England as Henry's regent, narrowly escaped a conspiracy on her life. But these queens and their children also sustained public awareness of Henry's marital difficulties and of the potential threat they posed to public order (by way of uncertainty about the heir to the throne); unsettledness on this subject interacted with the more general questions of order and degree which the English continuously debated, upheld, and subverted. After Henry's death, the incapacity of the sickly Edward VI, the rival claims of Jane Grey and Mary Tudor to the throne, the upheavals and bloodshed connected with their reigns, the tumultuous reign of Mary Tudor (Henry and Catherine of Aragon's daughter), and the general resentment of the influence of her foreign husband all contributed to the public debate about the fitness of women to rule the country. Finally, the accession of Elizabeth (Henry and Anne Boleyn's daughter), her long reign, her inscrutable way of dealing with the questions of her marriage and successor, and the example she gave of capable, enlightened female rule stimulated further controversy over the "woman question."[20]

The lives and achievements of many other exceptional women also had an impact on the period, both during Henry's lifetime and after his

death. Without limiting our view of women's history to "the tradition of Women Worthies [and] the biography of the individual woman,"[21] we should study this impact. Some of these exceptional figures have been included in traditional studies: Anna Bacon is noted as a significant Tudor translator in standard histories of English literature; Margaret Roper, Mildred Cecil, Mary Herbert, Elizabeth Cary, and Mary Wroth, while less celebrated than they should be in scholarly literary histories, are not totally forgotten figures. Other exceptional women are also noted in careful, standard histories: women of the royal family and the nobility like Catherine Parr, Henry's sixth and surviving wife; Margaret Pole, one of Henry's Tower Hill victims; Elizabeth (Bess of) Hardwick, a woman who manipulated the system to rise to the ranks of the nobility; and Anne Clifford, who endured years of strife over an inheritance, which she finally gained; and nonconforming women like Anne Askew, the early Protestant martyr; Margaret Clitherow, a Catholic martyr; Moll Firth (alias Cutpurse, Middleton and Dekker's *Roaring Girl*); and Mary Ward, founder of a system of lay institutes for Catholic women.[22] In their own time, these women were both celebrated and notorious; their very existence altered the contours of both the possible and the forbidden for women and thereby influenced, though sometimes indirectly, the lives of lesser-known contemporary women during England's golden age.[23]

4

From this vantage point, even a rapid analysis of the "golden age" of Shakespeare uncovers an England that was often not a merry one for men or for women. It is necessary to examine this situation with care to distinguish the position and treatment of women and men in Renaissance England. Scholars vary in interpreting some of the phenomena in this period that relate directly to women, but I believe that if we examine some of the broader trends and realities of the society of Shakespeare's age, donning Joan Kelly's spectacles to couple this examination with some of the consequences of these trends for women, we emerge with a picture of the time that is often chilling.

The notion of democratic governance was abhorrent to the powerful in Renaissance England, and they instilled this abhorrence in their "inferiors." While the country lacked a professional police force, the ever-stronger central government maintained a fairly efficient surveillance over even the distant parts of the kingdom, partly with the help of domestic spies and partly through the assize courts. The disadvantaged were viewed with distrust and suspicion, and were, for the most part,

kept under, although the completeness with which the ideal of order and degree was revered and the extent to which the social order was under actual challenge are currently matters of scholarly debate.[24]

The ideal of government, from the point of view of the governing, was absolutist, although the bitterness of absolutism was sweetened by the clever Tudors with shows of love and of merciful concern for both the privileged classes and the common people. Both men and women, even of exalted rank, were often restricted unfairly by the hierarchical nature of English Renaissance patriarchy, as a necessary function of hierarchical conditions operating on persons of varying ages, classes, and status within the family and the society.[25] (This is the essence of the ideal of the great chain of being discussed by Tillyard.) But, as the researches of such scholars as Kelly show, women as a group suffered a uniform disability in the patriarchal tradition of Christian Europe. By the onset of the Renaissance, *all* women had come to be considered inferior to men by virtue of their sex; regardless of class, they *all* suffered a potential disadvantage beyond the *varied* disadvantages suffered, under *varied* circumstances, by *various* men of *various* classes.[26] Moreover, women's sphere of activity had come to be severely limited by law, custom, and theory; women experienced limitations beyond those of men in interpersonal relationships, role possibilities, and patterns of behavior. These limitations held both inside and outside the confines of the home and family—in the dairy, the poultry, the home pharmacy, the kitchen; at the spindle; in the universities, the law courts, the professions, the streets, the theaters, the taverns, the shops, the court.[27]

If the standard of living of royalty and the highest nobility was moderately tolerable from our more comfortable perspective on such matters as sanitation, privacy, and diet, that of even the relatively prosperous citizen was rugged, and that of the vast majority of the population marginal. Events that caused swings in the economic pendulum, such as bad harvests, could result in the uprooting of large portions of the populace who fled desolate areas in search of hoped-for succor in urban centers, in increases in crime among the desperate, and in starvation for those who were not clever or mobile enough to react effectively to threatened or actual disaster.[28]

The vagrant population may not have increased as drastically as the popular literature of the time suggests and as scholars have assumed in the past, but there was some social instability connected with uprooted country folk, with soldiers returned from foreign wars, and, at least at first, with displaced members of dissolved religious orders. "Masterless" persons of both sexes were widely distrusted, and statutes were enacted for the purpose of eliminating their potential for disorder. Not surpris-

ingly, in a time characterized by the generalized conception of women as insatiably lustful, they were singled out in the contemporary literature on vagrants for their sexual license. But respectable and viable options available even to quick-witted women were far more limited than those open to men in a society that had internalized postulates subordinating and limiting women's activities. Displaced women were therefore in a particularly disadvantaged position in restoring themselves to respectable social status: their chief option was domestic work, which often became coupled with illicit liaisons with coercive employers; many were forced into outright prostitution; large numbers as well were driven to crime (usually sex related) through association with urban cony catchers of various types.[29]

If we turn now to consider developments in the field of medicine (particularly in the subfields of obstetrics and midwifery), we can begin to see some of the multiple, sometimes dire (if perhaps indirect) consequences that could result from restrictions on women's activities, restrictions that were reinforced by negative perceptions of women. The right to practice in these fields, which were ominously connected in traditional, misogynist theory with witchcraft, was denied to women by the establishment in 1518 of the Royal College of Physicians, chartered by the central government. This development effectively removed even highly skilled women from medical practice, reducing them to the status of unlicensed lay practitioners, although medical teaching was hardly more advanced than their traditional healing therapies. Cunning folk and midwives—overwhelmingly female groups—were thus placed at high risk of prosecution, and even of being branded as supposed black witches by those who wanted to limit female competition for patients, or by those whose treatment by local cunning women was unsuccessful, or by those who vented hostility toward women by making accusations of witchcraft.[30]

Even midwifery, a field that had traditionally been the homely preserve of women, was gradually taken over by jealous male physicians, an encroachment that became secure in the seventeenth century with the introduction of the "mysterious" forceps by the Chamberlain family. The contrast between the impassioned and unprecedented efforts of London midwives to be allowed to practice their calling and the cynical disregard by the Chamberlains of the life-saving, pain-saving need of women for the effective tool they had developed speaks eloquently of the loss to Renaissance women of the nurture of other women. However, in addition to this denial to women of the right to practice midwifery, and the loss to patients of the nurture of female practitioners of obstetrics, the increased marginalization of outcast women, a factor linked to the

INTRODUCTION

"criminalization of women" during this period, drastically limited the access of many lower-class women to any obstetrical treatment.[31]

True, the primitive state of Renaissance medical knowledge and practice created sex-specific danger for women of *all* classes because of the seeming inevitability of pregnancy among sexually active women at a time when contraceptive knowledge and practice were limited and largely ineffective and repeated childbearing and delivery were highly risky. But those married women who could afford a fee were able to secure obstetrical attention, even if its worth was questionable. As noted above, however, growing numbers of lower-class women were being forced by economic hardship to migrate to cities where the lack of respectable work options for women drove many into illicit sex. Simultaneously, fear of perceived social disorder, and particularly fear of disorderly women (extensively conflated in Renaissance England with promiscuous women), led, over the sixteenth century, to repeated and gradually harsher governmental efforts to control unbridled women. Official pronouncements, comments in obstetrical journals, and popular denunciations suggest that single women in this unenviable situation, afraid of the social and legal penalties for bearing illegitimate children, tried increasingly to conceal their pregnancies, to deliver in secrecy, and to commit neonaticide. In the early seventeenth century, as a result of an official perception of a growth in illegitimate births and infanticides, growing governmental fear of disorder, and local efforts to limit (newly instituted) parish support to often poor mothers and their infants, a statute was enacted sentencing to death these "many lewd Women that have been delivered of bastard children [and who] to avoid their shame, and to escape Punishment do secretly bury or conceal the death of their children. . . ."[32] In this grim social climate, women were literally victimized and rendered unable to help themselves by the social and theoretical codes of a hierarchical society that responded to their "fearful" sexuality by subordinating them.

Male anxiety about female sexuality, male efforts to control it, and female efforts to resist this control are dealt with in the three essays that constitute section two of this anthology, "Woman on the Renaissance Stage." Viewed from a slightly broader perspective, these essays consider imaginings of female empowerment, suppression, and resistance in Renaissance drama. While it is at best difficult to disentangle life and art in literary portrayals, these portrayals certainly fall within the circumference of the imaginable to the English Renaissance mind, and therefore of the range of options for female sexual behavior conceivable in the period.[33]

In Her "Sin and the Politics of Penitence: Three Jacobean Adulter-

esses," Anne M. Haselkorn analyzes the portrayals of Evadne (*The Maid's Tragedy*), Vittoria (*The White Devil*), and Bianca (*Women Beware Women*) to demonstrate the impulses of three male dramatists to bring sexually active women under control. Although Haselkorn's essay does not deal with actual women in English Renaissance society, it does grapple both with the use of sexuality by women as a means of advancement and with the reactions of men to sexually aggressive women. The courtly adventurers with whom Haselkorn deals tried to gain power through sexual maneuvers that universally destroyed these unsympathetically portrayed women.

The subject of Tina Krontiris's "Style and Gender in Elizabeth Cary's *Edward II*" is the tendency by a woman playwright to rewrite negative accounts of the adulterous Queen Isabella by earlier male dramatists and historians. Although Cary could not change the bitter historical ending of Isabella's life, she evinces considerable sympathy for the queen's misfortunes. Krontiris suggests that Cary's sympathy for Isabella's misfortunes and actions are a result of this unusual woman writer's own hard struggles against suppression and for religious independence.

The male tendency to "possess [women who are] beyond possession," to immobilize women in order to control them, is discernible in Shakespeare's plays, as Abbe Blum demonstrates in her essay, " 'Strike all that look upon with mar[b]le': Monumentalizing Women in Shakespeare's Plays." Focusing on the complex statue scene which concludes *The Winter's Tale*, Blum considers the Western tendency to set up unavailability as a feminine quality in order to "render certain and permanent what is unknowable, unavailable, lost." Hermione's enigmatic return to life enables Blum to pose questions about some "provisional, constructed aspects of gender and identity" in the play.

5

That a society in which both life and art suppressed women so severely was ruled by a woman for close to fifty years is highly ironic. Yet, although many women did rule in Europe during the sixteenth and seventeenth centuries, there is no doubt that the woman ruler was incongruent with the mores of this period concerning woman's place. The adroitness and political genius of Elizabeth Tudor endeared her to her subjects, but her rule was not established easily or unshakily: broad, traditional questions concerning the rule of a woman, inflamed in England by the clumsiness and misgovernance of Mary Tudor and Mary Stuart, were aroused by her accession. The notoriously ill-timed tract by John Knox which heralded Elizabeth's accession to the throne is but one

INTRODUCTION

well-known sally in an involved, long-standing controversy on the woman ruler.[34] This debate was muted while Elizabeth ruled, in part through her flair for self-camouflage and her empathy with her subjects' thinking. But such fundamental dislike of a woman's rule was not ended by Elizabeth's competence. Elizabeth did not interest herself in bettering the lot of other women—perhaps because she felt that her own success depended on setting herself apart from them. Both the contemporary impact of Elizabeth's presence at the top of the English social pyramid and her continuing influence on a society in which women were normally subordinated are difficult to assess. But debate on the propriety of a woman's rule grew vociferous under her successor, James Stuart.

Even at the height of her power, Elizabeth could not exercise power as straightforwardly as her male counterparts, though, unlike the two Marys, she learned to develop sophisticated methods for circumventing invidious constraints.[35] Still, it is widely recognized that Elizabeth's firm grasp of the power she wielded so effectively was accomplished only through her personal sacrifice of ordinary domestic life. This sacrifice was a necessity if she was to remain an independent ruler, whatever the effects on her "political body" of the fictions enacted by Parliament. Although Elizabeth's rhetorical strategies for dealing with the pervasive prejudices against female sovereignty have been dealt with in the past, her less-studied comments at important moments—at the time of James Stuart's birth, for example, and just before her own death—are not only revealing, but also pitiful.[36] They highlight the fact that in an age when male authority was buttressed by traditional religious and political thought and when treatises trumpeted the near-universal assumptions of male headship and female subordination, the woman ruler—present in historical fact in abundance—was an anomaly at best.

Section three of this volume, "The Woman Ruler," crosses disciplinary boundaries to deal with representations of the empowerment of and restrictions on the female ruler during the English Renaissance. In "Representing Political Androgyny: More on the Siena Portrait of Queen Elizabeth I," Constance Jordan analyzes Elizabeth's manipulation of official portrait imagery to create a visual androgyny to match her oratorical androgyny. The result, Jordan shows, is an oxymoronic portrait that portrays Elizabeth simultaneously as virginally intact and sexually unbridled, possessed of an acceptably princely masculinity.

Clare Kinney considers Shakespeare's figuring of a historically chimerical woman ruler in "The Queen's Two Bodies and the Divided Emperor: Some Problems of Identity in *Antony and Cleopatra*." In a close and exciting reading of Shakespeare's play, Kinney distinguishes between

the gender-bound identifications of Cleopatra with Egypt and of Antony with Rome.

And Josephine A. Roberts suggests the ambivalence in the mind of even a woman writer concerning a woman's rule in her "Radigund Revisited: Perspectives on Women Rulers in Lady Mary Wroth's *Urania*." After tracing the tradition in which Radigund had appeared before Wroth's use of this figure, Roberts suggests that Lady Wroth, writing some twenty years after the death of Elizabeth I, had internalized negative, patriarchal conceptions about the woman ruler and was unable to imagine a woman ruler who could successfully combine the contradictory private and public personae required of this figure.

Since some Renaissance Englishwomen besides the reigning monarch did manage to circumvent the usual and heavy restrictions on women's public and economic functioning, it cannot be said that all women were reduced to domestic roles in Renaissance England. Two of Henry's wives, Catherine of Aragon and Catherine Parr, ruled England as his regents. Some noblewomen were enabled by various factors, sometimes in the form of powerful male relatives, to participate actively in public life. Margaret Beaufort, the mother of Henry VII, probably was named high commissioner of the Council of the North, and Anne Clifford served as sheriff of Westmoreland in the seventeenth century; many women served as executors of their husbands' wills, and some, including the countess of Shrewsbury, may have served as justices of the peace and as churchwardens. In times of extraordinary disorder Renaissance Englishwomen were sometimes called upon to act in the place of a man, as medieval women had frequently been called upon to do. But the movement of the period was toward an increasing rationalization of law, which meant a standardization of inequality under law. Late in the period, during the Civil War, women of lesser status tried, with little success, to act collectively on public matters.[37]

6

Restrictions took hold as the Renaissance advanced. Active participation by women in their husbands' guilds, an important right at the beginning of the Renaissance, became increasingly restricted. And opportunities for women in trade—with landless men and women thrown into a cheapening pool of wage laborers—became concentrated in subsistence areas. Crafts dominated by women—spinning, for example—plummeted in prestige and pay, while women were excluded from more prestigious occupations, like weaving. The role of women in the economy generally became limited to less creative and entrepreneurial

roles, subsidiary to those of male producers. And the wages paid to women were always lower than those paid to men. Finally, fewer women of humbler circumstances were able to ply trades and to earn profits from their own produce. Many families were driven off the land, eliminating the source of, say, surplus dairy goods for marketing. And more time had to be devoted by many housewives remaining on the land to subsistence activities.[38]

Since the ruling woman was a dual-figured anomaly during the English Renaissance, functioning as ruler to her people but as subordinate to her husband, and since the public role of women became increasingly diminished, the private woman became "Everywoman." Her lot, succinctly described, was suppression. Legal and conventional restrictions limited most women to a private life, in which the hierarchical arrangements that characterized the political scene were consciously extended into theory about and practice within the family and about the place of the daughter/mother-wife-mistress/widow within it. It is true that woman's status in the family was the subject of intense, sometimes sympathetic attention at this time; under extraordinary and restricted circumstances she was granted freedom to follow her conscience. Nonetheless, as I shall argue below, the duty of the "ordinary," subordinated Renaissance Englishwoman was to maintain an absolutely chaste, obedient, silent, and pious private life, and this role was not necessarily a pleasanter one than the woman ruler's more complex task. The exception was the widow, who often enjoyed great independence. Still, the widow was commonly viewed with suspicion and disapproval; her chastity was often considered suspect.[39]

In this regard, the widow was treated like all other women, for though both men and women in Renaissance England were constantly admonished to be chaste, the onus of this requirement fell more heavily on women. Arranged marriage, a not uncommon, if sometimes debated practice, demonstrates this point. It is true that upper-class men, like women, were often bound by their parents' (read fathers') choices of "suitable" marriage partners. But it is also true that men had both professional and sexual opportunities for relieving needs that were unmet in their marriages, while most women were rigidly confined to a private life and held to a more rigorous standard of chastity than men. Even if affective family ties were often strong, a point that twentieth-century scholars debate fiercely, no one debates the relatively restricted position of women within the family. The results of this inequality for even titled women were often hideous.[40]

Wives were also held to an absolute standard of obedience to their husbands. Here is the frequently reprinted Vives on the duty of obe-

dience: "a woman ought to absteyne from yll, but in al good thynges, to obey none other wyse, than though she had ben bought in to the house as a bonde and hande mayde."[41] Scholars have noted repeatedly that wife beating was legally allowed the husband, if sometimes disapproved. The injustice of the wife's position was not widely questioned. The well-known plights of Anne Askew and Catherine Parr suggest that the ideal of obedience held grim sway in many cases. It is likely that Askew, who had joined a coterie of learned, pious women centered on Catherine, was tortured in order to implicate Catherine in charges of conspiracy. But Askew's supposedly arbitrary separation from her husband and Catherine's supposed insubordination to Henry were powerful elements in the attempt to discredit both women. Askew, in fact, became a martyr to the Protestant cause; Catherine was reduced to demeaning herself abjectly to avoid a like fate.[42]

7

As to silence, frequent and uncompromising injunctions on this score reverted to Paul (1 Cor. 14:34, and 1 Tim. 2:11) and were commonplaces, roundly hurled at women. It is often said that the very frequency with which Englishwomen were admonished to obey their domestic lords in silence shows that they resisted this ideal vociferously and successfully. Common sense, church sentences for shrewish women, and various literary portrayals of "curst" women all suggest that this must have been true, at times. But idealized portraits of silent women, such as that written by Phillip Stubbes after the death of his young wife, and frequent references by women writers to the impropriety of their breaking silence, even with the written word, show that this ideal, if not always honored, was deeply entrenched.[43]

The three essays in section one of this anthology, "The Outspoken Woman," explore outspoken stances adapted by some actual women and allotted to some fictive women during this period which so often imposed silence (as well as chastity and obedience) on women in theory and in practice.

Ann Rosalind Jones's "Counterattacks on 'the Bayter of Women': Three Pamphleteers of the Early Seventeenth Century" analyzes various stances adapted by both fictional and actual women in three exuberant pamphlets written in 1617. The pamphlets, which fall within the category of "defenses of women," are, in actuality, attacks on *The Araignment of Lewde, idle, froward, and unconstant women* (1615), by Joseph Swetnam, a notorious male pamphleteer. Appearing under sometimes identifiable women's names, these pamphlets, which expand and

INTRODUCTION

accelerate the traditional *querelle des femmes,* instance variations on the positions open, clear, and expressible by women, embodying the gamut of possible female views on the nature and capabilities of women during the English Renaissance. They demonstrate the development of a mini-tradition for female defenses and contain both traditional and innovative arguments for female resistance and subversion under patriarchy.

Ira Clark's essay, "The Power of Integrity in Massinger's Women," analyzes the partial political empowerment, by means of public speech, of two of that playwright's chaste female characters. Allowed a public voice in defense of their rights, Camiola in *The Maid of Honour* and Cleora of *The Bondman* speak out in public forums to attain a degree of autonomy within relatively beneficent patriarchal constraints. From this perspective, they constitute a less radical, but palpable, version of female dignity and integrity than Jones's more outspoken writers.

Similarly, the many female personae constructed by Thomas Campion to voice lyric complaints about faithless male lovers evince a perception, perhaps even an advocacy, by that male poet, of the existence of a female point of view. The poems discussed by Gail Reitenbach demonstrate the irony of the first line she has quoted in the title of her essay, " 'Maydes are simple, some men say': Thomas Campion's Female Persona Poems." The voices provided by Campion for his female speakers extend the range of woman's voice in Renaissance poetry. His female personae can be profitably compared with Mary Wroth's Pamphilia (discussed by Naomi Miller, in section five, below).

8

A fourth quality deemed essential to the Renaissance woman was piety. In England, little attention was paid before the Renaissance to the education of secular women, including their education in piety. In this, England was like the rest of Christian Europe which had never questioned the assumption that the daughters of Eve, who like her were inferior to the male and punished for her revolt in Paradise, were condemned to subordination to their husbands (read obedience) and to silence and were of course expected to be chaste. Christian Europe had largely ignored and had commonly denigrated the capacity of women for enlightened religious experience, aside from those women who had renounced their feminine nature. All women were expected to conform to pious standards of behavior, although such behavior was not inculcated by formal education. But, as I will show at greater length below, the English Renaissance, unlike the earlier Renaissance in southern Europe, was characterized by a renewed and profound Christianity,

joined to serious reform efforts by both Catholics and Protestants. Equipped with largely similar programs for religious reform, leaders from both these groups consciously attempted to inculcate a relatively learned piety even in secular women. Such piety was the bedrock on which women's obligations were based or, more baldly, the basis for their continued acceptance of subordination.[44]

The reformers were interacting with a religious mentality that, when it had developed beyond a superstitious belief in church magic, was traditionally Roman Catholic, and that viewed women in the pit-pendulum positions of Eve and Mary. The misogynist trappings of the demonized pole of this opposition, it is now widely recognized, were somewhat offset by the Catholic models of woman as saint, intercessor, and healer, though such exceptional women did not validate the woman in the world. Where traditional belief was supplanted by Protestantism, women lost the softening models of Mary and the saints, but gained concretely from the theoretical importance ascribed to domestic life and child rearing by the Protestants, as well as from their interest in the priesthood of all believers. Catholic women made individual gains, too, as the Catholic church reacted to Protestant criticisms through internal reforms. There is good reason to note the positive effects on Renaissance women of both Protestant and reformed Catholic theory.[45]

However, while an interest in addressing the religious needs of secular women was an advance of sorts for women, especially as it recognized their intellectual capacities and as it attempted to raise the level of family life and child rearing, it was not an effort to enlarge the rights of women, who continued to be confined to domestic roles. Sir Thomas More's letters to his beloved daughter Margaret indicate that women in England were not expected to publish their learned work. Theorists of the period did not interest themselves in the public functioning of women, at least not outside Utopia. Similarly, an early document in English commending the education of women, Richard Hyrd's laudatory preface to Roper's anonymously published translation of a treatise by Erasmus, praises the joy that the translator and her husband take in their privately shared studies.[46]

True, such privatization was not universal: many upper-class and urban women became deeply involved in religious factionalism. Religious strife provided an opening of sorts into religious institutionalism, and women, in whom intense religious devotion was increasingly inculcated, frequently stepped into this breach, providing material and personal support for various factions. The enthusiasm with which this support was received demonstrably underwrites the importance of women as partisan supporters of various religious groups, and scholars

INTRODUCTION

have documented the immensely important and powerful role that women played in both the Catholic and Protestant camps. But despite temporary, largely individual gains, women did not achieve institutionalized power within the churches. Englishwomen were not allowed to act as official functionaries of either the established or the reformed churches, even though they played an important, sometimes vital role in the evolution of those churches and responded with understanding and commitment to contemporary religious ferment. Seen more cynically, therefore, male enthusiasm for their support amounted to a form of manipulation because women did not achieve institutional gains from their partisan efforts.[47]

9

There was even negative fallout for activist women. The wives of Protestant ministers in England experienced great distress because their status was equivocal at a time when the English church switched back and forth from the ministry of celibate priests to that of married men. Even under the undoubtedly Anglican rule of Elizabeth, the status of these women was unenviable because the queen did not approve of married clergy and refused to acknowledge the existence of her ministers' wives. By the mid-seventeenth century, the activism of women in the Protestant sects had become suspect. In the Catholic camp, the importance of women in maintaining the vigor of the recusant cause was so great that the Catholic community in Renaissance England has been termed "in effect a matriarchy" by its greatest historian. But the political position of Catholics of both sexes was certainly a precarious one.[48]

It should be noted that the general population, including the masses of women (as opposed to educated, urban trend-setters), remained long indifferent to and ignorant of the wide swings in England's official religious policy. This indifference and ignorance is to be attributed to such factors as the ineptitude and personal corruptibility of much of the clergy rather than to governmental inaction or indifference. Because of governmental fear of religiously tinged subversion, factionalism became so suspect in the last years of Henry VIII's reign that Anne Askew was tortured by high officials with their own hands, a most unusual treatment for a woman of gentle blood.[49] To the same end, though less violently, Edward VI initiated the reading of *Certayne Sermons*, a cycle of authoritative lectures to be delivered from the pulpit in order to popularize official religious tenets. Among these sermons were a trumpet blast "Against whoredom & adultery," and "An exhortation to Obedience," an espousal of hierarchy in all of society, which included

descriptions of ideal domestic behavior by wifely subordination to the husband on the model of the subject's submission to the prince. The readings of these sermons, discussed in this volume by R. Valerie Lucas, were continued unabated by Elizabeth, who, despite her promise to forebear "inquisition of their [her subjects'] opinions for their consciences," maintained a network of spies to uncover religious sedition, always connected in the official mind with political sedition (as the entrapment of Mary Stuart indicates).[50] But the efficacy of this governmental decree was uneven, since many parishes lacked a competent, or even a resident vicar.

There is every reason to believe that officials joined political and religious notions about the subjection of women to bind women even more than they bound men. As the author of an early seventeenth-century treatise on law states, "Women have no voyse in Parliament, They make no Lawes, they consent to none, they abrogate none. All of them are understood either married or to bee married and their desires or subject to their husband, I know no remedy though some women can shift it well enough. The common Law here shaketh hand with Divinitie. . . ."[51] And the result of the inculcation of piety in women was a willingness on the part of women to accept the strictures of the period on silence, chastity, and subordination to men on religious grounds. The entanglement of religious and political beliefs about women's place and the internalization and absorption of these beliefs by women are treated in section four of this anthology.

In "Griselda, Renaissance Woman," Judith Bronfman discusses the proliferation during the English Renaissance of accounts of Griselda, that standard of perfect, willing subordination. Celebrated on the stage and in broadside tracts and ballads, Griselda was a model used to teach the virtues of submissiveness to wives throughout the Renaissance.

In her "Puritan Preaching and the Politics of the Family," R. Valerie Lucas analyzes the efforts of three Puritan preachers to imbue their sometimes recalcitrant female listeners with the ideal of the absolute subordination of wives to their husbands. Using the "Homily of the state of Matrimony" and sermons by William Whately and Thomas Gataker as copy text, Lucas dissects the effective methodology of these preachers in presenting a patriarchal conception of the family as mandated by God. But Lucas also shows that some of the women in the Puritan audience were unhappy with these preachings.

And in "'His wife's prayers and meditations': MS Egerton 607," Betty S. Travitsky examines the manuscript writings of Elizabeth Egerton, countess of Bridgewater, to demonstrate the assimilation by this countess of the axioms of female subordination and obedience. In addi-

INTRODUCTION

tion to her avowedly religious compositions, the countess's writings throw light on her strong feelings about her family. And the manuscript includes two essays on marriage and widowhood that attest to her acceptance of subordination to her husband as a religious duty.

10

Rigid hierarchization of society, increasingly rigid religious standardization, rigid domestication of women, and denial of equal opportunity to them in both public and private capacities, then, are the facts of Renaissance Englishwomen's lives, which emerge from recent scholarly investigations of the question as to whether women had a Renaissance. Englishwomen of all classes were denied opportunities open to men, were subjected to legal, economic, and religious constraints, made susceptible to criminalization, and (especially younger and older women) made vulnerable to scapegoating as lewd women or witches. These tendencies support Joan Kelly's skepticism. Still, I believe, on the basis of the records that they left behind them, *some* Englishwomen did experience a Renaissance during the English Renaissance. Their writings are an effect of the new Renaissance educational ideals for women which differed from those of medieval England. And these artifacts show that despite the barriers to their experience of some form of that humanism which is, perhaps, to the twentieth-century scholar the essence of the privileged Renaissance experience, many educated Renaissance women did develop the "interiority" that is the most enduring of Renaissance legacies.[52]

The advocacy of women's education by Christian humanists and Protestant reformers (alluded to earlier in this introduction) was the incubator of this development. Yet, as our discussion of piety suggests, this advocacy was paradoxical: while humanist and Protestant theorists paid startlingly new attention to women's minds, they did so to uplift women's personal spirituality and to equip them better for their traditional, domestic roles. Moreover, the theorists plied their attentions unevenly. The humanists simply did not develop a practical system for educating women, and the only women affected by their relatively esoteric theories were therefore noblewomen and (occasionally) women from humanist or court-affiliated families of lower status, like the Mores and Cookes. The somewhat later Protestant religious reformers did attempt to reach a wider range of women with a more modest program of studies, but the moderately educated lower-class women who were the targets of their simpler educational goals were not widely evidenced until late in the seventeenth century. And even the most advanced of the

theorists did not advocate identical educational programs for men and women. Neither group of men suggested public or professional applications for the educated women whom their theories produced. They did not advocate, and would not have approved, the printed works of these educated women, which are, perhaps, the most lasting effect of their program.[53] (See Elaine Beilin's annotated bibliography of these writings in this volume.)

11

If we examine the known corpus of writings by Renaissance Englishwomen, especially published writings, we do not, in absolute terms, find a large number of women writing at all, and this is not surprising, given the milieu and training outlined above. We note that almost all the women who wrote were members of the educated, more privileged classes. But we do find during this period, as one important consequence of the educational changes for women and their growing self-awareness, that privileged Englishwomen did begin to write—usually with apologies for their temerity, usually in conformity with the ideals of their time—in numbers enormously increased over those of earlier periods.[54] Knowing that these women had been restricted to the private sphere and to a subordinated role, and that they had been instructed in the ideals of chastity, obedience, silence, and piety, we wonder whether the enhanced sense of self-purpose and of self-respect that we would expect to result from a strong education could coexist well with such suppression. But we do not find a large number of women enacting or expressing a consciousness of this contradiction, much less a resentment of it.

The unusual education and milieu of the women writers of Renaissance England perhaps explain why these women differ from the six types of women writers that Katharina Wilson has identified on the Continent.[55] For obvious reasons, English women writers do not include *nuns* with the exception of several early figures and, later, continental exiles.[56] They do not include any *cortigiana onesta* (or parallels to the Greek *heteira*), the closest among them to an identifiable, arguably free spirit being Isabella Whitney, a self-supporting urban woman whose interests, however, have been described by one critic to have "revolved around living the godly life in a middle-class environment."[57] The *scholars* among them tend to be the subjects of male-written works on the education of women, rather than the authors of original, learned works.[58] In addition, women scholars seldom published original, learned works; their writings tended to be translations rather than original treatises. Speaking roundly, even the *grandes dames* among

INTRODUCTION

English women writers, if that term means rulers and other high ranking women, tended to publish more religious than secular works.[59] *Religious political activists* tended, before 1640 at any rate, to be privileged women, not members of the urban poor.[60] And *gentlewomen writers, members of the provincial urban patriciate* were rare almost to the point of invisibility.[61] (The subcategory of *urban women writers* is small, and such women, while sometimes drawn from court-servitor circles, were not generally members of the upper classes.)[62]

Given the constraints on the women writers of the English Renaissance, such as their education within a highly pious and conformist tradition and the restrictions imposed by even the most liberal educators of women on female creativity in words, we would not expect highly innovative, genre-shattering forms of writing from their pens. We would instead expect just that diffidence and/or self-consciousness that those who do break silence express about their boldness in doing so. Nonetheless, we do not find that their writings are merely an echo of the writings of Renaissance men. If Renaissance Englishwomen can be said to have developed a new genre, this innovation would be the mother's advice book, actually a variation on the more traditional advice book by a father. And, among their unpublished writings we are perhaps not surprised to find early specimens of what Domna Stanton has termed "autogynography."[63] (See the essay by Betty S. Travitsky in this volume for some discussion of this new woman's genre.) On the whole, though, while the women writers do sometimes break some new structural ground, the differences between their writings and those of their male compatriots are thematic rather than formal. It is primarily in the point of view of the writers, the expression of a different frame of reference, a different dimension of experience, such as family affairs, or a twist on a familiar theme, rather than a feminine development of new forms, that the distinctive contribution of these women lies.

As noted above, several contributors to this collection discuss women writers of the English Renaissance. Ann Rosalind Jones considers two— or three—women pamphleteers of the early seventeenth century who employ the debate tradition to attack male detractors of women.[64] Jones illustrates the successful take-over by these women of the tactics of male controversialists as well as their innovations, such as the mock trial of Joseph Swetnam in Ester Sowernam's pamphlet. Tina Krontiris analyzes a little-known work by Elizabeth Cary that is poised between biography and drama, showing that Cary, the only Renaissance Englishwoman to write and publish an original drama in English, takes an original, sisterly position toward Queen Isabella. And Betty S. Travitsky dis-

cusses the lack of independence shown by Elizabeth Egerton in her manuscript periodic journal when that countess discusses the nature of marriage and widowhood.

The women of the Sidney family are outstanding among women writers of the English Renaissance for both the quality and the nature of their writings. Section five of this collection concentrates on the prominent Sidney family, which is outstanding for major contributions and alterations to the English literary tradition effected by both male and female writers. Beth W. Fisken and Gary F. Waller take different positions on the poetic independence of Mary Herbert and raise provocative questions about the reading of texts by women. Maureen Quilligan, Margaret Anne McLaren, and Naomi J. Miller discuss Mary Wroth's writings in the context of writings by Philip and Robert Sidney and Edmund Spenser, alerting us to oblique and silent factors in the tradition Wroth emanated from and in her own contributions to our literary tradition.

In "The Countess of Pembroke and Gendered Reading," Waller considers Mary Herbert, sister of Sir Philip Sidney, as translator of the Psalms (perhaps more accurately as a rewriter of the Psalms as new poems), of Petrarchan poetry, and of religious tracts, and discusses the gender-sensitive readings that should be brought to a consideration of her works. In " 'To the Angell Spirit . . . ': Mary Sidney's Entry into the 'World of Words,' " Beth Wynne Fisken considers the countess as the author of a poem of mourning for her brother. As translator, Herbert advanced English prosody by her careful, committed writing and revision. As mourner for her brother and collaborator, she advanced female poetic independence in writing about Sir Philip.

Mary Wroth, Sir Philip's (and Mary Herbert's) niece, is considered in this volume as the author of a masque, of a romance, and of a crown of sonnets, all works within the family literary tradition and all works marked by differences that can be traced to her gender. In "Rewriting Lyric Fictions: The Role of the Lady in Lady Mary Wroth's *Pamphilia to Amphilanthus*," Naomi J. Miller considers the differences between Wroth's sonnet sequence, particularly her crown of sonnets, and those composed by Sir Philip and by his brother, Sir Robert, Wroth's father. And Margaret Anne McLaren considers "An Unknown Continent: Lady Mary Wroth's Forgotten Pastoral Drama, 'Loves Victorie,' " a courtly masque, which McLaren shows to be marked by the language of avoidance. This peculiarity is linked by McLaren to the patriarchal climate of James I's court. Finally, Wroth's romance is considered within the gendered Sidneian tradition by Maureen Quilligan. In "Feminine End-

INTRODUCTION

ings: The Sexual Politics of Sidney's and Spenser's Rhyming," Quilligan considers Wroth's *Urania* in the context of the romance traditions established in Elizabethan England by Spenser and Sidney.

The final essay in this anthology, Elaine V. Beilin's painstaking, descriptive "Current Bibliography of English Women Writers, 1500–1640," establishes the current parameters of scholarship on the Renaissance English woman writer. Her list, which is organized generically and which includes later reprints of writings by women of the Renaissance, delimits the present "canon" of Renaissance Englishwomen's writings and provides comments and a focus which are useful for future scholarship on this subject. Beilin's essay suggests prospects for editing, for publishing, and (by extension) for disseminating and teaching the writings of Renaissance women. As this introductory essay has argued, these writings provide us with access to the tenuously modulating position of women during this period and with a clue to their development of Renaissance "interiority." For this reason, and also because the record of restrictions on and resistances by women can be traced in them but cannot be studied as directly in the writings of Renaissance men, the inclusion of women's writings in the canon is essential to an adequate understanding of the period. As archival work on Renaissance Englishwomen continues, additional records will undoubtedly come to light. Our knowledge and understanding of the written records of the English Renaissance will be further balanced by considering new material, and a measure of gender-balance will be introduced into the study of a period that, until recently, has been too often limited to study of the male perspective. The essays in this volume are presented as a contribution to this evolving study.

Notes

I am very grateful to Margaret W. Ferguson, Jean Howard, and Arthur Kinney who took the time to read early drafts of this essay and to suggest many valuable improvements. The faults that remain are my own.

1. Barbara Herrnstein Smith, "Value," in *Canons,* ed. Robert von Hallberg (Chicago: University of Chicago Press, 1983), 28; see esp. 27–35.

2. Rosalie L. Colie, *The Resources of Kind: Genre-Theory in the Renaissance,* ed. Barbara K. Lewalski (Berkeley: University of California Press, 1973), 76.

3. Joan Kelly-Gadol, "Did Women Have a Renaissance?" in *Becoming Visible: Women in European History,* ed. Renate Bridenthal and Claudia Koonz (Boston: Houghton Mifflin, 1977), 137–64.

4. I refer particularly to Natalie Davis, " 'Women's History' in Transition: The European Case," *Feminist Studies* 3 (1976): 83–103, esp. 90, and to Davis's *Society and Culture in Early Modern France* (Stanford: Stanford University Press, 1975). Of course, there are many other outstanding historians of women who are contributing greatly to

our knowledge of the early modern period, but the contributions of Davis and Kelly to this effort are fundamental.

5. Joan Kelly, "The Doubled Vision of Feminist Theory," in *Women, History, and Theory: The Essays of Joan Kelly,* ed. Catharine R. Stimpson et al. (Chicago: University of Chicago Press, 1984), 51–64.

6. For recent discussions of the power of the female monarch, see Carole Levin, "Queens and Claimants: Political Insecurity in Sixteenth-Century England," in *Gender, Ideology, and Action: Historical Perspectives on Women's Public Lives,* ed. Janet Sharistanian (Westport, Conn.: Greenwood, 1986), 41–66, and Patricia-Ann Lee, "Reflections of Power: Margaret of Anjou and the Dark Side of Queenship," *Renaissance Quarterly* 39 (1986): 183–217.

For a sampling of recent assessments of highly learned women, particularly on the Continent, see Patricia H. Labalme, ed., *Beyond Their Sex: Learned Women of the European Past* (New York: New York University Press, 1984). For less learned women, in England, see David Cressy, *Literacy and the Social Order: Reading and Writing in Tudor and Stuart England* (New York: Cambridge University Press, 1980); Keith Wrightson and David Levine, *Poverty and Piety in an English Village: Terling, 1525–1700* (New York: Academic Press, 1979), esp. 142–72; and Margaret Spufford, "First steps in literacy: the reading and writing experiences of the humblest seventeenth-century autobiographers," *Social History* 4 (1979): 407–35.

A recent study that focuses on the economic activities of women in England is Susan Cahn, *Industry of Devotion: The Transformation of Women's Work in England, 1500–1600* (New York: Columbia University Press, 1987). Alice Clark, *The Working Life of Women in the Seventeenth Century* (1919; reprint, Routledge and Kegan Paul, 1982), remains extremely valuable, as Cahn demonstrates. Recent studies of the economic activities of continental women include the following: Barbara A. Hanawalt, ed., *Women and Work in Preindustrial Europe* (Bloomington: Indiana University Press, 1986); Martha C. Howell, *Women, Production, and Patriarchy in Late Medieval Cities* (Chicago: University of Chicago Press, 1986); Merry E. Wiesner, *Working Women in Renaissance Germany* (New Brunswick, N.J.: Rutgers University Press, 1986).

For some studies of women's participation in religious life, see Natalie Davis, "City Women and Religious Change," in her *Society and Culture in Early Modern France,* 65–95, a rigorously balanced assessment of the effects of the Catholic and Protestant positions on women; Kathleen Davies, who questions the originality of Protestant ideology about women in "The sacred condition of equality—how original were Puritan doctrines of marriage?" *Social History* 5 (May 1977): 563–80; and Sherrin Marshall Wyntjes, "Women in the Reformation Era," in Bridenthal and Koonz, *Becoming Visible,* 165–92, which concentrates on Protestant changes.

The absence of Judith Shakespeares is posited by Virginia Woolf, *A Room of One's Own* (New York: Harcourt, Brace and Co., 1929), esp. 71–87. For recent studies of writings by women, see Betty Travitsky, ed., *Paradise of Women: Writings by Englishwomen of the Renaissance* (1981; reprint, New York: Columbia University Press, 1988), hereafter *PW;* and Elaine V. Beilin, *Redeeming Eve: Women Writers of the English Renaissance* (Princeton: Princeton University Press, 1989), hereafter *RE.*

On the exclusion of women and their contributions from the record, see Minna F. Weinstein, "Reconstructing Our Past: Reflections on Tudor Women," *International Journal of Women's Studies* 1 (March–April 1978): 133–40.

For a sampling of this refinement of scholarly perspective, see Retha M. Warnicke, *Women of the English Renaissance and Reformation* (Westport, Conn.: Greenwood, 1983); Linda Woodbridge, *Women and the English Renaissance: Literature and the Nature of*

INTRODUCTION

Womankind, 1540–1620 (Urbana: University of Illinois Press, 1984); Lisa Jardine, *Still Harping on Daughters* (Rutherford, N.J.: Barnes and Noble, 1983); Elizabeth H. Hageman, "Women Writers, 1485–1603" (409–25), and Josephine A. Roberts, "Mary Sidney, Countess of Pembroke" (426–39), in *English Literary Renaissance* 14, no. 3 (1984); and Elizabeth H. Hageman, "Recent Studies in Women Writers of the English Seventeenth Century," ibid. 18, no. 1 (1988): 138–67.
 Possibly the most exciting and probably the most ambitious project in prospect at this time is a newly funded NEH program to be directed by Susanne Woods. Currently titled "Women Writers in English, 1330–1830," this collaborative effort will put together a computer data base of pre-Victorian women's writings in English, tagged for computer retrieval. Hard copy of some of the texts is also anticipated.
 7. Margaret W. Ferguson, Maureen Quilligan, and Nancy J. Vickers, eds., *Rewriting the Renaissance: The Discourses of Sexual Difference in Early Modern Europe* (Chicago: University of Chicago Press, 1986); Mary Beth Rose, ed., *Women in the Middle Ages and the Renaissance: Literary and Historical Perspectives* (Syracuse, N.Y.: Syracuse University Press, 1986); Carole Levin and Jeanie Watson, eds., *Ambiguous Realities: Women in the Middle Ages and Renaissance* (Detroit: Wayne State University Press, 1987); Margaret P. Hannay, ed., *Silent But for the Word: Tudor Women as Patrons, Translators, and Writers of Religious Works* (Kent, Ohio: Kent State University Press, 1985); Katharina Wilson, *Medieval Women Writers* (Athens: University of Georgia Press, 1984), and *Women Writers of the Renaissance and Reformation* (Athens: University of Georgia Press, 1987).
 8. Jacob Burckhardt, *The Civilization of the Renaissance in Italy*, trans. S.G.C. Middlemore, ed. Irene Gordon (1860; reprint, New York: New American Library, 1960), 280–81, 281.
 9. For some outstanding sallies in this controversy, see G. R. Elton, "History According to Saint Joan," *American Scholar* 54 (Autumn 1985): 549–55; and the replies to Elton by Judith M. Bennett, Natalie Zemon Davis, and Joan Scott in the Spring 1986 issue of the same journal (286–87). See also Lois G. Schwoerer, "Seventeenth-Century Women Engraved in Stone?" *Albion* 16, no. 4 (1984): 389–403.
 10. For a continental example of some of the obstacles and of women who overcame them, see Stanley Chojnacki, "Patrician Women in Early Renaissance Venice," *Studies in the Renaissance* 21 (1974): 176–203. For a study closer to home, see Pearl Hogrefe, "Legal Rights of Tudor Women and the Circumvention by Men and Women," *Sixteenth Century Journal* 3, no. 1 (1972): 97–105.
 11. Kelly's consideration of some of the writings of Renaissance women, the focus of her posthumously published essay, "Early Feminist Theory and the *Querelle des Femmes*," *Signs* 8, no. 1 (1982): 4–28, suggests that she may have modified her own thinking; in that essay, she recognizes a protofeminism which she states, in her earlier essays, is lacking among early modern women. For another attempt to develop Kelly's theories more precisely, this time in the area of economic history, see Judith C. Brown, "A Woman's Place Was in the Home: Woman's Work in Renaissance Tuscany," in Ferguson, Quilligan, Vickers, *Rewriting the Renaissance*, 206–24, esp. 206–8.
 12. Catherine Belsey, *The Subject of Tragedy: Identity and Difference in Renaissance Drama* (New York: Methuen, 1985), 1–2.
 13. On the unlikelihood of reconstructing much of this history, see Weinstein, "Reconstructing Our Past," esp. 137–38. And see G. R. Elton, *England 1200–1640* (Ithaca: Cornell University Press, 1969), for an assessment of "the state of the evidence" (238) as it limits and/or controls historical research (esp. 237–50).
 See Alan Macfarlane, one of the collaborators in the Cambridge Group for the History of Population and Social Structures (*Reconstructing Historical Communities* [New York:

Cambridge University Press, 1977], 207), on the privatization of past women. And see Barry Reay, "Introduction," in *Popular Culture in Seventeenth-Century England,* ed. Barry Reay (New York: St. Martin's Press, 1985), 2. Susan Dwyer Amussen provides an interesting twist on the notion of privatization in *An Ordered Society: Gender and Class in Early Modern England* (London: Basil Blackwood, 1988), 2 et passim.

14. Herrnstein Smith, "Value," 16.

15. Foster Watson, *Vives and the Renaissance Education of Women* (London: Edward Arnold, 1912), 4. While Watson is now considered overenthusiastic in his appraisal of Juan Luis Vives, his assessment of Catherine's influence should not be tarred with the same brush. See James K. McConica, *English Humanists and Reformation Politics under Henry VIII and Edward VI* (Oxford: Clarendon Press, 1965), 7–8, 53–58.

16. Vives's progressiveness has been strongly questioned by Gloria Kaufman, who has pointed out some of his more reactionary stands in her "Juan Luis Vives on the Education of Women," *Signs* 3, no. 4 (1978): 891–96.

Watson gives sections of seven works bearing on women's education that were produced in England during the "Age of Catherine of Aragon"; citing Alice Hentsch, *De la Litterature Didactique du Moyen Age s'addressant specialement aux Femmes* (Cahors, 1903), he states that "in the long span of the Middle Ages there were only seven writers in England on women's education," several of which dealt with the education of women in religious orders (*Vives,* 3–4).

Dorothy Gardiner provides a solid discussion of Catherine's significance; see her *English Girlhood at School* (London: Oxford University Press, 1929), 158. For a sharp, recent assessment, see Constance Jordan, "Feminism and the Humanists: The Case of Sir Thomas Elyot's *Defence of Good Women,*" *Renaissance Quarterly* 36, no. 2 (1983): 181–201.

17. Ruth Kelso, *Doctrine for the Lady of the Renaissance* (Urbana: University of Illinois Press, 1956), 78.

18. Garrett Mattingly, *Catherine of Aragon* (Boston: Little, Brown and Co., 1941), 335, 374–75. This contemporary attitude is reflected by William Forrest, described by his editor as "sometime chaplain to Queen Mary," who dedicated his "History of Grisild the Second: A Narrative, in Verse, of the Divorce of Queen Katherine of Arragon" to her. The poem, which consists of 492 halting, rime royal stanzas, celebrates Catherine and discusses not only her divorce but her remaining years as well. It was "edited, for the first time, from the author's MS in the Bodleian Library, by the Reverand W. D. Macray" (London: Printed by Whittingham and Wilkins, at the Chiswick Press, 1875). For other uses of the Griselda story, see Judith Bronfman's essay in this volume.

19. On the commission, see Chilton L. Powell, *English Domestic Relations, 1485–1653* (New York: Columbia University Press, 1917), pp. 117–19. For discussions of relative gains and losses, see Davis, "City Women"; Roland M. Frye, "The Teachings of Classical Puritanism on Conjugal Love," *Studies in the Renaissance* 2 (1955): 148–59; and Margo Todd, "Humanists, Puritans and the Spiritualized Household," *Church History* 49 (1980): 18–34.

20. Alison Plowden describes Henry's matrimonial adventures graphically in her *Tudor Women: Queens and Commoners* (New York: Atheneum, 1979). She also recounts the apocryphal story of Christina of Milan who "rejected Henry's flattering proposal on the grounds that she had only one head" (86). Foxe's account of the narrow escape from suspicion of Catherine Parr, the wife who survived Henry, illustrates the slippery ground on which Henry's wives stood. (See Carole Levin, "Women in *The Book of Martyrs* as Models of Behavior in Tudor England," *International Journal of Women's Studies* 4, no. 2 [1981]: 196–207, esp. 197–99.)

The traditional statement on Elizabethan ideals of order and degree is E.M.W.

INTRODUCTION

Tillyard's *Elizabethan World Picture* (London: Chatto and Windus, 1943); for a recent statement which emphasizes subversions of the ideal, see Jonathan Dollimore, "Introduction: Shakespeare, cultural materialism and the new historicism," in *Political Shakespeare: New essays in cultural materialism,* ed. Jonathan Dollimore and Alan Sinfield (Ithaca: Cornell University Press, 1985), 2–17.

For some background on the controversy over "the woman question," see Doris M. Stenton, *The English Woman in History* (New York: Macmillan, 1957), 125–27; Carroll Camden, *The Elizabethan Woman* (New York: Elsevier Press, 1952), 252–55; Warnicke, *Women of the English Renaissance,* 47–66; and Constance Jordan, "Woman's Rule in Sixteenth-Century British Political Thought," *Renaissance Quarterly* 40 (1987): 421–51.

21. Davis, "Women's History," 83–84.

22. For Bacon, see C. S. Lewis, *English Literature in the Sixteenth Century Excluding Drama* (Oxford: Clarendon Press, 1953). "Bacon," Lewis states, "deserves more praise than I have space to give her" (307).

Roper, Cecil, Herbert, Cary, and Wroth are noted by such writers as George Ballard, *Several Ladies of Great Britain* (1752; reprint, Detroit, 1985); Louisa Stuart Costello, *Memoirs of Eminent Englishwomen* (1844); Alexander Dyce, *Specimens of British Poetesses* (1827); May Green, *Letters of Royal and Illustrious Ladies of Great Britain* (1846); Mary Hays, *Female Biography* (1803); Georgianna Hill, *Women in English Life* (1896); Horace Walpole, *Catalogue of Royal and Noble Authors* (1806); and Jane Williams, *Literary Women of England* (1861). They figure prominently in the important dissertations of two early twentieth-century scholars: Ruth Hughey's "Cultural Interests of Women in England, from 1524–1640, Indicated in the Writings of the Women" (Ph.D. diss., Cornell University, 1932); and Charlotte Kohler's "Elizabethan Woman of Letters, the extent of her literary activity" (Ph.D. diss., University of Virginia, 1936).

Early, fairly conservative sources on exceptional women include Myra Reynolds, *The Learned Lady in England 1650–1760* (Boston: Houghton Mifflin, 1920); Mary Agnes Cannon, *The Education of Women during the Renaissance* (Washington, D.C.: National Capitol Press, Inc., 1916); Camden, *Elizabethan Woman.* The *DNB,* while not organized on principles that make women easy to research, does often contain useful basic information.

23. Richard Mulcaster advocates the education of young girls on the model of the English "diamond" Elizabeth (*Positions* . . . [1581], 173); Erasmus and More warn about the jealousy of men at the new, learned woman. (For Erasmus, see "The Abbott and the Learned Woman" [1524], one of the "marriage group" of colloquies, in *Colloquies of Erasmus,* trans. Craig Thompson [Chicago, 1965], 217–23; for More, see the "Letter to William Gonnell" [1518?], in *Saint Thomas More: Selected Letters,* ed. and trans. Elizabeth F. Rogers [New Haven: Yale University Press, 1961], 103–4.

Popular moralists denounce particular women as horrible exemplars of wickedness and commend conventional ones as mirrors of proper behavior. (For an example of each type, see John Dickenson, *Greene in conceipt* [1598]; and Robert Greene, *Penelopes Web . . . a Christall Mirror of feminine perfection* [1587].) Among women writers, we find signs of an awareness of a mini-literary tradition (e.g., Ester Sowernam on Rachel Speght, at several places in her *Ester hath hang'd Haman* [1617]). We also find an awareness of the parameters for women's writings (e.g., Margaret Tyler, "Prefatory Letter," *A mirrour of princely deedes and knighthood* [1578]). And, ubiquitously, in the writings of the women themselves, we find justifications for writing of any kind by a woman (see *PW,* esp. 114).

24. A well-known summary of the era's attitude toward democracy is given by A. L.

Rowse, *The England of Elizabeth* (New York: Macmillan, 1950), 261–311. Two famous literary statements of this abhorrence can be found in Spenser, *Faerie Queen*, 5.2. 29–54, and in Shakespeare, *Troilus and Cressida*, 1.3.75–137.

For the power of the assize courts, see J. S. Cockburn, *A History of English Assizes, 1558–1714* (Cambridge: The University Press, 1972), esp. "Introduction," 1–11; and Rowse, esp. 339–42.

For a series of recent essays that focus on the degree of subversion of the ideals of order and degree, see Dollimore, *Political Shakespeare*. Traditional accounts of disorder can be found in A. V. Judges, *The Elizabethan Underworld* (London, 1930); and Frank Ayedelotte, *Elizabethan Rogues and Vagabonds* (Oxford, 1913). For some recent reassessments, see A. L. Beier, especially "Vagrants and the Social Order in Elizabethan England," *Past and Present* 64 (1974): 1–29; and *Masterless Men: The Vagrancy Problem in England, 1560–1640* (London: Methuen, 1985); Paul A. Slack, "Vagrants and Vagrancy in England, 1598–1664," *Economic History Review*, 2d ser., 27, no. 3 (1974): 360–79; and Peter Clark, "The Migrant in Kentish Towns 1580–1640," in *Crisis and Order in English Towns 1500–1700: Essays in Urban History*, ed. Peter Clark and Paul Slack (London: Routledge and Kegan Paul, 1972), esp. 122–63.

25. See J. E. Neale, *Queen Elizabeth I* (London: Jonathan Cape, 1934), 205–18; and Rowse, *England of Elizabeth*, 261–68, 295–303, for glimpses of Elizabeth's methodology; see also n. 35 below. A concise and very readable account of Elizabeth's character is given by Lacey Baldwin Smith, *Elizabeth Tudor: Biography of a Queen* (Boston: Little, Brown and Co., 1975).

26. In his early study, *English Domestic Relations*, Chilton Powell also commented on the disability suffered by women, esp. 169–70. See also Carl Bridenbaugh, *Vexed and Troubled Englishmen, 1590–1642* (New York: Oxford University Press, 1968), 27–28, for a discussion of the universal disadvantage suffered by women.

27. See Cahn for a recent overview of the English scene (*Industry of Devotion*). Cahn's work provides the information that D. E. Underdown calls for in "The Taming of the Scold: The Enforcement of Patriarchal Authority in Early Modern England," in *Order and Disorder in Early Modern England*, ed. Anthony Fletcher and John Stevenson (Cambridge: Cambridge University Press, 1985), 116–36, esp. 135–36, but suggests a diminishment of woman's power in areas Underdown hypothesized might have seen improvement. For a sensitive analysis of male authority, see Jonathan Goldberg, "Fatherly Authority: The Politics of Stuart Family Images," in Ferguson, Quilligan, and Vickers, *Rewriting the Renaissance*, 3–32. See Amussen for an analysis of the intertwining, on a village level, of "the gender order . . . the hierarchy of class, and the political order of society" (*An Ordered Society*, 133). For a contemporary statement of women's disability under law, see T. E.'s *Lawes resolutions of Womens Rights* (1632). Some idea of woman's status under law can be gleaned from legal history studies, such as Sir Frederick Pollock and Frederic William Maitland, *History of the English Law*, 2 vols. (Cambridge, 1898), esp. 1:482–85; William Holdsworth, *The History of English Law*, 12 vols. (London, 1903–1938); and J. H. Baker, *Introduction to English Legal History* (London: Butterworths, 1972). Ian Maclean provides useful information on legal notions of women (as well as on thinking about women in other disciplines) in his valuable *Renaissance Notion of Woman* (Cambridge: Cambridge University Press, 1980).

28. On the standard of living, see Cahn, *Industry of Devotion*, esp. 11–23; Keith Wrightson, *English Society, 1580–1680* (London: Hutchinson, 1982), 142–48. On swing events, see William Hunt, *The Puritan Moment: The Coming of Revolution in an English County* (Cambridge: Harvard University Press, 1983), 41–46; C.G.A. Clay,

INTRODUCTION

Economic Expansion and Social Change: England 1500–1700 (Cambridge: Cambridge University Press, 1984), vol. 1, *People, Land, and Towns,* 139–40, 221–22; Wrightson and Levine, *Poverty and Piety,* 2–7.

29. The size of the vagrant population is discussed by A. L. Beier, in "Social Problems in Elizabethan London," *Journal of Interdisciplinary History* 9, no. 2 (1978): 203–21; and also in "Vagrants" and *Masterless Men;* and in Slack, "Vagrants and Vagrancy."

Especially important statutes were 14 Elizabeth I, c. 5; and 18 Elizabeth I, c.3. For a concise, still viable summary of the development of the Elizabethan poor laws, including what are now known as the statutes for "personal control" and "social control," see W.A.S. Hewins, "The Poor Laws of Elizabeth" and "The Problem of Pauperism," in H. D. Traill, *Social England* (London: Cassell and Company, 1903), 3: 352–66, 750–63, and 4: 387–402. For a more recent and concise discussion, see Wrightson, *English Society,* 149–82.

Early examples of works conflating women, vagrancy, and sexual license are John Awdeley, *Fraternitye of Vacabondes* (1561), and Thomas Harman, *Caveat for Commen Cursetors* (1567). For a discussion of this conflation, see Betty Travitsky, "Child Murder in English Renaissance Life and Drama," *Medieval and Renaissance Drama in England* 5 (1989), forthcoming. For a useful collection of contemporary texts debating the nature of women, including several on women "deviants," see Katherine Usher Henderson and Barbara F. McManus, eds., *Half Humankind: Contexts and Texts of the Controversy about Women in England, 1540–1640* (Urbana: University of Illinois Press, 1985).

As D. C. Coleman puts it, in discussing efforts to control laborers, "The Tudors made several attempts to regulate, control, and generally impose order upon the whole complex muddle of work (or lack of it). The high points of this policy were the Weavers Act of 1555, the Statute of Artificers of 1563, and the Poor Law enactments of 1536, 1572, and 1576 together with the consolidating statutes of 1597 and 1601" (*The Economy of England 1450–1750* [New York: Oxford University Press, 1984], 180). Alice Clark argues that the regulation of wages was disastrous for women, particularly for female wage-earning heads of households, who were paid below subsistence level and reduced to pauperism (*Working Life*). And see Vivien Brodsky Elliott, "Single Women in the London Marriage Market: Age, Status and Mobility, 1598–1619," in *Marriage and Society: Studies in the History of Marriage,* ed. R. B. Outhwaite (New York: St. Martin's, 1981), 81–100, esp. 91.

On domestic service, see Bridenbaugh, *Vexed and Troubled,* 367; Beier, "Social Problems," 216–17; J. A. Sharpe, *Crime in Seventeenth-Century England* (New York: Cambridge University Press, 1983), 60 and 136; and Lawrence Stone, *Family, Sex and Marriage in England, 1500–1800* (New York: Harper and Row, 1977), 519, 615–16. Put more positively, prostitution was one method of advancing on the economic scale. See Anne M. Haselkorn, *Prostitution in Elizabethan and Jacobean Comedy* (Troy, N.Y.: Whitson, 1983), 12–13.

On women driven to crime, see Awdeley, *Fraternitye of Vacabondes;* Harmon, *Caveat;* Reginald Scot, *Discoverie of Witchcraft* (1584), which contains many chapters on legerdemain; William Harrison, *Description of England* (1577), chap. 10; Aydelotte, *Elizabethan Rogues;* Judges, *Elizabethan Underworld;* Beier, "Social Problems," esp. 220–21; and Bridenbaugh, *Vexed and Troubled,* 362, 390.

30. For the misogynist tradition, see Heinrich Kramer and James Sprenger, *The Malleus Maleficarum* (ca. 1485; reprint, New York: Dover, 1971), 1, Question 11 (p. 66), an influential statement of the belief that witchcraft and the practice of midwifery were

often connected. See also Barbara Ehrenreich and Deidre English, *Witches, Midwives, and Nurses: A History of Women Healers* (Old Westbury, N.Y.: Feminist Press, 1973).

On medical teaching and the status of the woman practitioners, see Hilda Smith, "Gynecology and Ideology in Seventeenth-Century England," in *Liberating Women's History: Theoretical and Critical Essays,* ed. Berenice A. Carroll (Urbana: University of Illinois Press, 1976), 97–114; Cahn, *Industry of Devotion,* esp. 58–60.

On the witch, see Alan Macfarlane, *Witchcraft in Tudor and Stuart England* (London: Routledge and Kegan Paul, 1970), summarized in his "Witchcraft in Tudor and Stuart Essex," in *Crime in England 1500–1800,* ed. J. S. Cockburn (London: Methuen, 1979), 72–89; Keith Thomas, *Religion and the Decline of Magic* (New York: Charles Scribner's Sons, 1971), "Witchcraft," 435–583; Ehrenreich and English, *Witches, Midwives, and Nurses,* 6–20; Joseph Klaits, *Servants of Satan: The Age of the Witch Hunts* (Bloomington: Indiana University Press, 1985), esp. chap. 3, "Sexual Politics and Religious Reform," 48–85, esp. 64–70; and chap. 4, "Classic Witches: The Beggar and the Midwife," 86–103, esp. 94–103.

31. On the usurpation of midwifery by physicians, see Hilda Smith, "Gynecology and Ideology," esp. 109–10; Audrey Eccles, *Obstetrics and Gynecology in Tudor and Stuart England* (Kent, Ohio: Kent State University Press, 1982).

On the need to examine the medical record from the woman's viewpoint, see Schwoerer, "Seventeenth-Century Women," esp. 391–92, 400–401.

Christina Larner discusses the "criminalization of women" in her "Crimen Exceptum? The Crime of Witchcraft in Europe," in *The Social History of Crime in Western Europe since 1500,* ed. V.A.C. Gattrell, Bruce Lenman, and Geoffrey Parker (London: Europa Publications, 1980), 49–75.

32. On Renaissance "birth control," see E. A. Wrigley, "Family Limitation in Pre-Industrial England," *Economic History Review* 19 (1966): 82–109; Lawrence Stone, *Crisis of the Aristocracy, 1558–1641* (New York: Oxford University Press, 1965), 633 ff; Bridenbaugh, *Vexed and Troubled,* 369.

For a summary of governmental efforts to control women, see Peter C. Hoffer and N.E.H. Hull, *Murdering Mothers: Infanticide in England and New England, 1558–1803* (New York: New York University Press, 1981), esp. 3–31. Relevant statutes include 18 Elizabeth I, c. 3 and 7 James I, c. 4.

Official pronouncements are given in Paul L. Hughes and James F. Larkin, *Tudor Royal Proclamations,* 3 vols. (New Haven: Yale University Press, 1964), and in Robert Steele, *Bibliography of Proclamations, 1485–1714* (New York: Burt Franklin, 1967); a contemporary practitioner's observations are given in Percival Willoughby, *Observations in Midwifery* (first printed from MS, 1863; reprint S.R. Publishers, 1972). See Travitsky, "Child Murder"; Hoffer and Hull, *Murdering Mothers;* Stone, *Family,* esp. 479; Thorsten Sellin, *Slavery and the Penal System* (New York: Elsevier Press, 1976).

The statute sentencing mothers to death is 21 James I, c. 27. Concealment of the death was tantamount, under this statute, to murder (William Holdsworth, *History of English Law,* 12 vols. [London, 1903–1938], 4:501).

33. Belsey, *Subject of Tragedy,* 5.

34. See Lacey Baldwin Smith, *Elizabeth Tudor,* 102; Patricia-Ann Lee, "Reflections of Power," esp. 210–11; and Carole Levin, "Queens and Claimants," for women monarchs.

The fundamental arguments are provided by Ernst Kantorowicz, *The King's Two Bodies: A Study in Mediaeval Political Theology* (Princeton: Princeton University Press, 1957); and Marie Axton, *The Queen's Two Bodies: Drama and the Elizabethan Succession*

INTRODUCTION

(London: Royal Historical Society, 1977). For a recent summary of the debate, see Jordan, "Woman's Rule"; and Jordan's and Josephine A. Roberts's essays in this volume.

35. For keen analyses of Elizabeth's methods see Allison Heisch, "Queen Elizabeth I: Parliamentary Rhetoric and the Exercise of Power," *Signs* 1 (1975): 31–55; and Leah S. Marcus, "Shakespeare's Comic Heroines, Elizabeth I, and the Political Uses of Androgyny," in Rose, *Women in the Middle Ages and the Renaissance*, 135–53.

36. "Alack, the Queen of Scots is lighter of a bonny son, and I am but of barren stock" (cited by Antonia Fraser in *Mary Queen of Scots* [New York: Delacorte Press, 1969], 268, who quotes from Melville's *Memoirs* [published from MS in 1683], 131.) Lacey Baldwin Smith also recounts this comment (*Elizabeth Tudor*, 130), and is moving on the subject of Elizabeth's last days (esp. 218–19). Neale dismisses the remark, "It is a good story; probably nothing more" (*Queen Elizabeth I*, 142). But he retells "melancholy" comments of Elizabeth's last days movingly in his chapter "Passing of the Queen," 376–89, esp. 385–89.

37. In *Tudor Women: Commoners and Queens* (Ames: Iowa State University Press, 1975), Pearl Hogrefe cites specific instances of women who were able to rise above the usual limitations on women's activities. However, she is on less sound ground when she generalizes on the basis of these exceptions that "the women of Tudor England made no excessive effort to remain passive, if we may judge from individual lives" (3). For her discussion of Shrewsbury and others, see 27–36.

For lengthy discussions of medieval women acting in the place of a man, see Eileen Power, *Medieval Women*, ed. M. M. Postan (Cambridge: The University Press, 1975); and Shulamith Shahar, *The Fourth Estate*, trans. Chaya Galai (London: Methuen, 1983); see also Warnicke, "Introduction" to *Women of the English Renaissance*.

See Gattrell, Lenman, and Parker, *Social History of Crime*, chap. 1, "The State, the Community and the Criminal Law in Early Modern Europe," 11–48, esp. 34–48, on the movement toward legal rationalization.

A concise summary of women's activities during the Civil War is provided by David Weigall ("Women Militants in the English Civil War," *History Today* 22 [June 1972]: 434–38). For a discussion of the women petitioners that does not consider their ineffectuality, see Margaret J. M. Ezell, *The Patriarch's Wife: Literary Evidence and the History of the Family* (Chapel Hill: University of North Carolina Press, 1987), 90–91.

38. In "Women and the New Economic Order" (*Industry of Devotion*, 33–57), Cahn discusses these issues quite comprehensively, basing much of her information on Alice Clark, who discusses them throughout *Working Life*.

39. On the place of women within the family, see Davis, "Women on Top," in *Society and Culture*, 124–51, esp. 127–28; S. D. Amussen, "Gender, Family and the Social Order, 1560–1725," in Fletcher and Stevenson, *Order and Disorder*, 196–217, esp. 196–205.

For a particularly lucid discussion of such freedom of conscience, see William and Mandeville Haller, "The Puritan Art of Love," *Huntington Library Quarterly* 5 (1941–42): 235–72. For sympathetic attention to women, see T. E. (n. 42, below).

"Chaste," "obedient," and "silent" are terms that have been popularized by Suzanne Hull in her *Chaste, Silent, and Obedient: English Books for Women, 1475–1640* (San Marino, Calif.: Huntington Library, 1982). Sara Heller Mendelson notes that "piety was another feminine 'ornament' regarded as a special talent of the sex" (*The Mental World of Stuart Women: Three Studies* [Amherst: University of Massachusetts Press, 1987], 9).

The exceptional status of the widow is a commonplace; for an interesting discussion, however, which highlights some of the grays in this black-and-white picture, see

Charles Carlton, "The Widow's Tale: Male Myths and Female Reality in 16th and 17th Century England," *Albion* 10 (Summer 1978): 118–29.

40. Even reformist thinkers did not promulgate a single standard zealously; see the stern Juan Luis Vives on the wife's need to avoid sexual jealousy, *Instruction*, Bk. 2, chap. 7, "Of Jeolosy," sig. f2v: "For the man is nat so moche bounde as the woman to kepe chastite, at leaste wayes by the lawes of the world, for by godis lawe both be bounde in lyke. Let her consydre that the man lyveth more at libertie than the woman. . . ." The standard scholarly treatment of this issue is Keith Thomas's famous essay, "The Double Standard," *Journal of the History of Ideas* 20 (1959): 195–216.

Antonia Fraser gives graphic examples of forced matches (*The Weaker Vessel* [New York: Alfred A. Knopf, 1984], 9–25). For less dramatic accounts of the situation, see Stone, *Family;* Miriam Slater, "The Weightiest Business: Marriage in an Upper-Gentry Family in Seventeenth-Century England," *Past and Present* 72 (1976): 25–54; and David Atkinson, "Marriage under Compulsion in English Renaissance Drama," *English Studies* (1986): 483–504, esp. 484–88.

For the argument that the "patriarch" was less central to this process than is usually asserted, see Ezell, *Patriarch's Wife*, esp. 9–35.

For debates on family ties: Stone, *Family,* esp. chap. 1, 3–41; Christopher Hill, "Sex, Marriage, and the Family in England," *Economic History Review* 2d ser. 31, no. 3 (1978): 450–63; Alan Macfarlane, "The Family, Sex and Marriage in England," *History and Theory: Studies in the Philosophy of History* 18, no. 1 (1979): 103–26; Schwoerer, "Seventeenth-Century English Women."

For some lurid examples of unequal restrictions even among the nobility, see Warnicke, *Women of the English Renaissance,* 12; and Barbara Harris, "Marriage Sixteenth-Century Style: Elizabeth Stafford and the Third Duke of Norfolk," *Journal of Social History* 15, no. 3 (1982): 371–82. Fraser retells the sorry story of the abduction of Frances Coke by her jurist-stepfather, Sir Edward Coke, and her forced marriage to the manic Sir John Villiers in 1617, a misalliance presided over by James I who gave away the bride (*Weaker Vessel,* 12–20).

41. Vives, *Instruction,* Bk. 2, chap. 4, "Howe she shall behave her selfe unto her husbande," sig. c1v.

42. On wife beating, see Warnicke, *Women of the English Renaissance,* 156; L. B. Wright discusses an unusual tract on the subject in his *Middle-Class Culture in Elizabethan England* (1935; reprint, Cornell University Press, 1958), 485–86.

For comfortable acceptance of the injustice of family power relations, see George Savile, first marquis of Halifax, "The Lady's New-Year's Gift; Or, Advice to a Daughter," from *Miscellanies by the Right Noble Lord, The Late Marquess of Halifax* (London, 1700), 1–46, esp. 7–19. Reprinted in *Complete Works of George Savile, First Marquess of Halifax,* ed. Walter Raleigh (Oxford: Clarendon Press, 1912); for sympathy toward the wife, see T. E., Bk. 3, sec. 7, "The Baron may beate his Wife."

The incident of Parr and Askew is related by John Foxe in his martyrology. Carole Levin discusses it at some length in "Women in *The Book of Martyrs*," esp. 197–99.

43. Basic injunctions for women include the following passage: "Let your women keep silence in the churches: for it is not permitted unto them to speak; but *they are commanded* to be under obedience, as also saith the law. And if they will learn any thing, let them ask their husbands at home: for it is a shame for women to speak in the church" (1 Cor. 14: 34–35). The theme is taken up, not surprisingly, in "An exhortation to Obedience" in *Certayne Sermons.* See R. Valerie Lucas's essay in this volume for a discussion of this subject.

INTRODUCTION

Stubbes's moving memorial is called *A Christal Glas for Christian Women* . . . (1592); a more ironic celebration of silence is Ben Jonson's *Epicoene* (1620); a startling instance of women's strong use of their tongues is that of the queens in Shakespeare's *Richard III* (1597); a humorous instance is Richard Brathwaite's *Ar't asleepe Husband? A Boulster Lecture* . . . (1640). Women writers constantly comment on their perversity and overboldness in breaking silence, as demonstrated in *PW*, esp. "Prefaces," 141–63.

44. Another passage from the New Testament that was frequently cited in regard to women's subordination is the following: "In like manner also, that women adorn themselves in modest apparel, with shamefacedness and sobriety; not with braided hair, or gold, or pearls, or costly array; But (which becometh women professing godliness) with good works. Let the woman learn in silence with all subjection. But I suffer not a woman to teach, nor to usurp authority over the man, but to be in silence. For Adam was first formed, then Eve. And Adam was not deceived, but the woman being deceived was in the transgression. Notwithstanding she shall be saved in childbearing, if they continue in faith and charity and holiness with sobriety" (1 Tim. 2:9–15).

On traditional Christian thinking on female sexuality, see Rosemary Radford Ruether, "Misogynism and Virginal Feminism in the Fathers of the Church," in *Religion and Sexism: Images of Women in the Jewish and Christian Traditions*, ed. Rosemary Radford Ruether (New York: Simon and Schuster, 1974), 150–83, esp. 161–64.

Margo Todd's *Christian Humanism and the Puritan Social Order* (Cambridge: Cambridge University Press, 1987) traces continuities between the Christian humanist and the Puritan positions on secular women.

45. On the popular mentality, see Thomas, *Religion and the Decline of Magic*, esp. 41–50, 70–74, and 159, and chap. 6, "Religion and the People," 151–73, esp. 159–66. For another very careful analysis of this point, see Barry Reay, "Popular Religion," in Reay, *Popular Culture*, 91–128, esp. 111–19.

For the Eve-Mary dichotomy see Eileen Power, "The Position of Women," in *The Legacy of the Middle Ages*, ed. C. G. Crump and E. F. Jacob (Oxford, 1910), 401–33; and William Monter, "The Pedestal and the Stake: Courtly Love and Witchcraft," in Bridenthal and Koonz, *Becoming Visible*, 119–36; on Mary, see Marina Warner, *Alone of All Her Sex: The Myth and the Cult of the Virgin Mary* (1976; reprint, New York: Vintage Books, 1983).

On women in religion and women in the world, see Ruether, *Religion and Sexism*. For a fascinating discussion of a mediating figure, see Clarissa W. Atkinson, "'Your Servant, My Mother': The Figure of Saint Monica in the Ideology of Christian Motherhood," in *Immaculate and Powerful: The Female in Sacred Image and Social Reality*, ed. Clarissa W. Atkinson, Constance H. Buchanan, and Margaret R. Miles (Boston: Beacon Press, 1985), 139–72.

On Protestant influence, see Nancy L. Roelker, "The Appeal of Calvinism to French Noblewomen in the Sixteenth Century," *Journal of Interdisciplinary History* 2 (1972): 391–418. Stone, however, notes that Protestant women who were ideally tied to their husbands not merely by law but also by a duty to "affection" might be even more severely subordinated within the family than those bound only superficially (*Family and Sex*, 202). David Underdown makes some interesting observations on the Puritans in his *Revel, Riot, and Rebellion: Popular Politics and Culture in England 1603–1660* (Oxford: Clarendon Press, 1985), 99–100. For positive effects of religion, see Davis, "City Women." (Davis does deal with the negative effects of Protestant theory, too, in this essay.)

46. See *Utopia*, ed. Edward Surtz, S.J., and J. H. Hexter, *Complete Works of Saint*

Thomas More, 15 vols. to date (New Haven: Yale University Press, 1963–), vol. 4. More describes public lectures that both men and women would attend in Utopia (159); he allows elderly widows to become priests (229). However, his Utopia is quite patriarchal: "Social Relations," 135–45, esp. 135, 137, 143; also "Public Worship and Private Confession," esp. 233. Some theorists remained overtly hostile to learning in women. See Janis Butler Holm, "The Myth of a Feminist Humanism: Thomas Salter's *The Mirrhor of Modestie,* in Levin and Watson, *Ambiguous Realities,* 197–218.

The early commendation of the education of women is Richard Hyrde's "Dedicatory Letter," to *A devout treatise upon the Pater Noster* (1523), trans. Margaret Roper (1524). See Elizabeth McCutcheon, "Margaret More Roper: The Learned Woman in Tudor England," in Katharina Wilson, *Women Writers of the Renaissance and Reformation,* 449–80; also *RE,* 3–28.

47. On women's involvement in factionalism: Davis, "City Women"; Roelker, "Appeal of Calvinism"; and Wyntjes, "Women in the Reformation Era"; Keith Thomas discusses the English scene in "Women and the Civil War Sects," *Past and Present* 13 (April 1958): 42–62. For a discussion of the Catholic camp, see John Bossy, *The English Catholic Community, 1570–1850* (New York: Oxford University Press, 1976).

48. On married clergy, see Joel Berlatsky, "Marriage and Family in a Tudor Elite: Familial Patterns of Elizabethan Bishops," *Journal of Family History* 3, no. 1 (1978): 6–22, esp. 7–10. Rowse also describes Elizabeth's attitude toward clerics' wives quite graphically (*England of Elizabeth,* 411–14). An undocumented but widely circulated anecdote about Bishop Cranmer conveys the atmosphere. As retold by Macray, Cranmer was known for "carrying his wife about with him in a great chest full of holes, for which chest on the occasion of a fire at his palace in Canterbury all other care was set aside, the archbishop crying out that it contained his evidences and other writings which he esteemed above any worldly treasure" ("History of Grisild the Second," xxviii [n. 18, above]). Alfred Frederick Pollard recounts the same tale (as apocryphal), stating that "Cranmer carried her [his wife] about in a chest with holes bored into it to admit the air; on one occasion, when the chest was placed upside down, the lady had to make her presence known by screams" (*Thomas Cranmer and the English Reformation 1489–1556* [New York: G. P. Putnam's Sons, 1904], 325 n. 1).

For reactions to activist Protestant women, see Thomas, "Civil War Sects." Bossy, in *English Catholic Community,* 153, equates the community with a matriarchy.

49. On relative ignorance on religious matters, see Thomas, *Religion and the Decline of Magic,* esp. 164–65, 272–73; H. V. Routh, "The Advent of Modern Thought in Popular Literature," *Cambridge History of English Literature,* ed. A. W. Ward and R. Waller, 15 vols. (1907–16; reprint, Cambridge: University Press, 1961), 7: 366–97. On the clergy, see Wrightson and Levine, *Poverty and Piety,* esp. 11–12. On the background to the Askew case, see John Bowle, *Henry VIII* (Boston: Little, Brown and Co., 1964), 292; and Lacey Baldwin Smith, *Henry VIII: The Mask of Royalty* (Boston: Houghton Mifflin Company, 1971), 240.

50. The full title of the cycle is *Certayne Sermons or Homilies, appoynted by the Kinges Maiestie to be Declared and Read by All Parsons, Vicars, or Curates every Sondaye in their Churches* (London, 1547).

Elizabeth's comment is quoted by Lacey Baldwin Smith, *Elizabeth Tudor,* 157. Perhaps the most famous summation of Elizabeth's policy on religious dissent is that attributed to Francis Bacon who observed that "her Majesty not liking to make windows into men's hearts and secret thoughts, except the abundance of them did overflow into overt and express acts or affirmations tempered her law so as it restraineth only manifest

INTRODUCTION

disobedience" (*Letters and Life of Francis Bacon,* 7 vols. [in *Bacon's Works,* ed. James Spedding, Robert Leslie Ellis, and Douglas Devon Heath, 14 vols. (1862; reprint, New York: Garrett Press)], 1: 98).

On Mary Stuart, see Neale, *Queen Elizabeth I,* 257–82; Fraser, *Mary,* 475–500.

51. T.E., *The lawes resolutions of Womens Rights: Or, the Lawes Provision for Woemen,* Bk. 1, sec. 3, "The punishment of Adams sinne," sig. B3v.

52. On medieval educational ideals, see Joan M. Ferrante, "The Education of Women in the Middle Ages in Theory, Fact, and Fantasy," in Labalme, *Beyond Their Sex,* 9–42. On "interiority," see Belsey, *Subject of Tragedy,* 33–42. In her discussion of women's "uncertain place" as character in texts by men, Belsey emphasizes the "instability . . . in the utterances attributed to women . . . a discontinuity of being, an 'inconstancy' which is seen as characteristically feminine" (149). The writings by Renaissance Englishwomen, in contrast, demonstrate the achievement by individual women of the status of "subject."

53. On women affected by humanism, see Warnicke, *Women of the English Renaissance,* esp. 3–4, 205–6. Reynolds does not make this point, but her description of "Learned Ladies in England before 1650" fits this pattern (*Learned Lady,* 1–44). On later educational progress, see Cressy, *Literacy,* esp. 127–29, and Wrightson and Levine, *Poverty and Piety,* 147. And see Spufford, "First Steps," esp. 410, 417, 427, 434–35.

For an "advanced" theorist, see Vives, Bk. 1, chap. 4, "Of the lernyng of maydes" (sigs. D2–E3) and chap. 5, "What bokes be to be redde, and what nat" (sigs. E3–F2v). Despite Vives's censorship of many types of literature, Valerie Wayne maintains that "the rigid life he prescribes for women in his book was not the worst alternative for them then; it was one of the best available" ("Some Sad Sentence: Vives' *Instruction of a Christian Woman*" in Hanny, *Silent But for the Word,* 15–29 [p. 28]).

54. *PW,* esp. 3, 141–63; *RE,* 4. See the Hageman and Roberts bibliographies (n. 6 above) for a mass of information on studies of Englishwomen writers.

55. Wilson, *Women Writers of the Renaissance and Reformation,* xxviii–xxix.

56. The early figures are Margary Kempe, Juliana of Norwich, and (possibly) Juliana Berner. Later women include Mary Ward (discussed by Reynolds, *Learned Lady,* 28–40), Alexia Grey (see *PW,* 157–58), and Gertrude More.

57. The quotation about Whitney is from *RE,* 88. For an opposing view, see Betty Travitsky, "The 'Wyll and Testament' of Isabella Whitney," *English Literary Renaissance* 10, no. 1 (1980): 76–94; and R. J. Fehrenbach, "Isabella Whitney, Sir Hugh Plat, Geoffrey Whitney, and 'Sister Eldershae,'" *English Language Notes* 21 (September 1983): 7–11.

58. A prominent example of a man's work on women's education is Hyrde's "Dedicatory Letter" to a translation by Margaret Roper (see n. 46 above).

59. See the bibliographies in *PW,* 265–73 and in *RE,* 335–38; for comments on the religious nature of Renaissance Englishwomen's writings, see Hughey, "Cultural Interests of Women," 256–59, and *PW,* 89–91.

60. Among religious political activists are Lady Jane Grey, Lady Anne Bacon (subject of an unpublished paper by Janet Gross entitled "Lady Anne Bacon: Protestant Translator"), and Catherine Parr (see *RE* and *PW*).

61. Women who seem to fit the category of gentlewomen writers include Anne Dowriche, Jane Owen, and Anne Prowse (see *RE* and *PW*).

62. Women writers associated with the court include Mary Fage, Amelia Lanyer, and Alice Sutcliffe. Urban women, apparently from the middling classes, include Rachel Speght, Ester Sowernam, and Isabella Whitney. (For further information, see *RE* and *PW.*)

63. Wayne, "Some Sad Sentence," esp. 21–29, deals with restrictions upon women writers' creativity.

See *PW*, 141–63, for examples of comments on these restrictions in prefaces written by Renaissance Englishwomen for their own writings.

See *PW*, 50–68, for selections from mother's advice books. Mendelson comments that "Women's fear of death in childbirth inspired a specific genre, the maternal advice book, intended for children whom the mother might not live to educate" (*Mental World,* 29). This is the case for some, but not all, of the advice books. See, for example, *The Answere of a Mother* . . . , and *The Mothers Counsell* . . . , in *PW* (63–68). One medieval work of motherly advice is *How the good wiif taughte hir Doughtir* (ca. 1430).

See Domna C. Stanton, "Autogynography: Is the Subject Different?" in *The Female Autograph,* ed. Domna C. Stanton (New York: New York Literary Forum, 1984), 5–22. Colie also comments on women writing in this genre (*Resources,* 92).

64. Woodbridge describes this tradition at great length, and questions the identity of several of the "women" authors of the early seventeenth century (*Women and the English Renaissance*). For a somewhat different approach, see Betty Travitsky, " 'The Lady Doth Protest': Protest in the Popular Writings of Renaissance Englishwomen, 1566–1640," *English Literary Renaissance* 14, no. 3 (1984): 255–83.

I

The Outspoken Woman

ANN ROSALIND JONES

Counterattacks on "the Bayter of Women"
Three Pamphleteers of the Early Seventeenth Century

In 1615 Joseph Swetnam published *The Araignment of Lewde, idle, froward and unconstant women,* a pamphlet in which he gathered together misogynist commonplaces from the debate over women throughout the preceding century in England. What was new about Swetnam's tract was its success (by 1634 it had been republished ten times) and its capacity to stir up counterresponses. Five of Swetnam's contemporaries wrote against him, including three using women's names.[1] These first three contributions to the controversy reveal the potentials of protofeminist discourse at the end of the Renaissance. Rachel Speght, Ester Sowernam, and Constantia Munda began to pose questions about the social construction of gender that went beyond the theological and philosophical frameworks in which women's nature had been debated. In the double role played by its feminine participants, the Swetnam controversy exhibits clear symptoms of an ideological transition: each writer adopted an acceptable woman's voice in order to be heard, but at the same time she attempted to shift the woman debate out of its old ruts. Joan Kelly-Gadol argues that the shift from defenses of women to critiques of gender ideology marked the first stages of feminism in Europe, which she dates as early as the fifteenth century. In addition to contributing to this new emphasis as individual combatants against Swetnam, the three pamphleteers also operate as trio. Serially, they assemble a critique of misogyny that moves the gender debate out of its old scorekeeping patterns, its listing of good women against bad ones, defined according to masculine criteria.

To begin with a question often posed about Swetnam: What gave *The Araignment* its ability to stir up responses? Most commentators agree that it is pretty feeble stuff. Coryl Crandall criticizes its disorganization ("Cultural Implications," 137), Linda Woodbridge dismisses much of it as "verbal diarrhea" (85), and Simon Shepherd describes it as "grossly derivative in its language and ideas" (53). But *The Araignment* succeeded nonetheless in fulfilling its purpose, which was to create an uproar. Swetnam's tract is neither learned nor coherent, but it did not have to be; as the title-page illustration of a woman carrying the feather fan

45

emblematic of pride suggests (see illustration), his intention was to turn the *Querelle des femmes* into a predictable and profitable farce, capable of amusing as many readers as possible. But precisely because he aimed so low, he was a useful target. Unlike the arguments of theologians and humanists whose erudition lent their pronouncements on women the authority of wisdom and reason, Swetnam's tract could be dissected as evidence of how irrational and self-interested misogyny was. In a strategic misunderstanding, the women writers misread Swetnam. It was not the seriousness with which he wrote but the serious misogyny he could be taken to represent that gave his critics a purchase on his work. Rachel Speght caught him out in his misuse of the Bible; Ester Sowernam diagnosed the processes through which the misogynist projects his own sins onto women; Constantia Munda pointed out the opportunism of the writer who manipulates the woman question for his own profit. If every misogynist had been so open to attack, antiwoman ideologies might have been defeated much earlier than has been the case.

Swetnam asks for trouble from the first page of his pamphlet, which he dedicates to contradictory audiences. To men readers, he offers entertainment, promising to show them a "Beare-bayting of Women," which he dedicates indulgently "neither to the wisest Clarke, nor yet to the starkest Foole, but unto the ordinary sort of giddy-headed young men." In his epistle to women, however, he adopts a scornful, judgmental tone. He turns the conventional self-justification of the satirist into a gag for women, challenging any woman to answer him; if she does, she will only prove that his accusations are true:

> whatever you think privately, I wish you to conceale it with silence, lest in starting up to find fault, you prove yourselves guilty of those monstrous accusations which are here following against some women, [for] those which spurne if they feele themselves touched, prove themselves starke fooles in bewraying their galled backs to the world. (A2r–v)

Swetnam is in fact the scolder and accuser throughout his tract, but he presents himself as a hero of reticence by appealing to the traditional link between women and shrewishness: "it is a great discredit for a man to be accounted for a scold, for scolding is the manner of Shrews: therefore, I had rather answer them with silence that find fault, than strive to win the Cucking-stoole from them (A3r)." This slippery aggressive-defensive posture is typical of *The Araignment*. Swetnam maintains a pose of defiant lightheartedness; on his last page he asks his readers to "take it merrily, and to esteeme of this booke only as the toyes of an idle head" (14r). But the jester's role goes hand in hand with a good deal of rough physical humor. Swetnam ends his epistle to women by transforming an image of maternal nurturance into an insulting rejection of

THE
ARAIGNMENT
OF LEWD, IDLE, FRO-
ward, and vnconstant Women: Or
the vanitie of them; choose you whether.

With a Commendation of the wise,
vertuous, and honest VVoman.

Pleasant for married men, profitable for young
Men, and hurtfull to none.

LONDON:
Printed for *Thomas Archer*, and are to be sold at his shop in Popes-
head Pallace neere the Royall Exchange. 1619.

Title page of the 1619 edition of Joseph Swetnam's *Araignment of Lewd, Idle, Froward, and unconstant Women*. By permission of the Houghton Library, Harvard University.

women's judgment: "Let it be well or ill, I look for no praise for my labour; I am weaned from my Mother's Teat, and therefore never more to be fed with her Pap: wherefore say what you will" (A3r). The woman reader, confronted with this introduction, is likely to feel that she has been dealt a slap but prevented from responding.

Swetnam's main ploy is to mix classical and biblical criticism of women and then to modernize it in the direction of pragmatic cynicism. He advises men as bluntly as a horsebreeder and as hardheadedly as a financier. Eve, he says, being made from a crooked rib, was quick to mischief; he concludes, "A Bucke may be enclosed in a Parke, a bridle rules a Horse . . . : but a Froward Woman will never be tamed, no Spurre will make her goe, nor no Bridle hold her backe" (B1v). Following Proverbs and contemporary marriage manuals, he makes a gesture toward counseling men on how to choose a good wife, but he actually sets up a series of double binds: there is no such thing as a good wife because the flip side of every virtue is a vice. This balancing formula was common in misogynist tracts,[2] but Swetnam pushes it to a new extreme: "Commonly Beauty and Pride goeth together, and a beautiful woman is for the most part costly, and no good Huswife; and if she be a good Huswife, then no servant will abide her fierce cruelty, and if she be honest and chaste, then commonly she is jealous" (B4r). He makes no exception for rank: class as well as sexual antagonism surfaces in his rejection of chivalrous estimates of women. He recounts a rustic anecdote to prove that all women are alike underneath:

> *Jone* is as good as my Lady; according to the Country-man's Proverbe, who gave a great summe of Money to lie with a Lady, and going homewards, he made grievous mone for his money, and one being on the other side [of] the hedge, heard him say, that his *Jone* at home was as good as the Lady. (C1r)

The "Jone and my Lady" anecdote is exactly the kind of narrative that Swetnam uses to appeal to readers. What is striking in his pamphlet is not so much his use (or misuse) of bookish commonplaces as his retailing of contemporary jokes that illustrate the everyday hatred attributed by misogyny to all sexual relations. Such anecdotes suggest that he was assembling a jestbook, which as a genre could break rules of realism and propriety. This was not a discourse open to women. But precisely as jestbook, *The Araignment* reveals the darker side of misogynist humor. Swetnam's vignettes of domestic mayhem approach the grotesque. His sketch of life with a widow, for example, positions all three characters in a low-life farce, according to a logic of male sexual rights that justifies husbandly tantrums as a "natural" reaction to frustration:

> thy widdow will not trust thee with a wench that is handsome in thy house; now if that upon just occasion thou throwest the platters at thy maids head,

seeing thy meate brought in by such a slut, and so sluttishly drest; then will thy widdow take pepper in the Nose, and stamp and stare, . . . saying, "If thou hadst not married with me, thou wouldest have been glad of the worst morsell that is here." (12v)

What kind of violence, however comical, is being assumed in this passage? What kind of comedy *is* popular misogyny? *The Araignment* gave women little to laugh at.

Instead, all three respondents focus on the character beneath Swetnam's jokes: their first maneuver is to take the joker seriously. Their second strategy is to construct a convincing feminine persona through which to demonstrate the falsity of Swetnam's remarks. Each writer positions herself as superior to Swetnam: spiritually, intellectually, socially. Thus the critique of the man is voiced by a speaker whose difference from him discredits generally accepted notions about women's minds and souls. Very little is known about who these writers were, but they share one common stance: they make their best points by refusing to connive with the supposedly jolly conventions of misogyny. They challenge misogyny, instead, by analyzing what lies beneath it.

Rachel Speght's *Mouzell for Melastomas* was published in 1617 by Thomas Archer, the London printer who had published Swetnam's *Araignment* two years before. But it is hard to imagine two more different texts. Where Swetnam is rowdy, Speght is demure; where he is popular, she is learned; where he is helterskelter, she makes a virtue of orderly deliberation. Her persona is that of the ideal Protestant maiden, meek and mild, but she takes the strongest possible line in that context: she accuses Swetnam of blasphemy. To condemn women as God's curse on mankind, she says, is to misread the Bible and to show ingratitude toward the Creator. In Speght's hands, theology is turned on its axis, tilted toward a liberalization of Protestant theories of marriage and a general defense of women's rights.

The daughter of a London minister,[3] Speght discredits Swetnam by enacting the piety and the rationality he accuses women of lacking. The anonymous poems that preface *A Mouzell* attest to the writer's humility: she is "a Virgin yong . . . / having not as yet seene twenty years," "a Pupill unto Pietie." Her choice of dedicatees contrasts to Swetnam's; rather than appealing to "the ordinary sort of giddy-headed young men," she addresses "all vertuous Ladies Honorable or Worshipfull, and . . . all others of Hevah's sex fearing God, and loving their just reputation." Speght humbly describes herself as "yong, and the unworthiest of thousands" and apologizes for her "insufficiency in literature and tenderness in years" (A3v). But this opening impression of simplicity is deceptive. Rational deliberation is the leading gambit in Speght's essay, which is much more carefully structured than Swetnam's pam-

49

phlet. She begins by announcing her outline. She will counter Swetnam's blasphemies under three headings: his perversion of Scripture; his disparagement of women, "that excellent worke of God's hands" (B2v); and his ungodly syncretism, his "hodge-podge of heathenish Sentences, Similies and Examples."

The sharpest focus in Speght's pamphlet is turned upon antiwoman elements in religion, which she criticizes in eminently Protestant fashion by insisting on attention to the real meanings of Scripture. She debates the use of Genesis to scapegoat Eve and to justify women's subjection by arguing that the creation story, attentively read, stresses the equality of Adam and Eve: Eve was created as a *worthy* helpmate to Adam, and they were equally promised salvation. If anyone is to blame for the Fall, she argues, it is Adam; being the head of the couple, he should have resisted temptation better than Eve. One of Speght's main purposes in answering Swetnam, in fact, appears to have been the elaboration of her own position within Protestant defenses of marriage: she challenges the conservative gender attitudes of contemporary divines by using the Bible against them. A case in point: Swetnam quotes St. Paul against marriage; Speght counters his citation by insisting on the historical circumstances in which Paul wrote. As long as the Corinthians were "persecuted by the enemies of the Church," celibacy was a practical advantage, but only as long as "these perturbations should continue" (7). She extends this argument by pointing out that Paul himself married and that the Bible is full of examples of wise and helpful husbands.

Much of this reasoning might have been carried out by a Protestant man of Speght's time, but her next move is to argue that Paul's prescription for a properly hierarchized marriage has been misinterpreted by her fellow believers. "Merri-age," she writes, is not the subordination of wife to husband, as Protestant treatises argued, but mutual assistance between them, with the greater responsibility falling on the man. She gives a new prowoman emphasis to the analogy that bases the authority of the man in the family on Christ's role as head of the church: "a truth ungainesayable is it that the *Man is the Womans Head:* . . . [but] herein is he taught the duties which he oweth unto her: . . . For he is her *Head,* as Christ is the Head of his Church, which hee entirely loveth, and for which he gave his very life" (16). Speght goes on to raise an issue untouched by Swetnam: the view, expressed by Puritan preachers such as William Gouge, that wives owed total obedience even to evil husbands as long as they were Christians.[4] The sarcastic tone of Speght's description of men who take this attitude suggests that this issue concerns her more than Swetnam's tract:

> Thus if men would remember the duties they are to performe in being heads, some would not stand a tip-toe as they do, thinking themselves Lords and Rulers, and account every omission of performing whatsoever they command, whether lawfull or not, to be matter of great . . . indignity done them. . . . for if a wife fulfill the evill command of her husband, she obeies him as a tempter, as *Saphira* did *Ananias*. (17)

In fact, most of Speght's response is pitched over Swetnam's head, and over the heads of his putative readers. She seems to be aiming instead at an educated audience seriously interested in biblical interpretation and marriage theory.

Many of her remarks on Swetnam's manipulations of Scripture acutely pinpoint logical flaws common to many antiwoman arguments. Her first point is that he reads too literally, taking allegory as fact. For example, against his claim that Hosea became an idolater when he married "a lewd woman," she points out that the Old Testament does not say this, "it onely containing a declaration of the Lords anger against the idolatrous Jewes, who had gone a whoring after other gods, set forth in a parable of a husband and an adulterous wife" (32). She also undercuts the use of random examples of feminine vice by herself referring only to Christian figures; her list of loyal and patient husbands includes one Roman emperor, Antonius Pius, but he was Christian. More broadly, she questions the validity of inductive reasoning: she rejects generalizations based exclusively on examples of good or bad women. Since most defenses and attacks were built upon lists of heroines or villainesses, this is a marked departure. Speght points out instead that the Bible acknowledges a range of feminine capacities: "In the *Revelation* the Church is called the Spouse of Christ; and in *Zachariah,* weaknesse is called a woman, to shew that of women there are both godly and ungodly" (18); more concretely, Mary was "a patterne of piety" but also a sinner, as proved by her rejoicing "in God her Saviour." She also suggests that misogynist writing is based on old saws rather than on direct observation. In contrast to the presumptuous Swetnam, she will not write of widows because she is "ignorant of their dispositions," just as she accounts it "follie for me to talke of Robin-Hood, as many doe, that never shot his Bowe" (37). All in all, Speght's pamphlet suggests that totalizing praise and condemnation are equally inaccurate; her performance sets up an exemplary counterdemonstration of interpretative precision and Christian tolerance.

In her second section, "Certaine Quares to the Bayter of Women," she shifts tactics, countering Swetnam in wittily satiric ways. She takes his disorganization as a symptom of his character, turning stylistic analysis

into moral criticism and into a justification for her point-by-point refutation:

> The Beare-bayting of Women, . . . being altogether without method, . . . it would admit no . . . order to be observed in the answering. . . . A crooked pot-lid well enough fits a wrie-neckt pot, an unfashioned shoe a misshapen foote, and an illiterate answere an unlearned, irreligious provocation. (19)

Though gayer and more boisterous than the first, this second section uses the same double play: Speght intercuts her self-deprecating pose with sharp critical practice. She apologizes again for her ignorance ("that little smattering in Learning which I have obtained, being only the fruit of such a vacant hours as I could save from affaires befitting my Sex" [19]), but she exposes Swetnam's tract to devastating scrutiny. She points out glaring grammatical errors because they have a political implication ("You count it wonderfull to see the mad feates of women . . . ; but me thinkes it is far more wonder-foole to have one, that adventures to make his Writing as publique as an In-Keepers Signe, . . . to want Concordance in his said Writing, and joyne together *Women* plurall and *shee* singular" [31]); she puns ("such a monster in nature *Asse* your selfe" [30]); she parodies his use of a few seductive women as proof of all women's iniquity: "I may as well say Barrabas was a murtherer . . . ; therefore stay not alone in the companie of any man" (37). And the final poem of the pamphlet revises Swetnam's nose-thumbing exit line by claiming not scattered insouciance like his but righteous fairness:

> Now that the taske I undertooke is ended,
> I dread not any harme unto me intended,
> Sith justly none therein I have offended. (38)

All in all, *A Mouzell for Melastomas* shows that a well-educated Protestant woman could use Swetnam's attack for her own purposes in several ways. Speght produced an acceptably feminized version of religious discourse, through which she made Swetnam look like a foolish if not downright dangerous scoffer at the true faith. What Puritan divine or Protestant husband could help approving of this pious, maidenly, and intelligent correction of an irreligious vulgarian? At the same time, however, she extended the Puritan defense of marriage to affirm women's claim to more egalitarian treatment. The fathers and husbands whose values she defends are called upon to acknowledge the solidity of her interpretation of the Bible and, as a consequence, to accept the liberal marital theory she derives from it. If Swetnam is something less than a Goliath, Speght is indeed, as she is called in one of the prefatory poems to *A Mouzell,* a "little David" (B4r). By maneuvering within the

central Jacobean discourse of revisionist Protestant theology, she is also, as the poem claims, "unto her Sex a faithfull friend."

In contrast to Speght's self-representation as a Protestant maiden, the character of a humanistically educated, secular woman of mature years was constructed by the writer who used the name Ester Sowernam. The pseudonym refers to Esther, the Old Testament heroine who defended her people against the treacherous Haman, and, through antithesis, to Swetnam (Swe[e]t/Sour).[5] The writer defends her right to respond to Swetnam by describing herself as "neither Maide, Wife nor Widdowe, yet really all, and therefore experienced to defend all," and her title suggests her confidence in disputation: *Ester hath hang'd Haman; or, An Answere to a lewd Pamphlet, entituled, The Arraignment of Women. With the arraignment of lewd, idle, froward and unconstant men, and Husbands.* The tract is interesting as evidence of the strategies that would have seemed appropriate for a well-educated bourgeois woman to bring to the gender debate in 1617: training in the classics and Scripture, combined with a sharpness of observation worthy of the new materialist science beginning in this period.[6] Sowernam scores most of her early points by referring to texts that Swetnam muddled or overlooked. But the real force of her attack comes in her seventh and eighth chapters, when she rounds upon Swetnam as the representative of masculine hypocrisy and begins a probing of men's motives which leads her to an innovative psychosocial critique of misogyny.

Sowernam establishes a brisk, no-nonsense persona from the beginning of the tract. She explains that she was led to compose it by a conversation in London; when a debate over women began, her dinner companions mentioned Swetnam's attack and Speght's response. Sowernam writes that she promptly borrowed the man's text and bought the maid's. She read both critically: she remarks that he damns all women although he claims to attack only the obviously flawed ones, while "the Maide, . . . undertaking to defend women, doth rather charge and condemn them" (A2v)—a perceptive comment on Speght's insistence that the female sex cannot be defined as entirely bad or entirely good. Like Speght, Sowernam confronts the necessity of defending herself as woman writer, but her excuse for going into action against Swetnam is less apologetic: "If in this answere I doe use more vehement speeches then may seem to correspond to the naturall disposition of a Woman; yet all judicious Readers shall confesse that I use more mildnesse then the cause I have in hand provoketh me unto" (B1r). Sowernam's first dedication rewrites Swetnam's by appealing to a more deserving audience than his: "To all worthy and hopefull yong youths of Great-Britaine; But respectively to the best disposed and worthy Apprentices of London" (A4r). Her exhortation to women likewise combines a compliment with

53

an injunction to serious reading: "You are women; in Creation, noble; in Redemption gracious; in use most blessed; be not forgetfull of your selves, nor unthankefull to that Author from whom you receive all." The moral authority claimed in this appeal identifies Sowernam as a writer worth paying attention to.

Sowernam's critique of Swetnam's use of the Bible is both pious and ingenious. She argues not for Eve's equality with Adam but for her superiority, often through quasi-scholastic reasoning, as in her rejection of the analogy between the substance from which Eve was made and her moral nature: "That which giveth quality to a thing, doth more abound in that quality, as fire which heateth, is it selfe more hot: . . . So, if woman receaved her crookednesse from the rib, how doth man excell in crookednesse, who hath more of those crooked ribs?" (B2r). Such logic-chopping was standard procedure in the woman debate,[7] but Sowernam gives it new force by parodying Swetnam's reasoning and turning it back on him: "Woman was made of a crooked rib, so she is crooked of conditions. Joseph Swetnam was made as [Adam] from clay and dust, so he is of a dusty and muddy disposition." To correct Swetnam's misattribution to the Bible of the misogynist cliché that women are a necessary evil, she tracks down the classical source of the statement: Euripides' *Medea,* which she cites in a Latin translation. Her comment discredits not only Swetnam but his publisher as well: "Thus a Pagan writeth prophanely, but for a Christian to say, that God calleth women *necessary evils,* is most intolerable and shamefull to be written and published" (C2r). Like Speght, Sowernam outfaces Swetnam by knowing more about his texts than he does.

But her most original interventions in the debate arise from her interpretations of the social practices she observes around her. She may give her ideas a scholastic formulation, as when she uses Aristotle's axiom that "every creature seeks its good" to argue that the extravagant passion of male lovers proves the superiority of the women they love (D3v), but her focus is consistently modern and empirical. An example: when a man marries, it can be seen that his reputation rises; why? because "hee hath a wife; she is the sure signe and seale of honestie" (D4r). Sowernam even uses the double standard to support her view of women's virtue: they are judged more harshly for fornication and drunkenness because they are assumed to have finer moral natures to start with. This is a technique of argument directly opposed to Swetnam's. He tells old jokes to confirm conventional deprecation of women; she studies the attitudes of her day—not necessarily progressive in themselves—in order to argue for a newly positive assessment of women. But she also recognizes that judgments based on the double standard are the

consequence of gender asymmetry in social arrangements. If women fall, it is because they have been relentlessly wooed: "Let there be a faire maide, wife or woman, in Countrie, Towne or Citie, she shall want no resort of Serpents, nor any varietie of tempter: let there be in like sort, a beautiful or personable man, he may sit long enough before a woman will solicite him" (E1r). Sowernam is also alert to the economic imbalance that leads to feminine weakness, which men condemn even while being its cause: men will spend "pounds in bawdie houses" but not "a penny upon an honest maid or woman, except it be to corrupt them" (G3v).

The second section of the pamphlet extends the defense of women into a full-scale attack on men. The title suggests that Swetnam no longer interests Sowernam except as a typical example of masculine bad faith: *The Arraignment of Joseph Swetnam . . . and under his person, . . . of all idle, franticke, froward and lewd men*. This part of the pamphlet may well have been the model for the anonymous 1620 comedy *Swetnam the Woman-hater Arraigned by Women* (see illustration). She interprets men's complaints about women as transparent attempts to shift guilt onto innocent parties. Adam was the first: blaming his sin on Eve, he "did cample and contest with God" (F1v). Sowernam's analysis of this kind of excuse positions Swetnam in a double bind. If, as men insist, they are the stronger sex, does he not slander his fellows by claiming that women's beauty is so irresistible? "Are men so idle, vaine and weake, as you seem to make them?" (F2v). Sowernam then diagnoses the defense mechanisms through which men project their sexual desires onto women. Her opening philological flourish leads into a hardheaded analysis of contemporary behavior:

> The prodigall person among the Graecians is called *Asotos*, as a destroyer, an undoer of himself: When a heart fraughted with sinne doth prodigally lavish out a lascivious looke out of a wanton eye: when it doth surfeit upon the sight, who is *Asotos?* Who is guiltie of his lascivious disease but himselfe? (F2r–v)

This point, that the corrupt see corruption everywhere, is obviously important to Sowernam. She reinforces it with a simply phrased example: "A man and a woman talke in the fields together[;] an honest minde will imagine of their talke answerable to his owne disposition, whereas an evill disposed minde will censure according to his lewd inclination." Swetnam is cited as a case in point: "When men complaine of beautie and say, *That women's dressings and attire are provocations to wantonnesse, and baites to allure men*. It is a direct meanes to know of what disposition they are" (F3r). Sowernam finally moves beyond satire to prescribe a remedy.

SWETNAM,
THE
Woman-hater,
ARRAIGNED BY
WOMEN.

A new Comedie,
Acted at the *Red Bull*, by the late
Queenes Seruants.

LONDON,
Printed for *Richard Meighen*, and are to be sold at his Shops at Saint *Clements* Church, ouer-against *Essex* House, and at *Westminster* Hall. 1620.

Title page of *Swetnam, The Woman-hater, Arraigned by Women* (1620). By permission of the Houghton Library, Harvard University.

Vituperation against women will cease when moral transformation occurs in men: "It is extreme folly to complaine of another, when the roote of all resteth within himselfe; purge an infected heart, and turne away a lascivious eye, and then neither their dressings, nor their beautie can in any way hurt you" (F3v). This is a real advance in the debate over women. Rather than countering accusations of women with denials or counterexamples, this tract pinpoints the hidden purposes fulfilled by misogyny. Sowernam shifts the attack from women to men, from surface to depth, from morality to psychosocial scrutiny.

The conclusion of *Ester hath hang'd Haman* combines two further critiques of misogyny: its convenient dismissal of argumentative women as shrews and its internal contradictions. Sowernam defends her own mode of argument in a cool, rational manner designed to discredit Swetnam as plaintiff and to destabilize his authority as judge. She is not a scold but a reasoned critic of his excesses:

> The difference between a railing Scold, and an honest accuser, is this: the first rageth upon passionate furie, without bringing cause or proofe; the other bringeth direct proofe for what she alleageth. . . . I charge you with blasphemie, with impudence, scurrilitie, . . . [and] I shew just and direct proofe for what I say. (G4r)

The pamphlet ends with a rollicking ballad called "A Defence of Women," which accomplishes through wit what Sowernam's farewell accomplished through reason: it points out the contradictions among Swetnam's judgments of women in order to shift the blame for inconstancy and irrationality from women onto men:

> The humours of men, see how froward they bee;
> We know not how to please them in any degree:
> For if we goe plaine we are sluts they doe say.
> They doubt of our honestie if we goe gay;
> If we be honest and merrie, for giglots they take us,
>
> If modest and sober, then proud they do make us:
> Be we housewifely quicke, then a shrew he doth keepe,
> If patient and milde, then he scorneth a sheepe. . . .
> Tis not so uncertain to follow the winde,
> As to seeke to please man of so humerous minde. (H2r)

The poem concludes with an appeal to women to resist occasions of defamation:

> Let Women and Maides, whatsoever they be,
> Come follow my counsell, be warned by me.
> Trust not men's sutes, their love proveth lust,
> Both hearts, tongues and pens do all prove unjust. (H2v)

That final reference to lying "pens" might be read as an invitation to other women to correct injustice by writing their own defenses. Certainly, Jacobean women had a good model in Sowernam. *Ester's* combination of classicizing humanism with pragmatic social psychology is an inventive maneuver. To use Aristotle to argue for women's virtue is more than a neat trick; it displays learning and wit, and it keeps both within the bounds of feminine propriety. Sowernam avoids inkhorn terms, but she exhibits enough education to impress an audience and enough down-to-earth shrewdness to persuade them. As rhetorician, this writer uses age, an appearance of bourgeois common sense and a measured, ladylike style to support a radical critique of gender relations. Swetnam merely repeats conventional male/female oppositions; Sowernam's text exposes the motives that construct such oppositions, in order to strip them of their ideological power.

The third of the anti-Swetnam pamphlets is a ferocious satirical denunciation, *The Worming of a Madde Dog,* by a writer using the pseudonym Constantia Munda (pure constancy). Several elements of the text make it possible that its writer was a man. For one thing, Constantia is more interested in excluding upstart scribblers like Swetnam from the press than in defending women in any sustained way. Constantia's remarks about women are brief and tend toward idealization, as in the opening poem of daughterly gratitude to an allegorical mother figure, "Prudentia Munda." The real target is Swetnam's appeal to a lower-class audience. In a spectacularly insulting vocabulary, far more violent than that used by either Speght or Sowernam, Constantia associates Swetnam with filth and vice and, calling him "Cerberus the Jaylor of Hell," threatens him with mob violence:

> we will cram you with Antidotes and Catapotions, that if you swell not till you burst, yet your digested poyson shall not be contagious. . . . tis not threatening a cuckingstoole shall charme us out of the compasse of your chaine, our pennes shall throttle you . . . : we will baite thee at thine owne stake, and beate thee at thine owne game. (16)

Rather than establishing an honorable difference between herself and Swetnam, Constantia imagines a battle between like and like.

The Worming is also a class attack upon Swetnam and his readers. Constantia mobilizes the verbal virtuosity of Juvenalian satire in defense of ranks and literary elites that she obviously perceives as threatened by popular culture. Swetnam's readers are attacked in the opening poem in an elaborately metaphorical passage that translates the writer's disdain or fear of the London crowd into scatological language that would have seemed highly indecorous coming from a real woman: "could the straine / Of that your barren-idle-donghill braine, / . . . so fill / The

itching eares of silly swaines, . . . / but to please . . . / The giddy-headed vulgar: whose disease / Like to a swelling dropsie, thirsts to drinke / And swill the puddles of this nasty sinke [cess-pool]?" (A4r–v). The attack is extended into a condemnation of popular writers as low-life hacks: "tis alwaies the badge and cognisaunce of a degenerous and illiberall disposition to be ambitious of that base and ignoble applause, proceeding from the giddy-headed Plebeians" (D3v). Constantia particularly accuses Swetnam of failing to distinguish between women of different ranks:

> How could your vild untutor'd muse infold
> And wrap it selfe in envious, cruell, bold,
> Nay impudent detraction, and then throw
> And hurle without regard your venom'd darts
> Of scandalous reviling, at the hearts
> Of all our female sexe promiscuously,
> Of commons, gentry and nobility? (B1r)

She also likens Swetnam's tract to a stage play for its dangerous exhibition of feminine vice. The interests of the Puritan censor rather than the defender of women underlie this passage:

> Every fantasticke Poetaster which thinkes he . . . can patch a hobbling verse together, will strive to represent unseemely figments imputed to our sex, (as a pleasing theme to the vulgar) on the publique Theatre: teaching the worse sort that are more prone to luxurie, a compendious way to learne to be sinfull. (B2v)

Constantia is less interested in denying the truth of Swetnam's attacks than in pointing out the dangers of allowing him a public.

The next line of argument in *The Worming* is an *ad hominem* attack on Swetnam. Invoking masculine ideals of chivalry, Constantia accuses him of cowardice: "if your currish disposition had dealt with men, you were afraid that *Lex talionis* would meet with you" (C4v). She interprets his attack on marriage as a revelation of his own marital failure: "you having peradventure had some curst wife that hath given you as good as you brought, you run a madding up and downe to make a scrole of female frailties, . . . ascribing them to those that are joyned in the sacred bonds of matrimonie" (C1v). Likewise, she reads his criticism of women's greed as proof of his own immorality:

> you might have told how in the beginning of your thirty years travell and odde, . . . you were addicted to prie into the various actions of loose, strange, lewd, idle, froward and unconstant women: how you happened (in some Stewes or Brothelhouse) to be acquainted with their cheats and evasions; how you came to be so expert in their subtile qualities. (C3r)

In each case, Constantia defends a particular class or institution against Swetnam's "barking": the nobility, the decently married, the "religious matron" as opposed to the prostitute. But aggression outweighs her social pieties. Rather than holding up good women as counterexamples, she represents them as fearless viragos, ready to take legal action against misogynist slander: "Know then that we will cancell your accusations, trauvers your bills, and come upon you for a false inditement" (B2v). We are a long way from the gentle remonstrances of Rachel Speght or from Ester Sowernam's reasoned examination of motives.

Indeed, no conventional notion of proper womanly style is invoked to justify the writing of this pamphlet. Moreover, its technical jargons suggest a range of reading and professional training unlikely to be available to a woman of Swetnam's time: Constantia alludes to Greek satire, cites contemporary writers in French and Italian, uses terms from law, medicine, and logic. And the class snobbery in this sneering critique of Swetnam's use of merely popular texts ("schoole boyes bookes") is typically corporeal in its abuse:

> in the handling of your base discourse, you lay open your imperfections . . . by heaping together the scraps, fragments, and reversions of divers english phrases, by scraping together the glaunders [horses' cysts] and offals of abusive terms, and the refuse of idle-headed Authors, and making a mingle-mangle gallimauphrie of them. (D4r)

Constantia Munda, in sum, writes more like a satirist on the attack than like a woman on the defense.[8] She sounds far more like Thomas Nashe or John Marston than like her Jacobean sisters. If "she" was in fact a man, cashing in on the controversy begun by Swetnam, the contrast between her text and those of Speght and Sowernam emphasizes their strategic adherence to traditional requirements for modesty in women's language. It is notoriously difficult to define a prose style as masculine or feminine, but the striking point about *The Worming* is that its writer was not interested in constructing a persona based on contemporary ideologies of the good woman. Instead, the text promotes an aristocratic perspective and displays a dense literary culture in order to take the offensive against Swetnam. Rather than claiming more freedom for women by criticizing Swetnam's misuse of religious discourse, this tract questions his right of access to any public discourse at all; rather than dramatizing the unfairness of his charges by offering a woman's lucid view of gender inequalities, the text denies the legitimacy of plebeian accusations. Speght and Sowernam manipulate mainstream discourses to earn men's respect from below or beside them; Constantia Munda thunders from above.

Taken together, however, these three writers challenge misogynist habits of thought from every angle available in 1617 and from some new ones. Sadly, though, as ingenious as their compromises and innovations were, they lost the contest. Swetnam's tract was published over and over again; theirs never were. Comic misogyny kept on selling books. Quite likely, it even fit into a backlash against women's questioning of gender arrangements. Male readers obviously preferred the old jokes to new critiques of masculinist ideology. Indeed, the subtlety of argument in the anti-Swetnam tracts probably worked against their authors' appeal to a popular audience.[9] To the extent that Speght's puns and Sowernam's ironies had to remain within the bounds of linguistic decorum for women, they lacked the mass appeal of an outrageous comic like Swetnam.

Nonetheless, for a twentieth-century reader, these pamphlets reveal more than the constraints within which a woman writer had to frame a defense of her sex. They also demonstrate the deepening scrutiny Jacobean thinkers were bringing to the *Querelle des femmes*. All three writers attack men and the male-dominated control of sexual systems from a new theoretical position. These writers ceased to argue that women were as good or better than men conceived of them as being. Instead, they questioned the authority of men as judges. Joseph Swetnam provoked his own arraignment, an arraignment that drew women together in a reduction of misogyny to the absurd. This was certainly a conceptual step forward in the dissolution of men's word on Woman as law.

Notes

1. Of the two men writing against Swetnam, the first was Daniel Tuvill in his *Asylum Veneris* (1616), the second the author(s) of the tragicomedy *Swetnam the Womanhater* (1620). For recent overviews of the controversy see Woodbridge 81–103 and Shepherd 9–23.

2. See Woodbridge for a definition of the balancing formula (67) and for its use in Swetnam (84–85).

3. Judging from entries in the British Library catalogue, I assume Speght's father was the James Speght who wrote *A Brief Demonstration who have, and of the certainty of their having, the Spirit of Christ* (1613) and who published a sermon "preached before the Lord Mayor and Aldermen of London," *The Christian Comfort*, in 1616. Shepherd confirms this identification (58).

4. For this position, see Gouge's *Of Domesticall Duties: Eight Treatises*, a much reprinted collection of the sermons he preached at his Blackfriars church (London: Edward Brewster, 1622; third ed., 1634), 317–18.

5. For a good statement of the difficulties in determining the gender of any of these writers, see Travitsky, 282–83 nn. 12 and 44. Shepherd points out the uncertain gender of Sowernam on the basis of the pseudonym (86), but he offers no specific arguments that s/he was a man.

6. For an argument that Sowernam's approach is akin to "contemporary developments in scientific thought," see Shepherd 17.

7. Both the ingenuity of this particular argument and its positing of Eve's superiority recall Cornelius Agrippa's *De nobiltate et praeccelentia foeminei sexus* (1532) (see Woodbridge 59).

8. Shepherd also argues that Constantia was the pen name of a man, on the basis of the Juvenalian quality of the prose, which he thinks unlikely to have been accessible to a woman (126).

9. For a similar argument about the failure to republish the women's tracts, see Crandall, *Swetnam*, 10.

Works Cited

Crandall, Coryl. "The Cultural Implications of the Swetnam Anti-Feminist Controversy." *Journal of Popular Culture* 2 (1968): 136–48. Based mostly on Louis Wright's work, this study is weakened by its one-dimensional definition of feminism as the belief that women were superior to men.

———. *Swetnam the Woman-hater: The Controversy and the Play*. Lafayette, Ind.: Purdue University Press, 1969. A facsimile edition of the comedy, with a brief introduction providing context and some literary analysis.

Henderson, Katherine Usher, and Barbara F. McManus, eds. *Half Humankind: Contexts and Texts of the Controversy about Women in England, 1540–1640*. Urbana: University of Illinois Press, 1985. Useful historical and biographical introductions to a variety of important feminist texts, some rather harshly abridged.

Kelly-Gadol, Joan. "Early Feminist Theory and the *Querelle des femmes*, 1400–1789." *Signs* 8 (Autumn 1982): 2–28. A very rich article: good coverage of continental as well as English feminism, full of suggestions for further research.

Shepherd, Simon. *The Woman's Sharp Revenge: Five Women's Pamphlets from the Renaissance*. New York: St. Martin's Press, 1985. Good modern-spelling edition of five pamphlets in their entirety (Anger, Speght, Sowernam, Constantia Munda, Tattlewell), with a sharp and appreciative preface.

Travitsky, Betty. "The Lady Doth Protest: Protest in the Popular Writings of Renaissance Englishwomen." *English Literary Renaissance* 14 (Autumn 1984): 255–83. Succinct introduction and study of the strategy, style, and humor of six polemical pamphlets written from 1567 to 1640, from Isabella Whitney's "Copy of a Letter" to Joan Tattlewell's "Womens sharpe revenge."

Woodbridge, Linda. *Women and the English Renaissance: Literature and the Nature of Womankind*. Urbana: University of Illinois Press, 1985. Rich study of the controversy over women as it shaped Elizabethan and Jacobean dialogues, pamphlets, poetry, and drama, including thoughtful readings of popular as well as canonical texts.

IRA CLARK

The Power of Integrity in Massinger's Women

MOST CRITICS have admitted the dominating power, or at least the willfulness, of women in the drama of Philip Massinger, premier professional playwright of the late Jacobean and Caroline theater.[1] But despite recognition of these women's superior wills and language, little note has been made of their exceptional personal integrity or of their extraordinary persuasiveness in public arenas. Nor has the significance of these women's powerful integrity and effective public speech been deemed potentially important for understanding a sociopolitical principle that Massinger consistently presented for the applause of his privileged audience of inns of court friends, Blackfriars' supporters, and noble patrons. Understanding the relative enhancement of women's status in Massinger's stage world is important for understanding a social principle he regularly presented—accommodation. Massinger's customary representation of ideologies of family and state as mutually supporting, in conformity with Stuart expression, further extends accommodation to a political principle. Moreover, the repeated success of his presentation of sociopolitical accommodation suggests inclinations toward that principle among the powerful Pembroke circle of political puritans Massinger courted.[2]

Throughout his dramatic works Massinger seems to have encouraged grateful incorporation of new needs and promise within revered customs and values in order to help ease growing dissatisfaction among leaders searching for a common ground that promoted increasing the power of country and city with the court, balancing the constitutional importance of the Parliament with the monarch, sponsoring lex over rex (law's superiority to royal will), and fostering social elevation for merit with degree—without dislocation or strife. Specifically his consistent presentation of accommodation proffers a moderate reform of traditional virtues based on the old principle of gratitude, with unusual emphasis on obligations of protection, support, and loving concern from the superior (king and father, noble and gentleman, husband and male) as well as duty, honor, and loving loyalty from below. The relative enhancement of women's status seems telling in Massinger plays because of his presentation of the greater likelihood of potential reforms in personal and social mores, particularly of making available greater choice in love, than of potential reforms in the state. Perhaps representation of meliorating reforms in sexual and familial relations made available a paradigm of

tradition accommodating change which might radiate from the extended family through the commonwealth, as suggested by his women's extraordinarily great say in public affairs.

Whether advocating Christian heritage or classical precept, promulgating ancient common law, or promoting polite personal conduct, early Stuarts commenting on women's affairs, be it their social rank, economic and legal dependence, or manners, overwhelmingly emphasized their subordination to a father or to a husband prospective, current, or deceased. Stuart woman was exhorted to obey. Second and third of her all-important traits, the private and the public signs of her obedience, were her chastity, including premarital virginity and marital fidelity, and her modest silence.[3] As the male's touchy defense of his honor displayed admirable self-assertion, so the woman's carefully guarded chastity, her honor, exhibited self-suppression within the double standard. And as the male's prerogatives of giving orders at home and especially of speaking for the family in public demonstrated his preeminence, so the woman's modest discretion, most obvious in public silence, exhibited her submission. Massinger habitually presents the traditional male-female hierarchy, yet his presentation also suggests the rewards of a significant increase in women's influence, especially in political and legal forums where women had no voice and few rights. Massinger's plays frequently represent women winning sufficient moral, social, and political leverage to improve their voiceless, weak status by exalting Western tradition's sine qua non, chastity, into proof of personal integrity and potent will. Through such an accommodation among traditional absolutes of feminine virtue—increasing the might of women's voices and the independence of their status by increasing the value of their chastity—Massinger's plays presented a reformation of gender roles that considerably increased women's power, without rupturing tradition.

Women's power appears even incidentally in Massinger's plays. Their submissiveness often contributes to disaster. Athenais's espousal of women's subordination threatens rule in *The Emperor of the East* (1631) and Theocrine's adherence to it augments horror in *The Unnatural Combat* (1624–25? with Field).[4] Women frequently wield sovereignty, the regent Pulcheria in *The Emperor of the East,* the queen in *The Queen of Corinth* (1616–17), and Cleopatra in *The False One* (1620?), both with Fletcher. It is significant that women's power usually derives from chastity and fidelity whereas their failures issue from the actual or perceived lack of it. Dorothea's power for Christian conversion in *The Virgin Martyr* (1620? with Dekker) is inherited by Paulina in *The Renegado* (1624). Conversely, Beaumelle's flaunted adultery in *The Fatal*

Dowry (1617–19? with Field) and Domitia's in *The Roman Actor* (1626) bring disaster, as do Sforza's suspicions in *The Duke of Milan* (1621–22?). Massinger's plays further present chaste integrity and sexual reform by consistently satirizing the male double standard and rewarding male loyalty. Seducing or assaulting placket knights in *The Parliament of Love* (1624), *The Picture* (1629), and *The Elder Brother* (1625? with Fletcher) become butts. Chaste lovers, the elder brother, Caldoro of *The Guardian* (1633), and Galeazzo of *The Bashful Lover* (1636) marry women they are true to. *The Double Marriage* (1621? with Fletcher) confirms the potency of chaste personal integrity; the weak husband and his society collapse because of their failure to match the chaste loyalty of an incredibly self-sacrificing first wife. Finally, Massinger's most obvious signal of reforming presentation of the traditional subordination of women appears in their persuasive public rhetoric. Nowhere except in chastening the vain chatter of Lady Frugal in *The City Madam* (1632) do Massinger's plays follow the trend of satirizing female volubility. His women seem trained in rhetorical tradition, like the daughter of the tutor Charomonte, who is provided with the identical upbringing (except in arms) given the heir apparent in *The Great Duke of Florence* (1627). Massinger's women voice his plays' most effective rhetoric, speaking eloquently in two public arenas that specifically barred women: councils of national policy and judicial hearings. Massinger's presentation of accommodating reform in women's traditional triple virtues—elevating their status within subordination by exalting their chastity into personal integrity and the strong will to speak out in public forums to demand private respect and move public policy—proffered women relief and hope within old forms. Given Stuart approval of the paternalistic exercise of power, Massinger's representations suggest considerable inclination and potential for meliorating reform.

Representative of Massinger's presentation are two women who choose their own husbands, affect public policy, and win quasi-legal hearings: Camiola, *The Maid of Honour* (1621–22?), and Cleora, the heroine of *The Bondman* (1623). Without any guardian, Camiola is left with unusual independence in choosing a husband among a foolish courtier Sylli, her dead father's gentleman retainer Adorni, the king's favorite Fulgentio, and King Roberto's bastard brother and paragon knight of Malta Bertoldo. Yet Camiola's status leaves her vulnerable to Roberto's disapproval of his brother and promotion of his minion. Her self-conscious integrity and independence, almost egoism, mainly follow from pride in her chastity. She demonstrates her will by refusing to succumb to public pressures and by standing forth to refute one after another of the play's host of selfish, arrogant characters.

Camiola is as repulsed by the presumptuous Fulgentio's native vices as she is attracted by Bertoldo's royal virtues. Therefore, despite the king's virtual command, she rejects the worthless favorite, "As I am a Queene in mine owne house" (2.2.77). When Fulgentio, by displaying the king's ring, tries to lure her ambitions and compel her obedience, she stands on personal integrity:

> Though the King may
> Dispose of my life and goods, my mind's mine owne,
> And shall be never yours. The King (Heaven blesse him)
> Is good and gracious, and being in himselfe
> Abstemious from base and goatish loosenesse,
> Will not compell against their wills, chaste Maidens,
> To dance in his mignions circles. . . .
> .
> I am still my selfe, and will be. (2.2.168–77)

Significantly Camiola not only proclaims her personal integrity, she identifies it with her sense of honor, her chastity. So Fulgentio threatens her chaste repute and spreads lies that she is lasciviously promiscuous. In attacking her primary token of value in the society, he takes advantage as well of the physical or cultural prohibition against a woman's avenging her wronged honor as a man might his. But because Camiola's will, fortified by chastity, is decisively superior, Fulgentio's actions redound to his own ruin.

Camiola's attraction to Bertoldo, as well as her revulsion from Fulgentio, requires that she demonstrate integrity of will. She takes action on learning that not only has Bertoldo lost his campaign and been imprisoned but also that Roberto has issued an edict against anyone's ransoming him. Refusing to blame her monarch, Camiola nevertheless disobeys out of some combination of love and pride. This "simple Virgin" resolves to redeem Bertoldo from disgrace and dungeon because "my aime is high, / And for the honor of my sex to fall so, / Can never prove inglorious" (3.3.162–64). When she commissions Adorni to ransom Bertoldo she further orders him to witness their betrothal (3.3.202–7). Moving boldly she defies her king and she puts aside Bertoldo's oath of celibacy as a knight of Malta, which she had heretofore respected.

More directly, Camiola asserts her personal rights against the king himself when, attended by Fulgentio, he arrives to compel her compliance. On their arrival his highness's "humblest hand-maid" kneels in a physical emblem of her political stance; before, she had evaded confronting the king by the popular ploy of proclaiming his goodness and his minister's misunderstanding. Now when Roberto announces that he has

The Maid of Honour.

Coy, and disdainefull.
 Cam. Save me, or else he'll beat me.
 Fulg. No, your owne folly shall, and since you put mee
To my last charme, look upon this, and tremble.
 Cam. At the sight of a faire ring? the Kings, I take it. *Shewes the*
I have seene him weare the like; if he hath sent it *Kings ring.*
as a favour to mee. *Fulg.* Yes, 'tis verie likely,
His dying mothers gift, priz'd at his crowne,
By this hee does command you to be mine,
By his gift you are so: you may yet redeeme all. (may
 Cam. You are in a wrong account still. Though the King
Dispose of my life and goods, my mind's mine owne,
And shall be never yours. The King (Heaven blesse him)
Is good and gracious, and being in himselfe
Abstemious from base and goatish looseneffe,
Will not compell against their wills, chaste Madiens,
To dance in his magnious circles. I beleeve
Forgetting it, when he washed his hands, you stole it
With an intent to awe me. But you are coozin'd,
I am still my selfe, and will be.
 Fulg. A proud haggard,
And not to be reclaim'd, which of your groomes,
Your coach-man, foole, or foot-man, ministers
Night phisicque to you?
 Cam. You are foule-mouth'd.
 Fulg. Much fairer
Then thy blacke soule, and so I will proclaime thee.
 Cam. Were I a man, thou durst not speake this.
 Fulg. Heav'n
So prosper mee, as I resolve to doe it
To al men, and in every place, scorn'd by
A tit of pen-pence? *Exit Fulgentio and*
 Sylli. Now I begin to be valiant *his Page.*
Nay, I will draw my sword. O for a butcher!
Doe a friends part, 'pray you carry him the length of't.
I give him three yeeres, and a day to match my Toledo,
 E And

Camiola defends her integrity. Philip Massinger, *The Maid of Honour* (1632), act 2, scene 2, sig. E1[a]. By permission of the Pierpont Morgan Library, New York. PML 6429 Sig. E1[a]. Massinger, P.

67

come "to correct / [her] stubborne disobedience" and will forgive her when she amends her fault, she denies that she has knowingly trespassed. When he declares that her rejection of Fulgentio has offended him, she reverses her physical as well as her political posture, effectively arguing her case:

> With your leave, I must not kneele Sir,
> While I replie to this: but thus rise up
> In my defence, and tell you as a man
> (Since when you are unjust, the deity
> Which you may challenge as a King, parts from you)
> 'Twas never read in holy writ, or morall,
> That subjects on their loyalty were oblig'd
> To love their Soveraignes vices.
> To such an undeserver is no vertue. (4.5.52–60)

Seeming to declare allegiance to absolute royal sovereignty, Camiola subordinates royal sovereignty to moral codes and considers continuance in that sovereignty dependent on personal adherence to them. Even as guardian of a subject who is an orphan, the king has no right to compel her choice; he must recognize lex over rex to remain monarch of a people happy because he is "Guided by justice, not his passionate will." Having earned the king's admiration by pleading her public issue, which challenges absolute monarchy, this "Excellent virgin" pursues her related private issue, the slander of her reputation. She demands that the chief custodian of justice enforce her rights by finding his favorite guilty of slandering her. Two remarkable social reforms are prominent through this scene. First, a woman is speaking out legally. Camiola argues her case in two roles that, as a woman, she has no right to assume. As a plaintiff she deems herself a citizen with considerable civil rights. As a spokesperson she argues as a lawyer, a counsellor. Second, a woman is acting on the grounds of her independent integrity, which Camiola regards as an extension of her traditional prime virtue, chastity. Basing reform for the future in the tradition of chaste integrity Camiola speaks out to win her case. Roberto banishes Fulgentio until he repents and gains her pardon.

Camiola's beloved Bertoldo and the Duchess Aurelia, whose domain Bertoldo besieges, provide contrasts to Camiola's integrity. Bertoldo is faulted for ingratitude to Camiola and vainglorious opportunistic love of Aurelia. On learning that Camiola has rescued him from abjection at considerable risk, he pledges love service to her, damning himself if he falters. But when Aurelia astoundingly offers herself and her duchy to him he feels besieged into submission, even though he fully understands that to do so demonstrates an ingratitude he deems the ultimate sin:

> No, no, it cannot be, yet but *Camiola,*
> There is no stop betweene me and a crowne.
> Then my ingratitude! a sinne in which
> All sinnes are comprehended! Aide me vertue,
> Or I am lost. (4.4.153–57)

Particularly because he is surrendering not to love but to his aspiration for a crown, he deserves Adorni's condemnation for all the audience, "The heavie curse that waites on perjurie, / And foule ingratitude, pursue thee ever" (4.4.190–91). Aurelia provides the central foil to Camiola, as her willfulness falls through infatuation into subservience. In the same peremptory way she won Bertoldo, Aurelia promises submission to her betrothed: "When you are made my consort, / All the prerogatives of my high birth cancell'd / I'll practise the obedience of a wife" (5.2.16–18).

There is no place for Aurelia's submissiveness in a maid true to honor, and therefore to independent personal integrity. Never so despotically capricious as her foil, Camiola is admirably more egoistic, more willful, more nearly absolute, in good and in ill. What she can be absolved of is the charge of social and political climbing.[5] She does reject the devoted and socially lower Adorni, who challenged and wounded Fulgentio on her behalf and who acted as her emissary for Bertoldo. And she challenges both state interdiction and religious vows in order to be betrothed to the brother of a king. These acts indicate her extraordinary pride. They do not represent climbing, an antithesis to that pride. Although she never encourages Adorni's attentions, she awards him one-third of her estate. She refuses Fulgentio, second only to the king in the island's hierarchy, as unworthy. And when she chooses to ransom and marry Bertoldo she is a superior saving an inferior perjured, dishonored, imprisoned, disowned, "Dead to all hope, and buried in the grave / Of his calamities" (5.2.109–10). These answers a proudly independent Camiola supplies during her climactic arraignment of Bertoldo, Aurelia, and their society. Because of Bertoldo's ungrateful desertion of her for the duchess, she demands her legal rights of prior betrothal:

> my towring vertue
> From the assurance of my merit scornes
> To stoope so low. I'll take a nobler course,
> And confident in the justice of my cause,
> The king his brother, and new mistrisse, judges,
> Ravish him from her armes. (5.1.105–10)

So sure is Camiola of her righteous position and especially of her personal chaste integrity, she chooses to display them in a public arena

dominated by the king she has challenged and the arrogant duchess who would have to surrender her prospective husband.

Camiola creates the final quasi-legal hearing at court by sweeping into the pomp celebrating Bertoldo's betrothal to Aurelia. Compounding the odds against her she invites the duke of Urbin, whose war for Aurelia's love created the initial stir, to join her other self-interested judges. Camiola's final plea to them makes one notable general political assumption, claims one important public social right, and establishes one central private privilege. She insists that to remain king, chief minister of justice, Roberto is obliged to decide his brother's case without prejudice, "not sway'd, or by favour, or affection, / By a false glosse, or wrested comment alter / The true intent, and letter of the law" (5.2.65–67). She further demands the right to argue her own case, in the eloquent plain style of truth, rather than be represented by a male lawyer, in ornate figures:

> The goodnesse of my cause
> Begets such confidence in mee, that I bring
> No hir'd tongue to plead for mee, that with gay
> Rhetoricall flourishes may palliate
> That, which stripp'd naked, will appear deform'd.
> I stand here, mine owne advocate; and my truth
> Deliver'd in the plainest language, will
> Make good it selfe. (5.2.70–77)

Winning assent for her argument against Bertoldo she once more exhibits the integrity derived from her honesty, her chastity. In fact, she displays egoism, describing herself as a superior beauty. But in a show of proud humility she establishes the importance of self-assurance that curbs overweening beyond the pride of integrity:

> Downe proud heart!
> Why doe I rise up in defence of that,
> Which, in my cherishing of it hath undone mee?
> No Madam, I recant, you are all beauty,
> Goodnesse, and vertue, and poore I not worthy
> As a foyle to set you off. (5.2.148–53)

Although she confesses the flaw she displays, Camiola does not surrender her principled stands. She does set an example for contrite confessions by others who need forgiveness and restoration into a reformed society.

On her model, with reformed respect for law, for women's status, and for women's integrity of will, Aurelia surrenders her arrogant claims and Bertoldo confesses his disloyal ingratitude. Surrendering Bertoldo to the

Order of Malta, sealing peace between the three dukedoms, and reinstating a penitent Fulgentio, Camiola concludes by reasserting once again the power of her integrity in chastity. Forgiving all, forsaking her rank, and distributing her wealth, she marries Christ in the church. Camiola's egoism seems more than her society will bear; it apparently has to consider her, and require her to consider herself, excessive. So her new role will discipline that excess, forgive that trespass, and restore her, just as the rest in that tragicomic society will also be forgiven and restored as they reform past tradition to meet future promise. Imperfect, as all are, Camiola stands "To all posterity, a faire example / For noble Maides to imitate" by her chastity, not her virginity. Though her actions are to be limited by self-confinement, nevertheless, on her chastity she has erected potent self-determining integrity and assertive speech rather than silent female submission.

In *The Bondman* Cleora's initial situation, her progress, and her ultimate marital choice diverge from Camiola's. But her major personal and social concerns come to mirror the maid of honor's and she achieves similar elevation of her gender. Daughter of the pretor of Sicily, Cleora at first demonstrates unquestioning obedience to patriarchy in a remarkable way—by intervening during her nation's formal inauguration of their martial savior in order to speak out eloquently and persuasively to the gathered citizens. Unlike Camiola's, Cleora's early public rhetoric exhibits not challenge but a rare form of feminine subordination. In exhorting Sicily's spoiled and frightened citizens to defensive warfare, she does not speak as a person but serves as a conduit for the ancient communal patriotic voice. Further from Camiola, Cleora initially embraces her society's assumptions about women's status. She dedicates her chastity to a man, offering herself as fuel for the patriotic fervor of a suitor, Leosthenes, and as reward for his military victory. But she is put off because Leosthenes continually presses his authority and rights of male conquest by abusive, battle-of-the-sexes language and because he increasingly exhibits possessive jealousy despite her own extreme and potently persuasive proof of chastity in silence. As her sense of individual integrity grows yet is not appreciated by the conqueror, she begins to incline toward a lover, Marullo, who respects her independent worth. Moreover, she begins to honor and favor him despite his apparent status as the slave who led a briefly successful slave rebellion in the absence of Sicilian armies. In a final love and civil court she has helped to install, she chooses Marullo, who turns out to be a disguised Theban gentleman, for her husband. From submission Cleora converts to choose a reformed, mutually considerate if paternalist marriage. She also chooses a reformed while traditional paternalistic social hierarchy fostered by her

father rather than the absolute male dominion commanded by her brother.[6]

For a woman to be praised as a political leader by virtue of serving as the public spokesperson rather than as a hereditary monarch during this time is remarkable. Yet Cleora is so hailed by all when she serves as the inspired "genius" of Sicilian civic heritage. Such commanding sway over her nation might indicate reformation of a patriarchy. But in the final analysis Cleora's exemplary public pledge of her personal effects for her country's defense and her stirring exhortation of her people's national valor—earning Timoleon's exclamation, "Brave masculine spirit" (1.3.305)—are directed by as well as at men. After the new military regent Timoleon has struck the Sicilians sick, drained them pale, and palsied them by his telling indictment and forewarning of humiliation, Cleora delivers two moving speeches: the first calls on the general citizenry to yield their personal fortunes to the commonwealth's necessities; the second exhorts the nobility to earn their honors and glory by military achievement. Significantly Cleora begins in self-deprecating submission to paternalism and patriarchy, viewing her public rhetoric as an extraordinary dispensation that only momentarily supersedes the sign of her obedient silence:

> If a Virgin,
> Whose speech was ever yet usher'd with feare,
> One knowing modestie, and humble silence
> To be the choysest ornaments of our sexe,
> In the presence of so many Reverend men,
> Strucke dumbe with terrour and astonishment,
> Presume to cloath her thought in vocal soundes,
> Let her finde pardon. (1.3.268–75)

Only after this "bashfull Mayd" and "ignorant Girle" has acknowledged her dutiful obedience to the new military governor, then begged permission from her father, the lords of the island, her brother, and the men at arms, and finally humbly thanked them, does she dare violate the customary signs of female submission by speaking in this public forum. And then her eloquent arousal of Sicilian dedication and valor is not attributed to her but is attested as oraculous. "Shee's inspired," Timoleon admires, "Or in her speakes the Genius of your Countrey" (1.3.362–63). When he dedicates the campaign to her and begs her favor as a knight, he actually witnesses that she is a divine instrument who will revert to her appropriate role of obediently silent woman, perhaps trophy. So it is that Cleora serves as a paragon maid for the reigning hierarchy of values and personages.

For a time Cleora continues to serve in a traditional feminine role, an

image for military dedication and a trophy for the victor. In the play's first lines her brother Timagoras virtually pledges her to Leosthenes' anticipated heroism: "what before you purchased / By Court-ship, and faire language, in these Wars / (For from her soule you know she loves a Souldier) / You may deserve by action." So Leosthenes dedicates himself to claiming her by right of martial heroics: "If faire *Cleora* were confirmd his prize, / That has the strongest Arme, and sharpest Sword, / I would court *Bellona* in her horrid trim, / As if she were a Mistresse." Early during Leosthenes' leave-taking Cleora embraces the traditional role of chaste lady offering the "sparke of honour" which "mount[s] up in glorious flame," her warrior's deeds (2.1.70, 72). The ensuing courtship is, then, appropriately couched in traditional terms of battle and conquest.

But Cleora is disturbed when Leosthenes captures the metaphor to worry about her virgin loyalty. He fears some besieger's artillery might "batter downe / The fortresse of [her] honour" (2.1.127–28), conquer her by storm with arrows of love, undermine her, or worst of all win her traitorous senses. Cleora is distressed by his implicit possessiveness:

> Will you then confirme,
> That love, and jealousie, though of different natures,
> Must of necessity be twins? the younger,
> Created onely to defeate the elder,
> And spoyle him of his Birth-right? 'tis not well. (2.1.161–65)

Moreover she feels "wounded with the arrowes" of her suitor's "distrust" of her chastity, the highest value her society has inculcated in her. In order to shame Leosthenes she vows to out-vestal the vestals: she forbears to kiss or speak to anyone and blindfolds herself so she cannot see anyone until he returns or she dies. Chastity, silence, and obedience have rarely achieved such hyperbolic rhetorical proof. Although Cleora hopes that her incredible, eloquent devotion to virginity and love fidelity will persuade everyone to laud her independent glory and Leosthenes to confess that "whither I live or die, / My Chastity triumphs over your jealousie" (2.1.198–99), she gets only acclaim. Her initial reactions change from commitment to the values and lover she has been reared to into discovery of her independent integrity.

By faithfully maintaining her excessive pledge through the threats and tribulations of the slave rebellion Cleora becomes increasingly aware of her independent worth. Speaking again after Leosthenes' return, she habitually swears "by *Diana*." Dreading more and more that Leosthenes might jealously deny her freedom, she tries to persuade and warn him one last time, "Well, take heed / Of doubts, and feares; For know, *Leosthenes*, / A greater injury cannot be offer'd / To innocent chastity,

THE OUTSPOKEN WOMAN

then unjust suspition" (4.3.197–200). She accurately gauges his scorn of valuing Pisander/Marullo's devoted protection during the slave rebellion to be arrogant possessiveness beyond jealousy:

> Why, good *Leosthenes,* though I endur'd
> A penance for your sake, above example,
> I have not so farre sold my selfe, I take it,
> To be at your devotion, but I may
> Cherish desert in others, where I finde it.
> How would you tyranize, if you stood possess'd of
> That, which is only yours in expectation? (4.3.175–81)

Precisely because she fears loss of her individual will, her integrity, she tries Leosthenes: "Are you sicke / Of your old disease? I'le fit you" (4.3.172–73). Although a temporarily chastened Leosthenes begs a kiss which she grants, he immediately reverts by refusing to listen to her describe the humble devotion of Marullo, who refused even to request a kiss when he could have compelled one. Leosthenes thereby guarantees that an apprehensive Cleora will test both wooers.

When Leosthenes is unable to acknowledge Cleora's integrity, her eloquently silent maintenance of her virginity under extreme duress and her consequent right to personal choice, he fails his test. His jealous sense of her as a possession, a trophy his efforts won, cannot proceed to the trust that will permit her to love him. For he cannot even recognize, much less understand, least of all adhere to a loving marriage as mutual choice and reciprocal consideration instead of the old male conquest and female surrender. Earlier Leosthenes had tried to subdue his jealousy when, overcrediting Cleora for his prowess, he told her brother he felt chastened by the "grievous pennance, / Shee did impose upon her tender sweetnesse, / To plucke away the Vulture jealousie" (3.4.23–25). But Timagoras had persuaded him that victory in battle redeems any fault: "A free confession of a fault winnes pardon; / But being seconded by desert, commands it" (3.4.73–74). Cleora can have no choice. So Leosthenes has reverted to arrogant possessive jealousy by the time the slave uprising is quelled. He refuses, despite the maid's testimony that Cleora has kept her vow, to believe that she has not been raped. And at the conclusion of that stormy reunion scene already noted, he himself admits that "those helpes, / Which confidence lends to others, are from me / Ravish'd by doubts, and wilfull jealousie" (4.3). It comes as no surprise, then, when Leosthenes feels, not hurt love, but proprietary jealousy and loss of personal honor after Marullo is captured in Cleora's chambers: "the Rape / Shee has done upon her honour, with my wrong, / [become] The heavy burthen of my sorrowes song" (4.4.75–77). He

reverts to rage when he learns that she has kept her promise to speak out for Marullo and to visit him even though he is imprisoned for rebellion. Eavesdropping on their conference, he declares her "my valours prize" no matter what she wants (5.2.84). Finally, in his closing plea in the court of love Cleora has been instrumental in establishing so as to offer Pisander/Marullo the opportunity to present his case, Leosthenes commits two unpardonable errors. First he argues that she belongs to his merits: "Ingratefull faire one; and since you are such, / 'Tis lawfull for me to proclaime my selfe, / And what I have deserv'd" (5.3.69–71). Then he fears aloud that Cleora's hesitation in offering herself to him signals her lust for a strong-backed slave. Such statements Leosthenes cannot salvage by his late claim to be a distraught lover. He has proved himself an arrogantly possessive male.

Just as Cleora's brother Timagoras encourages male possessiveness within old standards of martial love and marital dominion, so her father Archidamus supports the reformation that recognizes her personal integrity and free choice of a partner and leads to a more considerate and accommodating, if still paternalist, marriage. When Cleora is sharing with her father her mixed reaction of respect for Leosthenes and yet fear of his possessive jealousy over Marullo/Pisander, Archidamus responds by encouraging her independent choice of a husband: "Thou are thine owne disposer. . . . I will not / How ever I may counsaile, force affection" (5.1.1–4). Moreover, unlike many a patriarch who expresses such a sentiment while he enforces his choice, Archidamus promotes his daughter's free choice of a partner. A protective father, he blocks his son's attempt to coerce. And, at Cleora's urging, he argues for a public love and civil hearing where both suitors are allowed to present their cases. In the prison brawl Leosthenes causes by trying to break up Cleora's conference with Marullo, he claims her as his "valours prize." But the understanding father corrects him about her choice of guardian husband, "With her consent, not otherwise. You may urge / Your title in the Court; if it prove good, / Possesse her freely" (5.2.85–87).

Leading to the final court of love Marullo/Pisander has been passing Cleora's test just as consistently as Leosthenes has been failing it. He recognizes Cleora's integrity and free choice, particularly as they are earned by her chastity. And he expresses grateful consideration and obligation to her. If by rumor he threatens Cleora, in person he never so much as requests to touch her or disturb the least sign of her pledge. Even as the head of the slave rebellion controlling Syracuse, he "dare[s] not / Presume" to tell her his "dispairing Lover"'s story "till by some gratious signe / You shew, you are pleas'd to heare me" (3.2.51–52, 56–58). Astoundingly he honors Leosthenes and guards Cleora for him—

THE OUTSPOKEN WOMAN

for her sake. Reassuringly he explains why he must refuse to take advantage of his physical superiority despite the likelihood that doing so means he is unlikely to gain physical love:

> (nay, feare not Madam,
> True love's a servant, brutish lust a Tyrant)
> I dare not touch those viands, that ne're taste well,
> But when they are freely offred: only thus much,
> Be pleas'd I may speake in my owne deare cause,
> And thinke it worthy your consideration,
> I have lov'd truly, (cannot say deserv'd,
> Since duty must not take the name of merit). (3.2.82–89)

Typical of Massinger's style, central principles are embedded in the two explanatory parentheses. Love is segregated from compelling lust because it is based on free choice. And the corollary, love is not therefore earned by any meritorious duty or deed. Marullo is no possessive Leosthenes. He honors the woman's chaste integrity and free choice as the necessary condition of love. Consequently he pledges that his service is free, not obligatory.[7]

Pisander/Marullo always exhibits considerate love. Imprisoned and awaiting likely execution, for example, he begs Cleora's pardon, confesses his guilt, and vows penance for even thinking of the aggression of a slave rebellion to win her. His finest moment comes when, in the open court, he makes a considerate, liberal love plea for Cleora. His order of presentation reverses the principles of love he has already avowed. Recalling his previous service, he declares that it is wholeheartedly voluntary and that he can expect no return. And, noting his own weak humanity and lack of merit, he places all emphasis on Cleora's free choice:

> How I have lov'd, and how much I have suffer'd,
> And with what pleasure undergone the burthen
> Of my ambitious hopes (in ayming at
> The glad possession of a happinesse,
> The abstract of all goodnesse in mankinde
> Can at no part deserve) with my confession
> Of mine owne wants, is all that can plead for me. (5.3.124–30)

Throughout he contrasts his respect for Cleora's chastity, honor, and integrity to Leosthenes' disregard and he turns Leosthenes' martial figures against him as appropriate for jealousy but inappropriate for love:

> I never
> Durst doubt her constancie, that like a rocke
> Beats off temptations, as that mocks the fury

Of the proud waves; nor from my jealous feares
Question that goodnesse, to which as an Altar
Of all perfection, he that truly lov'd,
Should rather bring a sacrifice of service,
Then raze it with the engines of suspition. (5.3.136–43)

Not even after Pisander surprisingly reveals his noble heritage and Leosthenes' betrayal of betrothal to his sister, receives Leosthenes' confessions, and enjoys the victorious, and patent, reconciliations does he more than request that Cleora, a woman of proven chaste integrity, may "please / To thinke upon my service" in her free choice of a husband (5.3.206–7).

In *The Bondman* as in *The Maid of Honour* and throughout his works, Massinger presents a reformed social tradition of paternalism that accommodates within hallowed values compassionate, admiring recognition of women's integrity and independent marital choice and of their contributing public voice in political and legal affairs. His plays nowhere suggest gender revolution. He represents tradition—in recognizing ultimate female subordination, in accepting the overriding importance of marriage for all women, and in basing the power of their integrity on the Western sine qua non, chastity in premarital virginity and marital fidelity. Still, his plays promote accommodations within that paternalist tradition by recognizing women as individuals with free choice of husbands and as potential contributors to public as well as family matters. Most of all, his plays present these reforms with sympathy and admiration that seem to represent as great a transformation as early Stuart society was capable of conceiving without rebellion. Within his era's powerful sociopolitical constraints, which we are unlikely to accept, Massinger placed a faith, which we are less likely to affirm, in the potential miracles of personal and social charity necessary for his tragicomedies of accommodation. Yet by presenting a reformed status for women offering significant promise albeit final cooptation, his plays offered his audience a paradigm for moderate changes that suggest, with less hope, application to other social and political matters.

Notes

1. The fullest argument is Florence T. Winston, "The Significance of Women in the Plays of Philip Massinger" (Ph.D. diss., University of Kansas, 1972); the most recent confirmation, Philip Edwards's "Massinger's Men and Women," in *Philip Massinger: A Critical Reassessment*, ed. Douglas Howard (Cambridge: Cambridge University Press, 1985), 39–49.

2. For his life, see T. A. Dunn, *Philip Massinger: The Man and the Playwright* (London: Thomas Nelson & Sons for the University College of Ghana, 1957), and especially Donald S. Lawless, *Philip Massinger and His Associates*, Ball State Monograph, no. 10,

Publications in English, no. 6 (Muncie, Ind. 1967). These accounts have been corroborated and condensed by Philip Edwards and Colin Gibson for their indispensable edition of the *Works*, 5 vols. (Oxford: at the Clarendon Press, 1976); I cite and quote this edition and follow its dates. My emphasis on a reforming Massinger issues ultimately from S. R. Gardiner, "The Political Element in Massinger," *Contemporary Review* 28 (1876): 495–507, reprinted in the *New Shakespeare Society's Transactions* series 1, no. 4 (1875–76): 314–31; probably the most important of many revisions are incorporated by Margot Heinemann, *Puritanism and Theatre* (Cambridge: Cambridge University Press, 1980), especially around 102, 116, and 203.

3. I note only that most of the accumulating studies of Renaissance women confirm that the title of Suzanne W. Hull's annotated bibliography accurately highlights the era's trinity of female virtues: *Chaste, Silent, and Obedient: English Books for Women, 1475–1640* (San Marino, Calif.: Huntington Library Press, 1982).

4. One flaw in most considerations of Massinger is that scholars omit discussion of the majority of his output, which were collaborations, primarily with Fletcher in the so-called Beaumont and Fletcher canon. Terence P. Logan's bibliographical essay provides entry to attribution studies by Cyrus Hoy, Bertha Hensman, and others; see his "Philip Massinger," in *The Later Jacobean and Caroline Dramatists*, ed. Terence P. Logan and Denzell S. Smith (Lincoln: University of Nebraska Press, 1978), 90–119.

5. See Philip Edwards's influential "Massinger the Censor," in *Essays on Shakespeare and Elizabethan Drama in Honor of Hardin Craig*, ed. Richard Hosley (Columbia: University of Missouri Press, 1962), 344–46.

6. In "The plays and the playwrights: 1613–42," *The Revels History of Drama in English*, vol. 4, *1613–1660*, Lois Potter et al. (London: Methuen, 1981), 199–200, Kathleen McLuskie regards sexual politics in *The Bondman* as merely titillating. She misses the play's correctives. For instance, in an unnecessary extension of the source's account of ladies substituting slaves for absent husbands, Pisander/Marullo's friend Poliphron explains a new agreement after the overturn. He is no lord of his former mistress; he is her husband:

> When I was her slave,
> She kept me as a sinner to lie at her backe
> In frostie nights, and fed me high with dainties,
> Which still she had in her belly againe e're morning,
> And in requitall of those curtesies
> Having made one another free, we are married. (3.3.40–45)

What could have been presented as titillation is a statement about marriage partners granting each other free choice and mutual love instead of a superior commanding sexual service from an inferior. Likewise, Pisander/Marullo counters Leosthenes; he is not an amplification of male dominion, as McLuskie asserts.

7. A possible exception is Marullo's flash of anger when he is baited by Leosthenes and Timagoras (4.4.65–66). His rejoinder is qualified by the situation, the challenge not to her but to them, and the conditional modal verb.

Works Consulted

Jardine, Lisa. *Still Harping on Daughters: Women and Drama in the Age of Shakespeare*. Sussex: Harvester Press, 1983. The most balanced historical account of dramatic heroines against their economic, educational, and social backgrounds.

Kelso, Ruth. *Doctrine for the Lady of the Renaissance*. Urbana: University of Illinois Press, 1956. The fullest account of the era's enunciated ideals about feminine conduct.

Leech, Clifford. *Shakespeare's Tragedies and Other Studies in Seventeenth-Century Drama*. London: Chatto and Windus, 1950. This contains an early impressionistic but influential essay on the increasing importance of women among characters and audience during the Caroline era.

Leggatt, Alexander. *Citizen Comedy in the Age of Shakespeare*. Toronto: University of Toronto Press, 1973. This contains an extensive account in terms of genre of typical portrayals of merchants' maids, wives, widows, and whores in this popular form which probably presented a higher percentage of important women characters than any other.

Leinwand, Theodore B. *The City Staged: Jacobean Comedy, 1603–1613*. Madison: University of Wisconsin Press, 1986. An account of mercantile women similar to Leggatt's and more limited in time but against a helpful background of contemporary accounts.

Sedge, Douglas. *Social and Ethical Concerns in Caroline Drama*. Diss., University of Birmingham, 1966. Available through interlibrary loan, this dissertation offers one of the earliest nonimpressionistic and documented if still male chauvinist discussions of the increasing number and importance of female dramatic characters.

Shepherd, Simon. *Amazons and Warrior Women: Varieties of Feminism in Seventeenth-Century Drama*. New York: St. Martin's Press, 1981. An account of swashbuckling and other aggressive dramatic heroines.

Woodbridge, Linda. *Women and the English Renaissance: Literature and the Nature of Womankind, 1540–1620*. Urbana: University of Illinois Press, 1984. An analysis of the pamphlet controversy over the nature and status of women in terms of its patterns of discourse.

GAIL REITENBACH

"Maydes are simple, some men say"
Thomas Campion's Female Persona Poems

THOMAS CAMPION's reputation as the premier Renaissance musician-poet seems firmly established. The musical quality, tonal and metrical complexity, epigrammatic skill, and humanity of his verse have won him high praise from seventeenth- and twentieth-century critics who rank him among the greats of his day.[1] Campion's lyrics for female speakers, however, have never been singled out as warrant for his standing, even though the twelve poems (a relatively high proportion of his entire output) rival the best of their day.[2] Taken as a whole, they present more sharply defined, more individualized speakers with a greater variety of moods and minds than do other contemporary examples.[3] Campion's female personae belie the "simple" (foolish and simplistic) way men's rhetoric of love portrays them. Neither "foule [nor] fayre," these speakers reveal complex characters and motives that disprove the physical and moral dichotomization of womankind prevalent in Renaissance love poetry. Additionally, the best of these poems, with their strongly delineated speakers, implied auditors, and social (rather than undefined, mythological, or pastoral) contexts, stand as exemplary dramatic monologues.[4]

Ralph Berringer was the first recent critic to observe "how large a proportion of Campion's songs are for women—certainly a deliberate turnabout of the Petrarchan convention of the languishing lover" (941).[5] Yet, while Berringer's essay seeks to establish Philip Rosseter as poet as well as composer of the ayres in Part 2 of *A Booke of Ayres* (1601), he—along with other critics who debate its authorship—fails to use the absence of female speakers in Part 2 as one of his grounds for determining that Campion did not write the poems.[6]

Most commentators mention that Campion wrote poems for female speakers and perhaps comment on the charm of one or two of the ballads. More perceptive is Catherine Ing's comment about Campion's women in general: "His Corrinas and Lesbias and Bessies may be related to the Delias and Chloes and Sweet Kates, but they have their individuality, and it arises partly from the fact that Campion draws attention to qualities in them hardly noticed by other poets. They may have golden wires for hair and pearls for teeth, but he is not particularly interested if they have. Yet if they move or speak or sing, his awareness quickens at

Title page of Thomas Campion's *Third and Fourth Booke of Ayres*. Reprinted from *Campion's Works*, ed. Percival Vivian (Oxford: Clarendon Press, 1909). By permission of Oxford University Press, and by permission of the General Research Division, The New York Public Library, Astor, Lenox and Tilden Foundations.

once" (173). Campion's interest in women who "move or speak or sing" constitutes the major distinguishing feature of these poems—a not insignificant interest given the, theoretical at least, sanctions on women's tongue during the period.[7]

Benjamin Fuson explains that laments were "chosen more often by English poets as basis for feminine monologs than were all other contexts combined" (131). Campion wrote several female laments, many of them subtly modifying the typical attitudes and responses of the woman spurned. But, given the predominance of female complaints in the Renaissance, exceptions merit close scrutiny, and for that reason I will focus less on Campion's female complaints than on his other more unique female persona poems.[8]

Barbara Bloy, in a study of eighteen miscellanies published between 1557 and 1603, concludes that the poets "created two distinct types of female personae. This mistress is the woman in love, victim of the persuasion of a courtly lover; in falling from her pedestal she finds her tongue and voices her complaint. Her counterpart, the *femme d'esprit,* is willful, witty, and argumentative. She may be either amorous or a devotee of Diana" (5491A). What Campion does, however, is to complicate this dichotomy: his female complainers do not resign themselves to simple passivity or blanket condemnations of all men, and his *femmes d'esprit* show more complexity than the stereotypes of stalwart virgins or lascivious matrons. Bloy argues that "the language and imagery of both types is distinctly different from that of male personae. Their use of myth, especially of Cupid and of Venus and Diana, reinforces the two choices of life open to the Elizabethan woman: the religion of love or the worship of virginity" (Bloy 5491A). But, as the following examples illustrate, Campion's women frequently use the language and imagery of male personae—to ironic ends.

The speaker in "O Love, where are thy Shafts, thy Quiver, and thy Bow?" (4.13), for example, introduces a note of irony to the stock invocation of Cupid. She calls upon Cupid to avenge her rejection by wounding and preventing further flight of the unfaithful lover. She fantasizes, "O then we both will sit in some unhaunted shade, / And heale each others wound which *Love* hath justly made" (10-11), but soon acknowledges this vision as a hollow daydream. The final stanza presents a cryptic conclusion to her complaint:

> At large he wanders still, his heart is free from paine,
> While secret sighes I spend, and teares, but all in vaine;
> Yet, *Love,* thou know'st, by right I should not thus complaine. (13-15)

Why does she confess that she has no right to complain? In light of Campion's other female monologues, one might speculate either that she is fortunate in her loss or that she secretly wanted to lose her lover! However, the preceding stanza suggests a more plausible answer. We have here neither a disciple of Diana nor an imitator of Dido (the two most popular allegiances in Petrarchan complaints for the woman spurned); this speaker shows her acceptance of reality and reconciles herself with practicality. In line 11 she accepts the pains of love as "just." Likewise, she accepts, in the final stanza, the fact that complaint availeth naught. While Campion uses the figure of Cupid in this poem, he does so ironically, by exposing the speaker's experience of Cupid's unreliability and, further, by having the woman address Love in conspiratorial tones as if she and he both understand the charade of Petrarchan love conventions.

The young maid in "Maydes are simple" (3.4), like the speaker in the previous poem, shows herself wise to the language of love, and though she paints herself as frank rather than crafty, her warning against false lovers artfully illustrates the multiple connotations of the adjective "simple." By presenting the speaker as naive and then revealing her depth of native understanding, Campion invites his audience to see both the comedy and the wisdom of this monologist. The first stanza shows the maid's skepticism about the veracity of what "men say":

> Maydes are simple, some men say:
> They, forsooth, will trust no men.
> But, should they mens wils obey,
> Maides were very simple then.

When men call maids "simple" for not receiving their amorous advances, they insinuate that maids are foolish or silly. However, the speaker, redefining what constitutes silly behavior, argues that maids are "very simple," easily misled, if unsuspecting of male rhetoric.

The central stanzas explore the disjunctive relationship between men's language of love and women's experience of love, and the young speaker's explanation of her prudent reluctance to take would-be lovers at their word establishes her not as "simple" but as perspicacious. In the final stanza, rather than find herself "beguiled" by what poetic convention paints as an innocuous "poore blinde childe," the maid accepts the label that men would apply to her, but here with the sense that, being "simple," she remains "free from duplicity, dissimulation, or guile; undesigning, honest, open, straightforward."

"Good men, shew, if you can tell" (2.9) marks a departure from

established Renaissance complaint strategies by addressing—indeed, challenging—an actual public audience rather than a generalized or a classical auditor:

> Good men, shew, if you can tell,
> Where doth humane pittie dwell?
> Farre and neere her would I seeke,
> So vext with sorrow is my brest.
> She (they say) to all is meeke,
> And onely makes th' unhappie blest. (1–6)

The proof the poem goes on to offer of the absence of pity makes the title "Good men" an ironic one. Again, the woman challenges men to "shew" the evidence of what they "tell." Her skeptical parenthesis in line 5—"She (they *say*) to all is meeke"—foreshadows the woman's contention that she has not experienced "humane pity," though she well deserves it, being "Young . . . and farre from guile" (13). Her complaint centers not solely on the dissembling lover (though he comes in for his fair share of blame) but, more unusual in Renaissance complaints, on the absence in society as a whole of compassion for the victim of sexual duplicity:

> From me all my friends are gone,
> While I pine for him alone;
> And not one will rue my case,
> But rather my distresse deride:
> That I thinke there is no place
> Where pittie ever yet did bide. (25–30)

The speaker of "So many loves have I neglected" (2.15) explores explicitly society's sexual double standard. At first the poem appears to be the familiar lament of a lady who regrets having been too long coy. But, in seeking a way out of her situation, she discovers instead the cause of her predicament:

> O happy men, whose hopes are licenc'd
> To discourse their passion,
> While women are confin'd to silence,
> Loosing wisht occasion. (17–20)

By addressing her complaint to the "lucky men," she breaks the prescribed silence with her public retort to society's norms. She subverts the double standard by exposing its contradictions:

> Yet our tongues then theirs, men say,
> Are apter to be moving:
> Women are more dumbe then they,
> But in their thoughts more roving. (21–24)

Campion's 4 2 4 2 accentual pattern underlines the speaker's argument here. The emphasis of line 21 falls on the final accented foot "men *say*" and reinforces the lady's assertion that what men say of women does not coincide with what women *experience* as true.

Campion constructs another sound/sense pattern in the end rhymes, especially in the first rhyming words of each stanza. (This strategy would have received added emphasis in performance with the structure of musical phrases underlining the argument-in-rhyme.) Stanza one: the loves the lady has passively "neglected" have now actively "rejected" her. Stanza two: when she was "wooed" she was the passive one, yet now she herself has actively "vowed" her love. Stanza three: men's desires are actively "licenc'd" by public convention while "women are confined to silence" and passive denial of desire. Stanza four: the speaker's former passive "strangenesse" is contrasted with men's active "plainenesse."

> Should I then wooe, that have been wooed,
> Seeking them that flye mee?
> When I my faith with teares have vowed,
> And when all denye mee,
>
> When I compare my former strangenesse
> With my present doting,
> I pity men that speake in plainenesse,
> Their true hearts devoting; (10–13, 25–28)

Campion's antithesis within rhyme of the passive and active roles the culture ascribes to the sexes finds no synthesis in this poem. While it raises the issue of role reversals by putting this complaint in a woman's mouth, the speaker's difficulty remains unaltered at its end: "Maydes, I see, are never blest / That strange be but for fashion" (31–32).

Yet another poem, "Young and simple though I am" (4.9), exemplifies Edward Doughtie's conjecture that "perhaps the best way to determine what the original audiences thought new is to see which poems continued to be popular throughout the century." This poem "was set to music by Campion himself and also by Nicholas Lanier; ten other versions exist, one dating as late as 1673" (28). It begins:

> Young and simple though I am,
> I have heard of *Cupids* name:
> Guesse I can what thing it is
> Men desire when they doe kisse.
> Smoake can never burne, they say,
> But the flames that follow may.

Skeptical about what "they say," the maid shows herself not entirely "simple" by perceiving the hidden intentions and consequences of love

persuasions. Yet, in spite of her recognition of the danger of love, her sensual body would persuade her that she experiences the real thing. In the third stanza she tries to escape the trap her passions have set for her by imploring: "*Venus,* grant it be not love" (18). If it does prove to be love, she seems ready, in the fourth stanza, to accept the inevitable outcome:

> If if be, alas, what then?
> Were not women made for men?
> As good 'twere a thing were past,
> That must needes be done at last. (19–22)

But the final stanza qualifies her capitulation to her female destiny:

> Yet nor Churle, nor silken Gull
> Shall my Mayden blossome pull:
> Who shall not I soone can tell;
> Who shall, would I could as well:
> This I know, who ere hee be,
> Love hee must, or flatter me. (25–30)

In lines 6 and 7 the maid asserted that she does not conform to the dualistic categories to which men typically assign women: "I am not so foule or fayre / To be proud, nor to despayre." In lines 25 and 26 she cunningly turns such simplistic categorizations on men by swearing, "nor Churle, nor silken Gull / Shall my Mayden blossome pull." While she has admitted the inevitability of giving herself over to a lover, she remains determined to get the best deal possible: "who ere hee be, / Love he must, or flatter me."

Campion's female monologues infrequently find their way into anthologies, but when they do, this last poem and "Faine would I wed a faire young man" (4.24) are usually the editor's choices. Yet, while charming, these youthful meditations on love do not give, by themselves, an accurate impression of the range of female personae Campion creates.

"If thou longst so much to learne" (3.16) is a case in point. Of it, Lowbury, Salter, and Young write: "the female voice is that of a siren luring the clueless youth to an ecstasy of love from which he can't escape even when his rivals are suddenly preferred. . . . The verse is clever and accomplished, but less magical than that of the song which follows [in which the lover is left complaining at his mistress's closed door]" (132). That this female love-dissuasion should strike us as "less magical" is, I would argue, precisely Campion's point. The opening invitation also stands as a thinly veiled threat: "If thou longst so much to learn (sweet boy) what 'tis to love, / Doe but fixe thy thought on mee, and thou shalt

quickly *prove*" (1–2; my emphasis). Demystifying *experience* will prove love a changeling. Innocent overtures quickly give way to an image of captivity:

> Little sute, at first, shal win
> Way to thy abasht desire,
> But then will I hedge thee in,
> Salamander-like, with fire. (3–6)

The subsequent depiction of the conventional pastoral pleasures promised by Petrarchan love poetry (ll. 7–12) are superseded by warnings of rejections, the transition marked in line 13—the poem's midpoint—by one of Campion's favored terms:

> With thee dance I will, and sing, and thy fond dalliance beare;
> Wee the grovy hils will climbe, and play the wantons there;
> Other whiles wee'le gather flowres,
> Lying dalying on the grasse,
> And thus our delightfull howres
> Full of waking dreames shall passe.
>
> When thy joyes were thus at height, my love should *turne* from thee;
> Old acquaintance then should grow as strange as strange might be;
> (7–14; my emphasis)

Just as the speaker turns from affection to scorn, Campion overturns the traditional roles of vulnerable female and experienced, manipulative male. In doing so, he offers a woman, perhaps burned by love herself, who teaches a young boy to consider carefully his intentions before wooing glibly.

The address, "sweet boy," in the previous poem lends a sense of a particular auditor and situation. "So quicke, so hot, so mad is thy fond sute" (3.27) creates an even sharper picture of speaker and auditor. The first stanza establishes their relationship and the speaker's character. The snapping accelerated diction, of the first line especially, reveals the woman's exasperation:

> So quicke, so hot, so mad is thy fond sute,
> So rude, so tedious growne, in urging mee,
> That faine I would with losse make thy tongue mute,
> And yeeld some little grace to quiet thee:
> An houre with thee I care not to converse,
> For I would not be counted too perverse. (1–6)

Lines 5 and 6 mitigate, somewhat, the violent image in line 3. That she would not be counted *too* "perverse" implies her recognition that any

witty back-talking woman must necessarily be so labeled. Yet her perversity declares itself in her very words.

Her protestations in the second stanza completely subvert our expectations of familiar Petrarchan love scenes:

> But roofes too hot would prove for men all fire,
> And hils too high for my unused pace;
> The grove is charg'd with thornes and the bold bryer;
> Gray Snakes the meadowes shrowde in every place:
> A yellow Frog, alas, will fright me so,
> As I should start and tremble as I goe. (7–12)

Davis misconstrues Campion's use of imagery here when he says, "So little concerned is [Campion] with specificity of image, color, or shape that when we encounter an occasional 'yellow Frog' or 'Gray Snakes' we react with surprise—until we realize that the primary effect of such images is to subtly overplay a fearful state of mind" (xiv). True, Campion concentrates more on sound patterns than on visual imagery; however, he uses "yellow Frog" and "Gray Snakes" in this context to ironic ends: the woman's strategy is to demystify the unimaginative, romantic pastoralism of the lover's persuasions by revealing to him an infested earthly "paradise" of love. And the last stanza's final imperious barb should dissuade any reader from thinking that she even feigns a "fearful state of mind":

> Since then I can on earth no fit roome finde,
> In heaven I am resolv'd with you to meete;
> Till then, for Hopes sweet sake, rest your tir'd minde,
> And not so much as see mee in the streete:
> A heavenly meeting one day wee shall have,
> But never, as you dreame, in bed, or grave. (13–18)

The speaker of "Think'st thou to seduce me" (4.18) also verbally outwits her would-be lover. This lyric, however, explores the art of rhetoric in subtler detail. The first stanza derides the muddled lover for his uninspired, borrowed language:

> Think'st thou to seduce me then with words that have no meaning?
> Parats so can learne to prate, our speech by pieces gleaning:
> Nurces teach their children so about the time of weaning.

The third rhymed fourteener line serves the speaker's purpose of abuse by allowing an extra jab! Nevertheless, this woman eschews the violent language of the previous speaker in favor of derisive comparisons of the lover to parrots, who can only mimic what they hear, and to babies just learning to speak. The first analogy pairs the rejected lover with the

subhuman, yet the second seems almost worse, because it emasculates him.

The second stanza depicts the speaker as herself a master of rhetoric who appreciates the appropriate use of the conventions:

> Learne to speake first, then to wooe: to wooing much pertayneth:
> Hee that courts us wanting Arte, soone falters when he fayneth,
> Lookes a-squint on his discourse, and smiles when hee complaineth.
>
> (3–5)

As opposed to most of Campion's female speakers, she does not complain of the deceits of rhetorical conceits. Instead, she shows herself an exacting critic of love persuasions. Mocking the assumption that one type of persuasion could succeed with all women, she implies that each woman must be wooed according to her nature: "Skillfull Anglers hide their hookes, fit baytes for every season" (7).

The lady finally appears to show some pity for the lover's ineptitude in the fifth stanza, but the first line proves flirtatiously sarcastic in light of the unrelenting mockery of the last two lines:

> Ruth forgive me, if I err'd from humane hearts compassion
> When I laught sometimes too much to see thy foolish fashion:
> But, alas, who lesse could doe that found so good occasion? (10–12)

Without question, the woman of "A secret love or two" (2.19) is Campion's earthiest and most openly iconoclastic female speaker. The poem, staged as a trial, also stands among Campion's best dramatic monologues. That Campion should frame this lyric as a trial raises two interesting issues. Merry E. Wiesner says that Renaissance women needed, in most areas, "a male guardian, who was to . . . appear for them in court" (4). Given Campion's love of unmasking sham and hypocrisy, one cannot help wondering if he did not intend this monologist to stand as a subtle commentator on the injustice of restrictions on women's involvement in the legal process. Second, the Renaissance defendant had two options: to plead or to stand mute. Refusal to plead and stand trial by jury brought death by *peine fort et dure* (pressing to death), but since such a prisoner "had never been tried and never convicted . . . consequently his goods and chattels could not be forfeited to the Crown."[9] The married woman, then—with no property *to* protect—would have little reason *not* to plead!

The logic of the speaker's defense against charges of adultery follows the "a" end rhymes of the first stanza:

> A secret love or two, I must confesse,
> I kindly welcome for change in close playing:

> Yet my deare husband I love ne'erthelesse,
> His desires, whole or halfe, quickly allaying,
> At all times ready to offer redresse.
> His owne he never wants, but hath it duely,
> Yet twits me, I keepe not touch with him truly.

In the third line the speaker turns what initially appears a confession of guilt into a sophisticated equivocation: "Yet my deare husband I love *ne'erthelesse*." Similarly, the nonchalant "whole or halfe" of line four recalls the first line's "A secret love or two." In both cases she seems willing to give the "facts," yet manages to use them to her own ends. With Lowbury, Salter, and Young, I find the "metrical ambiguity" in this poem, but it does not, to me, "echo an ambivalence of content" (126). On the contrary, the wife does not vacillate between pleading fidelity and confessing infidelity, but grounds her defense in a wealth of analogies (many paradoxical) designed to reconcile the dualism of the law and the complexity of justice as she conceives of it applying to her case:

> The more a spring is drawne, the more it flowes;
> No Lampe lesse light retaines by lighting others:
> Is hee a looser his losse that ne're knowes?
> Or is he wealthy that wast treasure smothers?
> My churle vowes no man shall sent his sweet Rose:
> His owne enough and more I give him duely,
> Yet still he twits mee, I keepe not touch truly.
>
> Wise Archers beare more than one shaft to field,
> The Venturer loads not with one ware his shipping:
> Should Warriers learne but one weapon to weilde?
> Or thrive faire plants ere the worse for the slipping?
> One dish cloyes, many fresh appetite yeeld:
> Mine owne Ile use, and his he shall have duely,
> Judge then what debter can keepe touch more truly. (8–21)

She proves herself a "Wise Archer," bringing more than one piece of "evidence" and more than one line of argument to her defense. She begins by claiming in the first stanza that whatever her philanderings, her husband never suffers for them: "His owne he never wants, but hath it duely." In the second stanza this refrain becomes: "His owne enough and more I give him duely." Presumably, she deems her attentions to the husband "enough and more" for such a "churle." Finally, she unequivocally argues that from *her* perspective she is true to him, since she considers herself master of her own body: "Mine owne Ile use, and his he shall have duely."

Note the predominance of active and sensual images she draws on: archers, merchants, and warriors; water, fire, and plant. The second group of analogies serves as a type of argument from nature in support of her behavior while the first group associates her with "men of action" rather than with that paragon of Renaissance married women, the docile cipher. In each case she shows that, like the spring, lamp, and plant, the sharing of her sexual favors in no way diminishes their abundance; like the archer, venturer, and warrior, the more experienced she is in loving, the better able she is to satisfy her husband. Her examples culminate in the appropriately sensual maxim: "One dish cloyes, many fresh appetite yeeld." This and the other epigrammatic analogies stand both as a rebuke against the husband's jealousy and as an illustration of the woman's native wit and sensuality.

I claimed earlier that several of Campion's female monologues (including this last) stand as exemplary Renaissance dramatic monologues. Under the broadest definition of the dramatic monologue—"a poem," as Alan Sinfield describes it, "in the first person spoken by, or almost entirely by, someone who is indicated not to be the poet"(8)—all female persona poems are dramatic monologues. Campion's poems, however, fall somewhere between this broad definition and Sinfield's narrow definition based on the dramatic monologues Browning perfected: "a first person speaker who is not the poet and whose character is unwittingly revealed, an auditor whose influence is felt in the poem, a specific time and place, colloquial language, some sympathetic involvement with the speaker, and an ironic discrepancy between the speaker's view of himself and a larger judgment which the poet implies and the reader must develop" (7). The perfection of Campion's monologues varies, as we would expect, but in the most dramatically developed of them this second definition holds with a few noteworthy exceptions. Time and place are not as localized as in "My Last Duchess" yet the use of various markers (such as apostrophe or signals of the auditor's speech or action) gives the impression of a specific dramatic situation. With the possible exception of number 5 of *A Booke of Ayres,* none of the speakers unwittingly reveals her character. On the contrary, these speakers strike us as thoroughly self-aware of both their strengths and their frailties. Similarly, the irony in these poems does not undercut the speaker but, rather, the auditor. The speakers' mastery of rhetorical strategies and the exposure of their insubstantiality directs the irony against the lovers or against society's sexual double standard. In the few cases where the irony does strike home, the speaker recognizes and accepts the joke on herself.

Particularly in the speakers' self-awareness and conscious mastery of language, Campion's female monologues differ significantly from most

other Renaissance examples of the form. Well schooled in the observation of men's manipulation of love's language and in the experience of hyperbolic vows turned to unfaithful betrayals, these women challenge the assumptions of Renaissance love poetry. Their diverse characters—from innocent and canny young maids to remorseful, vindictive, amorous, and ironic women—belie the "simple" way men (and poetic commonplaces) portray them. Through witty yet subversive control (and sometimes inversion) of poetic convention, they expose the sexual double standard that grants dissembling male lovers immunity from social stigma while denouncing the female victim or female philanderer.

Were one to look for explanations for the comparative complexity, variety, and realism of Campion's female speakers, one might be drawn to two possible factors. Lowbury, Salter, and Young argue that Campion's being orphaned at an early age probably helped develop his "unsentimental view of life" (16), a perspective deepened by his work as a physician. The influence of his medical experience "may, perhaps, be discovered in Campion's varied psychological observation" (182). However, such biographical inferences must remain speculative. Whatever the poetry's sources, Campion's creation of multifarious and multidimensional female personae suggests a desire to bring the conventions of Renaissance love poetry and the experience of love in Renaissance society into closer balance. Delightful and instructive, these poems—which rank among his best—warrant a reevaluation of the Campion poems typically anthologized and taught.

Notes

1. For Camden's 1605 ranking of Campion with Sidney, Spencer, Daniel, Drayton, and Shakespeare, see Vivian, xxxviii. Edward Lowbury, Timothy Salter, and Alison Young note, "In 1932 . . . T. S. Eliot described [Campion] as 'except for Shakespeare, the most accomplished master of rhymed lyric of his time'" (12). And Yvor Winters, comparing Sidney and Campion, declares: "Campion's two best poems [in his opinion, "Now winter nights enlarge" and "When thou must home to shades of underground"] seem to me essentially richer and more moving poetry" (115).

2. John Donne's comic dramatic monologue, "Break of day," merits favorable comparison with Campion's female monologues but is the only poem in which Donne ever used a female speaker. I am concerned here with independent lyrics, not with those from prose works or pastorals or other contexts where the form dictates the necessity of a female speaker.

3. Ben Jonson, six years Campion's junior, is probably his closest rival in this category. While numbers nine and ten of *A Celebration of Charis* in *Ten Lyric Pieces* merely present two stock mirror images of women, the lyrics "In the Person of Woman Kind" and "Another. In Defence of Their Inconstancie" are more naturalistic and witty. The second, which begins, "Hang up those dull, and envious fooles," begs comparison with Campion's "A secret love or two." However, it is worth noting that although Jonson's

women speak as representatives of "womankind" and address the battle of the sexes in general terms, Campion's speakers typically speak for themselves and in response to a particular experience. One has the sense that Jonson's women act as rhetorical agents of the poet, whereas Campion's women appear less symbolic, more concretely "characters."

4. John P. Cutts's collection of Renaissance lyrics includes two unusually vivid and dramatic monologues, both exceedingly bawdy but less poetically accomplished than Campion's poems. "Fye away fye what meane you by this" (119) and "John yor my husbandes' man you know" (206) are both anonymous.

5. Ralph Berringer lists the following poems: "ix, xv, and xix of Book II; i, iiii, xvi, xxviii, and probably xxvi of Book III; ix, xiii, xviii, and xxiiii of Book IV" as well as 5 from *A Booke of Ayres* (941, n. 8). I would concur with his list except to argue that 26 of Book 3 has no signal, unlike the rest, to indicate a female speaker.

6. Each of Campion's books of airs, with the unsurprising exception of *The First Booke*'s "Divine and Morall Songs," contains one to five poems by female speakers. Other participants in the debate over Part 2's authorship include A. H. Bullen; Walter R. Davis; Miles M. Kastendieck; Lowbury, Salter, and Young; Thomas MacDonagh; and Vivian.

7. Linda T. Fitz's essay on the status of the Renaissance married woman explains that "if husbands were exhorted not to beat [their wives], wives were exhorted not to give occasion for beating, the most frequent cause of wife-beating apparently being the wife's insistence on talking." She goes on to cite the injunctions of Henry Smith: " 'husbands must hold their hands and Wives their tungs' . . . 'The ornament of a woman is silence'; 'As it becommeth her to keep home, so it becometh her to keep silence' " (4). On this subject, see R. Valerie Lucas's essay in this volume.

8. All Campion poems are cited from Walter R. Davis's edition. Titles of the poems and books will be abbreviated as follows: 3.1 (for number one in *The Third Booke of Ayres*). Line numbers are indicated in parentheses.

9. *Peine forte et dure* had evolved in England by the sixteenth century and was abolished in 1772. See Plucknett, 122.

Works Cited

Berringer, R. W. "Thomas Campion's share in *A Booke of Ayres*." PMLA 58 (1943): 938–48. Stylistic argument for assigning Part 2 of *A Booke of Ayres* to Philip Rosseter rather than Campion. The first to comment on the number of Campion's female persona poems.

Bloy, Barbara Jean McCarter. " 'Women's Exercise': Studies in the Female Personae of Elizabethan Miscellanies." DAI 38 (1977): 5491A (Tennessee). Studies poems using a female persona or direct discourse of a woman from the eighteen extant miscellanies published in London between 1557 and 1603.

Bullen, A. H., ed. *The Works of Dr. Thomas Campion*. London: Chiswick Press, 1889. First collection of Campion's works (omits his treatise on counterpoint). Argues that all the poetry of *A Booke of Ayres* was Campion's.

Cutts, John P. *Seventeenth Century Songs and Lyrics*. Columbia: University of Missouri Press, 1959. Over four hundred unidentifiable and generally unknown lyrics and songs collected from music MSS, presented in alphabetical order. Subject and proper name index.

Davis, Walter R., ed. *The Works of Thomas Campion*. London: Faber and Faber, 1969. Contains all the English and some Latin poems (with translations) and music for a few of the ayres.

Doughtie, Edward. *Lyrics from English Airs, 1596–1622*. Cambridge: Harvard University Press, 1970. Collects verses from all sixteenth- and seventeenth-century songbooks that contained "airs," with the exception of Campion's. With variant readings and extensive notes.

Fitz, Linda T. "'What Says the Married Woman?': Marriage Theory and Feminism in the English Renaissance." *Mosaic* 13, no. 2 (1980): 1–22. Claims that historians have erred in locating the source of modern feminism in Renaissance views of women and marriage. Reexamines the historical materials—ballads, pamphlets, letters, handbooks of marriage advice, sermons—and concludes that the link with modern feminism is less in the treatises than in the spirit of the Renaissance Englishwomen whose beliefs and behavior made such statements necessary.

Fuson, Benjamin Willis. *Browning and His English Predecessors in the Dramatic Monolog*. Iowa City: State University of Iowa, 1948. Identifies the history of female monologues as an important part of the tradition that prepared for Browning's dramatic monologues.

Ing, Catherine. *Elizabethan Lyrics: A Study in the development of English metres and their relation to poetic effect*. London: Chatto and Windus, 1951. Chapter on Campion recognizes his concern with auditory effects, his use of metrical form to create mood, and his interest in the human voice. Studies six poems in relation to Campion's theories.

Kastendieck, Miles M. *England's Musical Poet, Thomas Campion*. New York: Oxford University Press, 1938. First extended study of the relation of Campion's music and verse. Provides musical and poetic analyses of many ayres.

Lowbury, Edward, Timothy Salter, and Alison Young. *Thomas Campion: Poet, Composer, Physician*. London: Chatto and Windus, 1970. Offers sensitive readings of Campion's words and music, correcting Kastendieck's overemphasis on the necessity of treating the ayres' parts together. Notes the sense of dialogue in sequences of poems. Makes some speculative judgments about the influence of Campion's biography on his ayres' themes and style.

MacDonagh, Thomas. *Thomas Campion and the Art of English Poetry*. Dublin: Hodges, Figgis and Co., 1913. Published dissertation on Renaissance metrics and rhyme, drawing on Campion's poetry and poetry treatise (*Observations in the Art of English Poesie*, 1602), with special attention to quantitative verse.

Plucknett, Theodore F. T. *A Concise History of the Common Law*. 4th rev. ed. London: Butterworth and Co., 1948. A historical introduction to the study of law with emphasis on political, economic, social, and religious thought as they contributed to legal thought. Also contains introductions to the history of a few of the main divisions of the law.

Rose, Mary Beth, ed. *Women in the Middle Ages and the Renaissance: Literary and Historical Perspectives*. Syracuse, N.Y.: Syracuse University Press, 1986. A collection of essays with an interdisciplinary focus studying "the effect of sexual ideology on women, the representation of women in literature written by men, the role of women in education, the economy, and the Church, the status of women in politics and the law, and the participation of women in literary culture as patrons, translators, and writers."

Sinfield, Alan. *Dramatic Monologue*. London: Methuen, 1977. A history of the genre with emphasis on Browning. Classifies female persona poems as dramatic monologues because they are written in the voice of someone not to be taken as the poet; brief mention of Campion.

Travitsky, Betty. "The Lady Doth Protest: Protest in the Popular Writings of Renaissance Englishwomen." *English Literary Renaissance* 14, no. 3 (1984): 255–83.

Vivian, Percival, ed. *Campion's Works.* Oxford: Clarendon Press, 1909. First complete edition. Without music.

Wiesner, Merry E. "Women's Defense of Their Public Role." In Rose, *Women in the Middle Ages and the Renaissance,* 1–27. Moving from Joan Kelly's description of the period's sharpened division of public/private, male/female worlds, examines various justifications given by women of their "public role" and concludes that although most justifications were made in individual terms, women recognized that in a society that saw them as women first, "any claim to a public role would have to be based on either a rejection of their female nature or on support for all women."

Winters, Yvor. "The 16th Century Lyric in England: A Critical and Historical Reinterpretation." *Elizabethan Poetry: Modern Essays in Criticism,* edited by Paul J. Alpers, 93–125. New York: Oxford University Press, 1967. Assigns greater importance to the plain style than the Petrarchan in the late sixteenth century and classifies Campion as one of the strongest poets of the plain style school.

II
Woman on the Renaissance Stage

ABBE BLUM

"Strike all that look upon with mar[b]le"
Monumentalizing Women in Shakespeare's Plays

THE IMPULSE to monumentalize is, on one level, to remember, conjure up, commemorate what is valuable—often by altering, idealizing, idolizing the original proportions of a notable person, action, event. Commemorating fixes value, assigns noteworthiness, and it arises in part from a desire to possess what lies beyond possession—to render certain and permanent what is unknowable, unavailable, lost.[1] Shakespeare's plays reveal that monumentalizing often involves the effacement of the object of desire or the projection or displacement of concern with one's own subject-will onto an external object. This is a gendered process. It reflects Western culture's tendency to set up unavailability as a desirable and feminine quality, one that makes women especially prone to being monumentalized. In this essay I argue that the monumentalized woman is a boundary figure for culture; her commemorative "wholeness" exposes provisional, constructed aspects of gender and identity. To support my argument, I first survey aspects of the monumental in Shakespeare's work and then turn to what I see as the most complex example in the plays, the statue scene of *The Winter's Tale*, in order to consider how drama plays out the dynamic of this cultural pattern.

Aspects of the Monumental

Hardening gazes, "sacred" womanly places The woman character is sometimes associated with the monumental as a result of the violating gaze of an amorous male intruder. In such instances male desire partially results from female chastity; the woman's unconsciousness of lust adds early fuel to man's fire. While this essay concentrates on Shakespearean drama, the pattern is very clear in "The Rape of Lucrece." The poem's narrator specifically *commemorates* that Roman matron's chastity in company with Tarquin's rapacious vision. Lucrece's head is "entombed" between the hills of her pillow, "Where like a virtuous monument she lies / To be admired of lewd, unhallowed eyes" (390–92).[2] This unerotic, even distancing, description renders Lucrece a holy place, sanctified and deadened (holy because dead?) through an appropriating, sullying

gaze.[3] When applied to Tarquin, the material of monuments suggests that his desire endures, grows "stiffer" in conjunction with her resistance: "Tears harden lust, though marble wear with raining" (589–95).

Cymbeline reworks Lucrece's rape. Iachimo, who compares himself to "our Tarquin," takes inventory of the sleeping Imogen's chamber and person, fusing the two in his description. He calls on sleep to "lie dull upon her / And be her sense but as a monument, / Thus in a chapel lying" (2.2.12, 31–33) as he removes her bracelet from her arm.[4] The theft of the encircling treasure that was a parting gift from her husband signals Imogen's symbolic rape.

In his soliloquy at the start of act 5, scene 2 of *Othello*, Othello invests his thoughts of murdering Desdemona with an erotic energy complicated for an audience by its knowledge that Desdemona is both faithful and expecting Othello to fulfill the married "rites" of love. His imaging of her effacement yields a vision of a Desdemona already dead, perfectly commemorative, idolized: "Yet I'll not . . . scar that whiter skin of hers than snow, / And smooth as monumental alabaster." Her smothering prevents her scarring; stone is already impervious to easy marking.

These examples demonstrate the coincidence of the heroine's death, effacement, physical or visual violation with the imagery of funereal, sexual, and idolatrous monument. The aroused violators provoke the image, but the violation itself, the enforcement of the vision, seems, paradoxically, to confirm the women as sacred—a killing into wholeness. In each case simile becomes literalized, the woman hardened, at least temporarily.

Petrified silence, amplified voice Monumentalizing entails the relinquishment of woman's voice, self-expression and self-defense. The violation against Lavinia in *Titus Andronicus* consists not just of her rape but also of the removal of her tongue and arms and, with them, her ability to communicate. The imagery tying the monumental to silence occurs most strikingly when during Lucrece's ravishment in "The Rape of Lucrece" she is compared to a "poor lamb" seized by a wolf: "her voice controlled / Entombs her outcry in her lips' sweet fold" (678–79). The entombment suggests the sexual fold and confuses voice and sex, body and language.[5] A variation on this pattern occurs in *Much Ado About Nothing*, when Claudio "blots" Hero's reputation and she "swoons," unable to voice a defense (even her father notes, "she not denies it," 4.1.172). She then becomes associated with the "family's old monument" (4.1.204).

In the later tragedies, the "returned" voice of a silenced woman

informs another aspect of the monumental: the partial inscription of the already distant, unavailable (usually dead) and objectified other woman with the projected marks, desires, voice of those who have desired and harmed her. Hence, Desdemona's speech after Othello alternately entombs her in his mind as dead and looks for signs she is alive: "No more moving? . . . Still as the grave . . . I think she stirs again. No" (5.2.92, 93–94). Desdemona's brief return reinforces her role as masochistic victim: she herself, she says, has "done this deed" of her murder (5.2.115–23). Her partial resurrection literally speaks to the desire, embodied in and inscribed on the monument, to make the dead speak and hence to claim what is unavailable and lost. The same impulse occurs in *King Lear,* when Lear "hears" Cordelia after declaring her "gone for ever": "What is't thou say'st? Her voice was ever soft, / Gentle and low, an excellent thing in woman" (5.3.272, 274–75). Both of these examples suggest that monumentalizing entails the complex involvement of those who kill, objectify, idolize, or otherwise distance the woman into her stonelike state—an involvement that often constitutes identification with her.[6]

The monumentalized, silenced woman sometimes gains the amplifying substitute voice or presence of another woman. Lucrece's maid cries with her for "No cause, but company" ("The Rape of Lucrece," 1236), and Lucrece herself decides to "tune" her own "lamenting tongue" to a tapestry Hecuba who is a "poor instrument . . . without a sound" (1464–65). Emilia enters the bedchamber in *Othello* precisely when Desdemona speaks "beyond" death: "I must needs report the truth," Emilia declares (5.2.127). In *The Winter's Tale* Paulina serves as Hermione's very vocal agent after the queen is imprisoned on her childbed, "Tell her, Emilia, / I'll use that tongue I have" (2.2.51).[7] Beatrice, Charmian, and many others serve in a similar capacity.

Amplified voices at the time of monumentalizing suggest resistance to the effacement of the heroine. The monumental may then be a nodal point in the plays where cultural constructions of woman as other can be interrogated. The vigor of these amplifying voices might stem in part from the different and often lower class of the surrogate feminine voice.[8]

Monumental enclosure In some versions of the monumental the woman is literally or figuratively enclosed by projected ideas, another's will, or an actual commemorative structure. The silenced Hero is associated with the Leonati monument until her return at the end of *Much Ado.* In *Romeo and Juliet,* the erotic reanimation and undoing of Juliet's life (she is described, unlike Romeo, as "bleeding, warm, and newly dead," 5.3.175) occur within the Capulet monument, where family connec-

tions are belatedly asserted. Capulet and Montague unwisely repeat the impulse to monumentalize with their plan to re-create the lovers as golden statues. In *Antony and Cleopatra,* Cleopatra announces her determination to die in her monument: "I have nothing / Of woman in me; now from head to foot / I am marble-constant" (5.2.238–40). This passionate hyperbole ironically depends upon an image of stone to deny the changeable feelings associated with the feminine; Cleopatra ventriloquizes a masculine notion of the feminine while her monument emphasizes her public, political fame. It is no accident that a marble-constant Cleopatra seems improbable.

A number of monumental women are encased within particular virtues. Viola's love-worn "sister-self" in *Twelfth Night* sits silently "like Patience on a monument / Smiling at grief" (2.4.113–114). Hero, Desdemona, and the Cordelia who counsels patience are at least partially immobilized by the suffering passivity that is also conceived as a virtue. In *Measure for Measure,* the long-miserable Mariana declares that unless Angelo raises her from her knees as his wife she will "forever be confixed here / A marble monument" (5.1.230–31).

In *Pericles,* Pericles is the stonelike, incapacitated one who is returned to life by his daughter. His own silence results from a visit to yet another monument, Marina's false grave in Tharsus. After asserting "thou art a man, / and I have suffered like a girl," he observes that Marina "dost look / like Patience gazing on kings' graves and smiling / Extremity out of act" (5.1.137–40). His use of this simile indicates that Pericles recognizes his bond with Marina; his language also, however, replaces her with a figure inherently static and rejuvenating. Reunion here blurs roles and emotional positions.[9]

It has been argued that "Patience on a monument" resembles visual art renderings of both the allegorical Patience and Fortitudo. Some representations of Patience seat her, enchained, on a rock, Andromeda-style.[10] The woman's "embodiment" of such qualities partakes of what Marina Warner sees as the tendency for "allegorical figures representing abstract concepts [to] become such containers [of ideas of completeness, coherence], composed of strong, firm materials. . . ."[11] The symbol patience can, then, harden around and restrict the portrayal of the woman character. I would suggest further that containment—of both appropriate and inappropriate emotions and desires—is precisely what is being evoked through Shakespeare's playing out of the monumental. Women characters must literally and/or figuratively contain those emotions that they themselves supposedly provoke or that are projected upon them. The redundancy that informs certain examples supports this idea, for the portrayal of a stonelike (dead, still) woman encased within a

monument suggests defense by means of repetition. The defense once again indicates that we have run into the constructed, provisional nature of gender roles and boundaries.

Monumental emotions: stirring difference, stone wonder It should be clear by now that monumentalizing enacts specific versions of unequal power relationships. There would be no monument without the one who desires, views, needs to contain, and reacts to the monumentalized other. Nor would the monumental occur without the characters who, construed as other, seem to be delimited by means of a desire external to their own will. Monumentalized relationships draw upon a provisional dynamic (one closely resembling that of drama itself) that is invested in the redrawing of gendered cultural boundaries. The fusion and confusion of emotions, a blurring of subject and object, a wavering of gendered boundaries of power are aspects of what the process commemorates and tries to contain. I want to trace this undoing of distinctions by posing several questions: Why can one image equally describe too much or too little feeling? Why and when does it pertain to the response of both the immobilized and the immobilizer?

Some instances of unequal feeling describe the monumentalized who, "moving others, are themselves as stone" (Sonnet 94). The suffering lover "calcifies" the lack of response of the beloved. In *Twelfth Night,* Olivia protests that she has "said too much unto a heart of stone" (3.4.187), but even then she cannot halt her speech to the unmoved Cesario. Telling Olivia to live "the marble-breasted tyrant still" (5.1.118), Orsino prepares to perform mischief on the same Cesario. The unmoved one need not be a woman: in *Measure for Measure* Angelo is "marble to" Mariana's tears (3.1.24). Yet this imagery does often rely on the suggestion that the woman is especially unnatural. Lear describes the ingratitude in his "child" Goneril as a "marble hearted fiend" (1.4.259), and in *Titus Andronicus* Lavinia tells her soon-to-be violator Demetrius that the milk he had from his mother Tamora "did turn to marble" (2.3.144). Such women (and nurtured sons by association) are linked to unfamilial actions that betray the maternal or the filial. Clearly, failed rhetoric is also key in all cases; the ones who monumentalize have not adequately persuaded those who move them.

A woman's lack of response also signals her virtue, a quality that, paradoxically, can promote her victimization—as in the cases of Lucrece, Imogen, Desdemona, and Hermione. Bertram in *All's Well That Ends Well* attempts to seduce Diana by telling her she is "no maiden but a monument," like one dead, if she resists him (4.2.5–8). While Bertram's come-on advances the naturalness of Diana's "fire," it also

superimposes his desire onto hers. Also, that Bertram yields Diana his own "monumental ring," his token of his ties to father, king, and patrilineal legitimacy (4.3.17), further complicates matters.

When women use Bertram's line, the usual associations of chastity and womanly reticence are reversed. Venus accuses Adonis of being a "cold and senseless stone," an "image dull and dead," a "statue contenting but the eye alone" ("Venus and Adonis," 211–13).[12] Cleopatra notes that Octavia is more like "A statue than a breather" (3.2.24). Although Venus and Cleopatra have been seen as exceptional in their outspoken desire, I would argue that the monumentalizing that associates them with extremes of behavior exposes the stake the represented culture has in portraying woman's coldness, her lack of desire, as an originary one. It follows that woman is often first positioned in terms of being "intact," a virgin. Women's sexuality in particular is thus figured as a response to male desire.

To the extent that it functions as a trope of animation, the monumental manages feminine desire. The dead, unavailable, unfeeling woman must be re-vived, must respond to the one who has monumentalized her. If the feather stirs, Cordelia lives;[13] Desdemona's speech disrupts the stillness of her grave; Juliet is warm and newly dead. This might be thought of as a Pygmalion dynamic; not only does the sculptor fall in love with his own creation, but the sculpture becomes flesh under his hands: "at his touch the ivory [breast] lost its hardness and grew soft."[14] But Pygmalion first fashioned his ivory maiden in revulsion against women who felt and did too much, and for hire: his creation was in answer to the Propoetides, prostitutes whose lack of shame caused the blood to harden in their cheeks: "it required only a slight alteration to transform them into stony flints."[15] The distinction between Galatea and the Propoetides breaks down in the convergence of too much and too little womanly movement and desire; this traditional narrative of autonomous masculine creation is deconstructed by the hardened (in)different other.

One aspect of gendered monumental emotions has been brilliantly examined by Stanley Cavell as a problem of skepticism. Cavell argues that because Othello cannot forgive Desdemona for existing separately from him, his heart is "turned to stone" (4.1.177), and he "unstably projects upon her," and "makes of her the thing he feels."[16] "Thou dost stone my heart," he tells the woman who becomes for him, before her death at his hands, an object like "perfect chrysolite" (5.2.142) with skin as "smooth as monumental alabaster" (5.2.5). Cavell's idea of how *Othello* and *The Winter's Tale* "involve a harrowing of the power of knowing the existence of another" is a crucial insight for analyzing the

monumental, and one to which I am indebted. His formulation tends, however, to re-monumentalize the woman in that she becomes a problem in the hero's epistemology. To the extent that his argument depends upon the original "virgin" perfection of Desdemona,[17] and to the extent that he uses the breaking of the hymen as the scar or seaming that figures all human mortality and separateness, Cavell still participates in the cultural construction of the feminine as other. The woman "contains" and stands for both perfection and imperfection, an indeterminacy centered on her genitals. The subjectivity Cavell can imagine is still basically masculine and features the tragic hero whose action upon the other destroys him. Self does not figure into the equation for the female therein destroyed.

Those who respond with strong emotion to the already monumentalized or dead may themselves be immobilized. Hence, Collatine and his crew stand "Stone-still, astonished with this deadly deed" (1730) of Lucrece's report and suicide. The watchers become identified with what they see; too strong a response results in a sympathetic if temporary incapacitating. Troilus imagines that Hector's death is a word that "will Priam turn to stone" and make "Cold statues of the youth" (*Troilus and Cressida* 5.10.18,20). The irrepressible Benedick is "so attired in wonder" by the attack on Hero's virtue that he "know[s] not what to say" (*Much Ado* 4.1.142–43). Such responses point to the suspension of distinctive identity in a shared immobility.

The idea of immobilizing emotion was current in Shakespeare's time. In his *Natural History* (1627), Francis Bacon describes how "wonder causeth astonishment, or an immoveable posture of the body casting up of the eyes to heaven; and lifting up of the hands. For astonishment, it is caused by fixing of the mind upon one object of cogitation, whereby it doth not spatiate and transcur, as it useth; for in wonder the spirits fly not, as in fear; but only settle, and are made less apt to move."[18] According to Bacon, the wondering observer becomes still, centered on the focused object, fixing it (or heaven) through the mind-gaze. The astonished characters in Shakespeare focus on objects already stilled. What the plays dramatically enact is an identification, confusion, fusion, undoing of distinction between self and other—brought on for a variety of reasons. Cultural constructions like the monumental occur at those moments where values, identities, and alliances seem most provisional.

This aspect of the monumental plays out what might be termed a Medusa dynamic, in which those who gaze directly on the monumentalized are turned to stone. The power of the Medusa has been variously explained—as the deadening reflection of one's own early, narcissistic,

Ellen Terry as Hermione. From the Art Collection of the Folger Shakespeare Library. By permission of the Folger Shakespeare Library.

projected self; the terror of the unknown, innermost aspect of personality; the creative power of the Muse sought by the poet; or even the "moving" aspect of a created work, the power of rhetoric. Freud's interpretation is especially pertinent because it focuses on fear of women. He explains the paralysis of such gazers as apotropaic; their "stiffness" is a sign of erection that turned aside the threat of castration represented by Medusa's head (the threat of castrated woman, sight of the mother's genitals).[19] Might not the fear come from the instability of the split between the observer and what is seen, rather than from simply the supposed terror of castration? Immobilized wonder plays out the infantile belief in the omnipotence of thoughts, connecting the observer to what is observed while temporarily narrowing the world to an individual scope. A-stone-ished terror figures the loss of boundaries which the desire for connection can provoke. These extreme forms of identification are provisional and can be used for good or ill.

Marilyn Taylersen as Hermione in the Royal Shakespeare Theatre production of *The Winter's Tale* (1976). From the Tom Holte Theatre Photographic Collection. By permission of the Shakespeare Centre Library.

Hermione Like a Statue

Although the word "monument" never appears there, the statue scene of *The Winter's Tale* (5.3) plays out the monumentalizing process by embodying it in the "statue" of Hermione. All aspects of the monument recombine here: Abused and "killed" in part by Leontes' malign words and violating vision, Hermione reappears as a semi-sacred statue; the lost voice of infancy and grace returns through her and the amplifying Paulina; Hermione is doubly within her monumental form and the gallery-tomb; and last, the process of her re-animation provokes responsive immobility. Further, this scene demonstrates that the monumentalized woman is and remains, even after her reunion with her family, a character partially removed. Hermione does not or cannot express a completely singular, detached, detailed response (in important contradistinction to the trial scene); nor do audiences on stage or off have

sufficient time to think about that possibility. Instead, the scene focuses on her through the filter of those viewing her. Her "rebirth" is constructed through the wonder expressed by other characters about her. Even though we receive a late explanation for her appearance, it is not the one expected.

How does one play a character "like a statue," and does the actress strive to convey what is inside Hermione's (real? stone?) heart? Gemma Jones, who played Hermione in a 1981 Royal Shakespeare Company production, writes of Hermione that "She stopped. . . . She removed herself from life until the time was ripe for her reemergence. 'I have preserved myself,' she says to Perdita 'in a sort of Zen-like aspic.' But I find it indefinable in merely cerebral terms." Jones did not see Hermione as a big part, and felt that the time between the trial and final scenes is a hard gap for an actress, with act 5, scene 3 becoming "mainly a technical exercise in how to stand still."[20]

Helen Faucit (Lady Martin), the Hermione of Macready's 1830s production of the play, describes preparing for the difficulty of standing unmoving on stage for ten minutes by

> picturing what Hermione's feelings would be when she heard Leontes' voice, silent to her for so many years; . . . Her heart hitherto had been full only of her lost children. . . . To her own surprise her heart, so long empty, loveless, and cold, begins to throb again. . . . Of the sorrow she had wished for him she is now a witness, and it all but unnerves her. Paulina had, it seemed to me, besought Hermione to play the part of her own statue, in order that she might hear herself apostrophised, and be a silent witness of the remorse and unabated love of Leontes before her existence became known to him, and so be moved to that forgiveness which, without such proof, she might possibly be slow to yield. She is so moved; but for the sake of the loving friend, to whom she has owed so much, she must restrain herself, and carry through the appointed task. But, even though I had fully thought out all this, it was impossible for me to hear unmoved what passes in this wonderful scene. My first Leontes was Mr. Macready, and, as the scene was played by him, the difficulty of wearing an air of statuesque calm became almost insuperable.[21]

This actress gives us Hermione *as audience* in her account; her Hermione only "plays" at being a statue, and her focus is Leontes. She insists that both actress and character are deeply moved, if unmoving.

I submit, however, that we cannot be sure what Hermione hears or when, and that the emotional background necessary for Helen Faucit to play the part is fundamentally inaccessible to an audience. We are kept from seizing upon Hermione's steps toward forgiveness because she is

not altogether available. While the casting off of her numbness might well entail this process, it is, above all, simply her reanimation.

Hermione's unavailability leads Nevil Coghill to conclude that by presenting her as the statue of a character the audience had thought dead, Shakespeare sets out "a crisis in the life of Leontes, not of Hermione, and her restoration to him (it is not a resurrection) is something which happens not to her, but to him." Recovering Hermione is for Leontes most like the return of his own purged soul.[22] Coghill participates in the monumentalizing process by "fixing" Hermione in her usefulness to Leontes; he and Leontes can "repossess" her for the sake of Leontes' character development. Such analysis depends upon substituting the internalized conscience for the immobile stone on stage.

At the other extreme, Hermione is credited with a strength manifest because of her sixteen-year disappearance. According to Irene Dash, Hermione "remains statuesque, calm, and reserved . . . does not lay down her life on the level of [Leontes'] dreams. Instead, after fainting at the news of her son's death, she chooses to disappear, refusing to be a breeder of disposable children. The reason for her seclusion centers on the return of the infant."[23] This insistence on Hermione's active will is no less a reaction to her fundamental immobilizing, which is here greatly minimized in description.

I am by no means saying that Leontes, Hermione, and Perdita are not happily reunited—I do not think the same kind of hesitation or even denial by Hermione of Leontes is possible here in the way that has sometimes been played when Isabella is to take the duke's hand in *Measure for Measure*. The very reunion, a silent embrace scripted in relation to Paulina's mediating directions and Hermione's own final speech, suggests that aspects of the monumental remain in operation even when the impulse to monumentalize has been carried out and seemingly overgone.

Let us turn now to the monumentalizing elements in the scene. In a setting that establishes it as play-within-play, self-conscious theater with double audience, Paulina's "behold, and say 'tis well" invokes participation in judging how well the "life is lively mocked by" the statue (5.3.20, 19). Action takes place in a chapel that is both gallery and mausoleum, which recalls the monuments of Hero and Juliet.[24] Attention is called repeatedly to the *artifact* of Paulina's gallery: it is referred to as "stone" four times (once in 5.2), "statue" four times as well. Paulina also points out its "newly fixed" color (5.3.48).

Leontes originally immobilizes Hermione through his paralyzing story of her actions; he then becomes as stone to Hermione's and

Paulina's pleas. His projected imagination indirectly results in her "unnatural" death. Paulina vows, "if you can bring / Tincture or lustre in her lip, her eye, / Heat outwardly or breath within, I'll serve you / As I would do the gods" (201–5). Without breath or color, already cold, Hermione seems even then to be like stone.

The spectacle of act 5, scene 3 enacts the monumentalizing desire to possess and appropriate what is lost, removed, or only partially available. Yet the scene does not allow any spectator or participant to possess the event of reanimation completely, even though Hermione's reunion with Leontes is the culmination of the play, in some critics' minds. William Matchett argues that "silence . . . becomes the final language, the language of love and forgiveness which all can understand." The embrace is underscored by observers' comments and Leontes' "she's warm." (An undoing of Othello's "Cold, cold, my girl? Even like thy chastity," and Juliet's kissing of Romeo's newly dead lips.) But is it sufficient to conclude that "her forgiveness is acted, not spoken," as Matchett suggests?[25] I do not think so. "If she pertain to life, let her speak too," says Camillo (112);[26] Hermione does not remove herself from the monumental to become more fully human or part of community until she speaks.

The only time Hermione speaks, she addresses herself solely to her daughter and does so only after Paulina has directed her attention to her child with "Our Perdita is found" (121). The recognition scene of Perdita and Hermione, as orchestrated by Paulina, thus patterns speech and sight into a mother-daughter identification, which directs explanation and dramatic attention away from Leontes (though staging is important here, and one would want to know where Florizel is—is he as superfluous as the king of France in *Lear,* or part of the silent glue of the scene?). Leontes had not accepted that the infant Perdita was "the whole matter / and copy of the father" (2.3.97). Grown, Perdita is the image of her mother, as Leontes had earlier vouchsafed, and Hermione's reanimation consists in part of living again through her daughter.

Instead of immediately satisfying Polixenes' question of how she lived or was "stol'n from the dead," Hermione first blesses her child and then answers the question with a whole series of her own: "Tell me, mine own, / Where hast thou been preserved? Where lived? How found / Thy father's court?" (5.3.123–25—all questions an audience can answer). Even her vague response to what she did focuses further attention on the mother-daughter tableau: Hermione has "preserved" herself to see the "issue." "Preserve" is used twice in this speech and connects mother and child. The term also moves us away from the notion of immobility while creating a vague sense of Hermione's agency. The royal party had

originally visited the gallery because Perdita wanted to see her mother. The queen who had first appeared as an image in this scene (image being another name for statue), turns to her mirror version, "[her] own" Perdita (123), and in doing so creates a gap in the proceedings. We do not hear of vengeance, forgiveness, or any thoughts at all of Leontes. Nor can we be certain who ever "possessed" the statue: is it Julio Romano's "perform[ance]," Paulina's "poor image," or Hermione's "preserve"? Thus, while the body can be embraced or imprisoned, the spectator's gaze can be and is redirected, partly through speech and gesture. Neither speech nor image can be fully possessed.

The "doubling" of tongue through another woman that is part of the monumentalizing process takes place in this scene. Paulina has protested on Hermione's behalf for sixteen years but is never on stage with her until act 5, scene 3. It is as if Hermione's condemnations of Leontes have been displaced onto Paulina.[27] Paulina orchestrates this entire scene, as critics often note, and she tells Leontes, "If I had thought the sight of my poor image / Would thus have wrought you—for the stone is mine— / I'd not have shown it" (57–59); what can be termed Paulina's vision-image constitutes the subject of this scene as much as does the reunion of Leontes and Hermione. Note how often characters speak and probably direct visual attention to both Paulina *and* Hermione; Paulina often reroutes attention toward Hermione or toward the potential removal of Hermione's image (via the threat to draw the curtain). If monumentalizing involves objectifying the other, Paulina is put in charge of the process in this scene in a way that partially frees up and at least controls the pace of obsessive vision and violation. The stone is hers, and she "wrought" Leontes. She also is the one who shifts Hermione toward the image of her other self: "Turn, good lady, / Our Perdita is found" (120–21)—even if Leontes can at the end command "Peace Paulina," and bid his wife to look upon his "brother" (135, 147).

In act 5, scene 3, Hermione's silence and stillness become entangled in the emotional involvement of the spectators, especially Perdita and Leontes. Paulina gives plenty of cues for "more amazement" (87): her auditors' silence "shows off / [their] wonder" (20–21); she terms Leontes "transported" (68); Perdita could stand a "looker on" for twenty years (83–84). Leontes asks whether or not the stone rebukes him "for being more stone than it" (37–38); apparently Perdita is "fixed" as well, for Leontes in the same speech comments that this statue, a "royal piece . . . From thy admiring daughter took the spirits / Standing like stone with thee" (38; 41–42). Paulina draws all spectators into the circle of the stone: "It is required / You do awake your faith; then all stand still" (94–95). "Stir[red]" (73) by the sight, Leontes commands that "no

foot stir" during Paulina's magic, and Hermione "stirs" (101, 104) and descends. These repeated words and (e)motions suggest or are even perhaps meant to generate proximate states of mind. Even theater audiences have been described as responding with reciprocal wonder. The April 1848 *Glasgow Citizen* reported that Hermione's (Helen Faucit's) reanimation was entrancing: "actually suspending the blood, and taking the breath away. . . . till the descent was fully accomplished, and the stone turned to palpable woman again, something of a fine fear sat upon us like a light chilliness."[28]

Does this shared stillness followed by Hermione's "return" finally undo the monumentalizing process? Is it the case, as Stanley Cavell argues, that the scene presents the creation of Leontes and Hermione by one another as an antidote to stone—an acknowledgment that Hermione is separate from Leontes, has a life beyond his? "Each awakens," writes Cavell, "each was stone, it remains unknown who stirs first, who makes the first move back."[29] The symmetry of the mirrored response makes me suspect otherwise. The extended, suspending wonder reveals that while everyone on stage and in the theater has the reflex of identification, Hermione must be isolated before she is allowed to rejoin the community. That is, whether or not she is the agent of her preservation, her monumental otherness allows for the boundaries and values of her represented society to be scrutinized by this imitative wonder—and the impulses that caused her to be monumentalized to be subsequently recontained.[30]

The association of the statue scene with the power of the playwright has become commonplace, a shorthand for the Pygmalion dynamic: "the resurrection of the woman, is, theatrically, a claim that the composer of this play is in command of the art that brings words to life, or vice versa."[31] I would qualify this observation by adding that act 5, scene 3 shows that the impulses I have described in terms of Pygmalion and Medusa can be one and the same. To stir life from stone and to make stone of life positively and negatively represent the desire to create.[32] This is also a desire to identify and partake of an originary or originating moment beyond the strictures of subject and object—a concept identified with the preoedipal and the power of the mother.[33] The return of Hermione in act 5, scene 3 certainly stresses issue; critics regularly recur to her status as sanctified maternal deity (however human, "statue" in Shakespeare often refers to the sacred); we recall that the play is dominated by her pregnancy in many respects. C. L. Barber and Richard P. Wheeler write that in bringing beloved women back to life, "the thing that is most emphasized . . . [is] their power to create and cherish life, their potential or achieved maternity."[34] This notion circumscribes the

maternal power with that of the male playwright. How is it that we shuttle with such seeming inevitability between these two gendered notions of creation, with the former usually privileged over the latter? I want to end by providing a direction in which to answer this question. Monumentalizing might be reexamined, not in terms of the split between subject and object, observer and observed, but rather in terms of intersubjectivity. That is, we might think of experience as what happens "between individuals, and within the individual-with-others, rather than within the individual psyche."[35] Drama could not exist without betweenness. The tension observable in the last scene of *The Winter's Tale*—the shared immobility and the suspension of distinctive identity of the monumentalizing process—allows us to witness the playing out and redrawing of gendered cultural boundaries. It is time to travel beyond the moral progress of a single protagonist or his victims. We must consider what is omitted when we concentrate attention on character, theme, or even unequal power relations. We must look at all the agencies that participate in processes of identification in order to uncover and develop what lies between.

Notes

1. See Paul de Man, "Autobiography as De-facement," *Modern Language Notes* 94 (1979): 926–30, on apostrophizing an absent or deceased entity. See also Jonathan Goldberg, *Voice Terminal Echo* (London: Methuen, 1986), 124–58.

2. All quotations from "The Rape of Lucrece" are from *The Pelican Shakespeare*, ed. Alfred Harbage (Baltimore: Penguin Books, 1972). Unless otherwise noted, quotations from all plays other than *King Lear*, *Othello*, and *The Winter's Tale* are taken from this edition. For these three I use the Signet editions.

3. Coppelia Kahn points out the unerotic nature of this description in "The Rape in Shakespeare's Lucrece," *Shakespeare Survey* 9 (1976): 51. See also Nancy Vickers, " 'This Heraldry in Lucrece' Face,' " in *The Female Body in Western Culture*, ed. Susan Suleiman (Cambridge: Harvard University Press, 1985), 209–22. In a passage that anticipates *Othello*, Tarquin looks "with more than admiration" at Lucrece's "alabaster skin" (418–19).

4. The previous scene has already associated Imogen's person and genitals with a consecrated sexual place; a lord invokes the heavens to "hold firm / The walls of thy dear honor, keep unshaked / That temple, thy fair mind" (2.1.59–61).

5. See Joel Fineman, "Shakespeare's *Will:* The Temporality of Rape," *Representations* 20 (Fall 1987): 43.

6. According to de Man, who is speaking of inscribing monuments, the positing of a voice for a deceased entity reveals the limits of creation conceived as tropological. "By making the dead speak, the symmetrical structure of the trope implies, by the same token, that the living are struck dumb, frozen in their death" ("Autobiography as De-facement," 930). But who is doing so in these examples? Not just Othello, Lear, Shakespeare, or the audience. The idea of exchange, the fundamental need for some kind of reciprocity, emerges (is perhaps dis-embodied) with these voiced returns.

7. After I drafted this essay, I read and profited from Carol Thomas Neely's observations about heroines' surrogates in *Broken Nuptials in Shakespeare's Plays* (New Haven: Yale University Press, 1985). See esp. 199–210.

8. I thank Carla Freccero for suggesting this idea to me.

9. See C. L. Barber, " 'Thou that beget'st him that did thee beget': Transformation in *Pericles* and *The Winter's Tale*." *Shakespeare Survey* 22 (1969): 59–67.

10. William S. Heckscher, "Shakespeare and the Visual Arts," *Research Opportunities in Renaissance Drama* 13–14 (1970–71): 35–56. See David Bergeron, "The Restoration of Hermione," in *Shakespeare's Romances Reconsidered*, ed. Carol McGinnis Kay and Henry E. Jacobs (Lincoln: University of Nebraska Press, 1978), for the idea that funeral effigies in great state funerals may well have influenced the portrayal of Hermione as statue.

11. Marina Warner, *Monuments and Maidens* (New York: Atheneum, 1985), 258. I thank Sheila Cavanagh for access to her very pertinent " 'Gazing Still': Emblematic Women in the *Faerie Queene*" (unpublished).

12. "Stone(s)" was slang for testicles. Hence Mistress Quickly's report of Falstaff's death bathetically describes the monumental: "I put my hand into the bed and felt [the feet], and they were as cold as any stone. Then I felt to his knees, and so upward and upward, and all was as cold as any stone" (*Henry V* 2.3.21–24).

13. "O you are men of stones," Lear accuses those around him, "Had I your tongues and eyes, / I'd use them so / That heaven's vault should crack" (5.3.258–59). Cordelia's tongue cannot be used now, except as Lear "hears" it in his monumentalizing of her.

14. Ovid, *Metamorphoses*, trans. Mary M. Innes, (1955; reprint, London: Penguin Books, 1976), 10. 283–84.

15. Ibid., 242–44.

16. Stanley Cavell, *The Claim of Reason* (Oxford: Oxford University Press, 1979), 491.

17. Cavell uses Northrop Frye's argument from *The Secular Scripture*. According to Frye, virgin baiting signifies "a vision of human integrity imprisoned in a world it is in but not of. . . ." The virgin symbolizes a "human conviction" of the immortal and invulnerable at the core of fragile being. Quoted in *The Claim of Reason*, 486.

18. Francis Bacon, *The Works of Francis Bacon*, ed. James Spedding, Robert Ellis, and Douglas Heath. 14 vols. (London: Longman's, 1868–90), 2. 720.570. David Bergeron argues that the marvel passed on to the spectators is the "grace of reunion and redemption" ("Restoration of Hermione," 133).

19. For the Medusa story's relation to castration, see Sigmund Freud, "Medusa's Head," in *The Standard Edition of the Complete Psychological Works*, ed. James Strachey (London: Hogarth Press, 1955), 18:273–74. John Freccero discusses immobilizing poetic narcissism and eroticism in "Medusa: The Letter and the Spirit," *Yearbook of Italian Studies* (1972): 1–18. For other treatments of Medusa, poetry, and Muse see Vickers, " 'This Heraldry,' " 219–21; Goldberg, *Voice Terminal Echo*, 149–56; Miranda Johnson Haddad, "Ovid's Medusa in Dante and Ariosto" (unpublished). For a cogent discussion of the apotropaic in relation to politics and sexuality, see Neil Hertz, "Medusa's Head: Male Hysteria under Political Pressure," *Representations* 4 (1983): 27–54. On the feminine, undecidability, and the Medusa dynamic see Mary Jacobus, *Reading Woman* (New York: Columbia University Press, 1986), 122–36. See also n. 30 (below).

20. In Philip Brockbank, *Players of Shakespeare* (Cambridge: Cambridge University Press, 1985), 162.

21. Quoted in *A New Variorum Edition of Shakespeare*, ed. H. H. Furness, vol. 11, *The Winter's Tale* (1898), 292.

22. Nevil Coghill, "Six Points of Stagecraft in *The Winter's Tale*," *Shakespeare Survey* 11 (1958): 40.

23. Irene Dash, "A Penchant for Perdita on the 18th Century Stage," in *The Woman's Part*, ed. Carol Lenz, Gayle Greene, and Carol Neely (Urbana: University of Illinois Press, 1980), 278.

24. It is quite likely that the King's Men used one of their stage property tombs in which to play the scene. See Dennis Bartholomeusz, *"The Winter's Tale" in Performance in England and America: 1611–1976* (Cambridge: Cambridge University Press, 1982), 22–25, for a summary of this argument.

25. William Matchett, "Some Dramatic Techniques in *The Winter's Tale*," *Shakespeare Survey* 22 (1969): 105.

26. We have been prepared for Camillo's command by the Third Gentleman's remark in the previous scene that Romano "so near to Hermione hath done Hermione, that they say one would speak to her and stand in hope of answer" (5.2.107–9).

27. See Peter Stallybrass, "Patriarchal Territories: The Body Enclosed," in *Rewriting the Renaissance*, ed. Margaret Ferguson, Maureen Quilligan, and Nancy Vickers (Chicago: University of Chicago Press, 1986), 123–42, for a cogent discussion of how woman's language and body were conceived of in terms of "open" and "closed" states of property/propriety during the Renaissance. The unrestrained Paulina would undoubtedly function as an example of the female grotesque.

28. Quoted in Bartholomeusz, *The Winter's Tale*, 76.

29. Stanley Cavell, "Recounting Gains, Showing Losses: Reading *The Winter's Tale*," in *Disowning Knowledge in Six Plays of Shakespeare* (Cambridge: Cambridge University Press, 1987), 220. Cf. Neely who argues that the play presents a hard-earned marriage salvaged because Hermione is accepted as fully human, " 'freed and enfranchised' (2.2.60) from the rigid concepts and imprisoning roles projected onto [women] by foolish men" (*Broken Nuptials*, 209).

30. For the idea that when he or she is expelled from society as supernatural, the victim of superstition serves to "polarize all social variables and differences and to isolate a range of values for the society to scrutinize and imitate," see Tobin Siebers, *The Mirror of Medusa* (Berkeley: University of California Press, 1983), 54.

31. Cavell, "Recounting Gains," 218.

32. See John Freccero, "Medussa: The Letter and the Spirit," 13. See also Naomi Schor, *Breaking the Chain: Women, Theory, and French Realist Fiction* (New York: Columbia University Press, 1985), 43–47, on the Pygmalion myth's relation to hieratic code and the making of woman into stone.

33. See Catherine Gallagher, "Reply to Neil Hertz," *Representations* 4 (1983): 56, for the idea that woman's reproductive power is the terror behind the Medusa myth.

34. C. L. Barber and Richard P. Wheeler, *The Whole Journey* (Berkeley: University of California Press, 1986), 334.

35. Jessica Benjamin, "A Desire of One's Own," in *Feminist Studies, Critical Studies*, ed. Teresa de Lauretis (Bloomington: Indiana University Press, 1986), 92.

Works Consulted

I list here writings that have been of use not only in my essay about the monumentalizing process but also in my more general thinking about Shakespeare and feminist theory. This bibliography is by no means a complete record of the works I have consulted. I intend it rather as a help to those who wish to pursue the study of representations of women in Shakespeare's work, feminist theory and Shakespeare criticism, and *The Winter's Tale*.

1. *Shakespeare criticism and feminist theory*
Bamber, Linda. *Comic Women, Tragic Men: A Study of Gender and Genre in Shakespeare.* Stanford: Stanford University Press, 1982.
Belsey, Catherine. *The Subject of Tragedy: Identity and Difference in Renaissance Drama.* London: Methuen, 1985.
Dash, Irene G. *Wooing, Wedding, and Power: Women in Shakespeare's Plays.* New York: Columbia University Press, 1981.
Davies, Stevie. *The Feminine Reclaimed: The Idea of Woman in Spenser, Shakespeare and Milton.* Lexington: University Press of Kentucky, 1986.
Dollimore, Jonathan, and Alan Sinfield, eds. *Political Shakespeare: New Essays in Cultural Materialism.* Ithaca: Cornell University Press, 1985. See Kathleen McLuskie's critique of current feminist Shakespeare approaches.
Drakakis, John, ed. *Alternative Shakespeares.* London: Methuen, 1985. See especially the essays by Catherine Belsey and Jacqueline Rose.
Dusinberre, Juliet. *Shakespeare and the Nature of Women.* London: Macmillan, 1975.
Erickson, Peter. *Patriarchal Structures in Shakespeare's Drama.* Berkeley: University of California Press, 1985.
Erickson, Peter, and Coppelia Kahn, eds. *Shakespeare's "Rough Magic": Renaissance Essays in Honor of C. L. Barber.* Newark: University of Delaware Press, 1985. See especially the essays by Carol Thomas Neely, Janet Adelman, Coppelia Kahn, and Edward Snow.
Ferguson, Margaret W., Maureen Quilligan, and Nancy J. Vickers, eds. *Rewriting the Renaissance: The Discourses of Sexual Difference in Early Modern Europe.* Chicago: University of Chicago Press, 1986. In addition to having many very good essays on patriarchy and marginalization, this book has an excellent bibliography for anyone interested in Renaissance women and theory.
Greene, Gayle, and Carolyn Ruth Swift, eds. *Feminist Criticism of Shakespeare.* Two special issues of *Women's Studies: An Interdisciplinary Journal* 9 (1981): 1–217.
Hartman, Geoffrey, and Patricia Parker, eds. *Shakespeare and the Question of Theory.* London: Methuen, 1986. See especially the essays by Elaine Showalter and Nancy Vickers. Also, two critics should be examined for their position in relation to feminist criticism: Jonathan Goldberg criticizes Linda Bamber's notions of patriarchy and genre, and Joel Fineman takes on the idea of woman's language and linguistic indeterminacy.
Jardine, Lisa. *Still Harping on Daughters: Women and Drama in the Age of Shakespeare.* Sussex: Harvester Press, 1983. Critical of "nonhistorical" feminist analysis.
Kahn, Coppelia. *Man's Estate: Masculine Identity in Shakespeare.* Berkeley: University of California Press, 1981.
Lenz, Carolyn Ruth, Gayle Greene, and Carol Thomas Neely, eds. *The Woman's Part: Feminist Criticism of Shakespeare.* Urbana: University of Illinois Press, 1980. See especially the bibliography on "Women and Men in Shakespeare."
Montrose, Louis Adrian. *In Mirrors More than One: Elizabeth I and the Figurations of Power.* Chicago: University of Chicago Press, 1986.
———. "'Shaping Fantasies': Figurations of Gender and Power in Elizabethan Culture." *Representations* 1, no. 2 (Spring 1983): 61–94.
Novy, Marianne. *Love's Argument: Gender Relations in Shakespeare.* Chapel Hill: University of North Carolina Press, 1984.
———. "Shakespeare and Emotional Distance in the Elizabethan Family." *Theater Journal* 33 (1981): 316–26.
Schwartz, Murray M., and Coppelia Kahn, eds. *Representing Shakespeare: New Psychoana-*

lytic Essays. Baltimore: Johns Hopkins University Press, 1980. See especially the essays by David Leverenz, Janet Adelman, Madelon Gohlke, C. L. Barber, and Coppelia Kahn. This volume contains a very useful bibliography of psychoanalytic and psychological writings on Shakespeare, 1964–1978.

Williamson, Marilyn L. *The Patriarchy of Shakespeare's Comedies.* Detroit: Wayne State University Press, 1986.

Woodbridge, Linda. *Women and the English Renaissance: Literature and the Nature of Womankind, 1540–1620.* Urbana: University of Illinois Press, 1984.

2. The monumental process

Barthes, Roland. *A Lover's Discourse.* Translated by Richard Howard. New York: Hill and Wang, 1978.

Benjamin, Jessica. "A Desire of One's Own." In *Feminist Studies, Critical Studies,* edited by Teresa de Lauretis. Bloomington: Indiana University Press, 1986.

Cavell, Stanley. *The Claim of Reason.* Oxford: Oxford University Press, 1979.

———. *Disowning Knowledge in Six Plays of Shakespeare.* Cambridge: Cambridge University Press, 1987.

de Man, Paul. "Autobiography as De-facement." *Modern Language Notes* 94 (1979): 926–30.

Fineman, Joel. "Shakespeare's *Will:* The Temporality of Rape." *Representations* 20 (Fall 1987): 25–76. Fineman's argument is important for feminists to note. Fineman implies (70–71) that any argument that traces out the trajectory of that "old" or "traditional" conjunction of triangulated violence and desire itself has the vantage point of rape.

Gallagher, Catherine, "Reply to Neil Hertz." *Representations* 4 (1983): 55–57.

Goldberg, Jonathan. *Voice Terminal Echo: Postmodernism and English Renaissance Texts.* London: Methuen, 1986.

Heckscher, William. "Shakespeare and the Visual Arts." In *Research Opportunities in Renaissance Drama* 13–14 (1970–71).

Hertz, Neil. "Medusa's Head: Male Hysteria under Political Pressure." *Representations* 4 (1983): 27–54.

Jacobus, Mary. *Reading Woman: Essays in Feminist Criticism.* New York: Columbia University Press, 1986. See especially "Judith, Holofernes, and the Phallic Woman" for a discussion of how representation gives rise to structures and stories that combat indeterminacy—a crucial insight for monumentalization.

Kofman, Sarah. *The Enigma of Woman: Woman in Freud's Writings.* Translated by Catherine Porter. Ithaca: Cornell University Press, 1985.

Parker, Patricia. *Literary Fat Ladies: Rhetoric, Gender, Property.* London: Methuen, 1987. See especially "Coming Second: Woman's Place."

Rose, Jacqueline. *Sexuality in the Field of Vision.* London: Verso, 1986. Helpful on the subject of how definition produces woman as other.

Schor, Naomi. *Breaking the Chain: Women, Theory, and French Realist Fiction.* New York: Columbia University Press, 1985. See in particular "Smiles of the Sphinx: Zola and the Riddle of Femininity" for the idea of how the representation of woman is produced.

Siebers, Tobin. *The Mirror of Medusa.* Berkeley: University of California Press, 1983.

Stallybrass, Peter. "Patriarchal Territories: The Body Enclosed." In Ferguson, Quilligan, and Vickers, *Rewriting the Renaissance,* 123–42.

Stallybrass, Peter, and Allon White. *The Politics and Poetics of Transgression.* Ithaca: Cornell University Press, 1986.

Vickers, Nancy. "'The Blazon of Sweet Beauty's Best': Shakespeare's *Lucrece.*" In Hartman and Parker, *Shakespeare and the Question of Theory,* 96–116. This essay elaborates upon Vickers's earlier Lucrece piece.
Warner, Marina. *Monuments and Maidens.* New York: Atheneum, 1985.

3. The Winter's Tale

Barber, C. L. "The Family in Shakespeare's Development: Tragedy and Sacredness." In Schwartz and Kahn, *Representing Shakespeare,* 217–43.

———. "'Thou that beget'st him that did thee beget': Transformation in *Pericles* and *The Winter's Tale.*" *Shakespeare Survey* 22 (1969): 59–67.

Barber, C. L., and Richard P. Wheeler. *The Whole Journey: Shakespeare's Power of Development.* Berkeley: University of California Press, 1986.

Bartholomeusz, Dennis. *"The Winter's Tale" in Performance in England and America: 1611–1976.* Cambridge: Cambridge University Press, 1982.

Bergeron, David. "The Restoration of Hermione in *The Winter's Tale.*" In *Shakespeare's Romances Reconsidered,* edited by Carol McGinnis Kay and Henry E. Jacobs, 125–33. Lincoln: University of Nebraska Press, 1978.

———. *Shakespeare's Romances and the Royal Family.* Kansas: University Press of Kansas, 1985.

Coghill, Nevil. "Six Points of Stagecraft in *The Winter's Tale.*" *Shakespeare Survey* 11 (1958): 31–42.

Felperin, Howard. "'Tongue-Tied our Queen?': The Deconstruction of Presence in *The Winter's Tale.*" In Hartman and Parker, *Shakespeare and the Question of Theory,* 3–18.

Goldman, Michael. *Shakespeare and the Energies of Drama.* Princeton: Princeton University Press, 1972.

Gurr, Andrew. "The Bear, the Statue, and Hysteria in *The Winter's Tale.*" *Shakespeare Quarterly* 34, no. 4 (1983): 420–25.

Kahn, Coppelia. "The Providential Tempest and the Shakespearean Family." In Schwartz and Kahn, *Representing Shakespeare,* 217–43.

Matchett, William. "Some Dramatic Techniques in *The Winter's Tale.*" *Shakespeare Survey* 22 (1969).

Pyle, Fitzroy. *"The Winter's Tale": A Commentary on the Structure.* London: Routledge and Kegan Paul, 1969.

ANNE M. HASELKORN

Sin and the Politics of Penitence
Three Jacobean Adulteresses

IN JACOBEAN dramatic portrayals of women, we are confronted with a seeming paradox. On the one hand, we find many examples of the woman who is a paragon of purity, passivity, and submissiveness: Aspatia in Beaumont and Fletcher's *Maid's Tragedy;* Isabella in Webster's *White Devil;* Ophelia in Shakespeare's *Hamlet;* Virgilia in *Coriolanus;* Octavia in *Antony and Cleopatra*—to name just a few. These are virtuous women who are admired and acknowledged by the playwright and his audience as the embodiment of true womanhood. On the other hand, we find the independent strumpet who is the essence of sexuality, willfulness, and ambition: Evadne in *The Maid's Tragedy;* Vittoria in *The White Devil;* Cressida in Shakespeare's *Troilus and Cressida;* Cleopatra in *Antony and Cleopatra;* Bianca in Middleton's *Women Beware Women.*[1] But, while such women are always defeated, this unconventional, even unbridled type is also presented as attractive, stimulating, and provocative. The question then arises: Why did the Jacobean dramatists depict the provocative woman as admirable at all?

Explanations for revering the pure woman while castigating the sensual female have their roots in the societal expectations for women that had developed by this period and that were largely rooted in the Christian tradition with its dual conception of Mary Magdalen and the Virgin Mary, mother of Christ.[2] Suzanne Hull demonstrates that Renaissance women were expected to be "chaste, silent, and obedient," and these obligations were reinforced by a proliferation of conduct books and the reading of "Certayne Sermons, or Homilies" every Sunday in church.[3] Given these attitudes, independent women should have been shown to be merely evil, vicious, unredeemed voluptuaries. But they were not.[4]

Instead, the dramatist creates a literary construct on the basis of a male psychological construct:[5] bloodless heroines are juxtaposed with attractively seductive females who defy society's conventions. A simple Freudian explanation for this paradox is that the virtuous woman reflects the male's "superego" or inhibitory tendencies, and the sexual woman represents his libidinal or "id" tendencies. The chaste woman is identified with positive acts in a man's life, whereas the sexual woman arouses

him and tends to encourage sinful behavior.[6] Repeatedly, however, what his reason rejects, his heart embraces. The sexual woman intrudes into man's well-ordered existence as a disruptive but tantalizing force.[7]

Since restrictions for the woman in the Renaissance were awesome, there was no approved place for the strong-willed woman who persisted in appropriating masculine prerogatives of behavior to achieve selfhood. Such a woman serves as a tap for turning on male apprehension, a threat to the patriarchal privilege of control. Consequently, the woman in the drama outside the conventions, no matter how attractive, must in some way be brought low: cast out, branded a whore, forced to repent, killed.[8] This form of resolution often has nothing to do with the woman as an individual. This resolution demands abject behavior that does not grow easily and convincingly out of the demands of her character. It is a literary convenience that punishes the female character who persists in negating the normal expectations about her nature and her role.

The virtuous woman, on the other hand, accepts her submissive role and seeks fulfillment as wife and mother, in a character like Isabella in *The White Devil*. But should she grow insubordinate, she will be portrayed as a "strumpet," like Vittoria in the same play.

According to Freud, such a woman is invading "male territory" and is guilty of having a "masculinity complex."[9] But she would fare no differently if measured by Jungian "archetypal" patterns, which also subscribe to Freudian inequality.[10] For Jung's male questor, the shadow, a "collection of antisocial tendencies," lays open the path to adventure. But, for women, as Annis Pratt shows, "the shadow in the unconscious is society," and it mirrors "the marital norms and sexual prohibitions that impede her full development" (105–6). However much Jacobean portrayals suggest that the more attractive female would wish herself outside of her circumscribed existence and aspire to the independence of the dominant male, to Freud, Jung, and these dramatists, destruction awaits the aspiring female.

We might observe that the usual identification of the chaste woman with all that is "good" is sometimes permitted aberrations. As the embodiment of conscience, purity, or religious orthodoxy, she now and then becomes so distasteful because of her self-effacing, silent disapproval, that she provides the man some excuse to repulse her "good" but objectionable "perfection." For instance, Aspatia's immaturity and melancholy dependency become so repugnant to Amintor that he rejects her and ultimately causes her death. Isabella's cloying submissiveness so arouses Brachiano that he has her killed. Similarly, aberrations are permitted the impure woman. Vittoria is credited with deep love for Brachiano, and Bianca does not seek out the duke; sinfulness is thrust

upon her. The chiaroscuro of the character thus sometimes eludes the dramatist's "stereotype" and is so skewed as to allow divergent behavior.

With the preceding comments as backdrop, I offer the following as an interpretation of three aspiring strumpets: Evadne in Beaumont and Fletcher's *Maid's Tragedy;* Vittoria in Webster's *White Devil;* and Bianca in Middleton's *Women Beware Women.*

At the opening of *The Maid's Tragedy*,[11] the protagonist Amintor has broken his engagement with the lovelorn Aspatia and is preparing to marry the dazzling Evadne. Jilted and inconsolable, Aspatia bares her misery to Amintor and tries to arouse his guilt. We soon learn that Amintor is confronted with the "good" and "bad" woman: Aspatia the angel, and Evadne the whore. After Amintor has made his choice and has married Evadne, she mocks him fiercely and informs him on their wedding night that she is the king's courtesan.

More "masculine" than Amintor, unfaltering and fearless, Evadne is the consummate Machiavel; she prefers "to be envied and not pitied" (*Jew of Malta* 1.1.27), to be admired rather than loved. Unable to abide Aspatia's suffering and gloom (although in a contemptuous way she can pity her), Evadne cannot identify with her rival's masochism which presumes a condition of humility. She not only falls into the "error" of a "masculinity complex," but her egocentricism protests against traditional morality and ethics; she espouses a highly personal revolt in her search for fulfillment. Antithetical to the submissive, silent, female ideal, Evadne takes on the shape of a male questor in her intensification and glorification of will and ambition. Her thirst for power is a thirst for mastery over men: husband, brother, kingly lover. Prostitution for preferment—becoming whore to the king—offers her the tool for her sense of mission, for the realization of her "full development."[12] Her famous defiance of the king makes her quest explicit:

> I swore indeed that I would never love
> A man of lower place; but, if your fortune
> Should throw you from this height, I bade you trust
> I would forsake you, and would bend to him
> That won your throne. I love with my ambition
> Not with my eyes. (3.1.178–83)

A seductive woman, Evadne plays a dangerous role, subordinating love to ambition and mastery, and entering a no-woman's land. She loves only the "brave" (i.e., splendid) state (5.1.106)—power and preferment—which attends the royal favor. In trenchant contrast to Freud's concept of the female, her need is not for the usual female experience—conjugal bliss and progeny.

Amintor (Ronald Kuhlman), the King (Michael Durrell), Evadne (Susan Sandler) in the Equity Library Theatre production of *The Maid's Tragedy* (1972–73). By permission of the Equity Library Theatre, Gene R. Coleman, photographer, and the Billy Rose Theatre Collection, The New York Public Library at Lincoln Center, Astor, Lenox and Tilden Foundations.

Toward the end of the play, Evadne has been humiliated by her brother, whored by the king, pawned off in a convenient marriage to secure her lover's lust, and is sworn to the revenge of a "tiger" (5.1.66), not that of a "woman" (65); she is "anything that knows not pity" (66–67). In passion she cries "Hell take me, then!" (5.1.109) and stabs the king. Each stroke reinforces her repentance:

> This for my lord Amintor!
> This for my noble brother, and this stroke
> For the most wrong'd of women. (5.1.109–11)

After the final thrust her repentance is consummate: to the dead king, Evadne declares, "I forgive thee" (5.1.111). This is the Evadne who had an unbridled appetite for advancement, who delighted in cuckolding her husband, and who was compelled to commit regicide by her brother, on pain of death, to avenge her honor. What Evadne has become is a confused, dependent, inconsistent character, riddled with masochistic self-condemnation and misguidedly subjected to the will of all the men in her life—husband, brother, lover.[13]

Had Evadne been a male, a Tamburlaine, her cruelty would have been represented as regrettable but understandable: aspiring men of strong passions do act sadistically, but they are permitted death without repentance. Evadne's penitence is a betrayal of her character and can be viewed only as the male playwrights' restatement of the unequal social expectations for men and women in the Renaissance. Her repentance and the skewing of her character herald the restoration of hierarchy and banish the nervous balance of apprehension and fascination associated with the seductive female.[14] Patriarchy is buttressed; lust is brought low.

Like Amintor, Brachiano, in John Webster's play *The White Devil*, is confronted with two contrasting women—Isabella, the "angel," and Vittoria, the "devil."[15] The title calls this the tragedy of Brachiano: the depiction of his fall. At the start, still married to Isabella but captivated by Vittoria, Brachiano is poised between the two women. When he tells his wife, "Our sleeps are sever'd" (2.1.198), and yields to his passion for Vittoria, he falls. The white devil of the title would seem to be Vittoria. Isabella, conversely, is a white angel; as Webster portrays her she is the ideal wife. And Vittoria is the ideal courtesan.[16]

Isabella is the paradigm of obeisance: she is untainted; she forgives her husband his sins without recrimination; and she dies as his suppliant, kissing an icon of her lord. To a male playwright and a male spectator, Isabella may personify the perfect, pliant, feminine woman who accepts his hostility without complaint. To twentieth-century women, however, she may seem a projection of traditional Christian

doctrine designed for female consumption: restriction to domestic existence and subordination to the male. Vittoria, in contrast to Isabella, is an aspiring woman, intriguing and attractive, but hardly a black devil, a savage Evadne. Webster calls her the famous Venetian courtesan, and to Jacobeans, Venice was the pleasure-seeking center of Europe, the sink of sensual excesses, as Italy was of cravenness in general. The "famous courtesan" of Venice would indeed evoke images of the consummate siren. Brachiano may have felt toward Isabella and Vittoria as Freud's conflicted male feels toward women, and men in the audience may identify with Brachiano. He may be acting out their conflicting passions toward the female. What interests me is why a male playwright creates such an emotionally engaging heroine, and more to the point, why he finds it necessary to punish her.[17]

When the play opens, Vittoria is in a loveless marriage with Camillo, her ridiculous old husband, and loves the duke of Brachiano who has grown tired of his wife, Isabella. Vittoria, by relating to Brachiano a dream that she has had, spearheads his resolve to have both his wife and Vittoria's husband murdered. In presenting the dream, Webster never makes Vittoria's purpose completely clear. Still, Brachiano's love is a promise of power as well as devotion: "I'll seat you above law and above scandal" (1.2.263). "You shall to me at once / Be dukedom, health, wife, children, friends, and all" (1.2.267–68).

When the murders are committed, Vittoria is arrested for being an accessory to her husband's death, and she stands trial not for incitement to murder, but for her "black lust" (3.1.7). With an impressive absence of self-pity, she insists, throughout the trial, that the accusation against her be couched clearly in a language all can understand. Relentlessly she wages her defense "like a man." But in spite of her boldness, she has internalized society's injunctions to silence, particularly in the public sphere, and, consequently, prefaces her argument with "Humbly thus, / Thus low, . . . my modesty / And womanhood I tender" (3.2.130–33).[18] Recognizing the trial as a travesty of justice, Vittoria receives society's condemnation of her dissident behavior with nobility and magnificence:

> That my defense of force like Perseus,
> Must personate masculine virtue—to the point!
> Find me but guilty, sever head from body:
> We'll part good friends: I scorn to hold my life
> At yours or any man's entreaty, sir. (3.2.135–39)

Never does Vittoria envision herself as a whore. When the accusation is flung at her she makes it rebound and lays the fault at the feet of her judges:

Vittoria (Margaret Rawlings) in a scene from her trial in the 1947 Duchess Plays Limited (London) production of *The White Devil*. Angus McBean photograph. Harvard Theatre Collection. By permission of the Harvard College Library.

> For your names
> Of whore and murd'ress they proceed from you,
> As if a man should spit against the wind,
> The filth returns in's face. (3.2.148–51)[19]

The epithet, "most notorious strumpet" (3.2.244), is hurled at her by Cardinal Monticelso, and when she is sentenced to a house of penitent whores, she asks, "Do the noblemen in Rome / Erect it for their wives, that I am sent / To lodge there?" (3.2.267–69). Vittoria does not accept her condemnation to an ignoble status. To pursue an unorthodox course to fulfill her love is in no way for Vittoria a corollary of lust. Since her love is a metaphor for her destiny, conventional considerations and conventional morality do not lie heavily upon her. Her love is above

morality, and, consequently, any effort to achieve it transcends consciousness of the sinful. Her spirit fears neither damnation nor loss of salvation. She meets her punishment with a grandeur rooted in her integrity, so apparent in her reproach to the cardinal:

> It shall not be a house of convertites—
> My mind shall make it honester to me
> Than the Pope's palace, and more peaceable
> Than thy soul, though thou art a cardinal,—
> Know this, and let it somewhat raise your spite,
> Through darkness diamonds spread their richest light. (3.2.289–94)

Magnificently, integrally, Vittoria has made love her quest and has risked all for it. But rooted in her love for Brachiano and linked with her self-esteem is the need for the title of duchess: as protection for her illicit love; as vengeance for society's castigation; as a measure of power. As Brachiano says, "For you, Vittoria / Think of a duchess' title" (4.2.220–21).

Throughout the play, and especially in her many moments of humiliation and despair, Vittoria's courage and pride never desert her. But at the play's conclusion, we are presented with a demeaned Vittoria who seems to have subverted her audaciousness and defiance. She enters (5.6) with a book of devotions, rebukes her brother for his crimes, tries to outwit Flamineo in his efforts at a suicide pact, and finally, foolishly, tries to pander to her murderers so she may win pardon from them. True, during this display of humbling behavior, some bold verbal parrying and flashes of self-assertiveness appear to shore up the consistency of the character. But is this the unflinching Vittoria who could not pray to "cross-sticks" (1.2.236), and who "comes arm'd / With scorn and impudence" (3.2.120–21) to her trial? Suddenly, she is steeped in repentance: "Oh, my greatest sin lay in my blood. / Now my blood pays for 't" (5.6.240–41).[20]

The repentance is designed to punish the female, and more so, the seductive woman, for exceeding her allotted space, for asserting her sexuality and selfhood, and for speaking out. The dramatist demands from the female sinner the ultimate—the final act of contrition for making forays into the reality outside the circumscribed female orbit. The conversion rings false because true representation of her character would not sanction repentance. Vittoria is not as she is, but as Webster's male eye sees her. The repentance redirects the audience's sympathies toward socially sanctioned views of the female. Pandora's box has been resealed.

Like Webster, John Middleton apparently took at least part of his *Women Beware Women* from life. Bianca, his main female protagonist, is

apparently modeled after the renowned Florentine courtesan, Bianca Capello, who died in 1587.[21] Bianca is the least purposeful aspiring woman of all three heroines under discussion. She has a need for a "quiet peace" (1.1.127) and security. Tied to this are the immaturity and vulnerability that erode her virtue and lead her to become an adulteress. More able to accommodate and compromise and less driven than Vittoria or Evadne, her motivation falls short of the complete conviction and drive so indispensable to undaunted aspiration.

When we first see Bianca, she is a youthful rebel who has defied parental wrath. In her immaturity, and because of her sensuality, she has been physically attracted to Leantio, a clerk, and has eloped with him. Satisfied with her husband at the outset of their marriage, prepared to conform to the traditional role of wife, she says to her mother-in-law, "Nothing can be wanting / To her that does enjoy all her desires. / Heaven send a quiet peace with this man's love" (1.1.125–27). Away at work all week, Leantio closets Bianca up and leaves his mother to "police" her. But since she is young and beautiful and fair game, even locked doors cannot keep this "matchless jewel" (1.1.162) safe. Bianca's beauty attracts the eye of the duke as she is looking out the window, and he is captivated by the sight of her.

Married only a very short time, she is faced with the alternatives of defending her "virtue" or succumbing to the duke. A conflicted adolescent, Bianca confides her fears to him: "I'm not like those / That take their soundest sleeps in greatest tempests; / Then wake I most, the weather fearfullest, / And call for strength to virtue" (2.2.356–59). In the powerful duke's attempt to persuade her to become his mistress is a scarcely visible threat:

> Sure I think
> Thou know'st the way to please me; I affect
> A passionate pleading 'bove an easy yielding—
> But never pitied any: they deserve none
> That will not pity me. I can command:
> Think upon that. (2.2.359–64)

But the fifty-three-year-old duke, urbane and enamored of Bianca, realizes that gentleness and paternalism rather than "command" will win a sixteen-year-old. In addition, he can afford a generosity befitting his status, and he offers Bianca wealth, honor, love, and not least, security:

> To kiss away a month or two in wedlock,
> And weep whole years in wants for ever after?
> Come, play the wise wench, and provide for ever:
> Let storms come when they list, they find thee sheltered;

> Should any doubt arise, let nothing trouble thee.
> Put trust in our love for the managing
> Of all to thy heart's peace. We'll walk together,
> And show a thankful joy for both our fortunes. (2.2.381–88)

Less content, consequently, with her marriage, and reassured by the duke's proposal, Bianca yields to him. Nevertheless, her fall awakens ambivalent feelings of guilt and blame, and she faults others for acting as her pander and her bawd. Bianca adapts to her new situation with some bitterness which lies less in the loss of her virtue, for "she likes the treason well" (2.2.444), than in her betrayal by these characters. It is too disquieting for her to accept responsibility for her self-assertion, and she can reproach herself less if, embedded in her decision, is an element of coercion.

Historically, rulers or ruling groups have pitted members of a discriminated group against each other so they may act as betrayers for the exploiter. In this drama women are set against women and exploited for men's purposes. Livia helps to undo both Bianca and her niece Isabella. She is also the female character who expresses misogynistic comments. When Bianca reproaches her for being a bawd, she replies that women quickly lose their distaste for sin and, "'tis nectar ever after" (2.2.478). Livia also competes for Leantio's sexual favors and is quick to inform him about Bianca's sinfulness. Granted that male members of the court are also shown to be corrupt dissemblers, Middleton, nevertheless, seems more often to apply the idea of treachery and lack of loyalty to the female sex.

In her position as the duke's mistress, Bianca has accommodated herself to the comforts of the court and finds it increasingly easy to love the duke. But love is not Bianca's chief concern: her care is a safe existence, a calm assurance. Unfortunately, such is not to be her lot. Prudent, she has misgivings that her power may be threatened and stripped by those who presume to be the bastions of morality. To further her position and to safeguard it against any treachery, she seeks the legal sanction of marriage. Leantio, still smarting at the loss of Bianca, though Livia is now his mistress, has threatened a bloody revenge. Informed by Bianca of Leantio's "spiteful" utterances, the duke soothes her: "Do not you vex your mind; prithee to bed, go. / All shall be well and quiet" (4.1.123–24). Her reply underscores her need for a safe existence: "I love peace, sir" (4.1.124). The duke has Leantio murdered and after there are no impediments, he wishes to marry Bianca. But attempting to legalize their union proves a difficult task.

The duke's brother, the lord cardinal, is the establishment representative of society, and he cannot "sanctify hot lust" (4.3.18)—his brother's marriage to his whore. Bianca, in an eloquent speech to the cardinal,

endorses charity for sinners: "yet 'mongst all your virtues / I see not charity written, which some call / The first-born of religion; . . ." (4.3.50–52). The duke gives his approval with a kiss, but the cardinal's retort is: "Lust is bold, / And will have vengeance speak, ere't be controlled" (4.3.71–72). Even when the cardinal is finally brought round Bianca still fears that he is her avowed enemy and that his motives are suspect. Intuitively, she knows that this scion of respectability has "his times of frailty, and his thoughts / Their transportations too, through flesh and blood" (5.2.26–27).

Alarmed at the cardinal's enmity and his ambition for power, she plans for his murder. The move is a desperate one, formed out of fear, to safeguard what she has rather than to reach out for greater gains. It is her undoing.

Examining Bianca's character, I find it difficult to justify Middleton's "obligatory" repentance speech: "But my deformity in spirit's more foul: / A blemished face best fits a leprous soul" (5.2.202–3). Bianca is both prudent and intelligent. She has been sufficiently exposed to the court and to the manipulation of men to realize that it is they who dominate and define women's boundaries. Though such a finale is more fitting for her than either Evadne or Vittoria, the repentance leitmotiv, readily surfacing throughout the dramas under discussion, reinforces the ideological message of the plays: unorthodox female behavior must be exorcised.[22]

A rebellious adolescent, Bianca matures and attains a level of autonomy and assertiveness in the duke's court. More pragmatic and less forceful than Evadne and Vittoria, she is accustomed to turn to a male protector, husband, surrogate father, to achieve stability. Sensible Bianca knows that only men can make security a reality. Though her life is tainted by the corruption around her, her bent is toward compromise, acceptance; she cannot rise above her anxious nature to challenge this evil. Inadvertently, she becomes the victim of her own fears and desperation. Though seduced, she has still opposed society's "sexual prohibitions," and, therefore, is subject to the same penalties as those imposed on her more strong-willed and embattled sisters.

While other seventeenth-century dramatists are content to have the strumpet repent and die, Middleton demands more—a denunciation of half humankind by a woman:

> Oh the deadly snares
> That women set for women—without pity
> Either to soul or honour! Learn by me
> To know your foes. In this belief I die:
> Like our own sex, we have no enemy. (5.2.209–13)

Livia's role as bawd seems disproportionate to such condemnation.

Unable to change the circumstances of their lives, subject to the domination of father, brother, husband, and ruler, these women all bypass the traditional female route—Evadne for ambition, Vittoria for love, and Bianca for security. For a time, they overcome their powerlessness and fulfill their aspirations. The playwrights' initial empathy with these heroines appears to obliterate their gendered vision, but in the end, this imbalance is redressed. Patriarchal values reassert themselves. The women repudiate their acts, their repentance encoding patriarchy's creed for its own survival. For them, the repentance is an epitaph of infamy, for there is no value, no belief the penitent will not recant. When the final curtain comes down, Evadne, Vittoria, and Bianca have been condemned to suffer a fate that rings true, while their repentances ring false.

Notes

1. There are, of course, virtuous Shakespearean heroines like Beatrice, Viola, Portia, and Rosalind who are lively and exciting and who play more "masculine" or independent roles. However, the result of their activities is to further their marriages, even when they are impersonating males. See Marcus 147 and Rackin 31.

2. Marina Warner indicates that the "Church venerates two ideals of the feminine—consecrated chastity in the Virgin Mary and regenerate sexuality in the Magdalene. Populous as the Catholic pantheon is, it is nevertheless so impoverished that it cannot conceive of a single female saint independently of her relations (or lack of relations) with men" (235).

Concerning the Magdalene, Fred Waage notes, "Although Mary Magdalen does not appear in her own persona significantly in later Elizabethan and Stuart drama, whores bearing her physical and spiritual mark are everywhere" (128).

3. For a sampling of the conduct books, see Chilton Powell who provides comprehensive information on these tracts. See also Travitsky. Ian Maclean examines Renaissance attitudes to woman in theology and mystical writing (6–27).

4. Angela Ingram argues that in the first two decades of the seventeenth century there is a "reformulation of assumptions about women," which is due in part to playwrights being less concerned with "established morality," and "writing with increased sophistication." She asserts that the nonconforming women tend to be "vital characters whose actions and motives are shown to merit analysis, and even sympathy." Such characters, Ingram maintains, "at an earlier time would have been inflexibly judged and condemned" (14–15). While she recognizes the fact that women outside the conventions are less stereotyped and have more appeal, she nevertheless overlooks a major point: before the curtain comes down the fate of the "bad" or disorderly or disruptive woman in Renaissance tragedy is still the same. As a strumpet she is forced to repent and is suitably punished with blood or death or both. See Haselkorn for the various attitudes toward the stage prostitute which reflect society's views—both sympathetic and hostile—toward the nonconforming woman.

5. It is sad that Elizabeth Cary, the only woman in Renaissance England who wrote an original play (*Mariam*, 1613), apparently internalized this male construct. But see Tina Krontiris's essay in this volume for a discussion of another play by Cary.

6. See Freud, "Contributions to the Psychology of Love: A Special Type of Choice of Object made by Men."

7. In discussing women in Western mythology, Estella Lauter notes a number of "trouble spots": "the emphasis on the seductress in every woman; . . . the identification of woman with nature to the detriment of both; the assumption that woman is the guardian of love" (204).

8. Catherine Belsey states that in Restoration heroic drama, "The disruptive elements of female sexuality have been banished, along with the discursive instability which defined it, to find a place among whores, hysterics or sexual deviants: true love is moral, domestic, constant" (213). The female characters discussed in this paper seem to have presaged this trend.

9. Freud, "Some Psychological Consequences of the Anatomical Distinction between the Sexes." Freud's theory of penis envy allows him to define the female as passive, masochistic, and narcissistic. Freud assumes that the traumatic experience of being born without a penis is largely responsible for fixing the female's status and role. He attributes women's inferior position to anatomy and puts little stress on cultural factors. Penis envy is properly redirected to motherhood and reproduction, and women who do not sublimate their search for the penis and who persist in pursuing an autonomous existence fall into the "masculinity complex."

10. Jung states, "The conscious attitude of woman is in general far more exclusively personal than that of man. . . . The man's world is the nation, the state, business concerns, etc. His family is simply a means to an end. . . . The general means more to him than the personal; his world consists of a multitude of co-ordinated factors, whereas her world, outside her husband, terminates in a sort of cosmic mist" (7:209–10 [par. 338]. Estella Lauter and Carol Schreier Rupprecht call attention to Jung's thinking "in terms of rigid oppositions. He reinforced the stereotypes of man as thinker, woman as nurturer. By associating men with thought, the cultural category with the higher value in the twentieth century in most Western societies, he helped to perpetuate the inequality of women" (6). Demaris S. Wehr sees "Jung's concept of the gender-linked archetypes as both negative and positive" (44–45). Annis V. Pratt asserts that in spite of his gendered inequality, Jung "valued the feminine and the unconscious" (97).

11. First produced in late 1610 or early 1611, *The Maid's Tragedy* was anonymously printed in 1619, and was printed again with revision of the text in 1622. It appeared at last with the authors' names on the title page in the quarto of 1650. The sources of the tragedy are unknown. All references to the play are to the edition by Howard B. Norland.

12. Pratt points out that literary critics, women as well as men, are prone to overlook "symbols and narratives of feminine power" because of gender norms. She notes, "Feminine aspirations, existing in dialectical relationship to societal prescriptions against women's development, create textual mixtures of rebellion and repression which can be discerned by careful textual critics" (101). Evadne would seem to be a fit subject for this observation.

13. While Ingram is in accord with my view that Evadne's " 'virtuousness' constitutes a flaw in her characterization" (152), she does not acknowledge that her repentance is the linchpin that the dramatists use to secure the female firmly in her proper place in the hierarchy.

14. Lisa Jardine presents an interesting insight regarding apprehension and fascination associated with the "representations of threatening womanhood. On stage the male protagonist is galvanised into horrified action, as Macbeth is by his wife . . . and Tamora's sons (*Titus Andronicus*) are likewise goaded on to rape and mutilation by their mother." However, Jardine believes, "Off stage, the male member of the audience

recognizes the representation of perennially threatening woman . . . and recognizes equally its absurd excessiveness. No woman of *his* will ever get thus out of hand, and hence the representation is equally a source of delight" (97).

15. John Webster collaborated on a number of plays, but the first we have that was his own is *The White Devil; or The Tragedy of Paulo Giordano Ursini, Duke of Brachiano, With the Life and Death of Vittoria Corombona, The Famous Venetian Curtizan*, published and performed in London in 1612. In the play, Webster dramatizes events that had actually happened in Italy a quarter century earlier. The real-life Brachiano may have murdered his wife, Isabella, because it became known she had a lover. Later, enamored of Vittoria, Brachiano ordered the murder of her husband and then married Vittoria in secret. Brachiano died shortly after this marriage. Because she would not relinquish to Brachiano's son some of the ample fortune Brachiano had left her, Vittoria was later murdered by a kinsman of Brachiano's. We do not know what account Webster had of these events, so we cannot tell to what extent Webster's characterizations, or the pattern given the events, is his own. All we can do is look at the pattern. All references to the play are to the edition by John Russell Brown.

16. Belsey identifies Vittoria and Isabella as contrasted female stereotypes and maintains that the stereotypes encode society's message of what it approves and disapproves (165). Belsey compares Isabella with patient Griselda and examines the versions of the Griselda narrative, stressing the "silent endurance" of women "under patriarchal tyranny" (165–71). See Judith Bronfman's essay in this volume for a discussion of Griselda.

17. Critics have carefully studied Vittoria, and their conclusions confirm their diversity in characterizing her. Clifford Leech sees her as a strumpet; Leonora L. Brodwin defines her as honorable and committed to love; Una Ellis-Fermor speaks of Vittoria's nobility and courage even if it be satanic; Muriel Bradbrook, Lee Bliss, B. J. Layman, and Robert Ornstein contemplate her complexity. Waage argues that "Vittoria's contradictory qualities, as accused whore, are a direct expression of the problematic doubleness of the Magdalen of tradition, and this doubleness can be found in the stage whores, her sisters, who appear in earlier plays." According to Susan McLeod, Vittoria "in the language of the play," is "an excellent devil, a glorious strumpet, the devil in crystal, a diamond in darkness, a white devil" (285).

18. As Belsey states, "To speak is to possess meaning, to have access to the language which defines, delimits, and locates power. . . . In the Renaissance fear and condemnation of women's speech in the identification of female eloquence as a transgression and in the resistance of women to that identification . . . made explicit contradictions . . . which have contributed to the making of . . . patriarchy" (191).

19. See also Jonathan Dollimore (235–36) who argues that man's language as the dominant and more powerful can prescribe an identity for woman, the inferior, as when Monticelso names Vittoria "whore" (3.2.148–49). Thus when she "personate[s] masculine virtue" (3.2.136), Vittoria attempts to redress the imbalance. However, her far less powerful position sharply limits the effectiveness of her protest. Further, to "appropriate masculine virtue," according to Dollimore, was considered a most radical form of female disobedience, and the assertive woman was severely castigated from the pulpit, by order of James I, and in the cucking stool.

20. I am in agreement with Brodwin that Vittoria's religion is "of a very personalized nature" and that she allows Christianity to offer her only that which is consonant with her "deeper conviction." Brodwin argues, "If the day of judgment finds her free of sin, it will not be presided over by the God of Christianity." Further, Brodwin says since sin "can be redeemed only by repentance" in Christianity, and Vittoria "fully considers

herself to be innocent" personally as well as "in the eyes of God" (275), how can her repentance be reconciled with her beliefs? Has she not violated her integrity and shored up her salvation? On the other hand, has Webster, no less than Beaumont and Fletcher and Middleton, titillated the audience sufficiently with unorthodox behavior and unconventional Christian beliefs, before shutting Pandora's box? Vittoria's repentance would make it appear so.

21. Middleton is thought by some investigators to have derived his plot in part from a Spanish novel, *Hippolyto and Isabella*. In 1653, Humphrey Mosley made an advance entry of *Women Beware Women* in the *Stationers' Register*. Scholars generally date this play circa 1621. All references to the play in this paper are to Roma Gill's edition.

22. Paula S. Berggren is in agreement with my contention that Bianca, as well as Vittoria, "undermine[s] society's mores," and "the demands of self supersede, even precede, the expectations of society." She asserts that Middleton and Webster are preoccupied with these women not because they are "bad," but because they are "economically dependent, politically powerless, and sexually vulnerable." While Webster and Middleton may "locate this spirit of rebellion" (350) in Bianca and Vittoria, they do not condone it. The final repentance foisted on these women seems to undercut Berggren's analysis of the dramatists' motives. Their sympathetic portrayal may project some of the authors' own ideals, but in the end, the misogynist attitudes prevail.

Works Cited

Beaumont, Francis, and John Fletcher. *The Maid's Tragedy*. Edited by Howard B. Norland. Lincoln: University of Nebraska Press, 1968.

Belsey, Catherine. *The Subject of Tragedy*. New York: Methuen, 1985. Participates in the construction of a history of tragedy in the sixteenth and seventeenth centuries, gives woman space alongside man when the common gender noun seemed to exclude women from the spectrum of its many meanings, and integrates history and literature.

Berggren, Paula S. "'Womanish' Mankind: Four Jacobean Heroines." *International Journal of Women's Studies* 1, no. 4 (1978): 349–62. Webster and Middleton focus on the heroines' hopeless battle to achieve liberation—both domestic and social—in a controlling patriarchy. Both playwrights create such diminished heroic characters, appropriate to their age, that Berggren applies the term "womanish" to her description of mankind.

Bliss, Lee. *The World's Perspective: John Webster and the Jacobean Drama*. New Brunswick: Rutgers University Press, 1983. Gains new insights into Webster's drama by seeing connections between developments in Jacobean heroic tragedy and in ironic tragicomedy in terms of intellectual and moral analysis.

Bradbrook, Muriel C. *Themes and Conventions*. 1935. Reprint. Cambridge: Cambridge University Press, 1952. The basic structure of Elizabethan drama is language rather than narrative or characters. Elizabethan conventions existed but were unformulated and, therefore, unacknowledged; they were neither trivial nor arbitrary but had an underlying unity that formed a coherent whole.

Brodwin, Leonora. *Elizabethan Love Tragedy 1587–1625*. New York: New York University Press, 1971. The genre of love tragedy in the Elizabethan drama is broken into three categories: "courtly love," "false romantic love," and "worldly love." The study attempts to rectify the critical skewing that is the consequence of a wholesale neglect of the love theme in a majority of the plays in this category.

Cary, Elizabeth. *The Tragedie of Mariam, Faire Queene of Jewry. Written by that Learned, vertuous, and truly noble Ladie, E. C.* 1613. Reprint. London: Charles Whittington and Co., at the Cheswick Press, 1914.

Dollimore, Jonathan. *Radical Tragedy: Religion, Ideology, and Power in the Drama of Shakespeare and His Contemporaries.* Chicago: University of Chicago Press, 1984. Uses some of the most current historical methodology and critical theory to examine the relationship of literature to its historical context, with special relevance to Elizabethan and Jacobean drama. Identifies his study as "a critique of ideology, the demystification of political and power relations and the decentering of 'man.'"

Ellis-Fermor, Una. *Jacobean Drama.* 4th ed. rev. London: Methuen, 1961. Deals with major dramatists from about 1598 to 1625 and feels the works are characterized by the mood of tension and disillusionment of the period, as opposed to the faith and vitality of an expanding Elizabethan society.

Freud, Sigmund. "Contributions to the Psychology of Love: A Special Type of Choice of Object made by Men." In *Collected Papers.* General editor Ernest Jones. 4: 192–202. Authorized translation under the supervision of Joan Riviere. New York: Basic Books, 1959. In this essay, Freud describes the initial affectionate ties of a boy for his mother before he learns about his "pure" mother's sexual relationship with his father. Freud seems to claim that the male finds it almost impossible to completely unite both forms of attachment, the pure and the sexual. In pathological cases, the adult male sets preconditions for the type of woman he selects to love. She must be unavailable, involved with another man, and sexually impure. Her appeal for him increases with her lack of virtue.

———. "Some Psychological Consequences of the Anatomical Distinction between the Sexes." Edited by James Strachey. In *Collected Papers.* General editor Ernest Jones. 5: 186–97. New York: Basic Books, 1959. In this essay, Freud notes that during the Oedipal stage, a boy sees his father as a rival whom he wishes to displace. A girl in this stage abandons the mother as love object for the father. She also discovers the penis, develops penis envy, and an inferiority complex follows. The girl then becomes aware that she cannot compete with boys and must abandon this notion. When she recognizes the anatomical distinction between the sexes, she turns away from masculinity and develops feminine pursuits—motherhood and reproduction.

Haselkorn, Anne M. *Prostitution in Elizabethan and Jacobean Comedy.* Troy, N.Y.: Whitston Publishing Co., 1983. Three main views toward the stage prostitute are analyzed: "Cavalier," "Liberal," and "Puritan," which reflect society's attitude toward the nonconforming woman and some attempts at efforts to reclaim her. Her status in society serves as a vehicle for the examination of many questions concerning the sexual morality of the period.

Hull, Suzanne W. *Chaste, Silent and Obedient: English Books for Women 1475–1640.* San Marino, Calif.: Huntington Library, 1982. A valuable compilation of materials pertaining to Renaissance women, subdivided into five categories: "books specifically directed to women"; "subjects clearly within a woman's province"; "books with separate sections on women's duties or roles"; "histories or biographies of famous women"; and "books with multiple dedications to individual women."

Ingram, Angela. *In the Posture of a Whore.* Wolfeboro, N.H.: Longwood Publishing Group, 1984. Studies the whore in Elizabethan drama as a cohesive entity and breaks down the "bad" women into further groupings to shed light on components of character not otherwise apparent.

Jardine, Lisa. *Still Harping on Daughters: Women and Drama in the Age of Shakespeare.* Sussex: Harvester Press, 1983. Suggests "corrective possibilities" for seeing relationships between stage portrayals of women and social conditions outside the theater.

Jung, C. G. "Anima and Animus," 188–211, par. 338 (pp. 209–10), in *Two Essays on Analytical Psychology*, vol. 7, *Collected Works*. Translated by R.F.C. Hull. Bollingen Series 20. 2d ed. Princeton: Princeton University Press, 1966. The anima is the feminine aspect of man's soul that counterbalances the male consciousness. The counterpart for the female is the animus which is also the total of woman's primordial experiences of man. Both anima and animus serve to bring forth the creative and procreative essence in the other. The animus has a reciprocal relation with the woman's conscious attitude. It consists of the subjective, the personal, with her husband in the foreground. For the man, the objective, the general—nation, state, business—is superimposed on the personal.

Lauter, Estella. *Women as Mythmakers*. Bloomington: Indiana University Press, 1984. Examines the many processes of mythmaking that women use today and tries to understand where these processes are headed. Explores the methodology of specific works of poets and artists for their influence on our "cultural mythology."

Lauter, Estella, and Carol Schreier Rupprecht, eds. *Feminist Archetypal Theory*. Knoxville: University of Tennessee Press, 1985. United by their common concern for women's own images of their lives and drawing on different fields, five writers show how feminist views of archetype, myth, and dream can shed light on female experiences. They resist the belief that the archetype is permanent and invariable. Instead, they suggest that it is a tendency to form images in response to repeated and widely shared experiences.

Layman, B. J. "Equilibrium of Opposites in *The White Devil:* A Reinterpretation." *PMLA* 74 (1959): 336–47. Argues that misleading indications are obsessively emphasized in the play and these are Webster's response to the "Machiavellian thought revolution" of his day.

Leech, Clifford. *John Webster*. New York: Haskell House, 1966. Webster sees the world of *The White Devil* as one of discontent, and Vittoria as a woman to whom peace is totally alien; she exists in darkness. Nevertheless, both Vittoria and Flamineo face evil squarely, which lends them a kind of nobility.

Maclean, Ian. *The Renaissance Notion of Women*. Cambridge: Cambridge University Press, 1980. This study reveals beliefs about women in the Renaissance, and Maclean notes that at the end of this period there is a greater discrepancy between social realities and the current notion of women than at the beginning. Maclean investigates the fields of theology, medicine, ethics, politics, and law as a basis for his assertions.

McLeod, Susan. "Duality in *The White Devil*." *Studies in English Literature* 20 (1980): 271–85. The major force that propels the play is the basis on which it is constituted: the motif of duality animates "the characterization, the action, the visual elements and the very language" (285). Although it is not the "formal element" that appears in nineteenth- and twentieth-century drama, it serves as a guide throughout the complexity of the play.

Marcus, Leah S. "Shakespeare's Comic Heroines, Elizabeth I, and the Political Uses of Androgyny." In *Women in the Middle Ages and the Renaissance,* edited by Mary Beth Rose, 135–53. Syracuse: Syracuse University Press, 1986. Notes strong connections between "sexual multivalence" of Shakespeare's heroines and the speeches and writings of Queen Elizabeth I. In her final years, Shakespeare's plays did much to protect the fading image of the queen as an infinite amalgam of male and female identity.

Marlowe, Christopher. *The Jew of Malta and The Massacre at Paris*. Edited by H. S. Bennett. New York: Gordian Press, 1966.

Middleton, John. *Women Beware Women*. Edited by Roma Gill. New York: Hill and Wang, 1968.

Ornstein, Robert. *The Moral Vision of Jacobean Tragedy*. Madison: University of Wiscon-

sin Press, 1960. Webster's immoralists know that death follows sin, and they accept the fairness of their fates. Though virtue exists in Webster's plays, it is powerless and ultimately futile. The highlights of *The White Devil* are those of individual audaciousness and defiance.

Powell, Chilton. *English Domestic Relations*. New York: Columbia University Press, 1917. A study of domestic relations in England, in theory and practice, including both the contract of marriage (its making and breaking) and the subsequent life of the family, as manifested by the literature, law, and history of the period.

Pratt, Annis V. "Spinning Among Fields: Jung, Frye, Lévi-Strauss." In Lauter and Rupprecht, *Feminist Archetypal Theory*, 93–136. Indicates how the author is reworking materials provided by Jung, Frye, and Lévi-Strauss so that they may be instrumental as paradigms for feminist archetypal theory on a more limited scale. Pratt's model involves relationships among psychology, art, and culture in perpetual continuity.

Rackin, Phyllis. "Androgyny, Mimesis, and the Marriage of the Boy Heroine on the English Renaissance Stage." *PMLA* 102, no. 1 (1987): 29–41. Deals with the "changing conception of gender and of theatrical mimesis" as portrayed by transvestite heroines in five comedies on the English Renaissance stage.

Shakespeare, William. *The Riverside Shakespeare*. Edited by G. Blakemore Evans. Boston: Houghton-Mifflin Co., 1974.

Travitsky, Betty. "The New Mother of the English Renaissance (1489–1659): A Descriptive Catalogue." *Bulletin of Research in the Humanities* 82 (Spring 1979): 63–89. Indicates the changes made by humanists and reformers during the Renaissance in the lives of married women. In England, particularly, the "new" mother was both religious and educated, had some authority in the bringing up of her children, and was entitled to self-development.

Waage, Frederick. *The White Devil Discover'd: Backgrounds and Foregrounds to Webster's Tragedy*. New York: Peter Lang, 1984. Analyzes the archetype of Mary Magdalen that is manifested in prostitutes of the Jacobean drama.

Warner, Marina. *Alone of All Her Sex: The Myth and the Cult of the Virgin Mary*. London, 1978; Reprint. New York: Vintage Books, 1983. A riveting study of accretions of belief concerning the Virgin Mary over the Christian centuries. Clarifies the simultaneous adoration of Mary and denigration of ordinary women.

Webster, John. *The White Devil*. Edited by John Russell Brown. Cambridge: Harvard University Press, 1960.

Wehr, Demaris S. "Religious and Social Dimensions of the Archetype." In Lauter and Rupprecht, *Feminist Archetypal Theory*. 23–45. Looks at how Jung's view of the archetype has been "ontologized" and how this perception tends to reinforce the present position of women in society. Wehr suggests that we view Jung's work as a reflection of our cultural stereotypes and fears and that we use these misconceptions in an effort to redress the imbalance.

TINA KRONTIRIS

Style and Gender in Elizabeth Cary's *Edward II*

ELIZABETH CARY, Lady Falkland, has been known primarily as the author of *Mariam,* a closet drama she wrote at the age of sixteen or seventeen.[1] But it is now apparent that this is not her only surviving dramatic work. Some twenty-three years after her first published play, *Mariam,* and during a solitary confinement that followed her secret conversion to Catholicism, Cary wrote *History of . . . King Edward II,* which appears to be an unfinished play or a biography influenced by drama.[2] The work, which attests to Lady Falkland's development as a woman writer and dramatist, survives in two versions, both printed in 1680 by different printers. The longer of the two, published in a folio volume, seems to be closer to the form of a play.[3] It contains several speeches and is written predominantly in blank verse; it is also clearer, more coherent, and less sentimental in tone. The shorter version, which came out in a small Octavo book, seems to be a condensed account of the longer piece.[4]

Edward II was found among Lord Falkland's papers and for this reason it was attributed to him by the 1680 printers and subsequently by the editors of an eighteenth-century miscellany that reprinted the short version.[5] This attribution went unchallenged until relatively recently when Donald Stauffer proved it to be Lady Falkland's composition.[6] As there is still some uneasiness among critics about its authorship, I shall initially produce additional evidence, mainly internal, to strengthen Stauffer's argument. Stauffer has already called attention to the parts in the work that do not point to Lord Falkland as its likely author. I will concentrate here on the parts that point to Lady Falkland.

First, the work is sympathetic toward the adulterous Queen Isabel, an attitude unlikely to have been held by the ultraconservative Lord Falkland. But more important, there is an emphasis on certain aspects of the queen's life that are in agreement with Lady Falkland's personal experiences as her biographers have conveyed them to us.[7] There is, for instance, a noticeable emphasis on the queen's suffering and abandonment in times of affliction. This is evident from the amount of space devoted to Isabel's search for loyal friends as well as from the language used to describe her condition. She is referred to as a woman "dejected out of wedlock," a representative of the "unworthily oppressed" in her kingdom. In her affliction she is abandoned by all, even by her own brother, king of France, who places political expediency above his duty

to a "forsaken queen" and sister. Alleged friends recognize "the justice of her cause" but are unwilling to risk their position in order to support her. Her first loyal friend "finds her in her melancholy chamber, confused in her restless thoughts, with many sad distractions." "Domestic spies" seek to make her condition worse, while her husband writes to the pope and asks him to summon her back to England.

The queen's condition as described in this part parallels that of Lady Falkland shortly after her conversion to Catholicism in 1626. From this year to about 1629 (*Edward II* was written in 1627), Lady Falkland was isolated and reduced to poverty, her husband having cut off all financial support. She lived in an empty house without furniture and, except for the loyal Bessie Poulter, without servants—all having been removed by Lord Falkland's order. Meanwhile her angered husband tried to force her to recant. He wrote several letters to the king, the privy council, and the archbishop of Canterbury asking them to put pressure on the "apostate," as he called her.[8] Without money and rejected by her husband, Lady Falkland was in desperate need of material and moral support. Some of her friends remained loyal to her during this time but others deserted her, lest their reputations should suffer. Her own mother turned her out of doors. I suggest that Lady Falkland's preoccupation with loyal friends and Queen Isabel's similar preoccupation in *Edward II* have a common head.

There are even more direct parallels. Isabel's joy at receiving her first true friend, Robert of Artois, is very similar to that of Lady Falkland at receiving Mr. Clayton, the first friend to visit her in her isolation (Fullerton 97). Also, like Isabel, Lady Falkland thought of herself as suffering unjustly. In her letter to Conway she says that by helping her he "shall please God in helping the oppressed" (Fullerton 106–7). An even more striking parallel is the mention of "domestic spies" both in the history and in Lady Falkland's letters to Charles I and to Secretary Coke. She urges the latter not to believe "those pestilent servants of my lord's, who seek to make advantage of my misery . . . to work their own ends," while she tells the king that she can find no fault with her husband, "except with regard to his believing too much information of his servants against me, who, for their own interest seek to estrange his affections from me" (Fullerton 84–86, 89–90). The history states that "Many of her Domestic Spies were here attending, as she well knew and saw, to work her ruine" (113) and "to make her once more forsaken" (Octavo 52).[9] Apart from these parallels there is also a sympathetic attitude toward the Catholic figures mentioned briefly in the history. The pope, albeit misled by Edward's information, is "wisely foreseeing" (Octavo 15) and the black monks at the abbey of St. Hammonds "had

Edward II and Piers Gaveston. Every effort has been made to locate the publisher and photographer of this picture.

the honour to give their long-lost Mistriss the first Welcome" (117). It is very unlikely that Lord Falkland, who hated all "Popelings," as he called them and who at the time of the history's composition was at war with his estranged wife over her conversion to Catholicism, would have included even the slightest favorable reference to Catholics. Additionally, there is external evidence which leaves little doubt that the piece was written by Elizabeth Falkland. "The Author's Preface to the Reader" is signed E.F., but Henry Falkland's initials were H.F. Be it noted that during the period of the history's composition the letters of Lord Falkland to the king and the members of the privy council were signed H. Falkland; those of his wife, E. Falkland.[10] That the history was found among Lord Falkland's papers cannot be taken as evidence for its being written by him, for apparently in the last years of his life, when he was reconciled to his wife, he read her literary works and kept copies of them. The translation of Du Perron's *Reply,* which is indisputably Lady Falkland's and which was done in the same chronological period, was also found among his personal papers. Last, I would like to suggest that the author's sympathy for the neglected queen in the history could very well be a tribute to Queen Henrietta-Maria, who in the first years of her marriage (married 1625) was ignored and even avoided by her husband, and who was Lady Falkland's friend.[11] We know that the

translation of *The Reply* (1630) was dedicated to the Catholic Henrietta-Maria.

As in the case of *Mariam,* the author's choice of subject matter for this literary work is suggestive of her concerns. *Edward II* deals as much with the relationship between the king and the queen as with that between the king and his subjects.[12] Lady Falkland, then, is once more attracted to a story that focuses on the relationship between the two genders and that treats a situation she understood. In her version of Edward II's life she shows familiarity with a long line of writers who treated the same subject before her.[13] Highly eclectic in her use of available material, she seems to have relied primarily on Grafton and to a lesser extent on Marlowe, although her sources cannot be easily identified.[14] From Marlowe she has apparently borrowed the incident of the king being shaved in cold puddle water, Gaveston's Italian identity, and Edward's neglect of and callous behavior toward Queen Isabel.[15] But she has not lifted or borrowed material on a large scale from any particular author. This suggests that Lady Falkland felt the need to write an original story, not merely to retell one already told. Apparently she was not satisfied with the way the subject had been dealt with. Indeed she lets us know as much in her "Preface to the Reader" when she refers to the "dull character of our Historians," who write by inference and try to please "Time" rather than "Truth." Although, as I show later, her own statement about Truth needs to be taken with caution, she evidently felt that the story had not been told quite right. Her dissatisfaction seems to have been greater with the treatment the queen had received, for it is in this respect that her account differs most from the versions of her predecessors. Her portrait of Edward is not very different from Marlowe's. Nor does she have anything particularly new to say about absolute monarchy as a governing system; her criticism seems specifically aimed at Edward for using his power arbitrarily and setting a bad example for his subjects.[16] But the case is very different with respect to Queen Isabel. Unlike Marlowe and others who offer a perfunctory sketch of the queen and maintain an ambivalent attitude toward her, Lady Falkland treats Isabel with a great deal of sympathy, provides justification for her adultery, and labors to develop her into a consistent character.[17] In the remaining portion of this discussion I intend to show how Lady Falkland advances her defense of Edward's wife in contradistinction to previous writers and how she attempts to express herself without openly violating cultural norms or personal convictions regarding proper conduct in general and feminine conduct in particular. I shall also draw a brief comparison between *The History of . . . Edward II* and *Mariam* in order to show Lady Falkland's development as a woman writer. Finally, I shall refer to the possible influence of religion in her development.

The defense of Queen Isabel is attempted chiefly through a process of victimization. Almost throughout the work Isabel is shown to be a woman and a wife trapped in a situation to whose making she has not contributed and out of which she tries to escape. Her marriage to Edward has been a stop-gap solution to the king's homosexual passion: "the interest of a wife was thought the most hopeful inducement to reclaim these loose affections" that had gone to Gaveston (18). As a wife—"in name a Wife, in truth a Hand-maid" (52)—she is forced to play the standby role accorded her by her husband and his minions. Even her trip to France is originally engineered by Spencer, who wishes "to pare her nails before she scratch'd him" (87), with the consent of her husband who "could be contented well to spare her whose eyes did look too far into his pleasures" (88). This kind of presentation has the effect of legitimating many of Isabel's actions. Her flight to France becomes not a traitorous act but an attempt to escape oppression at home.

The process of victimization is also deployed in what perhaps constitutes the most daring aspect of the author's task—her justification of Isabel's adultery. This is apparent from the queen's first full appearance, one-third into the work:

> Love and Jealousie, that equally possess the Queen, being intermixed with a stronger desire of Revenge, spurs her on to hasten on this Journey [to France]. She saw the King a stranger to her bed, and revelling in the wanton embraces of his stoln pleasures, without a glance on her deserving Beauty. This contempt had begot a like change in her, though in a more modest nature, her youthful Affections wanting a fit subject to work on, and being debarr'd of that warmth that should have still preserv'd their temper, she cast her wandering eye upon the gallant Mortimer, a piece of masculine Bravery without exception. (89)

With psychological insight, the author here renders Edward responsible for his wife's infidelity. Unlike previous writers, she recognizes the affective and sexual needs of Isabel as a young woman ("her youthful Affections wanting a fit subject to work on") and treats Edward's homosexuality as a form of adultery. Through his behavior, Edward is shown to be the first to invalidate the marriage agreement. Hence the author justifies Isabel's lack of marital chastity and implicitly also opposes the role of the patient Griselda prescribed by her culture in similar situations.[18]

But adultery was a serious offense when committed by a woman and Lady Falkland was no doubt aware of her culture's judgment on this matter. If she wanted to engage the reader's sympathy for the queen, she had to be very careful.[19] Besides casting her heroine as a victim, Lady Falkland uses a number of other tactics that seem to work in favor of the

Isabella of France, queen of Edward II of England. Every effort has been made to locate the publisher and photographer of this picture.

queen's character. Elements of time and space seem deployed to control the reader's response to Isabel's adulterous actions. Accordingly, the queen's appearance in the history is strategically delayed until Edward's abuse has been sufficiently—and emphatically—exposed. Her affair with Mortimer is described only briefly, while he is made to appear more like a companion to her griefs (104) than a sexual partner. Conveniently, he is set aside and only occasionally referred to until the last few scenes, despite the fact that he accompanies the queen to France. Traditional notions of feminine sexual conduct are likewise appropriated to render the queen more acceptable and sympathetic. Thus Isabel's sexual behavior is of "a more modest nature" than her husband's (89), and her speech to her brother is characterized by "a sweetly-becoming modestie" (96). The "showre of Chrystal tears" she sheds (97) are pitiable and proper for a woman's supposed soft nature.

Furthermore, the author strengthens the queen's position in the history by endowing her with a caring nature and a motherly instinct. Her character, unlike her husband's, is fortified with a care for the oppressed: "'tis not I alone unjustly suffer," she pleads, "my tears speak those of a distressed Kingdom, which, long time glorious, now is almost ruin'd" (96). Although the presence of the eldest son is structurally necessary so that he can claim the throne when his mother's party returns from France, the specific reference to her son, especially in the short version, suggests more than is necessary for the structure of the plot: "Her eldest Son, her dearest comfort, and the chief spring that must set all these wheels a going, she leaves not behind, but makes him the Companion of her Travels" (Octavo 38). Additionally, the queen is credited with the good opinion and support of respectable people. Robert of Artois, a "steady States-man, not led by Complement, or feign'd professions," speaks of the queen's "deeds of Goodness" (105, 106); and the earl of Heinault, a man of "an honest Heart and grave Experience," decides to join his brother, Sir John, in defending "a Queen that justly merits Love and Pity" (112). Even Edward's own feelings regarding his wife's infidelity appear to be deployed somewhat in her favor: "he thinks the breach of Wedlock a foul trespass; but to contemn her he so much had wronged, deserv'd as much as they could lay upon him" (95).[20] Through these strategies, then, the author manages to preempt criticism of the queen as adulteress and disloyal subject.

In previous treatments of Edward's life, the queen's character had been denigrated by attributing to her both cruelty, which I shall discuss shortly, and hypocrisy. But in Lady Falkland's portrayal of Isabel hypocrisy is relatively absent. There are two obvious allusions to the queen's hypocritical behavior. One is shortly before her flight to France when

"She courts her Adversary [Spencer] with all the shews of perfect reconcilement," pretending to be "well pleased, and glad to stay at home" (90). The other occurs when she is about to escape from France: having been deceived by the French Council, she quits the French court "in shew contented" (108) and "praiseth Spencer, as if 'twere he alone had wrought her Welfare" (107). As may be discerned, however, this type of hypocrisy is presented as a valuable skill, one that Isabel learns of necessity and that finally saves her life.[21] It is not a blemish but an admirable quality allied to cunning and envied even by the cleverest politician. Rather than hold it against the queen, Lady Falkland uses it to poke fun at Spencer who, for all his ingenuity, is outwitted by a woman more than once: "[his] Craft and Care . . . here fell apparent short of all Discretion, to be thus over-reach'd by one weak Woman" (92); "Thus Womens Wit sometimes can cozen Statesmen" (109). In this way, Lady Falkland cleverly turns a characteristic other writers had presented as a vice into a skill.

The defense of the queen lapses at one point and discloses Lady Falkland's difficulty in handling her heroine. As we have seen, Isabel is not criticized for assuming political power. Although in the end she is shown to be susceptible to the corruptive influence of power, for the most part she is portrayed as an intelligent and skillful politician whose maneuvers in the battle with the Spencers win her a victory. (With one summons she manages to bring Arundel, Spencer, and the city of Bristol into her possession.) But she is severely criticized for the cruel treatment of her fallen adversaries, particularly and especially of Spencer:

> While She thus passeth on with a kinde of insulting Tyranny, far short of the belief of her former Vertue and Goodness, she makes this poor unhappy man attend her Progress, not as the antient Romans did their vanquish'd Prisoners, for ostentation, to increase their Triumph; but merely for Revenge, Despite, and private Rancour. . . . Certainly this man was infinitely vicious, and deserv'd as much as could be laid upon him, for those many great and insolent Oppressions, acted with Injustice, Cruel[t]y, and Blood; yet it had been much more to the Queens Honour, if she had given him a quicker Death, and a more honourable Tryal, free from these opprobrious and barbarous Disgraces, which savour'd more of a savage, tyrannical disposition, than a judgment fit to command, or sway the Sword of Justice. (128–29)

This is a severe condemnation and not the only one of its kind. But it does not mark a change in the author's overall attitude toward her heroine. As the phrasing in the passage just quoted might suggest ("far short of the belief of her former Vertue and Goodness"), Lady Falkland strives to make Isabel as consistent a character as possible. This pause in the queen's defense seems rather a manifestation of the author's difficulty

in reconciling the material she inherited from her sources, on the one hand, with her personal convictions and cultural values on the other. In order to better understand Lady Falkland's attitude toward cruelty, it would be useful to pay attention to other instances of it in the work. Early in the history, the beheading of Lancaster and twenty-two other nobles in "a bloody Massacre" is the act of the "cruel Tyrant" Edward (73). Bishop Stapleton's death is "inhumane and barbarous" at the hands of the "enraged multitude; who neither respecting the Gravity of his Years, or the Dignity of his Profession, strike off his Head, without either Arraignment, Tryal, or Condemnation" (121). Old Spencer is likewise treated "not with pity, which befits a Prisoner, but with insulting joy, and base derision" (128).

The above passages indicate, among other things, that the author holds strong views on the subject of cruelty and by extension suggest the difficulties she may have encountered in dealing with this aspect of her heroine's character. The historical sources had more or less established the major events of the story. Even Marlowe, who probably gives Isabel the most favorable treatment accorded by any male writer, shows her at the end to be a hypocritical and cruel woman. Lady Falkland could appropriate hypocrisy and turn it into an advantage, as we have seen. But cruelty was too strong a blemish. Silence on the matter was therefore neither possible nor desirable, since it would have left the queen exposed at a most critical point. A justification of cruelty, on the other hand, would have contradicted the author's own principles about proper Christian behavior. Indeed, implied in the author's criticism of cruelty is a notion of justice that combines Christian ethics with a sense of fairness in the exercise of power. According to this notion, revenge in the form of cruelty toward a powerless subject (in this case a fallen adversary) is both unfair and unchristian: "It is assuredly . . . an argument of a Villanous Disposition, and a Devilish Nature, to tyrannize and abuse those wretched ruines which are under the Mercy of the Law, whose Severity is bitter enough without aggravation. . . . In Christian Piety, which is the Day-star that should direct and guide all humane Actions, the heart should be as free from all that's cruel, as being too remiss in point of Justice" (129).

In her own life too Lady Falkland abided by these principles. Her biographers tell us that an obligation to treat the offender with kindness was one of her life-long convictions (Fullerton 29). The spectacle of cruelty itself was a violation of her ideas about comeliness and fitness.[22] Furthermore, in the author's culture cruelty was a characteristically unfeminine vice. The connection between cruelty and femininity is apparent even in the language that the author uses: "The queen's act is

far unworthy of the Nobility of her Sex and Virtue" (Octavo 59). Noticeably, there is no apology for Mortimer's cruelty. The author thus chose what seems like a twist: she maintained the defense of the queen but condemned her cruelty.

Departing once more from her predecessors, Lady Falkland confines Isabel's cruelty mainly to the case of Spencer. With the exception just discussed, she continues to defend the relative innocence of her heroine until the crucial last part—Edward's death. Significantly, the queen is shown to disapprove of the plans to murder the king: "The Queen, whose heart was yet believed innocent of such foul Murther, is, or at least seems, highly discontented" (151). This is made especially poignant and dramatic in the final speeches she exchanges with Mortimer in which she is made to declare: "ne're can my heart consent to kill my Husband" (152). The killing of Edward is presented as being almost entirely Mortimer's doing. When Mortimer suggests the idea, she tries to dissuade him. She finally succumbs to his pressure but on condition that she will be spared the spectacle and "be not made partaker, or privy to the time, the means, the manner" (154).

It is difficult to say how the dramatic situation would have ended had it been put in the final form of a play, but as it is the history lingers on after Edward's death, which is followed by long moralizing on how much he deserved his punishment. Both Edward and Richard II are mentioned as examples of oppressive kings who abused their right to kingship and who died providentially: "But his [Edward's] Doom was registred by that inscrutable Providence of Heaven who, with the self-same Sentence, punish'd both him, and Richard the Second, his great Grandchild, who were guilty of the same Offences" (Octavo 74). In the folio volume there is a more severe criticism of the subjects who betray the king and of their decision to depose and murder him. But even here the final responsibility for Edward's misfortune is made to fall on him: "had he not indeed been a Traytor to himself, they could not all have wronged him" (160). Clearly, then, the author makes Edward's end a providential piece of work, and while she implicates Mortimer she exonerates the queen. The deaths of Mortimer and Isabel do not fall within the same chronological range, but significantly, only Mortimer is reported to have paid for his actions by death. The queen, "who was guilty but in circumstance" (155), experienced only the pangs of conscience.

WHEN WE COMPARE *The History of Edward II* (1627) with *Mariam* (written c. 1604, published 1613), we notice that the later work evinces an assertiveness that seems to be lacking in the earlier one. "The

Author's Preface to the Reader," dated and prefixed to the folio volume of *Edward II*, provides the most direct evidence of Lady Falkland's ability to assert herself as a writer. The latter part of this preface is worth quoting:

> I have not herein followed the dull Character of our Historians, nor amplified more than they infer, by Circumstance. I strive to please the Truth, not Time; nor fear I Censure, since at the worst, 'twas one Month mis-spended; which cannot promise ought in right Perfection.
>
> If so you hap to view it, tax not my Errours; I my self confess them. (A2v)

What is interesting in this preface is that there is no apology for the author's sex or, more important, for the subject taken up. On the contrary, there is a boldness, not unlike that we find in her address to the reader in the translation of *The Reply of the . . . Cardinall of Perron*, published three years later. For the purpose of comparison I shall quote parts of this address:

> Reader Thou shalt heere receive a Translation wel intended. . . . I desire to have noe more guest at of me, but that I am a Catholique, and a Woman: the first serves for mine honor, and the second, for my excuse, since if the worke be but meanely done, it is noe wonder, for my Sexe can raise noe great expectation of anie thing that shall come from me: yet were it a great follie in me, if I would expose to the view of the world, a worke of this kinde, except I judged it, to want nothing fitt, for a Translation. Therefore I will confesse, I thinke it well done, and so had I confest sufficientlie in printing it.[23]

A boldness and a self-confidence characterize both addresses to the reader. In the address of *The Reply* there is of course the conventional apology for the author's sex. But such an apology is shown to be worn out, for in the next sentence the author turns around and repudiates the excuse. She confidently asserts that she finds the work very well done and that, woman or not, she would not have published it unless she thought it met her standards of publishable quality. In both addresses the reader's attention is diverted from the controversial subject itself— Catholicism in the one and criticism of absolute rule coupled with justification of adultery in the other—to the quality of the work. The focus is shifted to perfectability, the execution of the ideas. Most important, in both addresses the author presents her task as telling the "Truth" or "informing [the reader] aright." This is an appropriation of the notion of absolute truth, the one Truth that everyone has the right, indeed the obligation, to tell. This notion, which is found in much religious writing of the period and which Cary probably acquired from her long experience with religious materials, becomes in fact a very effective strategy, which allows the author to tell the story from her

perspective. In *Mariam* she had expressed several traditional notions of womanhood. Her heroine, idealized according to the standards of sixteenth-century culture, had to suffer patiently under a tyrannical husband and remain free from moral blemish: Mariam was not allowed to find recourse in adultery. In *Edward II* Lady Falkland still voices traditional notions of female conduct, but here these notions are deployed as writing strategies. As I have argued, this becomes especially apparent when it is viewed in conjunction with the author's appropriation of structural elements, such as space and time. If indeed the author had an audience in mind, she could not have afforded to alienate her readers. Expressing the ideas was as important as gaining acceptance of them.

The tone of voice in *Edward II* also marks a change from that in *Mariam*. This is particularly apparent in the narrative portions of the history, where Lady Falkland sounds what we today would call argumentative and moralizing. Here is an example:

> But what could be expected, when to satisfie his own unjust Passions, he had consented to the Oppressions of his Subjects, tyranniz'd over the Nobility, abus'd his Wedlock, and lost all fatherly care of the Kingdom, and that Issue that was to succeed him. Certainly it is no less honourable than proper, for the Majesty and Greatness of a King, to have that same free and full use of his Affection and Favour, that each particular Man hath in his oeconomic government; yet as his Calling is the greatest, such should be his care, to square them always out by those Sacred Rules of Equity and Justice. (Octavo 62)

Passages of this sort are not rare. In *Mariam* Lady Falkland had used didactic lines for the chorus, which served to express conventional wisdom on wifely conduct. But in *Edward II* this didacticism develops into a sophisticated argumentative technique. In the later work the appropriation of ideas and events seems to be a rhetorical strategy to gain her audience's acceptance rather than an attempt to refrain from offending the male reader. Furthermore, the moralizing is frequently expressed in religous terms. This I have already partly shown in my discussion of Lady Falkland's attitude toward cruelty. I shall here provide one more instance, which concerns the author's interpretation of Spencer's failure to prevent the escape of the queen and her party: "But when the glorious power of Heaven is pleased to punish Man for his transgression, he takes away the sense and proper power by which he should foresee and stop his danger" (92).

Given the events that intervened between the composition of her two dramas, it would be fair to say that this change in tone is at least partly the result of Lady Falkland's long and active experience as a recusant. This experience, which included the writing of saints' lives and the

translating of Du Perron's *Reply,* apparently helped her to become more assertive. The translation of *The Reply* in particular was an exercise not only in theological argument but also in the style of polemics, as that work is a long and vigorous defense of Catholicism against Protestant charges. Thus religious dissidence seems to have been a liberating catalyst for Viscountess Falkland as it was for many other Renaissance women. Anne Askew, Elizabeth Cary, Mary Ward, and the women who joined the sects differed in their religious allegiances but shared at least one characteristic: an independent, critical spirit.[24] Criticism of the officially sanctioned dogma, whatever that might be, could and often did encourage independent thinking and insubordination.

Notes

This study is part of a larger research project financed by the Greek State Scholarship Foundation.

1. Written around 1604 and published in 1613, *The Tragedie of Mariam, Faire Queene of Jewry* (London: Thomas Creede for Richard Hawkins; reprint, Malone Society, 1914) is the first recorded original drama composed by an Englishwoman.

2. See Donald Stauffer, "A Deep and Sad Passion," in *The Parrott Presentation Volume,* ed. Hardin Craig (1935; reprint, Princeton: Princeton University Press, 1967), esp. 300–311.

3. The full title of the British Museum copy is *The History of The Life, Reign, and Death of Edward II. King of England, and Lord of Ireland, With The Rise and Fall of his great Favourites, Gaveston and the Spencers. Written by E.F. in the year 1627. And Printed Verbatim from the Original* (London: J. C. for Charles Harper et al., 1680), STC 313.

4. *The History of the most unfortunate Prince King Edward II. With Choice Political Observations on Him and his unhappy Favourites, Gaveston and Spencer* (London: A. G. and J. P., 1680), STC 314. The authenticity of this shorter version has been called into question, mainly by Donald Stauffer in the article cited above. He thinks, on the basis of some linguistic changes, that this short copy was probably the printer's condensed version of the longer work (295 n). Betty Travitsky, on the other hand, believes that the short version was the germinal form which led to a more poetic elaboration ("The *Feme Covert* in Elizabeth Cary's *Mariam,*" in *Ambiguous Realities,* ed. Carole Levin and Jeanie Watson [Detroit: Wayne State University Press, 1987], 193 n.3). Given the existing evidence, it is difficult to say with certainty what happened. It may be that the printer of the Octavo volume corrected the language without actually condensing the original he printed from. Apparently neither of the two printers read the original manuscript very carefully; if they did, they chose to ignore an overwhelming part of the evidence that contradicted their prejudices and purposes. In his address to the reader, the publisher of the Folio volume praises the history for its "so Masculine a stile" (A2r), while the publisher of the Octavo even attempts to present the history as a favorable account of Edward II. He cites contemporary critics whose opinions contradict the facts in the Falkland history and, finding that "Our author closes his History without declaring the particulars of the Murder of this Prince" (A3r), he supplies these particulars from the version of one Richard Baker! The fact that he supplies them in the preface, however, is perhaps an indication that he did not tamper with the text too much.

5. *The Harleian Miscellany: or a Collection of Scarce, Curious, and Entertaining Pamphlets and Tracts*, vol. 1 (London: Printed for T. Osborne, 1744), 66–91; reprinted and edited in 1808 by J. Malham. The British Museum Library catalog still has *Edward II* listed under Lord Falkland's name.

6. Stauffer makes three points in presenting his evidence: (a) Lord Falkland was "a man of iron and violence" and did not possess the gift for statecraft that the author of *Edward II* displays; (b) the author of the history turns away shyly and with a shudder from the cruel murder of Edward, and this is incongruent with Lord Falkland's contempt for pain; and (c) it is unlikely that Lord Falkland, himself the favorite of a favorite, would write so critically about a king who resembled James I ("A Deep and Sad Passion," 311–14).

7. The biographical sources available for Lady Falkland include: R[ichard] S[impson], ed. *The Lady Falkland, her Life from a ms. in the Imperial Archives at Lisle* (London: Catholic Publishing and Bookselling Co., 1861), supposed to have been written by a daughter; Georgianna Fullerton, *Life of Elizabeth, Lady Falkland 1585–1639* (London: Burns and Oates, 1883), which will be cited hereafter in the text; Kenneth Murdock, *The Sun at Noon* (New York: Macmillan, 1939), 6–38; and the *DNB* entry under "Cary, Sir Henry, first Viscount Falkland."

8. The original copies of these letters, which attest to the conditions just related, are located in the Public Record Office. Many of them are reprinted in *The Calendar of State Papers Relating to Ireland, of the Reign of Charles I, 1625–1632* (London: Her Majesty's Stationery Office, 1900), and some in *The Calendar of State Papers, Domestic Series, 1627–1628* (London: Longman, Green, Brown, 1858). Fullerton also reprints several of them in *Life*.

9. Unless otherwise indicated, page numbers given in parentheses will refer to the Folio edition, which is the text I have mainly relied on in this study. The Octavo text I cite occasionally is the 1680 edition.

10. The signatures in the original copies of the letters are quite clear. See also letters reprinted in Fullerton 69, 82, 86, 92, 101.

11. In 1626, Charles I ordered the queen's entourage to quit the court.

12. As far as I know, this is the first detailed discussion of the work, aside from Stauffer's. Other sources that mention Cary's *Edward II* include: Nancy Cotton Pearse, "Elizabeth Cary, Renaissance Playwright," *Texas Studies in Literature and Language* 18 (Winter 1977): 601–8; and Betty Travitsky, *Paradise of Women* (Westport, Conn.: Greenwood Press, 1981), 214–18. Travitsky also reprints short selections from the two versions of *Edward II*, including "The Author's Preface to the Reader."

13. The list includes Fabyan, Grafton, Holinshed, Stow, Speed, Hardyng, Marlowe, Shakespeare, and Drayton. The last one, who had been Lady Falkland's tutor when she was young, took up the subject repeatedly. In 1628 one Francis Hubert or Hobert published a poem, "The Deplorable Life and Death of Edward the Second" (Stauffer, "A Deep and Sad Passion," 299).

14. Ibid., 309 n.

15. Marlowe was apparently the first to introduce Edward's attitude of neglect toward the queen. See R. S. Knox's "Introduction" to his edition of *Edward II* (London: Methuen, 1923), 14–15.

16. The basic notion she expresses is that the king "should on earth order his proceedings in imitation after the Divine Nature" (140). The subjects are justified in rebelling when the king tyrannizes over them.

17. This is also Stauffer's view ("A Deep and Sad Passion," 301).

18. Griselda, a wife who patiently endured a number of trials under the authority of

her cruel husband, represented the ideal subservience in women. See Suzanne Hull, *Chaste, Silent and Obedient* (San Marino, Calif.: Huntington Library, 1982), esp. 82. See Judith Bronfman, in this volume, for a discussion of Griselda.

19. We do not know what Lady Falkland's intentions were with respect to publication, but the very fact that she included a reader's preface suggests that an audience, if not immediately sought, may have been in the back of her mind.

20. The Octavo reads: "The King grows sad and melancholly, calling to mind the Injustice of his own Actions, and the fair Cause his Wife had to seek her right and refuge. The neglect and breach of Wedlock was so great an Error, but so to contemn so sweet and great a Queen, was a fault, in his own thoughts, deserv'd a heavy censure" (39–40).

21. It is likely that Lady Falkland recognized something of her own experience in this. We know that to achieve her conversion to Catholicism she had to dissemble and to carry out her plans secretly.

22. On her daughter's wedding ring Lady Falkland inscribed the motto, "Be and Seem," by which she meant that one's actions should be free from "what might have a show or suspicion of uncomeliness or unfitness" (Fullerton 26).

23. *The Reply of the Most Illustrious Cardinall of Perron, to the . . . King of Great Britaine* (Douay: Martin Bogart, 1630), A2v.

24. See Retha Warnicke, *Women of the English Renaissance and Reformation* (Westport, Conn.: Greenwood Press, 1983), esp. chaps. 8 and 9; and Keith Thomas, "Women and the Civil War Sects," in *Crisis in Europe 1560–1660* (London: Routledge and Kegan Paul, 1965), 320–40.

Works Consulted

General

Batsleer, Janet, et al. *Rewriting English: Cultural Politics of Gender and Class.* London: Methuen, 1985.

Beilin, Elaine. *Redeeming Eve: Women Writers of the English Renaissance.* Princeton: Princeton University Press, 1987.

Belsey, Catherine. *The Subject of Tragedy: Identity and Difference in Renaissance Drama.* London: Methuen, 1985.

Eagleton, Mary, ed. *Feminist Literary Theory: A Reader.* Oxford: Basil Blackwell, 1986.

Ferguson, Margaret, Maureen Quilligan, and Nancy Vickers. *Rewriting the Renaissance: The Discourse of Sexual Difference in Early Modern Europe.* Chicago: University of Chicago Press, 1987.

Ferguson, Moira, ed. *First Feminists: British Women Writers 1578–1799.* Bloomington: Indiana University Press, 1985.

Fraser, Antonia. *The Weaker Vessel: Woman's Lot in Seventeenth Century England.* London: Methuen, 1984.

Gilbert, Sandra, and Susan Gubar. *The Madwoman in the Attic: The Woman Writer and the Nineteenth Century Literary Imagination.* New Haven: Yale University Press, 1979.

Hughey, Ruth. "Cultural Interests of Women in England, 1524–1640, Indicated in the Writings of Women." Ph.D. diss., Cornell University, 1932.

Hull, Suzanne. *Chaste, Silent and Obedient: English Books for Women, 1475–1640.* San Marino, Calif.: Huntington Library, 1982.

Jacobus, Mary, ed. *Women Writing and Writing About Women.* London: Croom Helm, 1979.

Jones, Ann Rosalind. "Nets and Bridles." In *The Ideology of Conduct: Female Courtesy Books and Literature from the Middle Ages to the Present Day,* ed. Nancy Armstrong and Leonard Tennenhouse. London: Methuen, 1987.
Kelso, Ruth. *Doctrine for the Lady of the Renaissance.* Urbana: University of Illinois Press, 1956.
Kohler, Charlotte. "Elizabethan Woman of Letters, the extent of her literary activities." Ph.D. diss., University of Virginia, 1936.
Miller, Edwin. *The Professional Writer in Elizabethan England.* Cambridge: Harvard University Press, 1959.
Moi, Toril. *Sexual/Textual Politics: Feminist Literary Theory.* London: Methuen, 1985.
Newton, Judith, and Deborah Rosenfelt. *Feminist Criticism and Social Change: Sex, Class and Race in Literature.* London: Methuen, 1985.
Rowbotham, Sheila. *Women, Resistance and Revolution.* Harmondsworth: Penguin, 1972.
Russ, Joanna. *How To Suppress Women's Writing.* London: The Women's Press, 1983.
Stone, Lawrence. *The Family, Sex and Marriage.* London: Weidenfield and Nicolson, 1977.
Travitsky, Betty, ed. *The Paradise of Women: Writings by Englishwomen of the Renaissance.* Westport, Conn.: Greenwood Press, 1981.
Wandor, Michelene, ed. *On Gender and Writing.* London: Pandora Press, 1983.
Warnicke, Retha. *Women of the English Renaissance and Reformation.* Westport, Conn.: Greenwood Press, 1983.
Woolf, Virginia. *A Room of One's Own.* 1929. Reprint. London: Panther Books, 1977.
Wright, Louis B. "The Reading of Renaissance Englishwomen." *Studies in Philology* 28 (1931): 139–57.

Specific

Calendar of State Papers, Domestic Series, 1627–1628. London: Longman, Green, Brown, 1858. Contains transcripts of letters and other documents pertaining to Lady Cary and her family.
Calendar of State Papers Relating to Ireland, of the Reign of Charles I, 1625–1632. London: Her Majesty's Stationery Office, 1900. Contains transcripts of letters and other documents pertaining to Lady Cary and her family.
Cary, Elizabeth, Lady Falkland. *The History of The Life, Reign, and Death of Edward II . . . Printed Verbatim from the Original.* London: J. C. for Charles Harper et al., 1680. This folio volume is the longer of the two published versions and the one I most frequently cite.
―――. *The History of the most unfortunate Prince King Edward II. With Choice Political Observations on Him and his unhappy Favourites, Gaveston and Spencer.* London: A.G. and J.P., 1680. Reprinted with minor alterations in *The Harleian Miscellany: or a Collection of Scarce, Curious, and Entertaining Pamphlets and Tracts,* vol. 1. London: Printed for T. Osborne, 1744; rpt. 1808. This is the shorter version.
―――. *The Tragedie of Mariam, The Faire Queene of Jewry.* London: Thomas Creede for Richard Hawkins, 1613. The play was composed c. 1604, when Lady Cary was just married or about to be married.
―――. *The Tragedy of Mariam,* ed. A. C. Dunstan and W. W. Greg for the Malone Society. London: Charles Whittingham at the Cheswick Press, 1914. Includes a critical introduction by the editors.
―――, trans. *The Reply of the Most Illustrious Cardinal of Perron, to the . . . King of Great Britaine.* Douay: Martin Bogart, 1630. The work is dedicated to Queen Henrietta-Maria.

Dunstan, A. C. *Examination of Two English Dramas.* Köningsberg, Germany: Hartungsche Buchdrückerei, 1908. Analyzes Cary's *Mariam* and Sampson and Markham's *Herod and Antipater*, both based on the Herod story, and examines the relation of the dramas to their source in Josephus; compares the two dramas and concludes that Sampson and Markham, as well as Massinger later, were uninfluenced by Lady Cary's drama.

Fullerton, Lady Georgianna. *Life of Elizabeth, Lady Falkland 1585–1639.* London: Burns and Oates, 1883. This biography is slanted toward the Catholic side, but it is comprehensive; it reprints several letters and other documents.

Marriott, J. A. *The Life and Times of Lucius Cary, Viscount Falkland.* London: Methuen, 1908. Contains a short biographical sketch of Lady Cary, mother of Lucius Cary, second Viscount Falkland.

Marston, John. *The Workes of Mr. J. Marston.* London: Printed for W. Sheares, 1933. Includes a dedicatory letter to Lady Cary.

Murdock, Kenneth. *The Sun at Noon: Three Biographical Sketches.* New York: Macmillan, 1939. One of the three sketches is of Lady Cary, and it is perhaps the most complete modern biography of this important woman. Murdock presents her as an idealist who ignored practical obstacles.

Newdigate, Bernard. *Michael Drayton and His Circle.* Oxford: Basil Blackwell, 1941. Reprints Drayton's dedication to young Elizabeth Tanfield, later Cary, and suggests that Drayton may have been her tutor.

Pearse, Nancy Cotton. "Elizabeth Cary, Renaissance Playwright." *Texas Studies in Literature and Language* 18 (Winter 1977): 601–8. The first published article to discuss *Mariam* in terms of its withdrawal from publication and its author's position as Renaissance woman.

S[impson], R[ichard], ed. *The Lady Falkland, her Life from a ms. in the Imperial Archives at Lisle.* London: Catholic Publishing and Bookselling Co., 1861. Purported to have been written by a daughter.

Stauffer, Donald. "A Deep and Sad Passion." In *The Parrott Presentation Volume,* edited by Hardin Craig. 1935. Reprint. Princeton: Princeton University Press, 1967. This is an important study of the Falkland *History of . . . Edward II.* Stauffer discusses its relation to drama and challenges the sources that had attributed the piece to Lord Falkland. He presents evidence to show that Lady Falkland is the most likely author.

Thomas, Keith. "Women and the Civil War Sects." In *Crisis in Europe 1560–1660.* London: Routledge and Kegan Paul, 1965. Argues that the attitude of religious sects toward women as well as the active female role in these sects strengthened women's independence. The sects offered women an opportunity for actual participation in religious activity, taking them away from the authority of the husband and the confines of the home.

Valency, Maurice. *Tragedies of Herod and Mariamne.* New York: Columbia University Press, 1940. Valency speaks disparagingly about Lady Cary's *Mariam.* More useful is his suggestion that no dramatist produced a successful drama on the theme because the Herod story offers only limited possibilities.

Weber, Kurt. *Lucius Cary, Second Viscount Falkland.* New York: Columbia University Press, 1940. Includes a brief discussion of Lucius's mother and questions the picture of a "caged" Lady Cary presented in the daughter's biography.

III

The Woman Ruler

CONSTANCE JORDAN

Representing Political Androgyny
More on the Siena Portrait of Queen Elizabeth I

THE POLITICAL androgyny of Queen Elizabeth I was variously expressed in the culture of sixteenth-century England. She was known at home and abroad as a "female Prince," an anomaly only to those who could not appreciate how crucial were the reasons of state that required her to assume this oxymoronic identity, reasons that were already evident in the provisions that had been made for the rule of her sister, Queen Mary, the first queen regnant in English history. For given the formidable restrictions on the activities of women authorized by both custom and Christian doctrine; given, in fact, the commonly accepted notion of woman as the "weaker vessel," no woman could assume magistracy over a people without undergoing some sort of transformation of her social and political character.

It was generally accepted that the social and political character of woman as "weaker" than man was instituted at the moment of her creation from Adam's side and as his helpmeet ("And the rib, which the LORD God had taken from man, made he a woman, and brought her unto the man," Genesis 2). Her status as man's subordinate is specified after the couple's fall from grace when her husband becomes her head ("Unto the woman [the LORD God] said, thy husband . . . shall rule over thee," Genesis 3). A woman's relation to man was therefore determined by her creation as a helper, rather than an initiator, manager, and leader; if she was also a wife the terms of her subordination became more precise, in that she was particularly required to obey her husband. Both kinds of subordination are points of doctrine and are not qualified, even in treatises on marriage or defenses of women in which a woman is declared to be the equal of, or at any rate not inferior to, her husband morally and intellectually—a claim that can be made on the basis of her earlier creation in "God's image" (Genesis 1). In practice, of course, matters were not so clear-cut. A noblewoman exercised authority over certain men by virtue of her rank. At the same time, because she was a woman she was prevented from taking certain kinds of action (especially legal) that men of lower rank were permitted to take.

All this was clearly in the minds of the framers of the marriage treaty

between Mary Tudor and Philip II of Spain (1554). Their solution to the problem was astonishingly easy, considering the weight of doctrine and opinion against them. They merely declared that Mary, insofar as she was a queen regnant, was male.[1] This legal fiction was subsequently expressed in an act of Parliament of the same year, in which it is stated that the "supreme Governor and Queen of this realm" is to have all kinds of "regal power" in as "full, large, and ample manner" as "any other her most noble progenitors, kings of this realm. . . ."[2] The act transforms the political arena into a special world in which the queen regnant can act as only men have acted previously. Politically she is a man.

The reaction to Mary's rule on the part of the more radical of her subjects reveals how horrific this solution appeared to some of those whose view of the social and political role of woman was determined by Christian doctrine, whatever the concessions that could or ought to have been made to her capacity for spirituality based on Genesis 1. Mary's critics were, admittedly, almost all Protestant and their polemics against woman's rule are often so fused with condemnations of Catholicism that it is difficult to separate the two. The case against gynecocracy itself was nevertheless a strong one, and it emerges nowhere more clearly than in John Knox's *First Blast of the Trumpet against the Monstrous Regiment of Women* (1558). In a nutshell, Knox argues that a woman with political authority first violates a law of nature; second, disobeys Scripture; and third, disrupts "good order" which is maintained by having the "head" govern the "body" (here he makes an analogy between the physical body, the couple in marriage, and the [male] monarch in the body politic). He appears to dismiss the political significance of Mary's marriage treaty and the corresponding act of Parliament by denying that an instance of the rule of a particular woman justifies woman's rule in general: because a thing is done it is not necessarily lawful, he concludes (4:414).

The significance of the treaty and act is, by contrast, grasped by John Aylmer. He sees how easily the notion that a queen regnant is to rule just as her male forebears have could be assimilated to the well-established doctrine of the monarch's "two bodies" and so could serve to justify woman's rule in principle and in the terms of contemporary political thought. In his *Harborowe for Faithfull and Trewe Subjectes* (1559), defending the propriety of woman's rule in general and Elizabeth's in particular, Aylmer implies that the mysterious second body of the queen regnant can suffer no infirmity, even that of being female.[3] Those of his contemporaries who were familiar with theories of the crown as a corporation would have recognized that the provisions Aylmer makes for a queen—that politically she is male—are logical exten-

sions of those that common lawyers made for kings. Like the king's second body whose nature is unaffected by youth, age, or other forms of limitation, so a queen's second body cannot be but whole and perfect.

Following the usual formulations of the concept of the male monarch's body politic, Aylmer's analysis links the queen's second body to a providential concern with the fate of her kingdom. God, Aylmer claims, controls "enheritaunce and lyneall discent" of monarchs; if a woman is in line for the throne, it must be that God intended her to rule: "placeth he [on the throne] a woman weake in nature, feable in bodie, softe in corage, unskilfull in practise, not terrible to the enemy, no shilde to the frynde, well . . . if he put to his hande she can not be feable, if he be with her who can stande against her" (sig. B2v, B3). And, as Aylmer describes the actual scope of the queen's authority and power, it could only be by virtue of her second body that she govern men and especially her husband: "so farre as perteineth to the bandes of mariage, and the office of a wife, [a queen] must be a subjecte; but as a Magistrate she may be her husbands head" (sig. C4v). As head, she must govern in all political matters: "If he [the consort] breake any lawe, if it were capitall, she myghte strike with the sword, and yet be a wife good inough, for the dutye that she oweth to him is not omitted in that she observeth that she oweth to the common weale, wherein he is as a member conteyned. But if for her wedlocke dutie to him she will neglecte the commonwealth [*sic*]; then is she a loving wife to him and an evel head to the countrye" (sig. G3).[4] The dilemma Aylmer here describes perfectly fits what many English thought of the rule of Mary I, for neither of the documents that had legislated the terms of her rule had proved to be effective in preventing what the English had feared when Mary married: the actual power of her husband, exercising the customary male virtue of command, to determine the course of events both in England and on the Continent.[5] It was a dilemma in which her half-sister appears to have determined never to find herself.

The Two Bodies of Elizabeth I

Recent new historicist criticism has done much to draw the attention of readers to the strategies of a sexual politics that Elizabeth employed to secure her position in a patriarchal society. We are now aware that expressions of her imposing will are registered in different ways in the character and forms of the drama and courtly narratives. What has been less emphasized is how closely her sexual politics—her intrigues with courtiers, her arguments against marriage, her jealousy of other women at court—follow a rationale determined not by some special insight she

had into her nature or that of her courtiers but rather by the main lines of contemporary political thought. Her famous and now often cited claims to be "wedded to her realm" (Buchanan 59), that as "private woman" she could marry but as a "Prince" she would do better not to (Neale 127), find their actual reference in the tension created between her theoretical and legal status as a male and her real and physical condition as a woman. Observations like that of Sir James Melville, who writes in 1564 that he had observed to the queen that he knew she would not marry—"I knaw your staitly stomak: ye thhink gene ne wer maried, ye wald be bot Queen of England, and now ye ar king and quen baith; ye may not suffer a commander"—reflect what I suspect was a fairly common understanding of the complex doctrine establishing woman's rule.[6] How far Elizabeth perceived herself as politically and socially male is unclear. On at least one occasion she entertained a fantasy of being a husband rather than a wife. To the Spanish ambassador to England, Guzman De Silva (who reports her conversation to Philip II early in her reign), Elizabeth declared that she would like to meet the widowed Princess Juana, observing "how well so young a widow and a maiden would get on together, and what a pleasant life they could lead. She [the queen] being the elder would be the husband, and her Highness [the princess] would be the wife."[7] Given the prominence accorded her second male body in the world of diplomacy and courtiership, however, her reflections here are not as strange or as idiosyncratic as they would be were she not a queen regnant.

At least some of Elizabeth's courtiers followed her logic. Fulke Greville, reporting Philip Sidney's opinion of Elizabeth's relationship to the duke of Anjou, states that Sidney feared their marriage would end as Mary and Philip's. "Because the weaker sort here [i.e., Anjou], being fortified by strong parties abroad, and a husband's name at home, must necessarily have brought the native soveraigne under a kinde of *covert baron*, and thereby forced her Majesty, either to lose the freedom and conscience of a good Christian, and the honor of an excellent prince, or the private reputation of an obedient wife" (Brooke 4:53). In theory at least, that "kinde of *covert baron*" or political subordination to which Greville refers should have been rendered impossible by the significance of the queen's second body, to which she frequently and defensively alluded when the subject of marriage arose. As Leah Marcus has shown, Elizabeth in her speeches to Parliament and on other occasions continued to emphasize that in her womanly princeliness she needed no consort, and, in fact, that by being a *prince* she was also, in some sense, her own heir (141–43).

Elizabeth inherited her androgyny—that is, her male political body

fused with her actual female body—from her sister for whom it had not worked well. Given Mary's example and the drastic curtailment of public activities generally prescribed for women, I would argue, Elizabeth had reason to promote—that is, to allow to be created if not actually to commission—works of art that provided the imagistic possibilities of the legal fiction of a second male body. Elizabeth's professed virginity certainly gave credibility to the spiritual maleness of her second body by obviating the possibility of an actual pregnancy. I think there is some evidence that she also realized that a male sexuality was an important (and even an essential) feature of a monarch's power and that somehow she had to convey that in this sense too she was figuratively male. Her virginity had somehow to include the fiction of a male sexuality and the power it represented.

Contemporary treatises on women and the family (and here I would also point to works like Boccaccio's *De mulieribus claris* and Barbaro's *De re uxoria* which were reprinted throughout the sixteenth century) make clear that the greatest and most salient difference distinguishing the sexuality of men and women was that the effects of sexuality in men were not marked by their bodies—they did not get pregnant—but were rather discretionary: they might or might not claim their children. In women, by contrast, these effects were so marked and therefore not discretionary. In his essay on *A Midsummer Night's Dream,* Louis Montrose writes of the need of men to claim themselves as the only begetter of their children to the exclusion of women as mothers and he identifies this need as a feature of the exercise of patriarchal power (73). It is also the case that men did not always make these claims, specifically in situations in which they did not wish to own or to own up to the child in question, and that this, too, was an expression of patriarchal power. (*King Lear*'s Gloucester is a wonderful example of the use of this power to claim or not to claim.) The indeterminacy of biological paternity—which could be so importantly compensated for in patriarchy (think of the anxiety of Leontes in *The Winter's Tale*)—is therefore also, and in a sense paradoxically, equivocated as the sexual license granted to men as opposed to women. For Elizabethans, the fact that men could acknowledge or deny their sexual activity constituted a highly significant dimension of their political power.

The character and application of this power are often revealed in statements insisting on chastity as the *only* virtue required of women. A passage in the third book of Castiglione's *Courtier* is illustrative. The discussion is brought into focus by the misogynistic Frisio, who claims that every woman would satisfy her lust as Semiramis or Cleopatra had done if she had the political power—the "states, powers and riches"—to

do so. But Gasparo, who is also a critic of woman, points out the dangers attending this sort of behavior, observing that men who rule take sexual liberty because "they know by common opinion that to them wanton living is not so slanderous as to women. . . ." Upon women, by contrast, men have laid "feare of slaunder for a bridle, to keepe them (in a manner) whether they will or no in this vertue [chastity], without the which (to say the truth) they were litle to be set by: for the worlde hath no profit by women, but for getting of children. But the like is not of men, which governe Cities, armies, and doe so many other waightie matters, the which . . . I will not dispute how women could doe, [since] it sufficeth they doe it not" (220–21). In Gasparo's words, the political power of men is closely bound up with the relative ease with which they can dismiss accusations of "wanton living." Their political power is in a sense proved by the extent to which they can indulge in sexual activity and remain untouched by damaging scandal.

It is my contention that whatever Elizabeth's emotional requirements, she understood and wished to communicate her command of this kind of political power by creating the illusion that her princely nature also possessed the capacity to capture the objects of its desire and to leave the effects of that appropriation as vague as they would be were she a man. Of course there was no actual proof of her unchastity nor could her regal authority have survived if such proof had been forthcoming. As she said to the Spanish ambassador, De Silva: "I do not live in a corner—a thousand eyes see all I do, and calumny will not fasten on me [for] ever" (quoted in Johnson 117). Her chastity *as a woman* had to be beyond reproach. But her bearing, her actions, her language—in short, the image she presented, was at crucial times suggestive of the sexual license regularly accorded to men.

How Queen Elizabeth's image as sexually male might have worked in the practice of diplomacy is suggested by an interpretation of what the French ambassador Mauvissière had to say about the rumors surrounding the queen: "if one tries to charge her falsely with love affairs (*d'avoir de l'amour*), I would say honestly that these are fabrications of the discontented and [devised] in the offices of Ambassadors to put off those who could profit from an alliance with her." Mauvissière denies that she loved Leicester and insists that she only wanted to marry royalty. In any case, she was always "chaste and prudent": this is proved by her employment "in the affairs of State" which left her no time "to dally in amorous passion."[8] In fact, there was no one who showed greater caution with respect to making alliances than the queen herself, and the "fabrications" of the supposedly discontented that Mauvissière points to were far from detrimental to her diplomacy. Those who sought an alliance with her were forced to reveal themselves while she remained aloof, implying

that she did not wish or need to receive or give favors, that she was uninterested in becoming finally identified with the interests of a single party. The inverse of her reputed chastity, which meant that no one could have her, was therefore the fiction of her princely license. If no one could have her, she could have whomever she wished, at will.

When she was closer to home and the demands of domestic rule, her position was the same. The case of Robert Dudley, earl of Leicester, is illustrative. Leicester was the person most implicated in whatever grounds there were for supposing that the queen was not a virgin, and she reproved him smartly for considering himself to have an exclusive influence over her. Adept at clientage, Leicester effectively controlled those who had access to the queen's privy chamber. But when he prevented her own guard, Bowyer, from giving access to "a very gay captain" whom he, Leicester, declared to be "a knave [who] should not long continue in his office," Elizabeth intervened: "God's death, my Lord, I have wished you well but my favour is *not so locked up for you, that others shall not partake thereof*; for I have many servants, to whom I have, and will at my pleasure bequeath my favour, and likewise resume the same; and if you think to rule here, I will take a course to see you forthcoming. I will have here but one mistress and no master . . ." (my italics).[9] Her policy of openness, of giving "favour" to many, is both good government and, to Leicester, a kind of infidelity. Politically it is masterful, in that it appropriates all male authority to command: with her there are no masters but only a mistress.

Sir Christopher Hatton, whose relations with the queen were also widely reported to be intimate, got treatment similar to Leicester's; but he had the queen's "favour" described to him in terms more explicitly sexual than those that the queen had used to Leicester, and evidently with reason. His letters to the queen in 1573 suggest feelings in excess of the merely courtly, and Edward Dyer advised Hatton to behave circumspectly when he felt that the queen had lost interest in him:

> First of all, you must consider with whom you have to deal, and what we be towards her; who though she do descend very much in her sex as a woman, yet we may not forget her place, and the nature of it as our sovereign. Now if a man, of secret cause known to himself, might in common reason challenge it, yet if the queen mislike thereof, the world followeth the sway of her inclination, and never fall they in consideration of reason, as between private persons they do. For though in the beginning, when her Majesty sought you (after her good manner) she did bear with rugged dealing of yours, until she had what she fancied, yet now, after satiety and fullness, it will rather hurt than help you; whereas, behaving yourself as I said before, your place shall keep you in worship. . . . (Nicolas 17, 18)[10]

Dyer's reflections on the queen's "place" which causes "the world" to follow her will as it would not were she a private person indicate his awareness of the importance of her second body in her relations with men. Here she is represented as having had her fill of Hatton, whom she consequently has dismissed. Now he is in the position of a mistress of uncertain standing who can no longer risk "rugged dealing" with her master as she did before she gave what he "fancied."

Retrospectively, the sexual element of Elizabeth's male second body may have been perceived as Francis Bacon imagined. He writes: "if viewed indulgently, they [her flirtations] are much like the accounts we find in romances, of the Queen in the blessed islands, and her court and institutions, who allows of amorous admiration but prohibits desire. But if you take them seriously, they challenge admiration of another kind and of a very high order, for certain it is that these dalliances detracted but little from her fame and nothing from her majesty, and neither weakened her power nor sensibly hindered her business."[11] The "admiration" different "in kind" and of a "very high order" that Bacon alludes to is what is due not to a female queen, "indulgently" imaged in her court in the blessed isles, but to a male prince, who is "seriously" seen engaged in dalliances without scandal or threat to his authority and power. And by exciting "admiration," these flirtations not only did not detract from the queen's majesty, they actually enhanced it.

There were probably not many ways in which Elizabeth's politically motivated dalliance could find acceptable expression in art and literature. The risk of offending the queen through explicit reference was certainly high, and nothing seemed to provoke her anger more than discussion of the nature and quality of her favors by those who sought or received them. For this reason, no style was better suited to representing her in all aspects of her life than allegory. Her Siena portrait is a case in point. Like Spenser's *Faerie Queene,* itself a highly decorous compliment to the queen's multi-faceted persona, "shadowed" in many of the poem's different women characters and notably in those who are androgynous, the Siena portrait conveys through contradictory images of sexuality and political power the complex nature of this woman's rule.

The Siena Portrait

This portrait of Queen Elizabeth is one of four characterized by Roy Strong as "the sieve portraits," all dating from 1579 to the early 1580s.[12] Recently discovered to be by the little-known Antwerp painter Quentin Massys the Younger, it was found in 1895 in Siena, where it now hangs in the Pinacoteca. How it got there is unknown. In the style

The Siena portrait of Queen Elizabeth I. By Quentin Massys the Younger. By permission of Pinacoteca di Siena. Photo Soprintendenza B.A.S. Siena.

THE WOMAN RULER

of the Flemish mannerist painters, it is of the type of state portrait whose primary purpose was, as Strong remarks, "to invoke through [the ruler's] image the abstract principles of rule" (Strong, *Portraits*, 34).[13] Giovanni Paolo Lomazzo's *Trattato dell'Arte de la Pittura* (1584) states the aesthetic that had justified such portraiture in earlier decades: it should not only convey allusively the "greatest moral and natural secrets" but also "incite the spirits [of viewers] to great and productive enterprise."[14]

The painter shows the queen standing in what appears to be a space at the end of a long corridor, pensively looking out at some point beyond the viewer, her right hand resting on a painted column, her left holding an inscribed sieve, and there is a globe directly behind her. A nobleman followed by his page approaches her along the corridor; they are being welcomed (or dismissed) by two of her own guards. A woman looks on from behind a curtain. The imagery is clearly symbolic and, as I shall suggest, refers to principles of rule in the manner of a state portrait. They are principles, however, that pertain to woman's rule particularly as Elizabeth knew and practiced it.

There are four principal images to consider. First, the sieve, with its Italian inscription "a terra il ben mal dimorra in sella." Second, the column, which is painted with scenes from books one and four of the *Aeneid* and has at its base the imperial diadem, and which is inscribed with the Petrarchan verse "Stancho riposo, riposato affanno." Third, the globe, showing England and the Atlantic Ocean with its barely legible inscription "Tutto vede e molto mancha"; and finally the procession of courtiers in the background.

The inscribed sieve suggests most obviously that the painting is on one level a tribute to Elizabeth as a virgin queen. Her sieve is a symbol of chastity; according to William Camden, it was one of her favorite devices (Strong, *Portraits*, 66). The sieve itself is associated with chastity in the legend of the Roman virgin Tuccia, whose virginity allows her miraculously to carry water from the Tiber to the temple of the Vestal Virgins, according to both Valerius Maximus and Augustine. The most accessible source of the legend for Elizabethans would have been Petrarch's *Trionfo della pudicizia,* a poem in which Tuccia "to clear herself of every bad rumor / carried water from the river to the temple" (per purgarsi d'ogni fama ria, / porto del fiume al tempio acqua col cribro).[15] The sieve's inscription has received different translations. Frances Yates thinks it means "On earth the good remain in the saddle with difficulty" (116). Strong translates it as "The good falls to the ground while the bad remains in the saddle." In both cases, you have to add to the Italian, which says literally, "to earth the good, bad remains in the saddle"

166

which is closer to Strong than to Yates. Strong concludes what seems obvious: that the sieve here "fulfills its customary role as an emblem of the discernment of good from bad" (*Portraits,* 66–68), and he attributes to the sieve's significance as a symbol of virginity an additional meaning: "The English Vestal [i.e., Elizabeth] is not only chaste but wise" (*Gloriana,* 97). But a closer inspection of the sieve in its imagistic context reveals that it is an enigmatic image in the following ways.

First, does the association of chastity with wise discernment exhaust the meaning of a sieve of virginity—which according to legend is miraculously a container—that is represented, as it is here, as porous and a means of separating what is wanted from what is to be rejected? Second, why is this sieve of virginity identified with a "sella" or saddle? There is no etymological basis for this identification. "Sieve" in Italian is "cribro"; "sella" comes from the Latin "sedere," to sit, and means "seat" or "throne," and, by extension, "saddle."[16] And finally, if the sieve is a symbol of virginity and also identified with a saddle, is not its primary significance subject to ironic question? The idea of virginity it symbolizes is contradicted by the image of sexual passion, of riding, or of being in the saddle. The rider in this case does not seem to be one who, like the mythographers' Perseus, *controls* his horse of passion, i.e., is "good"; rather, he (or she) gives it rein, however discreetly and discriminately. These questions probably have no logical answer. But assuming that the inscription is supposed in some way to comment on or to interpret the significance of the sieve, as in conventional emblem literature, it is possible to see the complete image, that is, sieve and inscription, as a form of mediation of these contradictions, specifically by its evocation of the idea of political power as Elizabeth knew and used it. It is the power of the androgynous female prince, who is at once a woman and also a ruler by virtue of her two bodies. The sieve identifies this power as that of the virgin's refusal to be subordinate to man but also as a refusal of that refusal, in that its image, the sieve, is inscribed as a saddle, a device enabling one to ride, that is to be sexual. Moreover, the image of sexuality is politicized when the phrase "to be in the saddle" is recognized as an equivocation of "to be on top" or "in command." Dante, for example, speaks of the emperor's rule as a "sitting in the saddle," "seder in sella." In short, to ride is to rule. To ride on a saddle-sieve is to rule with and through passions that the ruler/lover has the power both to express and to deny.

The inscription's subversion of the notion of virginity in its most direct sense is signaled more allusively by its inversion of the usual or common function of the item pictured. This sieve does not retain the good (as the Vestal Tuccia's miraculous sieve had held the water of the

Tiber). It lets it fall to the ground: "a terra il ben," even perhaps as good seed fertilizes barren soil. In other words, the sieve symbolically enfolds its opposite, just as the virgin Elizabeth symbolically enfolds a sexually potent prince who rides and commands. In analyzing the image in this way, I do not want to contradict the view of Elizabeth as powerful *through* her virginity, that is, through her dismissal of suitors, a dismissal that depends to some extent on her being perceived as virile, as a Belphoebe or a Britomart, to refer to Spenser's characters. I wish rather to suggest that her power as a fictional male is represented as including the kind of power to control and possess her suitors that is entirely at her discretion, a power that her contemporaries saw as proper to male sexuality functioning in a patriarchal culture.

The imagery of the Vergilian column is similarly suggestive. Critics agree on the scenes depicted. Reading from the bottom right to left: (1) Aeneas fleeing Troy; (2) Aeneas arriving at Carthage; (3) Aeneas meeting Dido at the temple; (4) Dido and Aeneas strolling; (5) the banquet at which they fall in love; (6) the hunt during which they consummate their love; (7) Mercury warning Aeneas; (8) Dido on her funeral pyre; and (9) Aeneas's departure. Both Strong and Yates see this sequence as an allegory of chastity and imperialism and identify Elizabeth as *pius Aeneas* who leaves erotic entanglements in order to fulfill his divine destiny as founder of a new empire. The column's inscription (from Petrarch's *Trionfo d'amore* [4, P. 145]): "Exhausted, I rest; rested, I am exhausted" comments on the futility of sexual love. Strong concludes: "the parallel is a simple one between Aeneas lured from his heaven-appointed way by the powers of love and Elizabeth, similarly destined for empire, who, because of her virginity, has refused to be deflected from her path" (*Portraits,* 68).

The parallel is apt but, I would argue, not altogether simple. As Stephen Orgel has pointed out, Elizabeth was known as Dido, Elissa, or Eliza to her contemporaries, not the Dido of Vergil and Dante, who symbolizes a lack of chastity, but the Dido of the very text from which the sieve imagery is drawn.[17] In Petrarch's *Trionfo della pudicizia,* Dido is described as one "who died for faithful love for her husband, not for Aeneas, as is commonly thought" (ch'amor pio del suo sposo a morte spinse, / non quel d'Enea, com' è 'l publico grido [11.10–11; see also 11.155–59]). She is also celebrated as the preserver of her country by Boccaccio, in both his *De mulieribus claris* and his *De casibus virorum illustrium;* in each of these texts, her body's inviolability figures the independence of Carthage.[18] And, in fact, a couple of the medallions show the Vergilian Dido in attitudes that recall her chaste version even while they illustrate Vergil's text. The temple scene shows her in a regal

attitude, as if dispensing laws. It is an alteration of its source in Marcantonio Raimondi's series of prints entitled *Quos Ego*, in which Aeneas is shown standing rather than kneeling (Strong, *Portraits*, pl. 20). The scene of the hunt represents Dido, with rays coming from her body, in a manner that recalls Aeneas's earlier encounter with his mother Venus as a huntress, that is, as a figure of Diana: the viewer might be expected to remember that there Aeneas asks, "o quam te memorem *virgo* (my italics; *Aen*. 1.327). The point of these transformational representations of the Vergilian Dido is, I think, to recall *and* to suppress that queen's other and antithetical figure. What the medallions finally stress therefore is not so much the chastity of Elizabeth, which would be better illustrated by images of the Petrarchan Dido, but rather the male sexuality of Aeneas who *has* his love and then *leaves* her; who satisfies his desire but wisely spurns erotic entanglements (at least after the intervention of Mercury) in the full awareness of the greater importance of his imperial mission.

The Vergilian parallels are further complicated by an additional medallion at the base of the column that shows the imperial diadem in a slightly lopsided position, almost falling off its ledge. It is threatened, I would suggest, by the meaning of Petrarch's inscription—describing erotic temptation and its frustration—beneath it. The imperial and phallic column on which is inscribed the triumph of patriotic (male) duty over (female) love thereby loses some of its solidity. It suggests not only that the imperial will is capable of being deflected by love, but also that the exercise of imperial power is precarious and subject to dispute. The globe to the left and slightly behind Elizabeth illustrates the actual contest for empire that by 1580 the queen had entered against Philip II of Spain. Critics are in general agreement that the globe serves to remind viewers of Elizabeth's intended conquest of the new world, a conquest in which English power was to supersede Spanish power emanating, as it did then, from the imperial house of the Hapsburgs. The threatened empire signified on the Vergilian column alludes to the Spanish empire of the Americas, about to confront Elizabeth's colonizers who are sailing their small ships on the painted globe (Strong, *Gloriana*, 98–99). What we are seeing is another level of oxymoronic complexity: if in the column's medallions Elizabeth is shadowed in the Vergilian Aeneas who loves and dutifully leaves his Dido for the sake of the Roman empire, she is also signified by the ships sailing on the seas of the globe—an image of male sexuality[19]—thrusting into a space already claimed and occupied by one who is nominally the inheritor of that original Roman empire.

The last image to consider is the procession scene in the background

The procession scene (Siena portrait detail). By permission of Pinacoteca di Siena. Photo Soprintendenza B.A.S. Siena.

of the painting (see detail). There are four figures in question: standing at the entrance to the queen's space or inner chamber are Elizabeth's two guards with their long pikes; the nobleman behind them who is clearly on his way to see the queen; and finally the woman behind the curtain. Strong has identified the nobleman as Sir Christopher Hatton who, together with the astrologer John Dee, encouraged the prospect of expansion overseas and discouraged Elizabeth's match with the duke of Anjou (*Gloriana,* 101–7). Hatton's inclusion here gives a historical specificity to the imperial theme of the painting and also to the representation of the queen's chastity. At the same time it enriches the meaning of Elizabeth's androgynous rule by alluding to her princely license, practiced in this instance on Hatton himself who, as his own and Dyer's correspondence attests, was once intimate with the queen and was then rejected by her. The figures of the procession are shown in attitudes sufficiently ambiguous to suggest that the queen's rule is again represented as governed by the notion of androgyny. It is unclear in what attitude Elizabeth's guards are addressing the nobleman, who, if he is to speak to the queen, must cross the space occupied by the globe that figures her imperial will. The elder guard's pike is set at a welcoming rather than a forbidding angle. The younger guard, who has a frankly feminine appearance (his hugely protruding doublet, a kind of codpiece manqué, suggests pregnancy), both blocks the nobleman's entry to the queen and seems to be leading him to her.[20] And finally, the half-visible woman assumes a compliant rather than a censorious posture (you can even see a slight smile on her face); as a duenna figure, she seems as capable of facilitating as of hindering an assignation. Were viewers to search for a clue to the meaning of the procession scene as a whole, they might well select the figure of the strangely posed guards. They stand together almost as lovers, the elder open to the advances of the younger who, particularly, seems to represent man and also woman, to be at once phallic and also uterine. In his doubleness, he serves as the imagistic equivalent of Elizabeth the prince. He is the *haec vir* to her *hic mulier*. In sum, the contradictions that are figured symbolically in the sieve as non-sieve and stated enigmatically in the inscription of virgin as rider/ridden are here given a dramatic representation in the conflicted treatment of the figure of the approaching nobleman, who, it appears, is both welcomed and dismissed.

Literal representations of the queen's political androgyny were, as I have suggested, out of the question; they could only have entertained the grotesque and the comic. Allegorical representations of the attributes and virtues of persons and types were, on the other hand, an

accepted feature of the cultural language of Elizabethans, who were adept at figurative interpretation. They saw the "book of nature" as a system of signs conveying the "word of God," that is, they saw moral and spiritual meaning in ordinary phenomena. Conversely they saw in the abstracted forms of emblem and allegory allusions to real persons and events. They were accustomed to debate the hermeneutic principles upon which symbolic representation might be based. Erasmus's discussion of the signs of clerical office in *Encomium Moriae*, Rabelais's play with the garments of mourning in *Gargantua*, Sidney's witty commentary on chivalric imprese in *Arcadia*, the detailed accounts of the social meaning of kinds of clothing and material in Elizabethan sumptuary laws barely indicate the extent to which this culture was informed by an appreciation of semiotics. Spenser's solution to the problem of representing the queen's political androgyny is complimentary and conservative; he represents in Britomart, Belphoebe, Mercilla, and others aspects of a royal female androgyne whose chief political function is inspirational and moral. His principal heroine, the Lady Knight of Chastity, Britomart, does not fail to exhibit a phallic power, specifically in her triumphs over Guyon, the knight of Temperance, and Marinell, a Hippolytus figure. But her virginal force is subsequently overcome by the superior strength of her husband to be, the Knight Artegal (*Faerie Queene*, 4.6.18), and so is reconceived in conformity with the requirements of patriarchy. In the Siena portrait, by contrast, the queen appears as herself, a female head of state, and her attributes—those required of a ruling monarch—are provocatively and audaciously represented. As a queen regnant, it was imperative that Elizabeth have all the powers of a king, including those that while unspecified in official discourse were universally acknowledged as indices of social control. From Mary's example, she had learned that to marry was effectively to renounce these powers, the law notwithstanding. She did not marry. On the other hand, the history of her flirtations—recorded by her contemporaries—indicates that her chastity was in itself too negative a virtue to figure in what needed to be seen as the politically significant erotic life of a reigning monarch. In her case, representations of her chastity could well afford to express not only the kind of virility usually attributed to a virgin but also to a male monarch, a virility that would allow her to engage the attention of suitors with a perfectly controlled openness, a highly discriminated possessiveness, a carefully ruthless selectivity. The symbolic androgyny with which she is so frequently portrayed may accordingly be modified to figure the sexuality of a male monarch; it is wittily expressed in the oxymoronic imagery of her Siena portrait.

REPRESENTING POLITICAL ANDROGYNY

Notes

1. *Acta Regia: or An account of the Treaties, Letters, and Instruments Between the Monarchs of England and Foreign Powers* (London, 1728), vol. 3, 407–8. The history of the English succession during the sixteenth century is covered by Mortimer Levine in *Tudor Dynastic Problems, 1460–1571* and in *The Early Elizabethan Succession Question: 1559–1568*. For a study of woman's rule, see Scalingi; see also Jordan, "Woman's Rule in Sixteenth-century British Political Thought."

2. *Tudor Constitutional Documents: 1485–1603*, ed. J. R. Tanner (Cambridge: Cambridge University Press, 1948), 123.

3. The standard work on the theory of the monarch's two bodies is Ernst H. Kantorowicz, *The King's Two Bodies: A Study in Medieval Political Theology* (Princeton: Princeton University Press, 1957). With regard to Queen Elizabeth I, see Axton.

4. In quoting from Aylmer and subsequent sixteenth-century texts, I have modernized the use of vv/w; spelled out &; and altered punctuation when necessary.

5. See especially an account of the English attitude toward the war with France and the loss of Calais in Loades 241–43, 364.

6. Sir James Melville, *Memoirs of His Own Life,* ed. Thomas Thomson (Edinburgh, 1827), 122.

7. *Calendar of Letters and State Papers relating to English Affairs preserved principally in the archives of Simancas,* vol. 1, ed. Martin A. S. Hume (London, 1892; reprint, Kraus, 1971), 364. For this reference I am indebted to Carole Levin.

8. Michel de Castelnau, Seigneur de la Mauvissière, *Mémoires* (Paris, 1731), vol. 1, bk. 3, chap. 1 (pp. 62–63).

9. Sir Robert Naunton, *Fragmenta Regalia, &,* in *The Harleian Miscellany* (London, 1809), 83.

10. Hatton's most passionate letters were written in 1572 and 1573; for the entire correspondence of these years, see Nicolas 13–31. There is no indication in them that Hatton was the queen's lover, however. A letter to Sir Thomas Heneage, who frequently carried Hatton's messages to the queen, suggests that Hatton saw himself as a fit consort for Elizabeth "whom through choice I love no less than he that by the greatness of a kingly birth and fortune is most fit to have her" (155). But in a letter of the same year he also compliments her on her "long war" against "love and ambition": "they are the violent affections that encumber the hearts of men: but now my most dear Sovereign, it is more than time to yield, or else this love will leave you in war and disquietness of yourself and estate, and the ambition of the world will be most maliciously bent to encumber your sweet quiet, and the happy peace of this most blessed Realm" (157), and implies that no man has yet conquered her.

11. Sir Francis Bacon, *In Felicem Memoriam, Elizabethae Angliae Reginae,* trans. James Spedding, in *Works* (Cambridge: 1863), vol. 11, 460.

12. The painting was brought to my attention by Walter Oakeshott who asked me to elucidate its enigmatic Italian inscriptions, a request that at the time I met simply by determining that the translations in Roy Strong's study of the painting in *Portraits of Queen Elizabeth I* were literally accurate. When Oakeshott came to publish his article on the painting, in which he makes a case for the earl of Leicester's part in its conception, he kindly included me as coauthor, despite the insignificance of my contribution. This caused me to think again about the painting as a whole, which I decided could submit to a different kind of analysis than the essentially historical one that Oakeshott had given it, seeing it, as he did, as something of a visual record of Elizabeth's relations with

Leicester. In my subsequent investigations, I have relied heavily on the research of Roy Strong. Although my interest in the painting is fundamentally different from his, I have acknowledged my debt to him throughout this essay.

13. *Armada: 1588–1988* (London: Penguin Books in association with M. J. Rodriguez-Salgado and the staff of the National Maritime Museum, 1988), 86. Massys's signature was discovered during the cleaning of the painting in February 1988. For this information I am indebted to Clark Hulse. For more commentary on the portrait itself, see Strong's *Gloriana*. See also Yates; and Oakeshott and Jordan, 306–9.

14. Giovanni Paolo Lomazzo, *Trattato della Pittura, Scultura ed Architettura* (1584; Rome, 1844), 5.

15. Petrarch, *Opere*, ed. Giovanni Ponte (Milan: Mursia, 1968), vol. 11, 151–52.

16. See Carlo Battisti, *Dizionario etimologico italiano* (Florence: Barbera, 1950–57). There are a good many instances of the figurative use of *sella* in the sense of "to be in charge or on top"—*Vocabulario universale della lingua italiana* 7 (Mantua, 1855) cites Petrarch for *rimanere in sella* = *star di sopra*. See *Canzoniere*, 34.6: "vinca'l ver dunque, e si rimanga in sella, e vinta a terra caggia la bugia" (may the truth therefore conquer and remain in force, and may falsehood conquered fall to the earth). See also Dante, *Purgatorio*, 6.92: "Ahi gente che dovreste esser divota, / E lasciar seder Cesar nella sella" (O people who ought to be devout and allow Caesar to reign).

17. Stephen Orgel, "Shakespeare and the Cannibals," in *Cannibals, Witches, and Divorce: Estranging the Renaissance,* Selected Papers from the English Institute, 1985, n.s., no. 11, ed. Marjorie Garber (Baltimore: Johns Hopkins University Press, 1987), 40–66.

18. For Boccaccio's Dido, see my "Boccaccio's In-famous Women." The chaste Dido is pictured in a sixteenth-century Flemish tapestry now hanging in the Victoria and Albert Museum; it is reproduced in *Lord Morley's Tryumphes of Fraunces Petrarcke*, ed. D. D. Carnicelli (Cambridge: Harvard University Press, 1971), pl. 10.

19. Cf. Shakespeare, Sonnet 138, ll. 5–8.

20. Certainly the viewer has to make allowances for the stylistic exaggeration of a mannerist painter. Nevertheless, the young guard's doublet is comparatively very enlarged and pendulous; see by contrast "Unknown youth," 1576, and "Martin Frobisher," nos. 99 and 100 in Strong, *The English Icon: Elizabethan and Jacobean Portraiture* (New York: Pantheon, 1969). The shape of the doublet itself seems to imitate that of the breastplate; see Zuccaro's portrait of Leicester, 1575, no. 110 in Strong's *English Icon*.

Works Cited

Axton, Marie. *The Queen's Two Bodies: Drama and the Elizabethan Succession*. London: Royal Historical Society, 1977. The standard work on the representation of the female prince on the English stage in the sixteenth century. Much of Axton's work is based on her analysis of Plowden's reports in which the theory of the monarch's two bodies is developed with particular reference to queens regnant.

Aylmer, John. *An Harborowe for Faithfull and Trewe Subjectes*. Strasburg, 1559. The first protracted defense of woman's rule and in particular that of Elizabeth Tudor. Distinguishes between queen regnant as ruler and wife: she is subordinate to her husband only in strictly marital affairs.

Brooke, Sir Fulke Greville. "The Life of the Renowned Sir Philip Sidney." In *Lord Brookes Works*, edited by Alexander Grosart, vol. 4, 1–229. 1870. Contains Greville's reflections on Sidney's relations with Queen Elizabeth I, and especially on Sidney's

letter to the queen concerning her relations with the duc d'Alençon, i.e., the duke of Anjou.

Buchanan, George. *The Tyrannous Reign of Mary Stuart.* Translated and edited by W. A. Gatherer. Edinburgh: University Press, 1958. An *ad feminam* attack on Queen Mary; it does not entertain theoretical questions concerning woman's rule but rather Mary's own fitness to govern.

Castiglione, Baldassare. *The Book of the Courtier.* Translated by Sir Thomas Hoby. 1561. Reprint. London: J. M. Dent, 1966. The third book describes the ideal court lady. It contains many of the standard arguments in the *querelle des femmes.* Misogynist argument, chiefly based on Aristotle, is contested by arguments from history and experience.

Johnson, Paul. *Elizabeth I.* New York: Holt, Rinehart and Winston, 1974. A lively discussion of the queen, without, however, careful documentation of sources.

Jordan, Constance. "Boccaccio's In-famous Women: Gender and Civic Virtue in the *De mulieribus claris.*" In *Ambiguous Realities,* edited by Carole Levin and Jeanie Watson, 25–47. Detroit: Wayne State University Press, 1987. Shows Boccaccio's subversion of his apparent thesis—that women can demonstrate civic virtue as men do—by his composition of histories of women in public life who come to disastrous ends.

———. "Feminism and the Humanists: The Case of Sir Thomas Elyot's *Defence of Good Women.*" In *Rewriting the Renaissance: The Discourses of Sexual Difference in Early Modern Europe,* edited by Margaret W. Ferguson, Maureen Quilligan, and Nancy Vickers, 242–58. Chicago: University of Chicago Press, 1986. Discusses Elyot's defense in relation to its sources in misogynist and apologetic debate, especially the work of Vives and Castiglione, and situates it in the context of the controversy concerning the divorce of Henry VIII.

———. "Woman's Rule in Sixteenth-century Political Thought." *Renaissance Quarterly* 40, no. 3 (1987): 421–51. An analytic survey of texts on the question of gynecocracy. Discusses arguments based on divine and natural law and on the theory of the monarch's two bodies.

Knox, John. *The First Blast of the Trumpet Against the Monstrous Regiment of Women* (1558). In vol. 4 of *The Works of John Knox.* Edited by David Laing, 363–428. Edinburgh: Bannatyne Club, 1855. The most sustained and cogently argued of the sixteenth-century attacks on gynecocracy.

Levine, Mortimer. *The Early Elizabethan Succession Question: 1559–1568.* Stanford: Stanford University Press, 1966. Provides historical background to the question of woman's rule in England, as it affected Elizabeth I.

———. *Tudor Dynastic Problems, 1460–1571.* London: Allen and Unwin, 1973. Discusses the question of the succession as it concerned the Tudors; contains important references to the status of Mary Stuart.

Loades, D. M. *The Reign of Mary Tudor: Politics, Government, and Religion in England, 1553–1558.* London: Ernest Benn, 1979. The most comprehensive treatment of the reign of this queen. Useful for the way in which it documents her relation to her husband, Philip.

Marcus, Leah S. "Shakespeare's Comic Heroines, Elizabeth I, and the Political Uses of Androgyny." In *Women in the Middle Ages and the Renaissance,* edited by Mary Beth Rose, 135–53. Syracuse: Syracuse University Press, 1986. A discussion of the representation of androgyny on the Elizabethan stage with special reference to the queen's male body politic.

Montrose, Louis Adrian. "*A Midsummer Night's Dream* and the Shaping Fantasies of Elizabethan Culture: Gender, Power, Form." In *Rewriting the Renaissance: The Dis-*

courses of Sexual Difference in Early Modern Europe, edited by Margaret W. Ferguson, Maureen Quilligan, and Nancy J. Vickers, 65–86. Chicago: University of Chicago Press, 1986. The author analyzes and describes the ways in which the queen's representation of herself as an object of desire both shaped and was shaped by contemporary ideas of sex and gender.

Neale, J. E. *Elizabeth I and Her Parliaments, 1559–1581*. London: Jonathan Cape, 1953. The standard work on the subject.

Nicholas, Sir Harris. *Memoirs of the Life and Times of Sir Christopher Hatton, K. G.* London, 1847. Reprints the letters of this important courtier of Elizabeth I that allude to some of her relations with her male courtiers.

Oakeshott, Walter, and [Constance] Anson Jordan. "The Siena Portrait of Queen Elizabeth I." *Apollo* 124, no. 296 (1986): 306–9. An argument for the role of Robert Dudley, earl of Leicester, in the composition of the portrait.

Scalingi, Paula Louise. "The Scepter or the Distaff: The Question of Female Sovereignty, 1516–1607." *Historian* 41, no. 1 (1978): 56–75. Describes the objections to gynecocracy and how they were confronted by proponents of woman's rule.

Strong, Roy. *Gloriana: The Portraits of Queen Elizabeth*. London: Thames and Hudson, 1987. Further reflections on the queen's portraits. Identifies the courtier in the background of the Siena portrait as Sir Christopher Hatton.

———. *The Portraits of Queen Elizabeth I*. London: Oxford University Press, 1963. This comprehensive study of the queen's portraits is later complemented by his *Gloriana*.

Wiesner, Merry E. "Women's Defense of Their Public Role." In *Women in the Middle Ages and the Renaissance*, edited by Mary Beth Rose, 1–27. Syracuse: Syracuse University Press, 1986. The author establishes the principal positions in the argument on women and the *vita activa*. She covers the European as well as the English scene, citing examples from the sixteenth through the middle of the seventeenth centuries.

Yates, Frances. "The Triumph of Chastity." *Astraea: The Imperial Theme in the Sixteenth Century*. London: Routledge and Kegan Paul, 1974. A discussion of the iconography conveying the concept of the queen's virginity in the context of her commitment to imperialist expansion.

CLARE KINNEY

The Queen's Two Bodies and the Divided Emperor

Some Problems of Identity in *Antony and Cleopatra*

CLEOPATRA, like Falstaff, is always being called names. Almost every scene in *Antony and Cleopatra* generates new identities for her; over the course of the play she acquires at least forty different cognomens. She is gypsy, whore, trull, vile lady, grave charm, morsel, boggler, salt Cleopatra; she is great fairy, nightingale, serpent of old Nile, Egyptian dish; she is, furthermore, most sovereign creature, great Egypt, day o' th' world, lass unparalleled. Constantly avoiding the numerous (and largely male) attempts to fix or subsume her being within a single convenient or conventional category (such as Witch or Strumpet), she transforms and re-verses whatever labels are attached to her. Consider, for example, what happens to Cleopatra the Comestible. The "Egyptian dish" (2.6.123)[1] has been tasted by Julius Caesar, the elder Pompey, and Antony: all Rome, it seems, has had a piece of the pie, and at the nadir of his fortunes, Antony accuses her of being a rather nasty leftover:

> I found you as a morsel, cold upon
> Dead Caesar's trencher: nay, you were a fragment
> Of Gnaeus Pompey's. . . . (3.13.116–18)

But even as her last lover, the "pretty worm of Nilus," feeds upon her, the queen says to Charmian:

> Dost thou not see my baby at my breast
> That sucks the nurse asleep? (5.2.307–8)

The tempting and dangerous "morsel for a monarch" (1.5.31) becomes at the last this gentle nurturer, figuratively giving life even as she is preyed upon.[2]

Yet Cleopatra's happy capacity for such transformations does not mean that the speeches of Antony and Enobarbus praising her infinitely becoming acts of "becoming," her delicious variety (1.1.49–51; 2.2.235–40) constitute the last word on her. Inasmuch as her identity can be fixed it is located in the repeated metonymical epithet "Egypt." Whenever the word occurs a kind of referential oscillation between the woman and the

nation is triggered in the hearer's mind. The queen seems to be interchangeable with every aspect of her country and its denizens. She is its presiding goddess Isis (3.6.17), she is the "serpent of old Nile" (1.5.25), she is the Nile itself. Even as "Nilus' slime" (1.3.68–69) is quickened by the masculine sun (Phoebus, Horus), Cleopatra, "black" with "Phoebus' amorous pinches" (1.5.28), turns men's swords into ploughshares and brings forth a harvest: Caesar "ploughed her and she cropped" (2.2.228); she has borne children to Antony. Her Egyptian fecundity is indeed emphasized by Shakespeare's suppression of all mention of Antony's Roman offspring by Fulvia and Octavia. And when she calls for the general destruction of her land if she is cold and false to her lover, "Till by degrees the memory of my womb, / Together with my brave Egyptians all, . . . Lie graveless . . ." (3.13.163ff.), she instinctively couples her progeny and her people.

In fact, Cleopatra is coextensive with her subjects to such a degree that her last words can be completed quite naturally by her countrywoman Charmian.[3] "What should I stay—" says the queen, and dies; her attendant immediately supplies, "In this wild world?" (5.2.312–13). This uninterrupted transference of discourse between one speaker and the other retrospectively undercuts Octavius's rather cheap shot as he faces the queen and her ladies for the first time and asks, "Which is the Queen of Egypt?" (5.2.111). Cleopatra *is* Egypt, but Egypt is also Cleopatra; her Egyptians can speak for their monarch. Charmian's response to the soldier's "Is this well done?"—"It is well done, and fitting for a princess / Descended of so many royal kings" (5.2.324–26)—would have come equally fittingly from Cleopatra's own lips.

The equation of the woman so completely with her state conflates the monarch's "two bodies" and breaks down, or rather denies, the barrier between her public and private selves.[4] Even after her suicide—and despite her claim that death "shackles accidents and bolts up change" (5.2.6)—Cleopatra's identity is still oscillating between woman and queen, between the "lass unparalleled" and the "princess / Descended of so many royal kings" of Charmian's last encomia.[5] She asserts, after Antony's death, that she is "No more but e'en a woman, and commanded / By such poor passion as the maid that milks / And does the meanest chares" (4.15.73–75), but a scene or two later she has not lost her "Immortal longings" as she dons her crown and royal robes to revisit Cydnus (5.2.279–80). Lear's belated discovery that he is "a very foolish, fond old man" is part of his tragic education; Cleopatra's beautiful insistence at the end of act 4 on her private, limited human identity does not constitute an admission of anything she did not already know.

Perhaps the fascination and the infuriation that Cleopatra ignites in

Rome's autocrats derives in part from the fact that she can *be* Egypt in a way that neither Caesar nor Antony can ever embody Rome: they are merely Roman. For Rome demands of its rulers an obsessive privileging of the public over the private identity, and this is why it would be unthinkable for Caesar to accede to the defeated Antony's request that he might dwell "A private man in Athens" (3.12.15): as far as Octavius is concerned Antony doesn't have a private identity; indeed, on hearing of his enemy's death he declares Antony's "is not a single doom, in the name lay / A moiety of the world" (5.1.18–19). Roman manliness, the system of value that equates virtue with *virtus*, demands a kind of normative public behavior allowing infinitely less free play of identity than royal Egyptian femaleness. Philo's insistence, as the play opens, that "the triple pillar of the world" has become a "strumpet's fool" (1.1.12–13) emphatically asserts the noninclusive either/or nature of Roman values. One must enact a single, absolute condition or identity; one cannot supplement it or transform it into something else equally good or better, only relinquish it or perforce represent its (vilified) opposite.

Cleopatra's Egypt embraces multiplicity and difference, and for all its apparent "femininity" does not exclude maleness (the Greek suffix of the monarch's very name makes her father as well as mother to her country). Octavius snarls that "Antony is not more manlike / Than Cleopatra; nor the queen . . . / More womanly than he (1.4.5–7). But when she appropriates Antony's "sword Philippan" (2.5.23), Cleopatra is, as Janet Adelman suggests, not merely Omphale subduing Herculean Antony, or Venus disarming Mars, but also the vigorously androgynous figure of Venus *armata* (Adelman 92)—or at the very least an Omphale who doesn't just trap heroes in the female space of the bedroom but insists on invading the male space of the battleground. Of course, the fiasco of Actium is on one level attributable to Cleopatra's failure to "be a man"; certainly she does not meet the requirements of Roman *virtus*. But as even Enobarbus points out, Antony was not obliged to fly with her. Antony has defended Cleopatra's right, as "Egypt," to "appear for a man" (3.7.18) and lead her troops to battle, but he never properly comes to terms with her augmented identity. He cannot think of her as a fellow soldier whose shortcomings should not affect his own performance, but only as a bewitching female to be pursued at all costs.

Antony's sense that he is obliged to choose between *virtus* and Cleopatra at Actium, that he cannot be both soldier and lover, and that, having chosen to be the latter, he has "lost [his] way for ever" (3.11.4) and is Antony no more, is a by-product of Rome's characteristic attitude in this play toward gender relations and individual identity. It is not so much a

case of "male" values predictably being privileged over "female" ones, as of a complete suppression of the female term within a potentially complementary pairing while the male one is doubled. This obliteration followed by reduplication is most clearly illustrated when Antony marries Octavia. Octavius permits his exemplary female counterpart and beloved sister to be sacrificed to and subsumed by his problematic relationship with Antony. She becomes the (inadequate) glue holding together *their* unhappy marriage. In the summit meeting of act 2, scene 2—at the end of which, as Carol Neely points out (143), the two men enact a parodic betrothal ceremony in Octavia's absence—Caesar yearns for a "hoop" to bind together himself and Antony (2.2.115). But Octavia is never really permitted to *embrace* both men; tellingly, the stage directions for her very first appearance specify "Enter Antony, Caesar, Octavia between them" (3.3), and, in Caesar's words, she is to be "the cement of our love" (3.2.29). Octavia, however, recasts this image when, sensing the renewed antagonism between husband and brother, she laments,

> Wars 'twixt you twain would be
> As if the world should cleave, and that slain men
> Should solder up the rift. (3.4.30–32)

The sealing agent, the "solder" between the "world sharers," is not one woman's body but many corpses. The image is further revised when Enobarbus, hearing of Lepidus's fall, foresees open conflict between Caesar and Antony and declares,

> Then, world, thou hast a pair of chaps, no more,
> And throw between them all the food thou hast,
> They'll grind the one the other. (3.5.13–15)

Nothing can heal or seal the breach between the two, nothing can separate them, and Octavia (like everyone else) will presumably be one more victim consumed by their rivalry—and, ironically, just as much a "morsel" therefore as the "Egyptian dish."

The mediating female is gradually obliterated: Rome's central relationship is between male rivals, each of whom wants to *be* Rome. It is significant that the first epithet Octavius applies to Antony in the play is "great competitor" (1.4.3). The term is being invoked in its root sense of "associate or partner in the same enterprise or quest," but the inevitable double meaning underscores the generals' real relations. Even at the height of their apparent amity in act 3, Antony tells Octavius "I'll wrestle with you in my strength of love" (3.2.62); all loving-kindness is perforce expressed in terms of rivalry. In Egypt, the world that embraces

male and female possibilities, Antony celebrates the "peerless" alliance that makes Cleopatra and himself a glorious "mutual pair" (1.1.33–40)—the semi-tautology of "mutual pair" emphasizes their bond.[6] In Rome the significant pair-bonding is always male (wives are abandoned or absent) and perpetually competitive, because one will truly gain one's identity only by destroying a double or a parodic mirror image—not by representing one-half of a complementary pair.

Waiting to have her fortune told by the Soothsayer, Charmian comically sketches a career for herself that threatens to rival Cleopatra's: "Let me be married to three kings in a forenoon and widow them all; let me have a child at fifty to whom Herod of Jewry may do homage; find me to marry with Octavius Caesar . . ." (1.2.25–29). But she climaxes her wish "and companion me with my mistress." Such a desire could not, would not be articulated in the language of Rome; even Antony's last loyal companion, Eros, turns into a competitor when, killing himself instead of his lord, he beats him to a noble death.[7] Competition, in the shape of resented doubles, distorting mirrors, threats to individual male identity, is always present in this world. Antony is angrily aware that other "great competitors," Cneius Pompeius and Julius Caesar, have "always already" enjoyed Cleopatra, and I think it not insignificant that the auditor or reader of this play is perpetually in danger of confusing references to the dead Pompey and Caesar with their living namesakes. Furthermore, the "sons"—Shakespeare, tellingly, blurs historical family relationships: Sextus Pompeius is actually Cneius Pompeius' younger brother; Octavius is Julius Caesar's nephew—can never quite detach themselves from the "fathers" (although, as the harshest critics in the play of Julius Caesar and Pompey the Great's Egyptian mistress, Octavius and Sextus do their best.)

Doctor Johnson complained that in *Antony and Cleopatra,* the heroine apart, "no character is very strongly discriminated."[8] While one might not choose to agree with the suggestion that Antony and Octavius are not very clearly differentiated, it *is* true that both characters feel their discrete identities, their very selves, are put into question by the behavior of the other. Due to their unwillingness to embrace difference, the possibility of complementarity is sacrificed to the principle of mutual exclusivity ("I can't thrive while he's around"), but because they are partners as well as rivals, slightly skewed doubles as well as opposites, whenever one seeks to exclude or suppress the other he is always threatening to destroy himself.

After the battle of Actium, Canidius believes the fight would have gone well "Had our great general / Been what he knew himself . . ." (3.10.26–27). There is a lot of talk in this play about what it is to "be"

THE WOMAN RULER

Antony—talk that always seems to collapse into tautology, coming up with definitions that are at once circular and restrictive. At the end of act 1, scene 1, Philo complains that

> sometimes, when he is not Antony,
> He comes too short of that great property
> Which still should go with Antony. (1.1.57–59)

The suggestion here is that Antony is to blame for lacking the greatness that should always accompany Antony even (paradoxically) when he "isn't himself." His self is not his own; the "great property" that is supposed to define him is in a sense "common property"; his very existence is dependent upon his submission to Rome's code of values. An Antony who swerves from that value system is a "not-Antony" who is suppressed within three lines. Antony certainly can't reconcile the partial "versions of Antony" reflected back to him by Octavius or emanating from Rome with the competing sense of a transformed self generated by his love for Cleopatra. And yet, to the last, he is terribly dependent upon the mirror provided by Rome. "If I lose mine honour / I lose myself" he tells Octavia (3.4.22–23); "honour" is of course Roman *virtus,* and when Octavius defeats him and denies him his Roman identity by "harping on what I am / Not what he knew I was" (3.13.142–43)—refusing to reflect back to him that image by which Antony has constituted himself—the general's sense of self begins to dissolve. Antony can celebrate Cleopatra's multiplicity, her becoming "becomings," but he cannot himself become anything other than the Antony approved by Rome without confronting the prospect of *mere* formlessness and nonexistence. As the play opens, his "Let Rome in Tiber melt" defies Rome's categories and definitions, but when he believes his Romanness *is* melting away he has nothing to put in its place.[9] (Cleopatra's parallel "Melt Egypt into Nile" [2.5.78] is far less self-subverting because the Nile is also Egypt and she is both.)

Antony's presuicide meditation on the inchoate cloud forms that shift in seconds dramatizes his sense of self-loss. Like the disappearing cloud rack, "I am Antony, / Yet cannot hold this visible shape . . ." (4.14.13–14). It is noticeable that in a few words he moves from subjectivity ("I am Antony") to a sense of self constituted by others' regard ("this visible shape"). If he is invisible to Rome, he doesn't exist—and he can find nothing in the (as he thinks) treacherous flux of Egypt to give him new shape. Ironically, he can only regain his identity, put Antony back together again, through willed self-destruction. Dying, he tells Cleopatra:

> Not Caesar's valor hath o'erthrown Antony,
> But Antony's hath triumphed on itself. (4.15.14–15).

He displaces his rival's victory with his own, splits himself so that an Antony will survive as victor of his self-dissolution. Despite the fact that, hauled up into Cleopatra's Alexandrian monument, he is finally embraced by the womb/tomb of Egypt, this Antony will be a "Roman" Antony. At the last (and with the familiar circularity that always seems to accompany Antonine self-definition) he is, in his own words, "A Roman, by a Roman / Valiantly vanquish'd" (4.15.57–58).

When Octavius appears shaken by the news of Antony's death, Maecenas remarks upon the inescapable interdependence of the two generals' identities: "When such a spacious mirror's set before him / He needs must see himself" (5.1.34–35). If Romans are always lamenting the deaths of those they most wanted out of the way (Antony himself has wept for Brutus at Philippi), it is perhaps because the departed foe inevitably turns out to be much more a part of one's self than one had ever admitted. So it is not surprising that Octavius eulogizes Antony as

> ... my brother, my competitor
> ... my mate in empire,
> Friend and companion in the front of war,
> The arm of mine own body, and the heart
> Where mine his thoughts did kindle; ... (5.1.42–46)

Caesar wins his empire, becomes "Rome," through bereavement (the loss of a brother and friend), divorce (from a "mate in empire"), and self-mutilation (the cutting off of an arm, the tearing out of a heart). It has been suggested that in *Antony and Cleopatra,* although he does not lose himself, Octavius doesn't *become* anything (Adelman 92). I myself would propose that he does undergo a metamorphosis: his "becoming," however, is predicated upon a subtraction, because his identity is so dependent upon Antony's.

Cleopatra's being encompassed Egypt, all possible versions of womankind, and the male principle too; the Roman rulers can only "become" Rome in their absence, self-suppression, or self-diminishment. Antony is named "Emperor" by his mistress for the first time in the play when she tells Dolabella "I dreamt there was an Emperor Antony" (5.2.76); he has to die first. And, as we have seen, there is not much left of Octavius to become Augustus Caesar.

But is it fair thus to privilege Egypt's multiplicity over the fragmented and limited selves of Rome when Cleopatra herself seems to submit to Rome's categories of value at the last? Even as she begins to play with the idea of thwarting Octavius's ambitions by killing herself, she says, "Let's do it after the high Roman fashion" (4.15.87). Is she reconstructing her identity according to the requirements of *virtus?* Awaiting the arrival of the asp, Cleopatra proclaims:

I·AM·DYING·EGYPT

ACT·IV·SCENE·XV

The death of Antony. Drawing by John Byam Lister Shaw for the 1900 Chiswick edition of Shakespeare. From the Art Collection of the Folger Shakespeare Library. By permission of the Folger Shakespeare Library.

184

> I have nothing
> Of woman in me: now from head to foot
> I am marble constant. (5.2.237-39)

Her first words deny her femaleness and suggest a complete surrender to the Roman equation of virtue with *virtus*, manliness; her marble constancy, on the other hand, evokes a flickering reminder of the "holy, cold and still conversation" of that exemplary Roman matron Octavia (3.6.119-20). But to my mind, Cleopatra is not so much subordinating herself to Roman value systems as adding a couple of new "becomings" to her play of identity. In dying thus she not only escapes the actual bonds that Octavius would place upon her, but (in acting in a manner that assorts with *his* codes) prevents him from fixing her nature by reducing her to his "Egyptian puppet." She does not, moreover, slavishly imitate the "high Roman fashion" of death but rather appropriates it and remakes it in her own image. In a distinctly Egyptian variation on the theme of opening one's own veins, Cleopatra, the "serpent of old Nile," succumbs to another serpent of old Nile: Egypt is by Egypt valiantly vanquished. She lives on after death as Charmian's "lass unparalleled"; Octavius also lives on, but merely to be (in the queen's own words) an "ass / Unpolicied" (5.2.306-7). And Octavius, ordering her burial beside Antony in the Alexandrian monument, admits, perforce, that "No grave on earth shall clip in it / A pair so famous" (5.2.357-58): all-embracing Egypt finally wins out as the male/female union displaces the privileged pair-bond rivalry between the "great competitors."

Notes

1. All references to *Antony and Cleopatra* are taken from the edition of M. R. Ridley in the Arden Shakespeare series (London: Methuen, 1971).

2. If Cleopatra becomes the nurturing mother at the last, she does so, it might be argued, at the expense of her real children, whom Octavius has threatened to slay if she escapes him. Cleopatra, however, is in a double bind here. She has already sworn to Antony that, should she break faith with him and ally herself with Octavius, her progeny and people will perish (3.13.158ff). Whichever way she acts now, they are doomed. Her final victory over Octavius in death, her confirmation of her union with Antony, can thus only reassert her maternity in these figurative terms.

3. We do see a comparable phenomenon in *Henry IV Part I* when Hal concludes Hotspur's dying "Percy thou art dust / And food for—" with "For worms, brave Percy." But Hal's finishing off this speech seems more like a final "finishing off" of his rival and double.

4. The interplay between public and private identity achieved by Cleopatra throughout the play is particularly striking if we compare Shakespeare's Egyptian queen with John Webster's Duchess of Malfi, whose assertion of her private and sexual identity

challenges the public self largely constructed for her by her brothers. For an interesting discussion of the implications of "embodiment" in Webster's play see Wells 65–66.

5. For a related discussion of Shakespeare's multiple and ambiguous representation of Cleopatra at her death see Belsey 184.

6. Richard P. Wheeler remarks, "Cleopatra has offered Antony a mode of relating in which his manhood is completed in his response to the feminine in Cleopatra, and which releases the mutual interchange of masculine and feminine in both lovers" (158).

7. Of course competition is not entirely absent from the relations of the Egyptians; Cleopatra herself is anxious that Iras, having predeceased her, may steal a first postmortem embrace from Antony (5.2.300).

8. *Samuel Johnson on Shakespeare,* ed. W. K. Wimsatt, Jr. (New York: Hill and Wang, 1960), 107.

9. On the relation of Antony's identity to "political place" see also Belsey 39–40.

Works Cited

Adelman, Janet. *The Common Liar: An Essay on Antony and Cleopatra.* New Haven: Yale University Press, 1973. Adelman's account of *Antony and Cleopatra* focuses in particular on the subversive proliferation of commentators and interpretive perspectives within its action and examines in some detail the multiple iconographies and mythic identities of its hero and heroine.

Belsey, Catherine. *The Subject of Tragedy: Identity and Difference in Renaissance Drama.* London: Methuen, 1985. Explores the constitution of the liberal humanist subject— and more specifically, women's exclusion from the role of speaking subject—by way of readings of the tragic drama of the English Renaissance from the later Morality plays to the Restoration.

Neely, Carol. *Broken Nuptials in Shakespeare's Plays.* New Haven: Yale University Press, 1985. Examines the dramatic and psychological significance of courtship, marriage, and widowhood in Shakespeare's oeuvre. Neely is particularly interested in the shifting relationship between genre and gender in the plays and makes use of the repeated motif of the broken nuptial to discuss the different ways in which the female protagonist comes to an accommodation with, transcends, or is destroyed by her socially constructed role.

Wells, Susan. *The Dialectics of Representation.* Baltimore: Johns Hopkins University Press, 1985. Discusses the relationship in literary texts between the "typical register" (the set of verbal strategies whereby connections are established between the specific and the universal, the text and lived experience, the logic of the work and its rhetoric) and the "indeterminate register" (everything in the text that "rubs against the historical grain or runs on a bias to the main axes of social relations, everything that resists interpretation and refuses intersubjectivity"). Includes an extensive account of the tension between the private/subjective/"feminine" and the public/"masculine" systems of value in *The Duchess of Malfi.*

Wheeler, Richard P. "'Since first we were dissever'd': Trust and Autonomy in Shakespearean Tragedy and Romance." In *Representing Shakespeare: New Psychoanalytic Essays,* edited by Murray M. Schwartz and Coppelia Kahn, 150–69. Baltimore: Johns Hopkins University Press, 1980. Traces the tensions in Shakespeare's tragedies and last plays between the male protagonist's need to create an autonomous and individuated self and his desire to embrace the mutuality on which he can ground that self; such a relationship of trust and partial self-surrender is perceived as at once attractive and threatening and in general involves a member of the opposite sex, whether lover, wife, daughter, or mother.

JOSEPHINE A. ROBERTS

Radigund Revisited

Perspectives on Women Rulers in Lady Mary Wroth's *Urania*

ALTHOUGH English humanists and social thinkers had begun to debate the question of the legitimacy of rule by women long before the accession of Mary Tudor, the publication of John Knox's treatise *The First Blast of the Trumpet Against the Monstrous Regiment of Women* (1558) sparked a controversy that was to have far-reaching impact in many areas, including the literary representations of women in the Renaissance. In bold, vitriolic language, Knox sets forth his total condemnation of female rule (gynecocracy): "To promote a Woman to beare rule, superioritie, dominion, or empire above any Realme, Nation, or Citie, is repugnant to Nature; contumelie to God, a thing most contrarious to his reveled will and approved ordinance; and finallie, it is the subversion of good Order, of all equitie and justice" (4:373).

Knox's misogynist assumptions are clearly expressed in his claim that by nature women are "weake, fraile, impacient, feble, and foolishe . . . unconstant, variable, cruell, and lacking the spirit of counsel and regiment" (374). Despite his frequent and repetitive tirades against the female sex, Knox's work follows a tripartite structure in claiming that government by women violates natural law, God's law (as revealed in Paul's injunctions that women should keep silent in the congregation), and the political order of the commonwealth. Knox makes clear that his concern with the question of women's rule is by no means purely theoretical, for at the end of his treatise he describes the reign of Mary Tudor as a "wall without a foundation" and as a latter-day Joshua he sounds his trumpet to overthrow her empire. Knox had originally intended, according to his preface, to compose two further blasts, but the first provoked such extreme reaction that he never completed the rest. An outline of the "Second Blast," in which he proposed four additional arguments against gynecocracy, appeared at the end of his *Appellation,* published at Geneva in 1558 (539–41).

Knox's treatise nearly brought the walls down upon his own head when only eight months after its publication, Elizabeth I ascended to the throne. Early in her reign, Elizabeth expressed her displeasure with Knox (whose name was "odiouse" to her, according to William Cecil), and subsequently extended her hostility toward the entire Genevan

group. In self-defense, more moderate Protestants were quick to disassociate themselves from Knox's extreme views. In a long letter to Cecil in early 1559, John Calvin voiced his opinion that while female government is a deviation from the proper order of nature, occasionally women were raised up by divine authority to rule. He explained that God designed such examples either "to condemn the inactivity of men, or for the better setting forth his own glory."[1] As James E. Phillips, Jr., has shown, Knox eventually modified his initial position by following Calvin's direction and by accepting the compromise view that God sometimes sees fit to raise notable exceptions to the general law against women's rule.[2]

But Knox's original treatise also inspired a more positive defense of women, as expressed in John Aylmer's *Harborowe for Faithfull and Trewe Subjectes, agaynst the late blowne Blaste, concerninge the Government of Wemen*, published anonymously in 1559. Although Aylmer conceded that men are normally better qualified for the task of rule, he insisted that gynecocracy was not against the law of nature: "We see by many examples, that by the wholle consent of nations, by the ordinaunce of God, and order of lawe, wemen have reigned and those not a fewe, and as it was thoughte not againste nature: therefore it canne not bee saide, that by a generall disposition of nature, it hathe bene, and is denyed them to rule" (sig. C3v). Aylmer specifically cites many historical examples of women rulers, whose successful reigns give evidence of the female ability to govern. In contrast to the Calvinist theory of exceptional women raised by God, Aylmer argues that women rulers have always existed in substantial numbers and that women possess the virtues and abilities to rule as God's representatives. Aylmer's work, widely read throughout Elizabeth's reign, came to represent the Anglican position concerning female rule.

Yet the issues that Knox had raised in his *First Blast* were not put to rest despite the large number of defenses of gynecocracy, both from Anglicans and moderate Protestants. Near the end of the sixteenth century the debate underwent a revival as the question of the queen's successor became a pressing political concern. In part the continuing power of Knox's book to excite response long after his own death in 1572 lay in the fact that he presented deeply disturbing cultural images that could not be answered by logical or rational argument. One of the most troubling of these images occurs early in Knox's treatise when he begins to envision a female monarch, with her sword and scepter, in the act of transforming the entire human race:

> They shulde judge the hole worlde to be transformed into Amazones, and that suche a metamorphosis and change was made of all the men of that

countrie, as poetes do feyn was made of the companyons of Ulisses, or at least, that albeit the outwarde form of men remained, yet shuld they judge that their hartes were changed frome the wisdome, understanding, and courage of men to the foolishe fondnes and cowardise of women. (375)

For Knox, the ultimate horror of women's rule is the threat of emasculation—the internal transformation of men into women—which he identifies with the apocalyptic nightmare of a triumphant Amazon race. In singling out the example of the Amazons as the ultimate specter of female rule, Knox invoked the terror of a fictional race of women that was to fascinate the writers of the English Renaissance.

2

Among the many sixteenth-century literary representations of the Amazons, Spenser's Radigund is doubtless the most famous, but also the most difficult to interpret. Spenser's physical description of her, armed with the characteristic scimitar and shield (5.5.3.4–7), is in close agreement with the stereotypical Elizabethan image of the Amazon, as described by Celeste Turner Wright (433–35). Yet Spenser borrows her name from a French saint of the Merovingian period (519–87), who despite her marriage remained a virgin and escaped her lustful husband to found a convent at Poitiers (Cain 153).[3] The French origins of Radigund's name and the fact that she serves as a threat to the English royal line contribute to the historical allegory of the events in Book 5 of *The Faerie Queene,* but Spenser also exploits the irony inherent in the contrast between the chaste saint and the unchaste Radigund. Throughout the entire episode, Spenser reinforces the irony implicit in her name by emphasis on the contradictions in her behavior, which is as changeable as the moon, her iconographical symbol (5.5.3.9).

Spenser makes clear that Radigund's cruelty toward mankind is the result of her sublimated erotic desire. When Bellodant rejected her advances, she "turn'd her love to hatred manifold" (5.4.30.7) and determined to bring all knights under her power. Although renowned for her military valor, Radigund is willing to use any means to subdue her enemies, "by force or guile" (5.4.31.1). Her ultimate goal is not simply to rule men, but to bring them into total subjection—to despoil all signs of their knighthood and to force them to assume the traditionally female occupations of spinning and sewing. Radigund's scheme of emasculation sounds remarkably like the dire threat that Knox had prophesied in his *First Blast* concerning women's rule. Indeed, the entire treatment of Artegall's fall to Radigund seems at first to illustrate Knox's various charges against the "monstrous regiment," for Radigund

Entitled "Hispania," this engraving shows the Iberian peninsula forming the female sovereign's head, Sebastian Munster, *Cosmography* (Basel, 1588), p. 41. From the Art Collection of the Folger Shakespeare Library. By permission of the Folger Shakespeare Library.

replaces the laws of chivalry with her own law, uses political power for her personal satisfaction, and behaves as an absolute tyrant. All legal forms vanish as the knight Terpine is led without trial to the most ignominious type of execution, hanging (5.5.18).

But even the cruel Radigund cannot remain resolute in her plans of conquest, for her "wandring fancie after lust did raunge" (5.5.26.8), and she falls in love with her captive, Artegall. In the second half of the fifth canto, Spenser deflates the potential threat of the Amazonian tyrant by showing how quickly she throws aside all concern with politics in order to concentrate on winning the knight. Because her fierce pride prevents her from wooing him directly, she turns to her maid Clarinda as a go-between. Spenser's ironical treatment of this episode is suggested by Clarinda's first tongue-tied words to her queen:

> Ah my deare dread (said then the faithfull Mayd)
> Can dread of ought your dreadlesse hart withhold,
> That many hath with dread of death dismayd,
> And dare even deathes most dreadful face behold? (5.5.31.1–4)

The "dreaded" Amazon soon finds herself subject to the wiles and deceptions of her servant, who determines to win Artegall for herself. In borrowing one of the conventional plots of romantic comedy, Spenser playfully reverses the gender roles so that Radigund's position as the frustrated suitor is the least powerful. Although she insists upon the harsh treatment of Artegall—by the deprivation of food and the denial of comforts, techniques akin to those of Petruchio in *The Taming of the Shrew*—her servant reverses these commands to try to win the captive for herself (5.5.57.1–2). Radigund's emotional reactions wildly oscillate between rage and mild entreaty as she becomes subject to the governance of her maid. While Spenser's tone is not as broadly comical as Ariosto's in his treatment of Amazonian love, he makes clear that Radigund lacks the leadership ever to bring about her goals for the subjection of mankind.[4]

In fact, Spenser shows that despite her rule over "a goodly city and a mighty one" (5.4.35.8), the Amazon fails completely to exemplify the dual nature of a sovereign. According to the legal doctrine of the king's two bodies, as expounded by Plowden and other Tudor jurists, the monarch possessed a two-fold nature, consisting of the body natural and the body politic (Kantorowicz 7–14; Axton 11–37). Radigund occasionally expresses concern for the survival of the state, as when she protects her people from Talus's violent assault by enforcing a retreat to the safety of the city walls and by risking her own life in single combat with Artegall (5.4.46.8–9), but she is unable to place the ultimate welfare of the commonwealth above the fulfillment of personal desires.

This is clearly evident in the final combat with Britomart when Radigund appears to gain the physical advantage over her opponent but then squanders her opportunity by exploding into a jealous boast: "This token beare / Unto the man, whom thou doest love so deare; / And tell him for his sake thy life thou gavest" (5.7.32.4–6).

Previous scholars have often cited the Radigund episode as evidence of Spenser's revulsion for female rule. Phillips quotes the following stanza as consistently representative of Spenser's theory concerning gynecocracy:

> Such is the crueltie of womenkynd,
> When they have shaken off the shamefast band
> With which wise Nature did them strongly bynd,
> T'obay the heasts of mans well ruling hand,
> That then all rule and reason they withstand,
> To purchase a licentious libertie.
> But vertuous women wisely understand,
> That they were borne to base humilitie,
> Unlesse the heavens them lift to lawfull soveraintie. (5.5.25)

Phillips suggests that Spenser's "position is precisely that of the moderate Calvinists," for despite a strong condemnation of women's rule as unnatural, he makes provision in the last line for the possibility of exceptional women elevated by God ("Woman Ruler," 234). This passage has frequently been taken out of context, by scholars and even by Spenser's contemporary readers, as evidence of the poet's opinion concerning the natural subjection of womankind. The anonymous author of the tract *Hic Mulier* (1620), a misogynist tirade against women who wear masculine attire, offers these lines as an admonition to women, but significantly even he feels compelled to soften the description of "base humilitie" by substituting the word "mild" (sig. C2v).[5] Yet the original context of the stanza is critical. Occurring midway in the canto before the ironical deflation of Radigund's regiment, it represents the narrator's immediate, impassioned reaction to the humiliation of Artegall. Spenser's opinions concerning women's rule cannot be so easily abstracted from this single stanza in Book 5, or, on the other hand, from the passages praising women's skill in governance in canto 2 of Book 3 (Benson 277). Instead, the Radigund episode forms only a part of the much larger account in Books 3, 4, and 5 of the development of Britomart as a woman ruler. Britomart is, indeed, one of the extraordinary women ordained by God to govern, but she also demonstrates an ability for rule that is inherent (but not always actualized) in women.

From the beginning, Britomart's career is strongly identified with the

forces of divine providence that guide her first to look into Merlin's magic globe and then to launch her quest in search of Artegall. As part of his chronicle, Merlin promises Britomart that not only will her marriage produce the long line of English rulers culminating in Elizabeth, but also that she will serve side-by-side with Artegall: "Great aid thereto his mighty puissance, / And dreaded name shall give" (3.3.28.1–2). Before Britomart sets forth, her nurse Glauce reminds her of a series of historical Englishwomen who have served as victorious leaders: Bunduca, Guendolen, Martia, Emmilen, and finally, Angela, whose courage so inspires her people that "for her sake / And love, themselves of her name Angles call" (3.3.56.6–7). Many of these same women appear in Spenser's chronicle of English rulers, *Briton moniments,* in Book 2, where they receive more extended description.[6] This long line of women who have held power legitimately and ruled well serves to inspire Britomart to undertake the quest, but Spenser also emphasizes that from her royal progeny will emerge the triumphant figure of the bringer of "sacred Peace"—the virgin queen Elizabeth (3.3.49). As the critical link in Spenser's fictional genealogy between the great female rulers of the past and the future, Britomart appears less as an aberration, more as the exemplar of the potential for rule by women.

Spenser explains in his "Letter to Ralegh" that he uses the concept of the sovereign's dual nature as a means of portraying Elizabeth within his fiction. His division between Cynthia or Gloriana as "the body politic" and Belphoebe as "the body natural" is echoed within the proem to Book 3, where public rule and "rare chastitee" are designated as the virtues of each body (stanza 5). Yet in the poem as it survives to us, the figure of the body politic appears only through occasional, intermittent allusions, such as Gloriana's throne in Cleopolis (1.7.46) (Woods 148). Spenser devotes much greater attention to the portrait of the body natural, expressed in Belphoebe's role as a virtuous virgin who inspires the service of others, especially Timias. As Judith Anderson has recently shown, Spenser's treatment of Belphoebe touches upon highly sensitive subject matter and reveals an effort to fictionalize a reconciliation with Timias that did not yet exist in the troubled relations between the queen and Ralegh (65–66). Given the dangers inherent in any explicit presentation of Elizabeth's dual nature, Spenser seems to have turned aside from a full fictional portrayal of the interrelationship of Belphoebe's body natural and the body politic.

Perhaps his reluctance to deal with this concern directly also stems from Elizabeth's own intense concern with how the twin bodies should be publicly mythologized. Her speeches reveal that while she might present the body natural as that of a frail woman, she generally identi-

fied the body politic in masculine terms. For instance, in the famous speech at Tilbury, she offered this androgynous self-presentation: "I have the body of a weak and feeble woman, but I have the heart and stomach of a king, and of a king of England too" (Marcus 138). Elizabeth was careful not to push this androgynous model too far, and moreover she seems to have generally avoided the iconographical association with the militant Amazons; the very few representations of Elizabeth as "divina Virago" that survive come from the period of the Spanish Armada, when the need for a warlike leader was most pressing (Schleiner 163). Instead, she was more apt to refer to her body politic as that of a "prince" (in contrast to the feminine epithet "princess") and to insist upon her role as peacemaker. By the time that Spenser was composing *The Faerie Queene* in the 1590s, there were heightened tensions surrounding the queen's image as the distance increased between the evident mortality of the aging queen and the immortality of the body politic. Spenser's decision to shift away from the immediate presentation of Elizabeth's own dual nature to that of the youthful Britomart permitted him greater artistic freedom to address the question of female sovereignty with its significant political and cultural implications.

Even more important, the character of Britomart provided him the opportunity to trace the actual *process* by which the virtues of the body natural and the body politic may be joined. Throughout Books 3 and 4, Spenser shows how Britomart becomes the active champion of chastity (the virtue specifically identified as that of the queen's body natural) by overcoming the threat of Busyrane. Coming to the assistance of Scudamour, who is unable to dispel the wall of fears surrounding Amoret, Britomart demonstrates her ability to understand the psychological basis of Amoret's prison and to free her, so that the couple may be joined in a total union of body and soul. The difficulty of achieving such a union between man and woman is magnified in the complex allegory of the courtship between Britomart and Artegall in Book 4, where she, in defense of maidenhood, defeats his manhood, but then later yields to him (4.6.41). Despite Britomart's betrothal, the battle for "maisterie" between man and woman is not yet entirely resolved, and the Radigund episode in Book 5, in which Britomart frees Artegall from thralldom, can be seen as the final stage of their preparation for marriage. But the entire incident also needs to be understood as part of the political allegory of the poem, whereby the woman acquires her education in justice, the virtue of the body politic.[7]

Early in Book 5, Spenser points to the potential conflict of the sovereign's twin bodies, when Britomart suffers from the agonies of jealousy and suspicion on learning that Artegall has fallen into "harlots bondage" (5.6.11.5). She is at first tempted to allow her personal rage to

overcome all concern for the body politic, as Radigund does, but she quickly gains self-control and sets forth on her quest to rescue Artegall. Before confronting the Amazon, however, she must first receive a prophetic initiation in the Temple of Isis, one of Spenser's most extraordinary sacred houses. It is here that she experiences "a wondrous vision" of Isis and Osyris, the Egyptian rulers who represent the perfect union of the bodies natural and politic. Isis is strongly associated with the moon (5.7.4.7), the same symbol as Radigund's, but in this case it stands for a feminine principle of constancy that complements Osyris's sun, "for that they both like race in equall justice runne" (5.7.4.9). Isis is also identified with the political concept of equity, traditionally regarded as "the conscience of the law" or the power to modify rigid principles to suit particular circumstances.[8] When Britomart suffers from very human fears as she awakens from the terrifying spectacle of the crocodile as serpent-lover, Spenser's priest explains the larger political and mystical significance of the union and promises that together she and her husband will "joyne in equall portion of thy realme" (5.7.23.6) and rule with a balanced measure of justice and equity (Fletcher 259–75).[9] Although this episode is not often considered in discussions of Spenser's attitude toward gynecocracy, it is here that the poet assigns Britomart equal status in rule, based upon a virtue specifically associated with the female, equity.

Once Britomart receives her prophetic vision within the Temple of Isis, she is at last prepared to overcome the sole remaining obstacle to her union with Artegall—the tyrant Radigund. As we have seen, Radigund represents the violent perversion of authority, wherein the corrupt body natural subverts the body politic. Only Britomart, who now understands the proper relation of these forces, can overturn the Amazon. By rejecting Radigund's rules of combat, offered as a substitute for the law of chivalry (5.7.28), Britomart avoids the initial mistake made by Artegall, who had unwittingly agreed to the Amazon's unjust terms (5.4.49). Britomart also demonstrates an ability to use force to achieve a just end when at the climax of the gory combat with Radigund, she swiftly decapitates her opponent (5.7.34.6); her decisive action is in contrast with that of her mate, who had wavered in carrying out the death sentence. At the same time, Britomart calls a halt to Talus's slaughter of the rest of the Amazons (5.7.36), thereby showing the relationship of equity to justice. Her final public action, while Artegall recovers from his imprisonment, is to serve as ruler over the Amazonian state:

> During which space she there as Princess rained,
> And changing all that forme of common weale,

> The liberty of women did repeale,
> Which they had long usurpt, and them restoring
> To mens subjection, did true Justice deale:
> That all they as a Goddesse her adoring,
> Her wisedome did admire, and hearkned to her loring. (5.7.42.3-9)

In restoring order to the chaotic city, Britomart fulfils the vision of true justice that she had received in the Temple of Isis. Although her action of submission of wives to their husbands' authority may seem to contradict women's rule, it is part of her larger plan for the establishment of a hierarchical design, wherein the magistrates are forced to swear loyalty to Artegall, who in turn will serve as a joint ruler with Britomart. Phillips sees this final stanza as evidence that Britomart is merely one of the exceptional women whom God lifts up to lawful sovereignty—the view of the moderate Calvinists ("Woman Ruler," 233). But Spenser's treatment of Britomart resists such simple categorization since he has emphasized throughout Books 3, 4, and 5 the difficult process by which the warrior-woman has learned to unite the sovereign's twin bodies. As seen in the Temple of Isis, Britomart's quest has been directed by divine providence, but her ability to link equity to justice is in keeping with natural law, rather than exceptional to it. Her triumph over Radigund's "monstrous regiment" is also the ultimate answer to John Knox's hysterical specter of the emasculating threat of women's rule, for Britomart not only reverses Amazonian tyranny and establishes a hierarchy within the state, but also through her progeny provides a lineage to ensure the continuity of order.

3

The debate concerning the legitimacy of women's rule did not disappear in the twenty-five-year period that separates Spenser from Lady Mary Wroth, the first Englishwoman to compose an original work of prose fiction, *The Countesse of Mountgomery's Urania* (1621). The political situation that framed the controversy over gynecocracy changed radically with the transfer of power from a female monarch to James I, a believer in royal absolutism. As Retha M. Warnicke has shown, under the Jacobean reign women experienced a sudden decline in the areas of education and social freedom (194-95). James's personal attitude toward the female sex was doubtless a contributing factor in the more repressive atmosphere. The French ambassador Beaumont vividly described the king's behavior at court: "He piques himself on great contempt for women. They are obliged to kneel before him when they are presented, he exhorts them openly to virtue, and scoffs with great

levity at men who pay them honour. You may easily conceive that the English ladies do not spare him but hold him in abhorrence and tear him to pieces with their tongues, each according to her humour" (Willson 196). James also sought to discourage women from what he considered a masculine form of dress by ordering his clergy "to inveigh vehemently and bitterly in theyre sermons against the insolencie of our women and theyre wearing of brode brimd hats, pointed dublets, theyre haire cut short or shorne, and some of them stillettaes or poinards, and such other trinckets of like moment."[10]

In such a hostile atmosphere, it is not surprising that the publication of *Urania* created an immediate controversy. A storm of criticism came from powerful noblemen, who claimed that Lady Mary Wroth had presented thinly veiled accounts of their private lives under the guise of fiction. At the height of the crisis, the author was obliged to write to the duke of Buckingham denying any malicious intent and claiming that the book had been published and sold against her will.[11] Yet the outcry over the publication of the first volume of *Urania* did not stop the author from writing a second part of the romance, nearly 240,000 words in length, which survives in a unique, unpublished manuscript at the Newberry Library, Chicago (Case MS fY 1565.W95). The intense, ambivalent passion of Queen Pamphilia for Amphilanthus, emperor of the Romans, serves as the major focus of both parts of *Urania,* although the author creates in the unpublished continuation a second generation of characters, the children of the first, who serve as background figures. Since most of the characters belong to royal families, the question of women's ability and legitimacy to rule is one that appears prominently throughout the complete work.

Just as Spenser offers an array of female rulers, with positive examples, such as Britomart, Mercilla, and Gloriana, matched against Radigund, Duessa, and Lucifera, so does Lady Wroth provide a panorama of different types of queens. Among the decadent monarchs, the queen of Romania—described as that "devill of women"—is one of the most memorable.[12] Cleverly turning the king against his faithful son Antissius who is disinherited, she succeeds in making her own son heir apparent to the throne and in naming herself regent during his minority. "So cunning was she in her deepe deceits" (59) that the queen convinces a favorite servant to murder the old king and then arranges a poisoned banquet in which she destroys all of the accomplices, with the exception of her favorite. But she quickly throws aside political ambition when she attempts to seduce the ambassador of Morea. "Then growne immoderate and ungovernable, yeares increasing in her, and strength of judgement failing her more then in her youth" (59–60), the queen is led into a trap,

in which her jealous favorite reveals the manner in which she has seized the throne. She is brought to trial, "for being a subject, shee was under the law" (61), and executed. Although the legitimate ruler, Antissius, will eventually be restored to the throne of Romania, the queen's actions have reduced the country to a condition of chaos, in which new rebellions are spawned. Lady Mary Wroth's portrayal of the lustful Romanian queen, who governs neither herself nor the state, was so vivid that it later supplied the plot for James Shirley's play *The Politician* (1655).[13]

A similar case in which a woman's accession to the throne violates the natural order is that of Ramiletta, the daughter of the king of Negroponte. In a first-person narrative the king confesses his folly at disinheriting his son Dolorindus and installing his daughter on the throne. In a variation of the plot of *King Lear,* the ungrateful Ramiletta instantly falls into "ill government" (97) and has her father imprisoned. When Dolorindus comes to rescue him, the queen arranges a pair of armed combats, in which her brother overcomes both knights but suffers serious injuries. Rather than allowing him to die, Ramiletta provides medical care, for she fears "the love of the people would fall upon him" (98). Yet she subjects her father to mental torture by convincing him that Dolorindus has died. Only through the intervention of Amphilanthus and his friends does Ramiletta's tyrannous rule at last come to an end and is the old king reunited with his true and loving son.

Most frequently, Lady Wroth links illegitimate rule by women with pride and repressed sexual passion. Such is the case of Olixia of Epirus, a virgin queen who aggressively dominates her country until she suddenly finds herself attracted to Selarinus, a young knight she has imprisoned, son of the king of Albania. The queen discovers that she is ruled by passion, "a greater Prince, and a higher authority, which might, and would command" (255). Driven by desire, she tries to impress the young knight (disguised as Infortunius) with a lavish display of food and wealth, but he continues to resist her increasingly desperate advances. At last, Infortunius escapes her clutches during a trial by combat when he defeats his opponent but runs away from the lists to a nearby castle offering sanctuary. The queen is so angered that she threatens to execute his squire unless he returns with the master's head, which she plans to display as "a testimony of falshood, to be shewed to all men, and the cruell example for it" (261). When the squire returns with a substitute head, which is placed in a golden basin, only the queen discovers the deception and suffers the result of her destructive pride:

> Vext and angry she remaind, fed on her owne curstnes and scorne, hated food, as being too meane a helpe for her to receive after such an affront; in sum, she pind with meere ill nature and disposition of body and mind, so as

she fel into a fever, and willfully would not be ruld, who she said, was borne to rule, and so brought her selfe to the last act. (261)

Because the country of Epirus originally had belonged to the kings of Albania, the crown then passes into the hands of a male heir, Selarinus.

Although Lady Wroth exposes the cruel behavior of women rulers who hold power unlawfully (as in the three previous examples), she occasionally reserves criticism as well for rightful female sovereigns. The queen of Bulgaria, or "Empresse of Pride" (343), rules alongside her henpecked husband, who dotes upon her every whim. She is known for her extravagant dress and pompous display, as she travels in a chariot of blue velvet, embroidered with gold, attended by a troop of knights and ladies on horseback and in carriages (342). She nearly runs the Morean prince Rosindy off the road because he fails to show her proper obeisance, and her portrait is marked by comic exaggeration:

> Unsteady she was in her fashion, her head set upon so slight a necke, as it turned like a weather-cocke to any vaine conceit that blew her braines about, or like a staulke of Oates, the eare being waighty: her feete never but mooving, as not willing to stand, or sit still: her gate wagling and wanton, businesse she had perpetually in her selfe, and with her selfe, the looking-glasse being most beholding to her for stay. (346)

Her lover, the prince of Jambolly, amuses the court with his outrageous wooing (461), but her husband tolerates his presence because he knows that the fool is nothing more than a mirror to magnify her glory. Lady Wroth's satirical treatment of the Bulgarian royal couple continues throughout the Newberry manuscript of *Urania,* where the queen reappears as "matchles in noe thinge save pride" (2.1.f.62v). Later, the Bulgarian king recalls in a lengthy first-person narrative (in a euphuistic style worthy of Shakespeare's Osric) how he first fell in love and married his wife (2.2.ff.15–15v). When Amphilanthus rescues the royal couple from attack, he is comically waylaid on the one hand by the husband's endless litany of courtly compliments, and on the other by the queen's alluring invitations (2.2.f.29v).

A far more serious threat to Amphilanthus appears in the form of Musalina, who dresses as an Amazon, "though unfit habits for her, who was no hater of mankind" (362). Although now married to the duke of Tenedos, she was one of Amphilanthus's "first Loves in his youthfull travailes" (341). Like Radigund in Spenser's *Faerie Queene,* Musalina serves as a powerful force, blocking the courtship of the two principal figures in Lady Wroth's romance. When it becomes apparent that Musalina cannot regain control of her former suitor, she constructs the Hell of Deceit, an enchantment designed to destroy the bond between

Pamphilia and Amphilanthus. The entire episode bears a strong similarity to Spenser's account of the House of Busyrane, surrounded by flames, where the heart of Amoret is cut from her body (3.12.21). In Lady Wroth's account, Pamphilia enters the fiery chamber and discovers Musalina "sitting in a Chaire of Gold, a Crowne on her head" (494), and threatening with her sword to cut out the prince's heart. But unlike Britomart, Pamphilia fails to rescue the victim, and the flames drive her back out of the cave, just as they had done in the case of Spenser's Scudamour. Through her "divelish Art," Musalina also arranges that Amphilanthus will undergo a parallel experience in her Hell, where he sees a false vision of the dead Pamphilia, her breast cut open, and the letters of his name engraven in her heart. He, too, is powerless to rescue his beloved and is thrown out of the cave (554). Neither Pamphilia nor Amphilanthus is ever able to destroy the Hell of Deceit, symbolic of the inward forces of distrust and suspicion that divide them. The revision of the end of the Busyrane episode is also significant because it points to some of the ways in which the couple will fail to achieve the perfect union forecast for Britomart and Artegall.

Lady Wroth's treatment of Pamphilia is her most extended exploration of the female monarch who holds power legitimately and rules well. Selected by her uncle as his successor, Pamphilia is named in honor of the country in Asia Minor that she will later govern (120). She is described as an "excellent Queene, the true paterne of excellent affection, and affections truth" (315). Although she has many suitors, Pamphilia refuses to marry and declares to her father her intent to remain a virgin queen in a speech that is reminiscent of the language of Elizabeth I (Beilin 241). She explains that "his Majestie had once married her before, which was to the kingdome of Pamphilia, from which Husband shee could not bee divorced, nor ever would have other, if it might please him to give her leave to enjoy that happinesse; and besides, besought his permission, for my Lord (said shee) my people looke for me, and I must needs bee with them" (218).

But Pamphilia's total commitment to the body politic is threatened by her growing attachment to Amphilanthus, king of Naples and the emperor of the Romans (387). Because of Amphilanthus's frequent infidelities and reported death, Pamphilia is thrown into a state of confused depression, in which she retreats from court into the privacy of her own chamber. The narrator observes, "what a miserable spectacle was this, to see her, once the comfort of the Court, the starre that guided all the sweet delights, now the poore testimony of another creature, griefe having so decayed her, as she seem'd scarce so like her selfe as an ill picture to the life" (394). Her various friends, particularly Urania,

charge her with neglect of duty to the state: "if your people knew this, how can they hope of your government, that can no better governe one poore passion? how can you command others, that cannot master your selfe; or make laws, that cannot counsel, or soveraignise over a poore thought?" (398). The androgynous public identity that Pamphilia had assumed begins to crumble, as Urania observes: "you that have been admired for a Masculine spirit, will you descend below the poorest Femenine in love?" (398).

By the end of the published *Urania,* Pamphilia appears to regain some measure of self-control. The character Alarina explains to Pamphilia the significance that her personal struggle holds in political terms: "the greater your minde is, and the braver your spirit, the more, and stronger are your passions, the violence of which though diverstly cast, and determined, will turne still to the government of love; and the truer your subjects are to you, the firmer will your loyalty be to him" (411). When Amphilanthus rescues her from the king of Silecia, who threatens to destroy her country (482), he redeems himself both as Pamphilia's beloved and as an ally to her nation. Part one closes with the reconciliation of the lovers and their projected marriage, which is seen as a union of the political powers of the East and West: "Amphilanthus, now butt late the light of the westerne world, and never enough admired Pamphilia the Easterne starr" (2.1.f.49).

But in the unpublished continuation of *Urania,* this marriage is thwarted by continuing disillusionment and alienation. Pamphilia finds the task of reconciling the queen's two bodies extremely difficult and must turn again to her friends for support. On learning of Amphilanthus's new betrayal, Veralinda counsels Pamphilia: "butt say hee hath left you, lett him goe in his owne pathe, tread nott in itt, an other is more straite, follow that, and bee the Emperess of the world, commaunding the Empire of your owne minde" (2.1.40v). Even as the sole monarch over her country, Pamphilia is still subject to the authority of her father, for despite her exchange of a *de praesenti* vow of marriage with Amphilanthus, she must later ask her father's permission. When she learns that Amphilanthus has broken his vow and instead married the princess of Slavonia, she agrees to wed the king of Tartaria although "against her owne minde" (2.2.f.21v). From this point on in the Newberry manuscript, Pamphilia's role as queen becomes totally overshadowed by that of wife and mother.

Even though Pamphilia never achieves the same type of triumphant vision that Britomart experiences of the union of the sovereign's twin bodies in the Temple of Isis, the Newberry manuscript provides the hint of a possible future reconciliation with Amphilanthus. Pamphilia arrives

at a revolutionary model of male-female relations as "youke fellows, noe superior, nor commanding power butt in love betweene united harts" (2.2.f.51). Similarly, Amphilanthus vows to discover a new social role in which he will become "a new man as new borne, new fram'd and noe thing as I was before" (2.2.f.52). Yet the Newberry manuscript breaks off in an unfinished sentence before their union is ever achieved. This projected solution—the creation of new social roles for women and men—is in keeping with the dominant mood within the *Urania* of a "feminine consciousness in conflict with societal values" (Swift 346).

Like Spenser, Lady Wroth shows an awareness of the great burdens placed on her central character to integrate the queen's two bodies. In the published *Urania* Pamphilia's choice of absolute chastity, on the model of Elizabeth I, is set in contrast with the behavior of the decadent queens whose monstrous regiments illustrate the major dangers that Knox had outlined in *First Blast*. Lady Wroth even includes an Amazonian figure, an analogue to Spenser's Radigund, who serves as a threat to Pamphilia that she is unable to overcome. Within the unpublished continuation, she rejects her original integration of the queen's two bodies, but is unable to actualize an alternative model. Written in a culture that was more fragmented, more disillusioned, more hostile to the achievements of women, *Urania* offers a highly ambivalent view of female rule in which the central character struggles vainly to fulfill the dual nature of sovereignty.

Notes

1. John Calvin, letter to Sir William Cecil dated at Geneva (after January 29, 1559), letter 15 in *The Zurich Letters* (second series), trans. Rev. Hastings Robinson (Cambridge: Cambridge University Press, 1845), 34–35.

2. See Phillips's excellent summary of the gynecocratic controversy in "The Background of Spenser's Attitude Toward Women Rulers." Additional surveys of the debate over women's rule include Scalingi; Greaves 157–68; and Jordan.

3. Cain also mentions the obscene sense of Radigund's name, suggesting "counsel from the pudendum" (213).

4. Robinson offers a comparative treatment of the woman warrior by Ariosto, Tasso, and Spenser (387–92).

5. A condensed version of *Hic Mulier* appears in Henderson and McManus 264–76.

6. Robinson calls attention to these examples of women rulers (295–300).

7. Although not discussed in this essay, the historical allegory of the Radigund episode has received attention elsewhere. See Neill; and Graziani.

8. Fletcher offers an excellent account of the Elizabethan understanding of equity (276–87). See also the analysis of equity in Phillips, "Renaissance Concepts of Justice and the Structure of the *Faerie Queene*, Book V," 112–14; and in Kermode 50–59.

9. Jane Aptekar discusses the iconographical significance of Artegall's association with the crocodile (87–107). Robin Headlam Wells argues that Britomart's initiation in

the Temple of Isis recalls the medieval jurist's practice of personifying justice as a temple goddess who functions to mediate between divine and human law (126).

10. John Chamberlain to Sir Dudley Carleton, 20 January 1620, *The Letters of John Chamberlain*, 2:286–87.

11. For a fuller account of the author's life and the controversy over the publication of *Urania*, see my introduction to *The Poems of Lady Mary Wroth*, 3–40.

12. Wroth 58. All quotations from the printed *Urania* will regularize ∫ and s.

13. Shirley shifts the setting of his play to Norway and alters the names of the characters; the central female figure resembling the queen of Romania is called Marpisa, perhaps an echo of Ariosto's Amazonian knight Marfisa.

Works Cited

Anderson, Judith H. "'In liuing colours and right hew': The Queen of Spenser's Central Books." In *Poetic Traditions of the English Renaissance*, edited by Maynard Mack and George DeForest Lord, 47–66. New Haven: Yale University Press, 1982. Traces Spenser's growing awareness of the dangers and temptations of queenly power from the 1590 to the 1596 editions of *The Faerie Queene*, in which the distance widens between the ideal Belphoebe and the living figure of Elizabeth I.

Aptekar, Jane. *Icons of Justice: Iconography and Thematic Imagery in Book V of the Faerie Queene*. New York: Columbia University Press, 1969. Examines how Spenser's icons, such as the crocodile in Book 5, express his ambiguous concepts of Artegall and justice. Force and fraud, the enemies of justice, paradoxically become the means by which the monarch maintains order in a chaotic world.

Axton, Marie. *The Queen's Two Bodies: Drama and the Elizabethan Succession*. London: Royal Historical Society, 1977. Shows that the concept of the monarch's two bodies—the body natural and the body politic—remained a controversial idea in the Elizabethan period and expressed the delicate balance of power between the queen and the state.

Aylmer, John. *An Harborowe for Faithfull and Trewe Subjectes, agaynst the late blowne Blaste, concerninge the Government of Wemen*. Strasbourg [London]: 1559, *STC* 1005.

Beilin, Elaine V. "'The Onely Perfect Vertue': Constancy in Mary Wroth's *Pamphilia to Amphilanthus*." *Spenser Studies* 2 (1981):229–45. Considers how Lady Mary Wroth's sonnet sequence *Pamphilia to Amphilanthus* treats two aspects of constancy: faithful devotion to a beloved and a spiritual steadfastness that transcends earthly concerns. Pamphilia's growth from a constant lover to a lover of constancy mirrors the action of the prose romance *Urania*, where Wroth borrows from the symbolism of Elizabeth I in fashioning her own model of the ideal ruler and woman of virtue.

Benson, Pamela Joseph. "Rule Virginia: Protestant Theories of Female Regiment in *The Faerie Queene*." *English Literary Renaissance* 15 (1985):277–92. Argues that the two encomia of Elizabeth in Book 3 of *The Faerie Queene* and the treatment of Radigund in Book 5 reflect the Calvinist argument that women as a group were unsuited to rule although certain exceptional females might be raised to power by the wisdom of God.

Cain, Thomas H. *Praise in the Faerie Queene*. Lincoln: University of Nebraska Press, 1978. Describes Spenser's encomium of Elizabeth in three stages, from the pastoral mode in *The Shepheardes Calendar*, to heroic praise in the first three books of *Faerie Queene*, and to the foundering of praise and frustration of the poet in the last three books of the poem.

Chamberlain, John. *The Letters of John Chamberlain*. Edited by Norman E. McClure. 2 vols. Philadelphia: American Philosophical Society, 1939.

Fletcher, Angus. *The Prophetic Moment: An Essay on Spenser.* Chicago: University of Chicago Press, 1971. Treats *Faerie Queene* as a prophetic poem, in which the temple and the labyrinth serve as primary archetypes. Book 5 traces the troubled movement from chaos to cosmos, in which equity functions as the prophetic heart of justice.

Graziani, René. "Elizabeth at Isis Church." *PMLA* 79 (1964):376–89. Offers a topical reading of Britomart's dream of Isis as a reflection of Elizabeth's difficult decision in 1586 to order the execution of Mary, Queen of Scots. The crocodile is a symbol of two extremes, heartless cruelty and excessive leniency, but Isis, representing Parliament, beats back the crocodile, so that severity is reconciled with clemency.

Greaves, Richard L. *Theology and Revolution in the Scottish Reformation: Studies in the Thought of John Knox.* Grand Rapids, Mich.: Christian University Press, 1980. Regards John Knox's attack against women rulers in *The First Blast* as a pretext to encourage the English to rebel against Mary Tudor. Although Knox never repudiated his 1558 views on women rulers, the real object of his dislike was not so much female sovereignty as rule by Catholic queens.

Grund, Gary R. "The Queen's Two Bodies: Britomart and Spenser's *Faerie Queene*, Book III," *Cahiers Elisabéthains* 20 (1981):11–33. Traces the image of the hermaphrodite through Book 3 of *Faerie Queene* and shows that while Britomart's quest is not completed within the book, her experiences prepare her for the moment when public destiny and personal identity coincide. The unfolding androgyny of Britomart acts as an apocalyptic expression of the time when paradise will be reestablished on earth.

Henderson, Katherine Usher, and Barbara F. McManus, eds. *Half Humankind: Contexts and Texts of the Controversy about Women in England, 1540–1640.* Urbana: University of Illinois Press, 1985.

Hic Mulier: or, The Man-Woman: Being a Medicine to cure the Coltish Disease of the Staggers in the Masculine-Feminines of our Times. London, 1620, STC 13374. Condensed version of *Hic Mulier* appears in the anthology *Half Humankind*, edited by Henderson and McManus.

Jordan, Constance. "Woman's Rule in Sixteenth-Century British Political Thought." *Renaissance Quarterly* 40 (1987):421–51. Distinguishes two principal lines of argument in the debate concerning women's rule. John Knox and Christopher Goodman represent the most conservative position that God created woman as an inferior creature with no authority over man, a view that they support through an appeal to scriptural and Aristotelian authority. The more liberal position that woman is capable of governing man was espoused by John Aylmer for Elizabeth I and John Leslie and David Chambers for Mary, Queen of Scots, and was supported by the evidence of experience. Aylmer, Leslie, and Chambers attack the idea that a woman's place is fixed by the hierarchy of creation and show instead that it is subject to social and historical norms.

Kantorowicz, Ernst H. *The King's Two Bodies: A Study in Mediaeval Political Theology.* Princeton: Princeton University Press, 1957. Traces the evolution of the theory of the king's two bodies from its origins in medieval thought and political theory through to its presentation by sixteenth-century jurists, such as Edmund Plowden. The concept of the king's twin-born being, human by nature and divine by grace, may be found as early as A.D. 1100, but the theory underwent a series of transformations until it achieved its final formulation in the late gothic period, where it is most vividly expressed in the iconographical evidence of effigies and sepulchral monuments.

Kermode, Frank. *Shakespeare, Spenser, Donne.* New York: Viking Press, 1971. Devotes three essays to Spenser's *Faerie Queene* that insist upon the complexity of the allegory, with an account of the Protestant-imperialist ecclesiastical history in Book 1 and juristic-imperialist equity in Book 5. According to the historical allegory of the fifth

book, Britomart becomes transformed in her dream into an empress, who makes use of her prerogative courts of Chancery and the Star Chamber in order to maintain the proper relation between the common law (represented by the crocodile) and equity.

Knox, John. *The First Blast of the Trumpet Against the Monstrous Regiment of Women* (1558). In vol. 4 of *The Works of John Knox*. Edited by David Laing. Edinburgh: Thomas George Stevenson, 1855.

Levin, Carole. "Queens and Claimants in Sixteenth-Century England." In *Gender, Ideology, and Action: Historical Perspectives on Women's Public Lives*, edited by Janet Sharistanian, 41–66. Westport, Conn.: Greenwood Press, 1986. Argues that the many royal imposters and pretenders who appeared in the 1580s and 1590s reflect the populace's feelings of instability concerning rule by a woman, particularly by an elderly, childless queen who refused to name a successor.

Marcus, Leah S. "Shakespeare's Comic Heroines, Elizabeth I, and the Political Uses of Androgyny." In *Women in the Middle Ages and the Renaissance: Literary and Historical Perspectives*, edited by Mary Beth Rose, 135–53. Syracuse: Syracuse University Press, 1986. Analyzes Elizabeth's political rhetoric to show how she constructed a vocabulary of rule that was predominantly masculine. In four of Shakespeare's comedies—*As You Like It, Merchant of Venice, Twelfth Night,* and *Much Ado About Nothing*—the heroines perform a similar function by playing out male roles in order to promote stability and renewal and thereby help to sustain the self-contained, androgynous vision of Elizabeth in the late 1590s when her evident mortality subjected the myth to increasing strain.

Neill, Kerby. "Spenser on the Regiment of Women: A Note on the *Faerie Queene*, V, v, 25." *Studies in Philology* 34 (1937):134–37. Treats the Radigund episode in Book 5 of *Faerie Queene* as a historical allegory of the overthrow of Mary Stuart by Elizabeth. The controversy over women's rule in the 1580s particularly referred to Mary's claims for succession to the English throne.

Parry, Graham. "Lady Mary Wroth's *Urania*." *Proceedings of the Leeds Philosophical and Literary Society* 16 (1975):51–60. Presents a publishing history of the first part of *The Countesse of Mountgomery's Urania* (1621) and a brief account of Lady Mary Wroth's life.

Phillips, James E., Jr. "The Background of Spenser's Attitude Toward Women Rulers." *Huntington Library Quarterly* 5 (1941):5–32. Surveys the sixteenth-century controversy over government by women, in which there were three main groups: the Anglican spokesmen of Elizabeth and Catholic supporters of Mary Stuart, who defended the right and ability of women to govern; the "Puritan" group represented by Knox, Goodman, and Buchanan, who claimed that women had no right or ability to rule; and the moderate Genevans, led by Calvin and Bullinger (and eventually joined by Knox when he wished to reconcile himself with Elizabeth), who recognized the authority of women specifically called by God to govern.

———. "Renaissance Concepts of Justice and the Structure of the *Faerie Queene*, Book V." *Huntington Library Quarterly* 33 (1970):103–20. Argues that the seemingly miscellaneous events in Book 5 of Spenser's *Faerie Queene* are arranged according to the principles of logical analysis used by Renaissance theorists of justice, who divided the subject into three main topics: Justice Absolute, Equity, and Mercy or Clemency.

———. "The Woman Ruler in Spenser's *Faerie Queene*." *Huntington Library Quarterly* 5 (1941):211–34. Maintains that Spenser's attitude toward female rulers corresponds to that of the moderate Genevans, who believed that women in general were not equipped to exercise political rule but that God sometimes endowed certain exceptional women with the qualifications to govern. Thus Spenser designates Britomart, Mercilla, and Gloriana as exceptions elevated by God to earthly power.

Robinson, Lillian S. *Monstrous Regiment: The Lady Knight in Sixteenth-Century Epic.* New

York: Garland, 1985. Regards the female warriors in Ariosto's *Orlando Furioso*, Tasso's *Gerusalemme Liberata*, and Spenser's *Faerie Queene* as expressive of the political and dynastic concerns of the Renaissance state instead of as symbolic representatives of sexual equality. Particularly Spenser's Britomart embodies the female principle of flexibility that brings private and public demands into balance.

Scalingi, Paula Louise. "The Scepter or the Distaff: The Question of Female Sovereignty, 1516–1607." *Historian* 41 (1978):59–75. Examines how the debate over gynecocracy begins with the humanist writers More, Vives, Elyot, and Agrippa, who considered rule by women as an intriguing possibility, and how the ascent of Mary Tudor to the throne in 1553 radically changed the nature of the controversy. Of the anti-Marians, only Knox despised female sovereignty for its own sake; most of the other writers were more concerned with the religion, politics, and moral character of the ruler than with sex.

Schleiner, Winfried. "*Divina Virago:* Queen Elizabeth as an Amazon." *Studies in Philology* 75 (1978):163–80. Demonstrates that Queen Elizabeth was rarely compared to an Amazon, but that those few instances that survive relate to the Armada conflict, the most serious challenge to her reign.

Spenser, Edmund. *The Faerie Queene*. Edited by A. C. Hamilton. London: Longman, 1977.

Swift, Carolyn Ruth. "Feminine Identity in Lady Mary Wroth's Romance *Urania*." *English Literary Renaissance* 14 (1984):328–46. Considers how Lady Mary Wroth's *Urania* reveals the loss of identity that women experience in a society that victimizes them through its conventions regulating romantic love and marriage. Yet contradictions within the fiction reveal that the author occasionally validates social values that can destroy a woman's sense of self.

Warnicke, Retha M. *Women of the English Renaissance and Reformation*. Westport, Conn.: Greenwood Press, 1983. Distinguishes four generations of women writers, beginning with the humanists of Sir Thomas More's household (Margaret Roper, Margaret Gigs), followed by the Reformation generation (the Cooke sisters, Mary Clarke Basset), the mid-Elizabethan group (Anne Cecil, Arabella Stuart), and finally the Jacobean (Elizabeth Jane Weston, Lady Falkland, Lady Mary Wroth). In the last generation, women writers turned from translation to the challenge of creating their own original works of poetry, drama, and prose fiction.

Wells, Robin Headlam. *Spenser's Faerie Queene and the Cult of Elizabeth*. Totowa, N.J.: Barnes and Noble, 1983. Treats Spenser's *Faerie Queene* as an epideictic poem, in which the virtues of the six books are not simply facets of a Renaissance ideal of human conduct, but are attributes of Queen Elizabeth. As Vergil had praised Augustus through the noble deeds of his ancestor Aeneas, so Spenser used the myth of Britain's Trojan origins, together with religious typology, to portray Elizabeth as a Christian prince restoring peace and justice to a fallen world.

Willson, D. Harris. *King James VI and I*. London: J. Cape, 1956. Discusses James I's attitude toward women as part of the account of his life. His marriage to Anne of Denmark did little to remove the contempt with which he regarded the female sex. He was particularly hostile toward women of learning.

Witten-Hannah, Margaret Anne. "Lady Mary Wroth's *Urania:* The Work and the Tradition." Ph.D. dissertation, University of Auckland, 1978. Examines the genesis of Lady Mary Wroth's *Urania*, the relationship between the printed and manuscript versions, and the sources of the fiction, particularly the debt to the romance tradition, including the spectacular masques of Ben Jonson and Inigo Jones. *Urania* may be seen as a mannerist work that reveals the author's alienation from the ideals espoused by her society. (See Witten-Hannah [McLaren's] essay on Wroth below.)

Woods, Susanne. "Spenser and the Problem of Women's Rule." *Huntington Library Quarterly* 48 (1985):141–58. Argues that Spenser finds potential for rule inherent in women, not exceptional to them (as John Aylmer had claimed in his 1559 treatise). Spenser resolves the apparent conflict between cultural rejection of women's rule and the fact of a reigning queen by showing that the virtues of the body politic of the Faerie Queene are really an extension of those of the body natural. Despite the narrator's seeming condemnation of women's rule in Book 5, the treatment of Britomart is complicated by the presence of multiple ironies in the episode in which she gains the throne of the Amazon nation.

Wright, Celeste Turner. "The Amazons in Elizabethan Literature." *Studies in Philology* 37 (1940):433–56. Finds that in general Elizabethans regarded Amazons as dangerous examples of unwomanly conduct and portrayed them in literature as warlike, cruel, and unnatural malcontents, whose social system stood in direct violation of traditional order.

Wroth, Lady Mary. *The Countesse of Mountgomeries Urania*. London, 1621, STC 26051.

———. *The Poems of Lady Mary Wroth*. Edited by Josephine A. Roberts. Baton Rouge: Louisiana State University Press, 1983.

IV
The Private Woman

JUDITH BRONFMAN

Griselda, Renaissance Woman

ONE OF THE MOST famous women of the English Renaissance was not real but fictional and not English but Italian. Plays were written about her; a widely disseminated ballad celebrated her in song; chapbooks entertained and uplifted their readers with her story; a puppet show spread her tale to the illiterate. She was Griselda, the long-suffering peasant wife of the marquis of Saluce, the heroine of Chaucer's "Clerk's Tale."

Although the handling of the legend differed markedly from author to author, the major plot elements of the story told by Boccaccio, Petrarch, and Chaucer remained remarkably stable. A peasant girl promises absolute obedience to a marquis and marries him. Her two children are taken away, presumably to be killed; she is publicly repudiated and sent home. Later, she is recalled and reunited with her children and her husband. She bears all these tests patiently and uncomplainingly.

Chaucer's Clerk carefully and fully explains the story's moral, crediting it to Petrarch:

>This storie is seyd, nat for that wyves sholde
>Folwen Grisilde as in humilytee,
>For it were inportable, though they wolde;
>But for that every wight, in his degree,
>Sholde be constant in adversitee
>As was Grisilde. . . . (ClT ll. 1142–47)

Clear enough, but there is yet one oddity: the disclaimer that wives should not follow Griselda in her humility, because that is impossible. Later, in the end link, the Clerk will warn husbands not to try their wives as the marquis did Griselda. Why? "For in certein he shal faille" (ClT 1182). The warning and the disclaimer imply that there are other ways to look at this story.

In the middle of the sixteenth century, the story was revived and there began an outpouring of new versions of the tale with new un-Chaucerian morals. John Phillip in *The Commodye of Pacient and Meeke Grissill* (c. 1559), confronted Griselda's virtue with an antifeminist, snobbish Vice named Politic Persuasion. Phillip's subtitle and prologue indicate three different morals for the story: patience toward husbands, obedience to parents, and, harking back to Chaucer, that "wee always maye in trouble

bee content: / And learne with hir in weale and woe, the Lord our God to praise" (ll. 19–20). A broadside ballad, in existence by 1565, makes a single point: this was a good marriage challenged by an outside force, class prejudice, which forced the marquis to test his wife to prove her worth to his court and to expose the court's unjust prejudice toward her and the children. In 1599 Thomas Dekker collaborated with Henry Chettle and William Haughton to write *The Pleasant Comodie of Patient Grissill*. While Dekker picks up the class prejudice issue and points out that prejudice concealed beneath good manners is nonetheless prejudice, his principal interest is sovereignty in marriage. The marquis-Griselda marriage is counterpointed by a comic Welsh marriage with a sovereign wife. *The Ancient True and Admirable History of Patient Grisel*, a 1619 tract that ended this Renaissance sequence of Griselda works, had but one point to make, and its author made it with great passion: all wives should imitate Griselda.

The Commodye of Pacient and Meeke Grissill

John Phillip's source for his play was the 1558 *L'Estoire de Griseldis*, a French play widely available in England, which called itself "the mirror for married women."[1] Phillip's point is not so clear; his subtitle reads: "Whearin is declared, the good example of her pacience towardes her Husband: and lykewise, the due obedience of Children, toward their Parentes" (A1 recto); his preface adds the Chaucerian moral that Griselda illustrates human obedience toward the trials that God sends us. Synthesizing these three points would seem to present problems for Phillip, but he makes no effort to synthesize them. The Chaucerian point in the preface never recurs. Children's obedience to their parents is heavily stressed early in the play as Griselda shows her devotion to her father before her marriage; it is then dropped. The epilogue perfunctorily refers to Griselda's character, "This historie, wherin we have bin bould to shoe / What virtues in Grissell, that Ladie did floe" (2098–99), but stops short of specifying what those virtues are or of suggesting any application of them. The bulk of the epilogue is addressed to Queen Elizabeth, wishing her well in her reign.

However, Phillip's play is a comedy and its main interest is its lively, mischievous Vice, Politic Persuasion. He enters the play at its beginning when the court is urging the marquis to marry; he comments on marriage in an aside:

Marie quoth you? I hard many a one saye,
That the first day for weddinge all other doth excell,
For after they have not one merie daie. (183–85)

He fails to prevent the marriage, but he joins the court, presumably to see what will happen.

The Griselda tale's usual justification for the testing is reversed in Phillip's play. Traditionally the testing is done to prove her patience and her obedience to her marital promise. Here, however, her virtuousness is accepted; Politic Persuasion's task is to break that virtue, to *dis*prove her patience and obedience. His first attack, to the court, is antifeminist:

> Sume of them I tell you will be stoberne and unkynde,
> Denye them of ther willes and ye mar all,
> Ye shall see what there after is like for to fall,
> Ether brauling, jaulynge, sknappinge, or snarringe,
> Ther tounges shall not cease but alwaies be jarringe,
> Or els they will counterfait a kind of hipocrisye,
> And symper lyke a fyrmentie pot. . . . (423–29)

The courtiers, Fidence, Diligence, Reason, and Sobriety, are unimpressed, having already noted that he has a "mind malliscyous" (416).

Having failed to rouse antifeminism in the court, Politic Persuasion tries another argument when the first child is born:

> To commend her so highly very much to blame ye are . . .
> Is shee anie more than a Beggers brat, brought up in spinning,
> Her father is indigent, needie, and lame,
> An old doating foole, that Janickle hath to name:
> In her ther is no jot of noble sanguinnite,
> Therfore unfitly that her seed should rule or have dignitie.
> (921, 923–27)

Reason responds on behalf of the court, "Content thy mynd thy talke is vaine, thou seekst to heap up strif" (928), and the courtiers go off to see the new baby.

But Politic Persuasion succeeds with the marquis much better than with his court and easily persuades him that Griselda's famed patience can be broken. When the marquis falters during the testing scenes, as he does repeatedly, the quick-talking Vice is there to whisper in his ear and if necessary, as when the marquis banishes Griselda, to criticize his masculinity: "Are you not ashamed to blubber and weepe, / It is time to play the man, and not a symple sheepe" (1582–83). With Griselda banished, Politic Persuasion feels that his work is done, and he leaves the play. The denouement thus takes place without any direct confrontation between the Vice and Griselda, the Virtue.

What motivation the marquis had for testing his wife has always been a troublesome question, and Chaucer's explanation of it—"This markys in his herte longeth so / To tempte his wyf, hir sadness for to knowe"

(ClT 451-52)—has never been entirely satisfactory. But Phillip's solution, to relieve the marquis of responsibility and shift it to Politic Persuasion with his antifeminism and class prejudice, is even less satisfactory. The play's subtitle offers Griselda as an example of wifely patience, but the example is tainted when the husband whom she obeys is more often a "symple sheepe" than a man and is readily manipulated by a Vice figure. Ultimately, Phillip's message is a muddled one. A Vice is a corrupting influence and the value of Griselda's docile obedience to his instructions, even though these are relayed through her husband, is questionable. The implied analogy between God's trials and a Vice's mischief is even more questionable.

A *most pleasant ballad of patient Grissill*

In the Stationers' Register for 1565-66 are two licenses for printing ballads "to the tune of *pacyente* GRESSELL," so a Griselda ballad was known by then. The earliest extant ballad, however, is the Huth broadside of about 1600, now in the British Library. The ballad was reprinted with only minor variations throughout the next two centuries; the final version appeared about 1800.

Unlike Phillip's play, the ballad is clear and consistent in its viewpoint: the marquis and Griselda love one another and are sensitive to one another's feelings; their marriage is marred only by the prejudice of the marquis's subjects. The marquis tests her, not to prove her patience to himself (he has complete faith in her), but to prove it to his court and thus expose the court's unjustness toward both her and her children, who will be his heirs. His testing and her response allow the marriage to be permanent, peaceful, and happy, immune to outside disturbance.

The story usually begins with the marquis's court urging him to marry and getting his reluctant consent. Here the marquis sees Griselda as he is out hunting; she is "a proper Mayden . . . most faire & lovely, and of curteous grace" (ll. 2-3). He falls violently in love; she "set the Lords hart on fire" (6). When he proposes, he asks for a promise, but it is not the usual promise of absolute obedience; this marquis asks for her love: "graunte me thy love, and I wil aske no more" (26). She promises, and "being both contented / they married were with speed" (27-28). It is a rare Griselda author who worries about her contentment.

When the marquis realizes that he must test her, he is distressed; she is described as she "Whom he most deerely, tenderly, and entirely, / beloved as his life" (57-58). When he must banish her, he speaks to her privately and poignantly tells her of his distress and helplessness:

My Lady thou shalt be no more,
Nor I thy Lord, which grieves me sore,

A most pleasant Ballad of patient Grissell. To the tune of the Brides good morrow.

A Noble Marques as he did ride on hunting
 hard by a Forrest side:
A proper Mayden as she did sit a spinning
 his gentle eye espide. (the
Most faire & louely, and of curteous grace was
 although in simple attire: (louiously,
She sung full sweet with pleasant voyce me-
 which set the Lords hart on fire.
The more he looked the more he might,
 Beautie bred his hartes delight,
 and to this dainty Damsell then he went:
God speede quoth he, thou famous flower,
 faire mistres of this homely bower, (tent,
 where loue & vertue liues with sweete con-

With comely iesture & curteous milde behaui-
 she bad him welcome then: (our
She entertaind him in faithfull friendly manner
 and all his Gentlemen.
The noble marques in his hart felt such a flame
 which set his sences at strife: (thy name?
Quoth he, faire maiden shew me soone what is
 I meane to make thee my wife.
Grissell is my name quoth she,
 faire vnfit for your degree,
 a silly Mayden and of parents poore.
Nay Grissell thou art rich he sayd,
 & vertuous faire and comely Mayd,
 graunt me thy loue, and I wil aske no more.

At length she consented, & being both contented
 they married were with speede:
Her conray russet was chang'd to silk & veluet
 as to her state agreed.
And when she was trimly tyred in the same,
 her beauty shined most bright,
Far staining euery other braue & comly dame,
 that did appeare in her sight.
O my enuied be therefore,
Because she was of parents poore,
 and twixt her Lord & the great strife did raise:
Some sayd this, and some sayd that,
Some calld her beggers brat,
 and to her lord they would her soone dispraise.

O noble Marques (quoth they) why doe you
 thus basely for to wed? (wrong vs
That might haue gotten an honorable Lady,
 into your Princely bed.
Who will not now your noble issue still deride
 which shall hereafter be borne:
That are of bloud so base by their mothers side
 the which will bring them in scorne.
Put her therefore quite away,
Take to you a Lady gay,
 whereby your linage may renowned be:
This euery day they seemde to prate,
That malist Grisselles good estate,
 who tooke all this most milde and patiently.

When that the marques did see that they were
 against his faithfull wife, (bent thus
Whom he most dearely, tenderly, and entirely,
 beloued as his life.
Minding in secret for to proue her patient hart
 therby her foes to disgrace:
Thinking to play a hard vncurteous part,
 that men might pittie her case.
Great with childe this Lady was,
 And at length it came to passe,
 two goodly children at one birth she had:
A sonne and daughter God had sent,
 Which did their father well content, (glad.
 and which did make their mothers hart full

Great royall feasting was at these Childrens
 and princely triumph made: (christnings
Sixe weekes together, al nobles that came thi-
 ther entertaind and staid: (ther,
And whē that al those pleasant sportings quite
 the Marques a messenger sent: (were done
for his yong daughter, & his pretty smiling son
 declaring his full intent:
How that the babes must murdred be,
For so the Marques did decree,
 come let me haue the children then he sayd:
With that faire Grissell wept full sore,
She wrung her hands and sayd no more,
 my gracious Lord nurt haue his wil obaid.

She tooke the babies euen from their nursing
 betweene her tender armes: (Ladies
She often wishes with many sorrowfull kisses
 that she might helpe their harmes.
Farewell farewel a thousand times my childrē
 neuer shall I see you againe, (deere,
Tis long of me poor sad & woful mother heere
 for whose sake both must be slaine.
Had I been borne of royall race,
You might haue liu'd in happy case,
 but you must die for my vnworthines:
Come messenger of death said thee,
Take my despised babes to thee,
 and to their father my complaints expres.

He tooke the children, and to his noble maister
 he brings them both with speed:
Who secret sent them vnto a noble Lady,
 to be nurst vp in deed.
The faire Grissell with a heauy hart he goes
 where the fate mildly alone:
A pleasant iesture & a louely looke she showes,
 as if this greife she neuer had knowen.
Quoth he, my children now are slaine,
What thinkes faire Grissell of the same,
 sweet Grissell now declare thy mind to mee?
Sith you my Lord are pleasd in it,
Poore Grissell thinkes the action fit,
 both I and mine at your command will be.

My nobles murmure faire Grissell at thy honor,
 and I no ioy can haue: (sence
Til thou be banisht both frō my court and pre-
 as thou brutishly craue:
Thou must be stript out of thy costly garments
 and as thou camest to me: (all.
In homely gear in steed of biss & purest pall
 now all thy cloathing must be.
My Lady thou shalt be no more,
No, I thy Lord, which grieues me sore,
 the poorest life must now content thy minde.
A great to thee I must not giue,
To maintaine thee while I doe liue,
 against my Grissel such great foes I finde.

When gentle Grissell did heare these wofull ti-
 the teares flood in her eyes: (dings,
She nothing answered, no words of discontent
 did from her lips arise.
Her veluet gown most patiently she stipped off,
 her kirtles of silke with the same. (a scoffe
her russet gown was broght again with many
 to teare them all her selfe she did frame:
When she was drest in this array,
And ready was to part away,
God send long life vnto my Lord quoth shee
Let no offence be found in this,
To giue my Lord a parting kisse,
 with watry eyes, farewel my deere quoth he.

From stately Pallace vnto her fathers Cot-
 poore Grissell now is gone: (tage
Full sixteene winters she liued there contented
 no wrong she thought vpon: (thes went
And at that time through all the land the spea-
 the Marques should married be:
Vnto a Lady of high and great discent:
 to the same all parties did agree.
The Marques sent for Grissell faire,
The Brides bed chamber to prepare,
 that nothing therein should be found awry:
The Bride was with her brother come,
Which was great ioy to all and some:
 and Grissell tooke all this most patiently.

And in the morning when they should to the
 her patience now was tride: (wedding,
Grissell was charged her selfe in princely maner
 for to attire the Bride.
Most willingly she gaue consent to do the same
 the Bride in her brauery was drest:
and presently the noble Marques thither came
 with all his Lords as he request.
O Grissel I would aske quoth he,
If she would to this match agree,
 me thinkes her lookes are waxen wondrous
With that they all began to smile, (coy,
And Grissell she replide the while,
 God send Lord Marques many yeres of ioy.

The Marques was moued to see his best belo-
 thus patient in distresse: (ued
He stept vnto her, and by the hand he tooke her
 these words he did expresse:
Thou art my Bride, & all the Brides I meane
 these two thine owne children be: (to haue:
The youthfull Lady on her knees did blessing
 her brother as willing as she, (craue
And you that enuied her estate,
Whom I haue made my louing mate,
 now blush for shame, & honor vertuous life:
The Chronicles of lasting fame,
Shall euer more extoll the name,
 of patient Grissell my most constant wife.

FINIS.

"A most pleasant ballad of patient Grissell." From the Huth Collection at the British Library. By permission of the British Library.

215

> the poorest life must now content thy minde.
> A groat to thee I must not give,
> To maintaine thee while I doe live,
> against my Grissel such great foes I finde. (169–74)

When he recalls her and asks her before the court what she thinks of his presumed new bride, she replies: "God send Lord Marques many yeres of joy" (166). This marquis recognizes the pain of that response and moves to comfort her:

> The Marques was moved to see his best beloved
> thus patient in distresse:
> He stept unto her, and by the hand he tooke her. (167–69)

The cold otherworldliness that marked Chaucer's marquis has quite fallen away.

Nor is this the stoic Griselda whose only request is that her children's corpses not be exposed to wild animals. She loves both her husband and her children and she is unafraid to express that love. When she must leave the court, she defiantly says to the hostile courtiers: "Let no offence be found in this, / To give my Lord a parting kisse" (136–37). Nor does she give up her babies easily. She "wept full sore, / She wrung her hands . . ." (80–81), and "with many sorrowful kisses" (85) she wishes them "Farewel farewel a thousand times my childre(n) deere" (87). In addition, she tells the messenger "to their father my complaints expres" (96). As he is a husband worthy of her patience, so she is a loving wife and mother worth fighting for, and that is what this marquis does.

The class consciousness motif that dominates the ballad comes from the original sources, from Boccaccio, Petrarch, and Chaucer, whose marquis tells Griselda that his court and his people are opposed to her because of her low birth. It is a plausible excuse, but in the sources it is untrue. Here it is emphatically true. She is beautifully dressed and honored at her marriage, and:

> Many envied her therefore,
> Because she was of parents poore
> and twixt her Lord & she great strife did raise
> Some sayd this, and some sayd that,
> Some did call her beggers brat,
> and to her lord they would her soone dispraise. (35–40)

When she becomes pregnant, the gossip intensifies:

> Who will not now your noble issue still deride . . .
> That are of blood so base by their mothers side . . .
> Thus every day they seemde to prate. (45, 47, 52)

It is against this malice that the marquis must act. It is only after sixteen years of testing that the marquis is able to say to Griselda, "Thou art my Bride, & all the Brides I meane to have" (171), and to say to his court:

> And you that envied her estate,
> Whom I have made my loving mate,
> now blush for shame, & honor vertuous life:
> The chronicles of lasting fame,
> Shall ever more extoll the name,
> Of patient Grissell my most constant wife. (175–80)

The ballad has made the humanist point that people must be judged on their individual worth, not by their birth or social station.[2] Not only is Griselda a better wife than a less virtuous noblewoman would be; it is also important that she be publicly acknowledged and honored as such.

The Pleasant Comodie of Patient Grissill

The ballad was probably widely known by 1599 when Thomas Dekker collaborated with Henry Chettle and William Haughton to write *The Pleasant Comodie of Patient Grissill*. *The Pleasant Comodie* picks up the class prejudice issue from the ballad and adds an issue new to the Griselda tradition: sovereignty in marriage.

The play treats class prejudice with far more complexity than had its predecessors. When the marquis announces that he will marry Griselda, the courtiers voice the usual concerns: one says, "This meane choice, will distaine your noblenes" (1.2.275); another adds, "Shee's poore and base" (277); a third asks, "What will the world say when the trump of fame / Shall sound your high birth with a beggers name?" (279–80).

But the common people in this play are just as skeptical. Babulo, a servant who dresses in motley and functions as a Wise Fool figure, says: "Its hard sir for this motley Jerkin, to find friendship with this fine doublet" (1.2.304–5); later he is even more blunt: "beggers are fit for beggers, gentlefolkes for gentlefolkes" (317–18). When the marquis asks Griselda's family to leave the court, he says to them:

> Doe not my people murmure everie houre,
> That I have rais'd you up to dignities?
> Doe not lewde Minstrels in their ribalde rimes,
> Scofe at her birth, and descant on her dower? (3.1.75–78)

The court, which has better manners than the common people, needs some encouragement to expose their underlying prejudice. When the marquis decides to test Griselda—"Yet is my bosome burnt up with

desires, / To trie my *Grissills* patience" (2.2.20–21), a motivation as irrational as that of Chaucer's marquis—he decides to test the court as well. He tells his courtiers:

> *Mario, Lepido*, I loath this *Grissill*, . . .
> For Gods sake scorne her, call her beggers brat,
> Torment her with your lookes, your words, your deeds. (154, 159–60)

The courtiers readily comply. Yet later, when the marquis asks their opinion of her, one responds, "She is as vertuous and as patient, / As innocence, as patience it selfe," and the other adds, "She merits much of love, little of hate, / Onely in birth she is unfortunate" (3.1.136–39). The marquis muses at this contradiction, that they will admire her good qualities and yet treat her badly:

> Oh whats this world, but a confused throng
> Of fooles and mad men, crowding in a thrust
> To shoulder out the wise, trip downe the just. (157–59)

When Griselda and her children are reintroduced to the court at the final feast, the marquis will comment on these unjust prejudices:

> These two are they, at whose birthes envies tongue,
> Darted envenom'd stings, these are the fruite
> Of this most vertuous tree . . .
> With wrongs, with bitter wrongs, al you have wrong'd her. . . .
> (5.2.199–201, 203)

But the main theme of Dekker's play is sovereignty. To explore this theme, the play has two dovetailed plots, the serious main plot with the Griselda story and a comic subplot about the marquis's Welsh cousin Gwenthyan and her husband Sir Owen. In the main plot, the husband is sovereign, of course; in the subplot, Gwenthyan is hilariously sovereign. The marquis's unmarried but much-wooed sister, Julia, observes and comments on both types of marriages.

Gwenthyan's plot parodies the main plot. Griselda goes from her village rags to rich clothing; Gwenthyan takes off her rich clothes and dresses in rags to embarrass her husband when he has guests. Griselda is called to the castle to organize the feast that will be the climax of her plot; Gwenthyan's plot is climaxed by a feast that she turns into a debacle.

When Sir Owen goes to meet the marquis and his court who are arriving for a feast, Gwenthyan hastily invites in beggars, who, with her encouragement, eat all the food and leave a wreckage behind. Witnessing this scene, Julia angrily refuses her suitors' advances: "Not I, would you have mee pittie you and punnish my selfe? . . . *Gwenthyans* pee-

vishnes and *Grissils* patience, make me heere to defie that Ape *Cupid*" (4.3.204–5, 216–18).

The play's ending restores Sir Owen's sovereignty. After Griselda's reinstatement, Sir Owen's marriage remains problematic. He comments that having failed to tame his wife early as the marquis advised, his only choices now are to run away or to knock her brains out. To everyone's surprise, Gwenthyan announces that "as her cozen has tryed *Grissill,* so *Gwenthian* has Sir *Owen*" (5.2.262–63) and, now that she has proven her point, "Sir *Owen* shal be her head" (265).

The marquis announces that everything has ended happily, but Julia interrupts: "Nay brother your pardon awhile: besides our selves there are a number heere, that have behelde *Grissils* patience, your owne tryals, and Sir *Owens* sufferance, *Gwenthians* frowardnes, these Gentlemen lovertine [*sic*], and my selfe a hater of love: amongst this company I trust there are some mayde batchelers, and virgin maydens, those that live in that freedom and love it, those that know the war of marriage and hate it, set their hands to my bill, which is rather to dye a mayde and lead Apes in hell [the proverbial fate of unmarried women], then to live a wife and be continually in hell" (5.2.275–83).

The play is forceful and unequivocal in its condemnation of class prejudice. The subtle point that prejudice concealed beneath social conventions is as much to be condemned as its overt counterpart of "hourly murmurings" and "ribald rimes" is sound. The resolution of the sovereignty issue, however, is troubling. Julia, who condemns both kinds of marriages and elects to remain single, is the most eloquent speaker at the end of the play. Although the resolution seems curiously unsatisfactory, to question at all the quality of a marriage in which one person completely and irrationally masters the other is, in the Renaissance, a daring step into the modern world.

The Ancient True and Admirable History of Patient Grisel

The early works had tiptoed around the question of whether Griselda was a model for wives. The chapbook did not: for it, that was the main, the only, point.

The 1619 prose chapbook was published with a title page that read:

> The Ancient True and Admirable History of Patient Grisel, a poore mans daughter in France: shewing how Maides, By Her Example, In Their Good Behaviour May Marrie Rich Husbands; and Likewise Wives By Their Patience and Obedience May Gaine Much Glorie. Written First in French, and
> Therefore to French I speake and give direction,
> For English Dames will live in no subjection.

> But Now Translated Into English, and
> Therefore say not so, for English maids and wives
> Surpass the French in goodness of their lives. (Wheatley [1])

Like the ballad, the chapbook was reprinted continuously, although with some modifications, until about 1800.

The most striking difference between the prose history and its predecessors is the repeated stress on the court's and the people's support and admiration for Griselda. This author is intent upon persuading women to imitate Griselda's behavior, and thus he shows that everyone, from the lowliest peasant to the highest courtier, admires her. In her tribulations, she is supported and befriended throughout the chapbook.

The chapbook begins with the underlying assumption that marriage is, at best, a nuisance. The court speaks to the marquis about marrying because "he thought not of marriage, nor to entangle himselfe with the inconveniences of a wife" (4). However, he finally agrees to marry and selects Griselda, but he obtains from her a particularly lengthy and complex promise:

> onely I must be satisfied in this, if your heart afford a willing entertainement to the motion, and your vertue a constancy to this resolution, not to repine at my pleasure in any thing, nor presume on contradiction, when I determine to command. For as amongst good souldiers, they must simply obey without disputing the businesse: so must vertuous wives dutifully consent withoute reproofe, or the least contraction of a brow. (13)

It is upon this basis that the marriage is consummated, this promise that is tested.

The court is immediately impressed with Griselda. At the wedding, "no word of reproach was murmured, nor eie looked unpleasantly upon her; for by her wonderfull demeanour shee had gained so much of opinion that the basenes of her birth was not thought upon . . ." (15). As time passes, her renown grows, "Thus was she amiable to her lord, acceptable to her people, profitable to her country, a mirror of her sexe, a person priviledged by nature, and a wonder of the time . . ." (16).

In spite of this, the marquis tells her, as usual, that his subjects are dissatisfied with her low birth, but the chapbook is very clear that this is untrue. Even the messenger who comes to take her child away tells her: "But yet with what unwillingnes (God knowes my soule) in regard that you are so respected among us, that wee think of nothing but what may delight you, and talk not a word but of your merit and worthinesse" (21).

When she is later banished from the court, she receives more evidence of the high regard accorded her: "Did I say before, they began to weep? I

can assure you . . . they roared out-right" (34). When she is recalled to the court, not only are the Saluzzans on her side, but "when the strangers were made acquainted with the fortune of Grisel, and saw her faire demeanour, they could not but esteeme her a woman of great vertue and honour, being more amased at her patience than at the mutability of mans conditions" (41)—a comment perhaps specifically rejecting Chaucer's abstract moral.

Lest the reader of the chapbook miss the point about emulating Griselda, the author interrupts his narrative at two climactic points— when Griselda's child is taken away and when she is banished—to address his women readers directly before continuing with Griselda's response to the test. After inveighing against women who "dare out of impudency or cunning tell their husbands to their faces they will go where they list, and do what they please" (25), he goes on to give Griselda's response to her child's being taken away, but with a short initial comment: "if there bee hope of reformation, insert it as a caution to divert you from your naturall fiercenes" (26).

When Griselda is banished, the author again breaks off his narrative. Having answered the two objections to the story, "first, the impossibility of the story; secondly, the absurdity of the example," he delivers a three-page diatribe against the "two especially errours against the modesty of their sex, and the quietnes of their husbands, videlicet, superiority and desire of liberty (I name not irregular behaviour, household inconveniences, and domesticks strife)" (35). He then throws in a number of grievances, including opening the mail first ("yea, I have knowne them breake open letters before they came to their husbands' overlooking" [36]) and leaving the house without permission (here he lapses into the first person—"why, without my leave, and that upon good grounds, should shee wander in publike?" [37]). He ends "that woman that will not be ruled by good councell must be over-ruled by better example,—of which, this now in hand (of Lady Grisel) is a mirror, and transparent chrystall to manifest true vertue and wifely duty indeed . . ." (37).

The narrative then returns to the court and Griselda's response to her banishment, a steadfast, perhaps even stubbornly proud, adherence to her original promise:

> The company could not choose but weepe and deplore the alteration of fortune; she could not choose but smile, that her vertue was predominant over passion: they exclaimed against the cruelty of her lord, she disclaimed the least invective against him: they wondred at so great vertue and patience, she resolved them they were exercises befitting a modest woman: they followed her with true love and desire to doe her good, she thanked them

with a true heart, and request to desist from any further deploring of her estate. (38)

In his final speech to her before the court, the marquis bestows near-sainthood upon her and asserts that she has made him a better man: "Thou wonder of women, and champion of true vertue! . . . therefore, I will have no wife but thy selfe, and when God hath thought thee too good for the earth, I will (if it bee not too much superstition) pray to thee in heaven. Oh! 'tis a pleasure to be acquainted with thy worth, and to come neere thy goodnes maketh a man better than himselfe" (44). This author, with all the skill and verbosity at his command, has striven mightily to make Griselda a model for all wives and perhaps (remembering the first-person lapse in his diatribe) particularly his own wife.

During the English Renaissance, authors had struggled to find new meanings in this story. They discarded Chaucer's medieval meaning, "that every wight, in his degree, sholde be constant in adversitee," (ClT 1145–46), and searched for meanings relevant to the life around them. They explored class prejudice, the value of the individual, antifeminism, and the institution of marriage in the real world.

By the end of this period, it was clear that the two lasting works were the two that dealt with marriage: the ballad and the chapbook. Phillip's play, which is known through a single copy in the Yale University Library, printed by Thomas Colwell and undated, was apparently printed twice; the Stationers' Register licensed Colwell to print "an history of meke and pacyent gresell" in July 1565 and again in July 1568. Dekker's play was printed only once, in 1603 by Henry Rocket. The ballad, in spite of the ephemeral quality of broadsides, survives in at least seventeen different printings beginning with the 1600 Huth ballad and ending with one printed in London by Howard and Evans about 1800. The tract had a similar history; nine editions of it, spaced about twenty years apart, are extant, ending with the chapbook printed by Angus at Newcastle about 1800.[3] Publishers certainly, and probably readers as well, had decided against Phillip's muddled views and Dekker's complex ones. A simpler, more direct message that Griselda was a model wife was preferable.

In the ballad, she is so good that she is able to rise above her humble station and become lastingly famous. She is so clearly the model wife that the author does not need to urge her as one. In the chapbook/tract, which does urge her as a pattern for all women, her social station need not be risen above; she is universally admired and presumably so will be her imitators. Two hundred years of incessant repetition in songs and in popular books designed particularly for women have resulted in the

image of Griselda that has come down to us: paragon of patience, model of wifely behavior, icon of the perfect wife. Everyman's dream.

Notes

1. *L'Estoire de Griseldis* was a reprinting of the 1395 *Mystère de Griseldis*, a drama based upon Philippe de Mézières's prose version of the tale in *Le livre de la vertu et du sacrement de mariage et du reconfort des dames mariees*. *L'Estoire* begins: "ci commence l'estoire de Griseldis, la marquise de Saluce, et de sa merveilleuse constance. Et est appelle 'Le Miroir des dames mariees' " (Here begins the story of Griselda, the marquise of Saluce, and of her marvelous constancy. And it is called 'The Mirror of married women') (Craig 27). In the introduction to his dissertation, "An Edition of John Phillip's *Commodye of Pacient and Meeke Grissill*" (University of Illinois, 1938), Charles Walter Roberts charts the close correspondences between Phillip's play and *L'Estoire de Griseldis*.

2. Henry Medwall's play, *Fulgens and Lucres*, written about 1500, first made this point in English. In his *Tudor Plays: An Anthology of Early English Drama* (New York: Doubleday, 1966), Edmund Creeth called *Fulgens and Lucres* "a major document in English humanism" because of "its definitive resolution" (xiv) favoring virtue over ancestry; Medwall's Italian source had raised the issue but had not resolved it.

3. The ballad "Patient Grissel" and the chapbook *The true and admirable history of Patient Grissell* are both in the British Library.

Works Cited

Ancient True and Admirable History of Patient Grisel, The. See Wheatley, below.
Arber, Edward, ed. *A Transcript of the Registers of the Company of Stationers of London: 1554–1640*. 5 vols. London and Birmingham: privately printed, 1875–94. An invaluable reference for works licensed to be published in London in this period.
Chaucer, Geoffrey. *The Works of Geoffrey Chaucer*. Edited by F. N. Robinson. 2d ed. Boston: Houghton, 1957. A standard edition of Chaucer's works.
Craig, Barbara M., ed. *L'Estoire de Griseldis*. University of Kansas Humanistic Studies, no. 31. Lawrence: University of Kansas Press, 1954. A reliable transcript of the unique 1395 manuscript fonds francais 2203 in the Bibliothèque Nationale.
Dekker, Thomas. *The Pleasant Comodie of Patient Grissill*. In *The Dramatic Works of Thomas Dekker*, edited by Fredson Bowers. Vol. 1, 207–98. Cambridge: Cambridge University Press, 1953. The standard edition of Dekker's works.
Most pleasant ballad of patient Grissill, A. To the tune of the Brides good morrow. Ca. 1600. Huth Collection, British Library. STC 12384. The earliest known copy of the Griselda ballad.
Phillip, John. *The Commodye of Pacient and Meeke Grissill*. Edited by Ronald B. McKerrow and W. W. Greg. Oxford: Malone Society, 1909. To my knowledge, the only printed edition of this play.
Wheatley, Henry B., ed. *History of Patient Grisel. 1619*. Chap-Books and Folk-Lore Tracts. First Series, no. 4. London: Printed for the Villon Society, 1885. STC 12383. A book of the earliest known Griselda tract or chapbook; the original is in the British Library.

R. VALERIE LUCAS

Puritan Preaching and the Politics of the Family

FROM THE 1580s to the 1620s, following the Protestant Reformation in England, a reassessment of the nature and status of marriage found its way into print through the writings of Puritan divines who hoped to counter the medieval ideal of celibacy by proposing matrimony as "an hye, holy, and blessed order of life," decreed by "God in Paradise."[1] Although they proposed mutual affection between spouses, the continental reformers and their English followers advocated a patriarchal model for marriage, based upon biblical authority, which emphasized the necessity of wives' voluntary submission to their husbands' authority.[2]

The patriarchal bias of the Protestant church also served political and legal interests. Lawrence Stone claims that: "the growth of patriarchy was deliberately encouraged by the new Renaissance state on the traditional grounds that the subordination of the family to its head is analogous to, and also a direct contributory cause of, subordination to the sovereign" (152).[3] In *A godly forme of houshold government* (1630), John Dod and Robert Cleaver claim that "An Houshold is as it were a little Commonwealth, by the good government whereof, Gods glorie may be advanced. . . ." (sig. A[ii]). Since the preachers' model for marriage also provided theological justification for notions of female inferiority already extant in English law, one should consider women's legal rights and why they lost most of them upon marriage.

By the time of Edward I, an unmarried woman or widow had almost the same legal rights as a man of the same social class. These included the rights to inherit property, to own land or chattels, to make a will or contract, to sue or be sued, and to become guardian of her own or her tenants' children (Pollock and Maitland 1: 482–88). Once married, however, a woman had almost no legal right to hold or dispose of her property, unless she had managed to circumvent her husband's control by a settlement arranged before marriage (Stone 195; Hogrefe, "Legal Rights").

It was because the law considered a married woman to be a *feme covert*—that is, under the guardianship of her husband—that all her property came under his control during the couple's marriage. Sir William Holdsworth indicates the extent of the husband's control:

> From the end of the thirteenth century the common law has definitely decided that marriage makes the wife's chattels absolutely the property of her husband. . . . [He] could alienate them [transfer ownership to another person] while he was living, but if he had not done so, they became the property of his wife at his death. . . . Over the wife's freehold interest in land the husband has complete power—but only for as long as the marriage lasts, or if there has been a child of the marriage capable of inheriting during his life. If there was no child and if she died before him, the land passed to her heirs. (3: 525–27)

According to the law, then, if husband and wife were one person, that person was the husband. The author of *The Lawes Resolution of Womens Rights* (1632) suggests that married women became so much a part of their husbands that they were virtually obliterated: "A woman as soon as she is married is called *covert;* in Latine *nupta,* that is 'veiled'; as it were clouded and over-shadowed. . . . I may more truly, farre away, say to a married woman, Her new self is her superior; her companion, her master . . ." (T.E. 124). Since married women had no existence *de jure,* they also had no right to enter the public world: "women have no voice in Parliament, they make no laws, they abrogate none. All of them are understood either married or to be married, and their desires or [are?] subject to their husbands. I know no remedy, though some women can shift it well enough" (T.E. 6).

In addition to control over his wife's property, the common law granted the husband certain powers over her person: he could beat her with a rod no bigger than his thumb (Knappen 454)[4] and the 1608–09 Gager-Heale debate suggests that many men took advantage of their legal privilege.[5] Although William Whately, Henry Smith, and William Gouge condemned wife beating, other Puritan divines saw it as an unpleasant necessity. Robert Snawsel, in *A looking glasse for married folkes* (1610), advises methods of wife-taming befitting Petruchio, including irrational changes of mood and regular beatings (Snawsel 53, 60, 69, 80, cited in Davies 567 n. 15). L. B. Wright attributes a strongly biblical pamphlet of 1616 to a Puritan writer: although it condemns blows as "brutish," a husband is advised to beat his wife "for her good" (218). There was, of course, no legal redress for a battered wife: like outlaws, pagans, traitors, and *villeins,* married women could have no action in the common law (Camden 257).

A chilling example of the power a husband had over his wife is the Joan Wynstone case. After leaving her husband, Wynstone was considered "masterless" and therefore could be prosecuted under the 1572 statute against beggars and vagabonds. She was one of forty-four captured vagabonds brought before the Middlesex sessions between 1572

and 1575, and on February 6, 1576, was whipped, branded, and sentenced to death by hanging. However, her yeoman husband, Thomas, petitioned the magistrates, and on July 26, she was reprieved on the condition that she be set to service (i.e., to work as a servant) for two years in his household. Wynstone again ran away, was caught on October 3, 1577, and hanged. One can only guess at the nature of domestic unhappiness which drove her to risk, for a second time, an action punishable by death (Jeaffreson 1: 101–3).[6]

The powerlessness of married women provoked bitter comment later in the seventeenth century: William Wycherley's Widow Blackacre remarks that "matrimony to a woman [is] worse than excommunication in depriving her of the benefit of law" while Defoe's Roxana puts the case more strongly: "the very nature of the marriage contract was . . . nothing but giving up liberty, estate, authority, and everything to a man, and the woman was indeed a mere woman ever after—that is to say a slave."[7]

2

The legal status of the *feme covert* suggests that the majority of women were deprived of much of their economic independence and most of their rights under law. How, then, could one reconcile women to these disadvantages? It fell to the preachers, professional ideologists of the period, to deal with this knotty problem. Before turning to this issue, however, one should briefly consider two others: (1) How influential was preaching in shaping public opinion? (2) Why were sermons the best means?

During the sixteenth and seventeenth centuries, the Anglican church monopolized the areas of thought-control and opinion-forming: through the examination and licensing of schoolmasters, it controlled education; for most people in pre–Civil War England, sermons were the main source of political opinion and moral guidance.[8] Moreover, sermons were the most efficient means of presenting new ideas to a wide audience: since the Act of 1593 required everyone over the age of sixteen to attend Sunday church service "or in default be hanged or banished" (Wilson 44–45), it seems that preachers had a captive audience from all social classes.[9] A determined minister could use the pulpit to launch a long-running campaign for a favorite cause: such seems the case with William Gouge, whose seven-hundred-page *Of domesticall duties* was "first uttered out of the pulpit" (preface, p. 4). Contemporary practices suggest that the faithful regarded sermons very seriously: they took notes or transcribed them by shorthand (a common and deplorable female vice,

The Image of "True" Religion (title-page detail) from John Foxe's *Actes and Monuments* (1563). By permission of the Huntington Library, San Marino, California.

according to Sir Ralph Verney).[10] That so many were published attests to a considerable number of readers willing to buy copies for home study.

Recognized as moral guides, possessed of a steady clientele, preachers were in an ideal position to disseminate new ideas. How did their sermons try to make women accept their inferior status? The preachers developed a role model for women by expounding upon biblical paradigms set forth in Genesis and by St. Paul and St. Peter: "thy desire shall be to thy husband, and he shall rule over thee" (Genesis 3.16).[11] Since women's subjection was ordained by God, to disobey one's husband was to sin against God and divine law. St. Paul's advice was cited as the proper relation between spouses:

> Wives, submit yourselves unto your husbands, as unto the Lord.
> For the husband is the head of the wife, even as Christ is the head of the church: and He is the saviour of the body. (Ephesians 5:22–23)

The wife was justified in disobeying her husband only if his commands asked her to transgress God's laws.

With increasing vigor, Puritan preachers proclaimed man's superiority and woman's inferiority. In comparison to the Jacobeans, Elizabethan preachers seem relatively mild mannered: in his 1559 wedding

sermon at Strassburg, Edwin Sandys offers the following view: though a man should honor his wife, God gave her the law of subjection because of Eve's transgression. Thus she should willingly and dutifully obey her husband "else she disobeyeth that God who created woman for man's sake and hath appointed man to be woman's governor" ("The Sixteenth Sermon" quoted in Hogrefe, *Tudor Women,* 7). Note the difference between this and Thomas Gataker's 1624 wedding sermon, *A Wife Indeed.* Gataker takes the same position as Sandys, but with considerably more emotive force: "what a fearfull thing it is to be otherwise. For her that was made for a helpe, to prove not a helpe but an hurt: for her that was given for a blessing, to prove a crosse and a curse."[12]

Nor is this a unique example: rhetorical strategy intrigued these technicians of the sacred, and "the calculated effort to appeal to the popular audience affected the structure as well as the style of the sermon." (Haller 134). According to Puritan William Perkins, the most effective structure was an exposition of a precept from Scripture: the preacher would explain it within its context, then "divide" it into "a fewe and profitable points of doctrine," and finally, show its "uses" in the life and manners of men.[13] For many Puritans, this last was the real goal of preaching: to set the sinner on the path to moral regeneration through a discovery of the secrets of his own heart.

The remainder of this section will consider how preaching promoted the patriarchal family through its view of relations between spouses and will examine the rhetorical strategies of persuasion, manipulation, and (at times) evasion used to entice a female audience's acceptance of notions of male authority and female submission.

The "Homily of the State of Matrimony" is of particular interest in terms of audience and authorial intention: one of the most widely disseminated views of domestic relations (and, for many common folk, the only one they would get), it also belongs to a body of texts designed as government propaganda. Published in 1547, ostensibly to impart correct Anglican doctrine,[14] certain homilies, such as "An exhortation concerning good order and obedience to rulers and magistrates," argue for the necessity of social hierarchy: *"Take away kings, princes, rulers, magistrates, judges, and such states of God's order . . . there must needs be follow all mischief and utter destruction, both of the souls, bodies, goods, and commonwealths"* (Corrie 104–5).

The "Homily," while viewing the husband's authority over his wife as part of this established social order, is more subtle in its argument for domestic hierarchy: it creates the illusion of an equal partnership by defining male authority and female submission as complementary duties in marriage. Although souls are all spiritually equal before the Lord, on

earth the husband is the controlling force in the partnership, for "the woman is a frail vessel, and thou art therefore made the ruler and head over her, to bear the weakness of her in this her subjection" (Corrie 511). The husband is advised to provide a good example through his benevolent rule, giving way to his wife occasionally, and endeavoring to reform even the most shrewish through gentle words rather than by beating.

As in the concept of partnership, the homilist, in emphasizing the husband's benevolent rule, conceals the true nature of power relations. That the husband's authority over his wife is absolute becomes apparent only when one examines her half of their mutual duties: obedience, manifest in behavior and modesty of dress "to declare her subjection" (Corrie 507). While a husband should reform an ill-tempered wife, she must stoically endure an overbearing husband. The stylistic maneuvers of this passage, its use of theology and "mutual duties" to persuade wives to endure even tyrannical rule, merit some attention: "if thou canst suffer an extreme husband, thou shalt have a great reward therefor: but if thou lovest him only because he is gentle and courteous, what reward will God give thee therefor? Yet I speak not these things, that I would wish the husbands to be sharp towards their wives . . . when the woman is ready to suffer a sharp husband, and the man will not extremely entreat his stubborn and troublesome wife, then be all things quiet . . ." (508). Although it begins with the theological justification that God will give the wife of an oppressive man "great reward" for her sacrifice, the homilist is quick to deny that he licenses male tyranny; yet, by advising women to "patiently bear the sharpness of their husbands," he comes near to tacit approval of extreme rule. As if aware of this, he reintroduces the concept of mutual duties: either sex, if lumbered with an overbearing spouse, is counseled to be patient. While the advice may appear the same, the two main verbs—"entreat" and "suffer"—offer different possibilities: while a husband may choose to tolerate or reform his shrewish wife, she has no choice but to endure a tyrannical husband.

William Whately's *Bride Bush* (1617) and Thomas Gataker's *Wife Indeed* (1624), originally composed for one couple and later published for general readership, go beyond the homily's general outlines for the husband's benevolent rule and encourage him to promote his wife's voluntary subjection to his authority.

Although *A Bride Bush* offers one of the most uncompromising arguments for male authority, the coercive and repressive nature of patriarchy is disguised through the notion of "partnership" and the claim that obedience to one's husband is part of one's duty to God

himself. Whately opens with a discussion of the couple's mutual duties: to love each other, to learn the other's temperament and weaknesses, to not vilify or disgrace the partner, but to help "heale each others faults" (11) and to avoid "all things, which will cause such evils to breake out" (12). In addition, the two should provide for the needs of the family and offer moral and spiritual guidance to their children and servants. Such an opening is a cunning rhetorical tactic: inscribed within this context, male authority and female submission appear as complementary halves of a partnership rather than as power relations of dominance/submission, of master/inferior. Yet reduced to their simplest elements, the individual duties of husband and wife are: "for the husbands speciall duties they may be fitly referred to these two heads: *The keeping of his authority* and the using of it" (18) while the "whole duty of the wife is referred to two heads. The first to acknowledge her inferiority: the next to carry her selfe as inferior" (36).

His authority is divinely sanctioned, for the "Lord in his Word cals him the head . . . it is a sin to come lower than God hath set one. It is not humility, but basenes, to be ruled by her whom he should rule" (19). Yet, Whately cautions men against overbearing behavior:

> *Things are also best done when the will is allured, rather than the body compelled* [my emphasis]. If thou stand upon it, and come with flat commandements (as *you shall* and, *I will make you;* and, *you were as good as you did;* and, *you shall know that I am master,* &c. [Whately's emphasis] and the like big words,) the heart goes against that which the hand performes; and thou are disliked inwardly, though perhaps obeyed in shew: and *if obedience come not from the heart, can it last long?* [my emphasis]. This is the way to prevaile with the least burden to the inferiour, & toyle to the superiour, if with milde words hee wish this and this, rather then with imperious speeches enjoyne it. (29)

Instead, the husband should establish rule that does not look like rule, for "Authority is like the arts of Logick and Rhetoricke, that must in speaking be used, and yet concealed: and then they most prevaile when being used, they are at least seene" (29). For this reason, Whately counsels gentleness in command and reproof, and advises the husband to grant some of the wife's wishes, so that "Obedience would be inticed and allured" (27).

Whately, more than most divines, was aware that an ideology's effectiveness relies upon promoting its audience's misrecognition of its social reality: thus he advises men to behave so "that she may perceive herself to have entred, not into servile thraldome, but loving subjection" (28). If the wife believed she had freely accepted her husband's rule, not only would she be willing to obey him, but she might also internalize standards of male authority: "her-selfe shalle bee Judge against her-selfe, if shee give not what shee lookes to receive" (42).

Such self-indoctrination is precisely what Thomas Gataker has in mind in his sermon *A Wife Indeed*. Structured like a guessing game, it invites its audience to define "a wife indeed," and its questions lead women to examine their own consciences and, by doing so, to discover their wifely duties.

In reply to his initial question, "what is a wife?" Gataker offers Solomon's negative examples of the woman who shames her husband (Proverbs 12:4) and the "brawling woman" of Proverbs 21:9. However, by introducing a new term to the question—are these *good* wives?—he asks the listeners to deduce a definition of that term: if "Woman was at first made for mans goode," then only those who act for their husbands' good can merit the title of wife.

The listeners must now discover which acts are good through considering two more negative examples: the wife who "beareth *a Wives Name*, but doth not *a Wives worke*" (7) and the malicious wife who is "*a cancer* or *a gangreane*, in the bones of him that hath her" (11). With the *memento mori* of derelict duty and the maladies of deliberate malice firmly fixed in his listeners' minds, Gataker asks "But how may *a Woman* know then whether she be *a Wife* or no?" (13), and refers women to the authority of their *own* consciences to educate them and to amend their faults: "Reade over the Rules that *S. Paul* and *S. Peter* prescribe Maried Women; and examine thy selfe by them. Reade over the *Description* that *Salomons Mother* maketh of *a good Wife;* and compare thy selfe with it. There is set downe *a Paterne* and *a Precedent* for thee" (14). At the end of the page, the Apostles' definition joins those previously offered by Solomon, Gataker, and (one presumes) the definition of wife formulated by the attentive Bible reader: a true wife is "subject and obedient to her Husband as her Head" (14). Hardly surprising news—yet its position in the argument is intriguing in what it gives and takes away: like the key in the back of a "teach-yourself" manual, this answer at once confirms the reader's faith in her mastery of the lesson, *and* counteracts any tendencies toward self-congratulation by forcing her to reexamine her own behavior. Gataker warns that "many by this Rule, will hardly prove *Wives,* being *Mistresses*" (14) who overrule their husbands and turn them into "Bond-men" (16). Hard on the heels of this image of inverted order comes Solomon's mother's description: a wife is "not a *good Housewife* onely in the House, but *a good Wife* also to *her Husband,* that doth him good all his daies" (18). By yoking the two most extreme definitions—the enslaving mistress (associated in the text with pagan Rome and Persia) and the diligent, altruistic housewife—"willing subjection" appears the more attractive alternative. And, in letting a *woman* offer the final definition of an ideal wife, the canny ideologist disguises both his own viewpoint and the voice of patriarchal power.[15]

3

How did women view the submissive role model that preachers offered them? Some Puritan women, such as Lucy Hutchinson, actively promoted it: she proudly describes herself as her husband's "very faithful mirror, reflecting truly, though but dimly, his own glories upon him . . . (63).

Yet Puritan women were but one part of the divines' school for wives, and, moreover, not representative of the entire female population. The preachers' relentless insistence upon the necessity of female subjection suggests that women displayed considerable resistance to the role model set forth in sermons and conduct books. Unruly women and disobedient wives from all social classes recur in contemporary records. Some, like Lady Elizabeth Hatton, were aristocrats who circumvented their husbands' authority through premarital settlements that allowed them to retain control over their own property. But female insubordination was common even in the nongentry, where wives are generally presumed to be economically dependent *femes covertes*. In the act books of the ecclesiastical courts, then the adjudicators for most moral and sexual offenses, wives' unruliness is cited as a cause of marital discord and separation. An unnamed Essex husband, in 1562, assured the court that he would willingly keep his wife, "but she wanting government doth absent herself." When a presentment was brought against another Essex husband in 1574 for "turning away his wife, saying that she is not his wife," he replied that "he turned her away, for that she would not be ruled" (Emmison 163, 162).

Female insubordination could manifest itself in more ominous ways than desertion: cited for noncohabitation, Edward Rawlins of Rayleigh appeared before the Essex ecclesiastical court in 1597; the wardens testified that "his wife is willing to dwell with him, if he would suffer her." Rawlin's defense—"He discontinueth from her for fear she would poison him"—failed to sway the court, who ordered him to return to her and (one assumes) her dubious cuisine (Emmison 162). Husband battering is also recorded: at the Middlesex County assizes (October 23, 1621), Dorothy Turner was ordered to appear before the next session of the Peace "to answer for cruelly beatinge and abusinge her husband Anthony Turner" (Jeaffreson 2: 185).

The presence of these unruly wives underlies the preachers' insistence upon absolute male authority as the only means to stem the tide of female insubordination. The preachers themselves found women opposed to the new ideology. At Danbury, Essex, in 1578, Katherine Whithed disrupted a sermon given by the archbishop of Colchester: she "demanded of Mr. Doctor Withers if he were redie to doe his duetie she

was redie to do hers; whereby she trobled him in his sermone and caused the people to make a lafter" (Hair, case no. 272). When revising the conduct book *A godly forme of household government,* John Dod and Robert Cleaver rephrased passages on the husband's authority that might provoke a female readership. While the first edition of 1588 claims: "The husband ought not to bee satisfied, that hee hath robd [robbed] his wife of her virginitie, but in that hee hath possession and use of her will,"[16] the seventh and last edition of 1630 opens with a less extreme statement: "The husband ought not to be satisfied with the use of his wife's body, but in that hee hath also the possession of her will and affections . . ." (Dod and Cleaver, sig. Le). William Gouge complained that the parishioners of his Blackfriars church "murmured" and shifted in their seats when he preached to them on "Domesticall Duties." Faced with the censure of City of London women, the chagrined Gouge reproached their insolence to "God's Ministers who plainly declare their duty unto them"; women, he told them, should remember that the "ministers of the Gospell stand in the roome and stead of Christ." However, to defend himself against future female protest, in the preface to the second and third editions of *Of domesticall duties,* Gouge insists that for every duty for wives he has listed a corresponding one for husbands, and supplies marginal cross-references for both to consult (343).[17]

By the 1640s, especially during the English Civil War and Interregnum, women did more than "grumble": they became activists in many of the new religious sects. At the start of their movements, both Baptists and Quakers allowed women to participate in church government and to preach. Women preachers of the Brownists, prominent from 1641 through 1646, presented unorthodox views on marriage and male authority: Mrs. Attoway supported (and put into practice) John Milton's contention that one could divorce for reasons of religious difference,[18] while Katherine Chidley questioned the doctrine of absolute male authority by claiming that a husband could not dictate his wife's choice of religion: "it is true that he hath authority over her in bodily and civil respects, but not to be lord over her conscience" (26). With this statement, however, Chidley goes beyond championing the dictates of individual conscience; she undermines one of Puritan preaching's rationales for patriarchal authority, the contention that one was obliged to obey father, husband, or king because his authority represented God's will on earth. This undermining of "divine right" as the rationale for social and familial authority was, in Keith Thomas's view, the most important achievement of the radical religious sects of the English Civil War, for "once religious sanction had been taken away or weakened then the whole society was subject to challenge and rescrutiny

THE PRIVATE WOMAN

from a new point of view—that of reason, natural right, popular consent, and common interest" (336). "Natural freedom" and government by consent are ideas more associated with Enlightenment thought than with Jacobean England. Yet preachers, through their insistence upon "willing subjection," and their female audience, who proved remarkably resistant, seemed aware of the fragility of that current domestic hierarchy. Recall, for a moment, St. Anne's Church in London; the period, the 1620s: William Gouge lectures his flock on the unwelcome topic of domestical duties. In Gouge's recalcitrant audience, shifting and grumbling in the church at Blackfriars, the seeds of later revolts are already present.

Notes

Another version of this essay was presented at the 1983 conference of the International Society of the History of Rhetoric; the writer thanks Catherine Belsey and Clive Hart for their generous advice and Sue Emery and Michael Rothwell for preparing the manuscript.

1. Albertus Magnus claimed virginity was the sign of pure and total love of God, while Aquinas believed the Christian seeking perfection would lead a life of virginity because he would thereby be able to contemplate the truth freed from worldly distractions. Also see John K. Yost, "The value of married life for the social order in the early English Renaissance," *Societas* 6 (1974): 26. Quoted material is from Thomas Becon, *The golden boke of holy matrimony* (1560) in *Worckes,* vol. 2 (London: John Day, 1564), 1–2.

2. Ephesians 5 (on wives' obedience of husbands) and 1 Corinthians 2 (mutual duties of spouses) are cited in numerous wedding sermons such as William Whately's *Bride Bush* (1617) and William Gouge's conduct book, *Of domesticall duties eight treatises* (1622). Genesis 3, Proverbs, Exodus 20, 1 Corinthians 7 and 14, and 1 Peter 3 were also influential in shaping the post-Reformation view of domestic relations.

3. See also Stone 151–220, and Schochet.

4. The common law gives no further restrictions. A husband who beat his wife to death could plead guilty to the lesser crime of manslaughter rather than murder *if* he could prove "only an intent to chastise and not to kill" (Blackstone 4: 200).

5. In 1608 Dr. Gager maintained that it was lawful for men to beat their wives due to women's questionable morality and incapacity for learning; William Heale's refutation. *An apologie for women,* was published in 1609.

6. Until 1752, March 15 was both the civil and the legal New Year's Day (John Richardson, *The Local Historian's Encyclopedia* [New Barnet, Hertfordshire: Historical Publications Ltd., 1981] 124).

7. William Wycherley, *The Plain Dealer* (1677), act 5, scene 3; Daniel Defoe, *Roxana or, The Fortunate Mistress,* ed. J. Jack (Oxford: Oxford University Press, 1964), 148. Quoted in Stone 195.

8. The examining and licensing of schoolmasters, initiated by Mary I, was continued by Elizabeth I, this time in the service of Anglicanism. Elizabeth's injunctions of 1559 forbade any man to teach unless the local bishop had licensed him. The canons of 1571 added the licensing and examination of private tutors (Lawson 90). Christopher Hill claims sermons were the main source of political information because, until 1641,

publication of home news was forbidden, and, although there were privately circulated newspapers, they were beyond the means of the poor (*Society and Puritanism*, 32).

9. Compulsory church attendance is specified in earlier acts, but the 1593 act is the most relevant for the period 1580–1620.

10. Sir Ralph Verney, writing in 1652, warns the overambitious Dr. Denton: "let not your young girl learn Latin, nor shorthand: the difficulty of the first may keep her from vice . . . but the easiness of the other may be a prejudice to her; the pride of taking sermon notes hath made multitudes of women unfortunate. . . ." Quoted in Pearson 215.

11. All biblical citations are from the King James version.

12. Gataker 20.

13. Perkins, "The Order and Summe of the sacred and onely method of Preaching," required that the preacher present the sermon in this order. (Quotations from Perkins are from Haller 134.)

14. The preface to the expanded edition of *Homilies* (1574) makes the promotion of state authority one of the goals of preaching: the homilies should be "preached unto the people, that thereby they may both learn their duty towards God, their Prince, and their neighbors, according to the mind of the Holy Ghost, expressed in the Scriptures . . . to move the people . . . diligently to serve him; every one according to their degree, state and vocation" (Corrie xvii–xviii). For a fuller discussion of the state's use of religion to promote its own authority, see Siegel.

15. Many others besides Gataker believed that the wife's voluntary submission to her husband's will was better than his taming his wife into a token obedience. Whately, in *A Bride Bush*, compared his ideal to a well-trained horse: "she submits her-selfe with quietness, cheerfully, even as a well-broken horse turns at the least turning, stands at the least check of the riders bridle, readily going and standing as he wishes that sits upon his backe" (43). Gouge, in his *Of domesticall duties* was most severe in his claim that a "wife must be milde, gentle, obedient, though she be matched with a crooked, perverse, prophane, wicked Husband: thus shall her vertue and grace shine forth the more clearly, even as the Starres shine forth most brightly in the darkest night" (26).

16. [Robert Carr?] 167. The British Library catalogue gives Robert Carr as the author of the 1588 edition.

17. For the list of corresponding duties, see the fifth and sixth pages of the unnumbered 1630 preface; the "complementary" duties of husband and wife do not, however, suggest a relationship of equals: for example, Gouge claims that the husband's duty is to assert his authority as head of household, and the wife's is to obey.

18. In his "Women and the Civil War Sects," Keith Thomas maintains that preaching by women began in certain Baptist churches in Holland, that by 1636 the phenomenon had reached Massachusetts, and London by the 1640s (324). Even more progressive were the Quakers, who took the orthodox tenet of equality of souls as justification for both male and female Friends to speak and prophesy on a basis of complete equality. Women were among the first Quaker preachers in London, Oxford and Cambridge, Dublin and the American colonies (Thomas 325); from 1671 onward Women's Meetings were organized on a countrywide basis to allow women a share in church government; however, even by the start of the eighteenth century, women did not enjoy wholly equal status with men (Arnold Lloyd, *Quaker Society History* [London and New York: Longmans, Green, 1950], 112). For a discussion of the notorious Brownist women preachers, see Lucas; also Williams. The Brownists were a strongly antipapist sect, opposed to idolatry and images, and they argued for the church's independence from state control; for Mrs. Attoway, see Edwards 2: 10–11; 3: 27.

Works Cited

Baker, J. H. *An Introduction to English Legal History.* 2d ed. London: Butterworths, 1979. A clear and concise introduction with excellent bibliography.
Baron and Feme. A Treatise of the Common Law concerning Husbands and Wives. London: Assigns of Richard and Edward Atkyns for John Walthoe, 1700. This and T. E.'s work are the two most important primary sources on the legal status of English women during the early modern period. *Baron and Feme* is more appropriate for post–Civil War than the Elizabethan period.
Blackstone, William. *Commentaries on the Laws of England.* 4 vols. London: J. Weir, 1786. A standard legal reference work, invaluable for those working on the legal background of the early modern period. Volume 4 is especially useful for history of the family.
Camden, Carroll. *The Elizabethan Woman.* Houston: Elsevier Press, 1952. Useful background material on Elizabethan manners and customs; primary sources are not always fully documented.
[Carr, Robert?]. *A godly forme of houshold government for the ordering of private families . . . now newly perused, amended and augmented by John Dod and Robert Cleaver.* London: T. Crede for T. Man, 1588. Possibly written by Robert Carr. Along with Whately, probably the most popular treatise on domestic relations during the 1580s through the 1630s. Remarkably prosaic, it argues for the husband's authority and wife's obedience but also emphasizes the need for monogamy and mutual love.
Cary, Elizabeth. *Mariam the Faire Queene of Jewry.* 1613. Edited by R. Valerie Lucas. Nottingham: Nottingham University Drama Texts, forthcoming. Critical edition (with biography) of the tragedy of Mariam, wife of Herod; the only known Stuart play by a woman writer.
Chamberlain, John. *The Chamberlain Letters.* Edited by Elizabeth McClure Thomson. London: John Murray, 1966. A selection from the correspondence of a gossipy court watcher on lives of the great in London, 1597–1626.
Chidley, Katherine. *The Justification of the Independent Churches of Christ.* London: William Larnar, 1641. A detailed polemic by leading Brownist woman preacher, arguing for the rights of those who differ with the Anglican church to establish their own churches. Chidley's battle with Rev. Edward Thomas is detailed in Williams and Hill.
Corrie, G. E., ed. *The Homilies of Elizabeth I.* Cambridge: For the Parker Society, 1850. Intended to promote correct Anglican doctrine, the homilies also emphasized the "necessary hierarchy" of social and sexual relationships.
Davies, Kathleen M. "The Sacred Condition of Equality: How Original Were Puritan Doctrines of Marriage?" *Social History* 5 (1977): 563–80. A very comprehensive and clear summary of Puritan preachers' views on domestic relations, showing how most advocated the husband's dominance over his wife; with Haller and Haller's work, this article would be an excellent undergraduate introduction to Puritan views on husband-wife relations.
Dictionary of National Biography, The. Edited by Sir Leslie Stephen and Sir Sidney Lee. 21 vols. Oxford: Oxford University Press, 1921–22. Standard biographical reference work; occasionally difficult to trace women under their own names, as they are often listed in the entry pertaining to their father or husband.
Dod, John, and Robert Cleaver. *A godly forme of houshold government for the ordering of private famlies.* London: Thomas Man, 1630. An expanded version of Robert Carr's original work with greater emphasis on the relations between parents and children, masters and servants. Cleaver's interest in the former led him to publish a conduct book for sons, *Bathshebae's Instructions to her sonne lemuel* (1614).

Dusinberre, Juliet. *Shakespeare and the Nature of Woman.* New York: Macmillan, 1975. Discusses the representation of women in Shakespeare and provides useful background information on Renaissance opinions on female chastity, education of women, and the influence of the church in its creation of a role model for women.

Edwards, Thomas. *Gangraena.* London: T.R. for Ralph Smith, 1646. 3 parts, collected into one volume. A diatribe against the Brownists and other religious sects by a scandalized religious conservative; amusing for its tone of near hysteria and often perversely detailed anecdotes (e.g., transcripts of the letters of Mrs. Attoway, Brownist woman preacher, to her lover).

Elton, Geoffrey R., ed. *The Tudor Constitution.* Cambridge: Cambridge University Press, 1960. Valuable collection of political documents and statutes of the Elizabethan age.

Emmison, F. G. *Elizabethan Life: Volume Two: Morals and the Church Courts.* Chelmsford: Essex Record Office, 1973. Uses evidence mainly from ecclesiastical court records to discuss Elizabethan and Stuart sexual transgressions, illegitimacy, breach of promise, and bigamy. Useful summaries given by Emmison, an expert on Elizabethan popular culture.

Fitz, Linda T. "'What Says the Married Woman': Marriage Theory and Feminism in the English Renaissance." *Mosaic* 13, no. 2 (1980): 1–22. Discusses how ideas of monogamy and mutual love were important for women's greater equality in marriage.

Gagen, Jean. *The New Woman: Her Emergence in the English Drama 1600–1730.* New York: Twayne, 1964. Discusses the figures of the strong, outspoken, assertive women in Stuart and Caroline drama. At times naive, pushing the case that these were precursors of feminism.

Gataker, Thomas. *A Wife Indeed.* London: John Haviland for Fulke Clifton, 1624. Dedicated to an educated woman, Lady Brilliana Harley, and her husband, Lord Robert, this sermon on proper duties of a wife emphasizes female subservience. It is a companion piece to his other works on domestic relations, *A Good Wife Gods Gift* (1624) and *Marriage Duties Briefely Couched Togither* (1620).

George, Margaret. "From Goodwife to Mistress: The Transformation of the Female in Bourgeois Culture." *Science and Society* 37 (1973): 152–77. Very lively and wide-ranging account of Protestant clerics' role model of the submissive wife and women's responses to it, including discussion of *The Women's Sharpe Revenge* and Mary Astell's *Reflections upon Marriage.*

Glanz, Leonore M. "The Legal Position of Women Under the Early Stuart Kings and the Interregnum 1603–60." Diss. Loyola University of Chicago, 1973. Dry but comprehensive account of women's legal rights, especially regarding ownership of property, business activities, inheritance, wardship, and aristocratic title; good use of primary legal sources and court cases.

Gouge, William. *Of domesticall duties eight treatises.* London: John Haviland for William Bladen, 1622. With Dod and Cleaver's, the most influential treatise on domestic relations for the pre–Civil War period (seven editions between 1622 and 1630). Argues for the husband's almost-absolute authority over his wife; met with resistance from women in Gouge's London parish of Blackfriars (detailed in the introduction to the 1630 edition).

Hair, Paul, ed. *Before the Bawdy Court: Selections from Church Court and Other Records Relating to the Correction of Moral Offences in England, Scotland, and New England 1300–1800.* London: Elek Books, 1972. Transcripts (in original spelling) of court cases regarding sexual transgressions. Very little analysis; best used in conjunction with Emmison.

Haller, William. *The Rise of Puritanism.* New York: Columbia University Press, 1938. Very comprehensive historical work on the development of Puritan preaching, the rhetorical training of preachers, and biographies of individual divines.

Haller, William, and Malleville Haller. "The Puritan Art of Love." *Huntington Library Quarterly* 5 (1941–42): 235–72. An excellent introduction to preachers' views on the relationship between husband and wife; with Davies, recommended for undergraduate background reading.

Heale, William. *An apologie for women. Or an opposition to Mr. Dr. G{ager} his assertion. Who held in the Act at Oxford. Anno. 1608. That it was lawful for husbands to beate their wives.* Oxford: Joseph Barnes, 1609. Reprinted in the English Experience series, published in New Jersey by Walter J. Johnson, Inc., 1974. Argues against wife beating on grounds of civil, natural, and divine law, claiming that the husband's kind treatment and persuasion of his wife were the best means of ensuring obedience.

Hill, Christopher. *Society and Puritanism in Pre-Revolutionary England.* 1964. Reprint. London: Secker and Warburg, 1966. Extremely thorough work, based on primary sources, on the radical and innovative aspects of Puritan thought and its influence upon pre–Civil War culture.

———. *The World Turned Upside Down.* Harmondsworth, Middlesex: Penguin Books, 1975. Originative work on social change during the English Civil War; especially good on Puritan religious sects such as the Levellers and Brownists.

Hogrefe, Pearl. "Legal Rights of Tudor Women and the Circumvention by Men and Women." *Sixteenth Century Journal* 3 (1972): 97–105. Discusses ways in which aristocratic women such as Bess of Hardwick overcame the restrictions placed upon *femes covertes*.

———. *Tudor Women: Commoners and Queens.* Ames: Iowa State University Press, 1975. A bit thin on the legal and historical background but good on lives of individual aristocratic women who were active as scholars, patrons, writers, or in business.

Holdsworth, Sir William. *A History of English Law.* 5th ed. 16 vols. 1942. Reprint. London: Methuen and Co., 1966. A standard legal history. Volume 3 is very useful on legal rights of women during the Renaissance, especially regarding wardship, inheritance, ownership of property, and dower.

Hull, Suzanne M. *Chaste, Silent and Obedient: English Books for Women 1475–1640.* San Marino, Calif.: Huntington Library, 1982. Informative guidebook to the kinds of recreational, educational, and religious works published for female readers, with detailed summaries of individual texts.

Hutchinson, Lucy. *Memoirs of the Life of the Colonel Hutchinson: The Life of Mrs. Hutchinson.* London: George Bell and Sons, 1905. Adulatory biography of Puritan hero of the Civil War by his wife; her own self-effacing autobiography is of more interest. On other Stuart women's autobiographies, see Mary Prior's *Women in English Society 1500–1800.*

Jeaffreson, J. C., ed. *Middlesex County Records.* 2 vols. Middlesex: Middlesex County Records, 1886. Brief transcripts of cases brought before the Middlesex Sessions; of particular interest are cases of runaway wives, rape, theft by women, infanticide.

Knappen, Marshal. *Tudor Puritanism.* 1939. Reprint. Chicago: University of Chicago Press, 1970. Rather general introduction on Puritan ideology of the family, somewhat thin on primary sources.

Lawson, John. *Medieval Education and the Reformation.* London: Routledge and Kegan Paul, 1967. A social history of education; discusses ways in which education became a means for social control (through restrictions on the kinds of sermons preached and licensing of schoolmasters) under Henry VIII and Elizabeth I.

Leach, A. F. *Educational Documents and Charters.* Cambridge: Cambridge University Press, 1911. Good companion to Lawson: provides statutes giving guidelines for appointment of preachers and schoolmasters to promote correct Anglican doctrine and obedience to the State.

Lucas, R. Valerie. "When Women Preach and Cobblers Pray." Paper presented at the Canadian Society for the History of Rhetoric Conference, 1986. Account of work of Brownist and other women preachers and prophets during the Civil War and their reception by male theologians.

Macfarlane, Alan. *Marriage and Love in England: 1300–1840*. Oxford: Basil Blackwell, 1986. Using contemporary sources, discusses the evolving views of marriage, of relations between spouses and between parents and children; discussion of parent and child relations is particularly full, especially regarding the varying reasons for having children.

Maclean, Ian. *The Renaissance Notion of Woman: A Study in the Fortunes of Scholasticism and Medical Science in European Intellectual Life*. Cambridge: Cambridge University Press, 1980. A pithy and dense work on the theological, political, and medical perception of "woman" by male theoreticians, drawn from primary sources, many of which are quoted extensively.

Pearson, Emily Lu. *The Elizabethans at Home*. Stanford: Stanford University Press, 1957. Elizabethan social conventions, drawn from primary and literary sources. Unfortunately, literary sources are sometimes used as historical proof of certain social practices.

Pollock, Sir Frederick, and F. M. Maitland. *The History of English Law Before the Time of Edward I*. 3 vols. Cambridge: Cambridge University Press, 1911. Standard legal reference work. Volume 1 is useful for rights of single and married women, especially regarding property and inheritance.

Powell, Chilton Latham. *English Domestic Relations 1487–1653*. New York: Columbia Studies in English and Comparative Literature, 1917. Reprint. New York: Russell and Russell, 1972. Old, but still the most comprehensive book on the changes in religious and legal attitudes on relations between spouses during 1487–1653; includes specific cases (such as the debate over Henry VIII's divorce).

Prior, Mary, ed. *Women in English Society 1500–1800*. London: Methuen and Co., 1985. Essays on marital fertility and lactation, bishops' wives, Oxford women and the economy, stereotypes of remarrying widows, recusant women; two excellent bibliographical essays on Stuart women's autobiographies and published writings by Renaissance women.

Schochet, Gordon J. "Patriarchalism, Politics and Mass Attitudes in Stuart England." *Historical Journal* 12 (1969): 413–41. Argues that a patriarchal paradigm—that of father and child—was used by political theorists as a means of delineating the relationship between prince and subject.

Shepherd, Simon. *Amazons and Warrior Women: Varieties of Feminism in Seventeenth-Century Drama*. Brighton: Harvester Press, 1981. Lively survey of the figures of the Amazon, female transvestite, learned lady, and tavern wench in Stuart and Caroline drama. Very good use of contemporary historical material, especially useful for less familiar dramatists such as Beaumont and Fletcher.

Siegel, Paul N. "English Humanism and the New Tudor Aristocracy." *Journal of the History of Ideas* 13 (1952): 450–68. Discusses the ways in which the Elizabethan government used religion to promote subjects' obedience to the monarch.

Snawsel, Robert. *A looking glasse for maried folkes*. London: N. O[kes] for H. Bell, 1610. A conduct book to guide quarrelling couples to living peacefully together again. Takes the dramatized form of "conversations" between four women and a man, including some amusing interchanges between a patient model wife and a spirited "shrew."

Stone, Lawrence. *The Family, Sex and Marriage in England 1500–1800*. London: Weidenfield and Nicolson, 1977. Remarkably comprehensive, drawing on historical,

legal, and literary sources to chart the shift from an authoritarian, patriarchal model for marriage to a more egalitarian, companionate model.

Swetnam the Woman-Hater Arraigned by Women. 1620. Edited by R. Valerie Lucas. Nottingham: Nottingham University Drama Texts, forthcoming. A critical edition of a comedy generated by the Swetnam controversy (the refutation of Swetnam's misogynistic pamphlet by three women respondents). The refutations are reprinted in *The Womens Sharp Revenge,* ed. Simon Shepherd. See below.

T. E. *The Lawes Resolutions of Womens Rights.* London: John More, 1632. Reprinted in the English Experience series, published in New Jersey by Walter J. Johnson, Inc., 1979. With *Baron and Feme,* one of the two primary works on the woman's legal rights for the early modern period. Although it views Eve's transgression as grounds for women's inferior status, it is an extremely sympathetic legal guide directed to a female readership, with numerous accounts of cases. Juliet Dusinberre, in *Shakespeare and the Nature of Woman* (97, n. 65), maintains that the work is originally Elizabethan, as T. E. prepared the book written by one I. J. at the end of the sixteenth century.

Thomas, Keith. "Women and the Civil War Sects." In *Crisis in Europe 1560–1660,* edited by Trevor Aston: 327–40. London: Routledge and Kegan Paul, 1965. Excellent piece that argues that the radical religious sects of the Civil War challenged "divine right" as justification for social as well as familial authority, and countered the patriarchal model for marriage by promoting a more egalitarian view of relations between men and women.

Whately, William. *A Bride Bush.* London: William Jaggard for Nicholas Bourne, 1617. Reprinted in the English Experience series, published in New Jersey by Walter J. Johnson, Inc., 1975. A wedding sermon advocating the husband's near-absolute authority over his wife, attained by persuading her to voluntary submission. A companion piece to *A Care-Cloth* (1624), a treatise on the troubles plaguing marriages and how to cure them.

Williams, Ethyn M. "Women Preachers in the Civil War." *Journal of Modern History* 1 (1929): 561–69. A short but detailed account of the activities of Brownist women preachers in the 1640s.

Wilson, Violet. *Society Women of Shakespeare's Time.* London: John Lane, 1924. Anecdotal accounts of the lives of Lady Hatton, Frances Coke, and others; few primary sources are cited, although much of the documentary evidence seems drawn from Chamberlain's letters.

Women's Sharp Revenge, The. Edited by Simon Shepherd. London: Fourth Estate, 1985. An anthology of women writers' defenses of women, including the Swetnam respondents, *Jane Anger Her Protection for Women,* and *The Women's Sharpe Revenge* (a work possibly by a male author).

Wright, Louis B. *Middle Class Culture in Elizabethan England.* Chapel Hill: University of North Carolina Press, 1935. Reprint. New York: Hippocrene Books, 1980. An excellent and well-documented history of Elizabethan popular culture, especially useful for students of the drama.

Wrightson, Keith. *English Society 1580–1680.* London: Hutchinson and Co., 1982. Immensely readable social history with good use of primary sources; very good section on kinship structures, relations between husband and wife, parent and child. More detailed on post–Civil War than Tudor period.

BETTY S. TRAVITSKY

"His wife's prayers and meditations"
MS Egerton 607

WE HAVE BEEN made sensitive over the last fifteen years to some of the invisible assumptions that have distorted historical and literary research in the past, at least insofar as they relate to European women. Consequently, with just a few notable holdouts, scholars now seem to agree that the historical experiences of women are not engraved in Stone.[1]

The subject of this paper, a manuscript by Elizabeth Egerton, countess of Bridgewater, now housed in the British Library as MS Egerton 607, has largely escaped the reevaluations of historical and literary materials of the last fifteen years,[2] although several commemorators of exceptional women have made mention of its existence and its remarkable author.[3]

While it would be highly misleading to speak of a "tradition" of portrayals of the countess, these commentators uniformly describe her as an "exemplary wife and mother," esteemed for "a very uncommon piety . . . which combined with her beauty, her accomplishments, her youth, [and] her descent" (Walpole 73).[4] These qualities are vividly attested to by the two extraordinary epitaphs composed by the earl and engraved on their tombs. It is rather remarkable that the earl bypassed such public facts about his life as his membership in the Privy Council and his appointment as lord lieutenant and *Custos Rotulorum* of Buckingham and Hertford (Clutterbuck 388), and described himself only in his roles as husband and widower, stating that he

> . . . desired no other Memorial of him but only This,
> That having (in the 19th year of his age) married the Lady *Elizabeth Cavendish,* . . . did enjoy (almost 22 years) all the happiness that a man could receive in the sweet society of the Best of Wives . . . after [whose death] . . . he did sorrowfully wear out 23 years 4 Months and 12 days [as a widower.] (Chauncey 488)

Perhaps the degree of disinterest concerning the countess can best be indicated by the biographical essay in the *DNB* by Francis Espinasse on her husband, "EGERTON, JOHN, second EARL of BRIDGEWATER (1622–1686)." Espinasse describes Elizabeth Egerton's manuscript, in the rather dismissive tone to which we have become sensitive of late, as

John Egerton, second earl of Bridgewater and his countess. Reprinted from Bernard Falk, *The Bridgewater Millions: A Candid Family History* (London: Hutchinson and Company, 1942). By permission of the U.S. History, Local History & Genealogy Division, The New York Public Library, Astor, Lenox and Tilden Foundations. Every effort has been made to locate the copyright holder of this work.

"*his* [the earl's] wife's prayers and meditations, with *his* [the earl's] autograph note, 'Examined by J. Bridgewater.'" This description was apparently included by Espinasse to impress *DNB* readers with the unusual devotion of Egerton to his wife, "a very devout lady," as he continues, "to whom *he* [the earl] seems to have been always passionately attached" (575, emphases mine). Such a description is not totally unlike the listing of Margaret More in the *DNB* under her father's and husband's names (13: 896; 17: 215–16) rather than under her own. Admittedly, the countess was not quite a Margaret More. Still, her relegation to a passing comment in a summary of her husband's life—a relegation that runs counter to the earl's own assessment—provides a striking instance of the near loss of half humankind to our knowledge of the past.

The disinterest of Espinasse and others notwithstanding, the countess has unintentionally left us a treasure trove. Her writings constitute a miscellany that includes original prayers, brief essays on marriage and widowhood, a profession of faith, several (very dreary) poems, and often searing records of her reactions to particular family calamities and threatened calamities. Because a great many of these materials deal with personal and family affairs, a reevaluation of the significance of her manuscript might usefully begin with a synopsis of her life.

Born in 1626, Elizabeth Cavendish was the second daughter of Sir William Cavendish and his first wife, Elizabeth Basset, who was reputed a "very kind, loving and virtuous lady" (Bickley 74).[5] Cavendish, a true grandson of Bess of Hardwick, was created first an earl, later a marquis, and finally the first duke of Newcastle, largely in return for his staunch, self-sacrificing loyalty to the royalist cause. At one time, he served as governor of the Prince of Wales, and he was an active and courageous—if perhaps uninspired—leader of Charles I's army.[6]

Cavendish's daughter Elizabeth, our subject, was married in 1641 or 1642, at the age of sixteen. Her husband was John Egerton, that Viscount Brackley who, as a twelve-year-old, had played the part of the older brother in the famous first performance of Milton's *Comus* (Michaelmas night, 1634), at Ludlow Castle, the home of his grandmother, Alice, countess-dowager of Derby. At the time of their marriage, Brackley was nineteen, and his bride was reportedly "too young to be bedded."[7] Although this was, to all appearances, an arranged, aristocratic marriage of the open lineage type, it proved a companionate one, as well.[8]

In April 1643, Elizabeth Basset died. Sir William remarried in 1644, at the age of fifty-two, choosing for his bride the daughter of Lord Lucas of Colchester, one Margaret Lucas, a young woman then nineteen years of age. Margaret Lucas, this stepmother who was Elizabeth Cavendish's

own age, was to become notable in later times as the rather outlandish Margaret Cavendish, duchess of Newcastle, an author who has been termed "the most volumnious dramatic writer of our female poets" (quoted by Ballard 278).[9] In his later years, Sir William also turned to writing, composing two well-known works on horsemanship as well as poems and plays.[10] Therefore, despite her relatively retired and conventional married life, Elizabeth Egerton had ties, never before noted, with several writers and with prominent persons of interest to a student of seventeenth-century literature and women's history. These included three powerful female personalities: her great-grandmother, Bess of Hardwick; her stepmother, Margaret Cavendish; and her husband's grandmother, Alice, countess-dowager of Derby, the third wife of Lord Chancellor Egerton, before whom *Arcades* and *Comus* had been first presented.

Despite these connections, however, Egerton has left little evidence of either a desire for notoriety or a personal taste for belles lettres. Her manuscript, MS Egerton 607, entitled "True Coppies of certaine Loose Papers left by the Right honorable ELIZABETH Countesse of BRIDGEWATE⟨R⟩ [,] Collected and Transcribed together here since Her Death Anno Domini 1663,"[11] contains only two—justly forgotten—efforts at light composition, "A contemplation upon the Sight of a Cushion" (128–30) and "Made on a Sight of the Countesse of Bridgewaters Picture" (127). During the close to twenty-two years of marriage when John Egerton, in his own words, "did enjoy . . . all the happiness that a man could receive in [her] . . . sweet society" (Chauncey 488), Egerton bore him nine children, three of whom they buried.[12] Perhaps the demands on her time and energy, perhaps a personal bent for the pious similar to that attributed to her mother and sister, precluded Egerton's absorption in relatively worldly matters.

The title of the British Library manuscript indicates that its contents were assembled, after Egerton's death, apparently at her bereaved husband's direction, and were recopied, possibly by an amanuensis. These "Loose Papers," written in a "fair" italic hand (Walpole 73), may in fact be shorter—even considerably shorter—than Egerton's original corpus. The mention, on her monument, that she had composed "divine meditations upon every particular chapter in the Bible written with her own hand, and never (till since her death) seen by any eye but her own, and her then dear but now sorrowful husband" (Chauncey 489), suggests that MS 607—which does not contain these materials—is either incomplete itself or is merely one of the countess's compositions. The great majority of the extant "Loose Papers" are religious in nature, the remainder are domestic, and many combine domestic and religious con-

"Newcastle and His Family." After Abraham van Diepenbeek. Reprinted from Francis Bickley, *The Cavendish Family* (Boston: Houghton Mifflin Company, 1914). By permission of the U.S. History, Local History & Genealogy Division, The New York Public Library, Astor, Lenox and Tilden Foundations. Every effort has been made to locate the copyright holder of this work.

cerns. Most of the entries seem to have been composed at moments of great stress and their composition may perhaps have provided a means for relief of that stress through private transcription.

The writings fall well within the limits allowed the conventional woman of the period, and John Egerton, noting his late wife's "eminent Piety in Composing, and . . . Modesty in Concealing" her work (Chauncey 489), was asserting that his countess remained within the bounds of silence prescribed for the seventeenth-century woman.[13] However, since the manuscript may have been edited by the "sorrowful" "J. Bridgewater" who examined it, or, alternately, may contain the only scattered papers that he discovered among his wife's effects, it is possible that these (now) bound papers do not represent the total range of the

countess's thinking. And they may not represent the evolution of her thinking, either, since the papers may have been deliberately—or even carelessly—disordered by Egerton or by his scribe.[14]

With these provisos in mind, the existing internal evidence—the date of the first entry, and the lack of any earlier dates—suggests that the manuscript's inception took place on June 1, 1648, when the countess had been married for six years. Some of the most poignant entries can be dated approximately: the illnesses of some of her children; the impending arrest of her husband. Her prayers concerning pregnancy and impending childbirth cannot usually be ascribed to any one of her pregnancies with certainty. Some entries, such as her meditations on marriage and on widowhood and her profession of faith, cannot be ascribed to particular circumstances. The last entry must have been written before her death on June 24, 1663. The total of forty-five entries, which extend to 149 pages (plus an index), may span as many as eleven years.

As it has come down to us, the manuscript is difficult to classify traditionally. It is not an ordinary, or regular, "autobiography," if we define that term as "a biography of a person written by himself," and even if we agree with Jean Starobinski that in autobiography, "it is essential to avoid speaking of an autobiographical 'style' or even an autobiographical 'form,' because [in autobiography,] even more than elsewhere, style is the act of an individual."[15] Given the lack of precision about the dates of the "entries" in the manuscript, and the possibility, moreover, that its present order does not agree with the order of its composition, we cannot even classify it, in Starobinski's manner, as "discourse-history," rather than as "*historic* statement" (287–90). Yet it is undoubtedly akin to autobiography, and since it appeared in the century in which the autobiographical genre took wing,[16] it is somewhat disappointing to be unable to consider Egerton's writings an instance of a woman's use of the "Eloquent I."[17]

Our disappointment is perhaps increased when we recall that autobiography had its English inception through a woman, and that several seventeenth-century women made important, even originative, contributions to the genre.[18] Moreover, a careful reading confirms that the manuscript is similar to female autobiographies in its "patterns of relationship and self-identity," and in its "self-discovery of female identity [through the] recognition of another consciousness and . . . the identification of some 'other'" (Mason 209–10): all the entries in MS Egerton 607 are empowered by the relationship of the countess either to God or to members of her family.

Aside from these similarities to female patterns of autobiography, the

manuscript differs from male autobiographies in which "the self is presented as the stage for a battle of opposing forces and where a climactic victory for one force—spirit defeating flesh—completes the drama of the self" (Mason 210; and see Starobinski 289). To read it is to read an instance of Gardiner's formulation that "female identity is a process . . . and that autobiographies by women tend to be less linear, unified and chronological than men's autobiographies" (185). If it is not the case that Egerton writes "predominantly about [her] . . . relationship with the m[a]n in [her] . . . life," it is probably true that her manuscript, however much its origin may have been in part an attempt to keep a spiritual journal, does, often consciously, "negotiate the boundaries of femininity."[19] Nevertheless, considering its largely undated materials and the likelihood that those "entries" at least that are extant were apparently composed infrequently, the manuscript is probably best classified as a journal, or even more precisely, as the "marginalized" literary form that Margo Culley has termed the "periodic life record" (3–26), a form that has earned a great deal of attention recently.

The sober tone of the countess's manuscript is established by the first of the entries, "A Confession of Faith, with Meditation & Prayer" (1–18), an entry that contributes to the reader's impression that these "Loose Papers" may have been part of a "spiritual autobiography that . . . chart[ed] the progress of the pilgrim's soul toward God" (Culley 4).

Generally, this confession is a straightforward statement of Protestant principle, enunciating such basic tenets of Anglicism as the efficacy of faith over works: "neither do I hold I can merit, by my works, but by Gods mercy, for I am a sinner, and such a sinner, that without his great goodnesse, I can hope of no redemption" (5); and "without his grace, my life cannot owne a place in Heaven" (6). Despite these assertions, however, the countess apparently took great comfort in the efficacy of prayer, stating, "neither do I hold Predestination, so as to think I shall be saved, though I be the vilest Creature on earth; but God hath given us the spirit of prayer" (4–6). In addition to faith and prayer, the countess admits her Puritan-like fondness for fasting, as this rather sheepish admission of the habit indicates: "For fasting, 'tis not that I think there is any merit in it, but that I hold a day of Fasting, and prayer, is fitting to goe together" (8–12).

Bolstering her predilections with frequent quotations from Scripture to validate her chosen practices, the countess shows herself a pious and knowledgeable daughter of the Reformation: "now we may see that by Faith, prayer and fasting, we may obteyne favour with God our Heavenly Father; yet we must have repentance, but it must come from the bottome of our heart" (10). We may well believe that this private

meditation speaks the thoughts of the countess's heart when we read its conventional, but fervent conclusion:

> . . . give me I beseech thee ever a watchfull knowledge of thy truth, that I may not suddenly be taken, when thou o God shalt call me, but that I may be ready to see thee the light of my salvation; Lord give me and continue me in Holy devotion to thee, and that I may not be ledd by the Devill, to any vile actions, or thoughts against thy divine Majesty, still keepe me from all sinne and prophanesse against thy Holy Church; make me to heare of Joy and gladnesse, that the bones which thou hast broken may rejoice, let thy merciful kindness be ever upon me, and make me still more and more put my whole trust in thee, o God, in thee o Father, Sonne and Holy Ghost. (17–18)

In recent years, texts by other Renaissance Englishwomen that deal with religious preoccupations have gained the attention of scholars (Hannay, Travitsky), and the original prayers that compose so great a part of Egerton's manuscript can now be examined with relative ease in the context of similar materials written by other Renaissance Englishwomen. The source that, to my knowledge, presents the most voluminous as well as the most obvious parallels to Egerton's compositions is Thomas Bentley's *Monument of Matrones: conteining seven severall Lamps of Virginitie* (1582), which includes tracts, catechisms, and prayers by well-known and more obscure Renaissance women (as well as some by men). These authors include Elizabeth Tudor (Lamps 2 and 3); Catherine Parr (Lamp 2); Lady Jane Grey (Lamp 2); Anne Askew (Lamp 2); Frances (Manners) Neville, Lady Abergavennie ["Abugavennie"] (Lamps 2 and 5); and Lady Elizabeth Tyrwhit (Lamp 2). The materials in Bentley's encyclopedic *Monument* range from well-known publications such as Catherine Parr's *Lamentation* and prayers pronounced by Elizabeth Tudor on public occasions such as her coronation day, to the private, otherwise unpublished devotions of Lady Abergavennie, and include many unattributed or loosely attributed writings as well.

In those prayers pronounced on public occasions or formulated for the unusual situations of exceptional women in either approved or frowned-upon positions, there is little that is relevant to the quiet affairs of the countess of Bridgewater. But there are obvious parallels between the prayers titled by Egerton "A Meditation mixt with Prayer" (50–52), "A Prayer before the receiving the Communion at Easter" (56–59), and "A Prayer before receiving the blessed Sacrament" (71–73), and prayers by Tyrwhit entitled "A Confession to be said before Morning praier," and "The conclusion after Evening praier" (Lamp 2, 103–4, 136–37); and by "Abugavennie" titled "A praier to be said before or after the Sermon," and "A praier to be said before the receiving of the Lords Supper" (Lamp 2, 162, 163–66).

More dramatic are the many prayers that Bentley records that relate to childbearing. Considering the religiosity of the Renaissance worldview, the nightmarish state of obstetrical practice during the Renaissance, the lack of effective contraception, and the fact of high maternal mortality,[20] concern and prayer on the part of the childbearing Renaissance woman are understandable. Bentley includes sixty-one folio pages of "Praiers to be said of women with child, and in child-bed, and after their deliverie" (Lamp 5, 95–156). Included among these supplications are such ominous titles as "A praier to be said in long and dangerous travell" (112); "If the woman have verie sore labour, and be long in travelling, and in danger of death, then let the mid-wife, and all the women assistant about hir, kneele downe, and praie one after another, hartilie and earnestlie, as followeth" (138–48); "When she is departing, and yeeldeth up the ghost, then adde and saie this that followeth" (148–49); and "Another praier while she yeeldeth up the ghost" (149).

It is not surprising, considering that Elizabeth Egerton was pregnant at least ten times, that her manuscript contains eight prayers concerning her pregnancies and labors. Although, as noted above, these prayers cannot be connected with specific pregnancies, the most poignant among them reflect the dangers to which she had been subject and some of the terrors and losses she had experienced. (Egerton herself was ultimately to die "in child-bed" [Espinasse], although she, of course, did not know her fate when she composed these materials.) "A Prayer when I continued with Child, after I thought I should have fallen in Labour" (35–37) and "Upon recovery out of a sicknesse after Delivery" (109–11) remind us that high rank did not shield the early modern woman from the hazards of childbirth.[21]

With so somber a backdrop in mind, we can empathize with the relief that must have been vented in Egerton's "Prayer after delivery, before receiving the Communion on Christes day" (68–71). However, a twentieth-century reader who can assess seventeenth-century medical knowledge and practice in the light of subsequent advances realizes that the perils attendant on childbearing and rearing did not end with a safe delivery in the seventeenth century. Further consideration of Elizabeth Egerton's manuscript brings this point home with great force, for the most moving of her entries are those concerning the deaths and illnesses of three of her children (see above, n. 12).

A particularly touching set of three consecutive entries on this subject records the countess's efforts to come to grips with the pain of her daughter Katherine's death. The series begins with the unaffected heading, "When I lost my Deare Girle Kate" (120). "My sorrow is great I confesse," the countess begins, "I am much greeved for the losse of my deare Girle Keatty who was as fine a Child as could be." The lines that

THE PRIVATE WOMAN

follow, filled with intimate details about this child who "was but a yeare and Ten Months old, when, by the fatall disease of the smale pox, it was Gods pleasure to take her from me" could serve as a seventeenth-century character. Charming Keatty, we learn,

> . . . spoke any thing one bid her, and would call for any thing at Dinner, and make her mind knowne at any time, and was kind to all, even to strangers, & had no Anger in her; . . . She was so good, She never slept, nor played, at Sermon, nor prayers; . . . She took delight in nothing but me, if She had seene me; if absent ever had me in her words, desiring to come to me, but She now is not in this world, which greeves my heart, even my soule, but I must submitt, & give God my thankes, that he once was pleased to bestowe so great a blessing as that sweet Child upon me. (120)

We admire Egerton's resolution and empathize when it breaks down in her next entry, "On the same occasion" (122). She begins calmly,

> It was Gods pleasure to afflict me, and not her, in calling her from me, for he hath made her happy, giving her the Joyes of Heaven, . . . the Kingdome of Heaven, it is of sweet Children, so innocent; thus do I not doubt her happinesse, but yet greeve I for my owne losse, and knowe it was gods punishment for my sinnes, to separate so soone that deare body and soule of my sweet Babe, though her soule is singing Alelujahs, yet is her sweet body here, seized on by wormes, and turned to dust. . . . (122–23)

Praying for comfort and future blessings, Egerton rouses our unanticipated pity by referring, not only "to us, and our deare ones, [but also to] the Child I am now withall, infusing his spirit of grace into it" (124–25), and reminding us of the hostages to fortune that any seventeenth-century woman was virtually powerless to prevent or protect.

Nor is this petition Egerton's last outpouring over Katherine. "On the same," which continues her accounts of this daughter's death, witnesses to her inability to accept it unfeelingly. The roll of the language warrants that it be quoted in full:

> In the sight of the unwise, the righteous seeme to dy; and their departure is taken for misery, and their going from hence, as utter destruction, but they are in peace; and my deare Jewell to shew she was going to happinesse, when her eyes were sett; (Death having seised upon her) the last word she spoke was to me, when in passion I asked her if I should kisse her, she sayd yeas, Lengthening the word as if she was in high blisse, and lay so sweetly, desiring nothing but her Lord Jesus. Thus her life and death was nothing but sweetnesse, shewing us what we should performe at our last day; And God found her worthy of himselfe; So must my sorrow submitt. (125–26)

In reading the varying tones of this succession of accounts that must have helped the countess to accept Keatty's death, we experience vicari-

ously the stages in the easing of her sorrow.[22] We may also note that aside from their inherent interest, these entries provide yet another set of refutations to one of Lawrence Stone's most controversial contentions—the idea that "low affect," or a low level of emotional attachment, characterized parent-child relationships in early modern England (*The Family*, 98).[23]

Of course, given our growing openness to an understanding of the historical experience of women, MS Egerton 607 would have significance as an unexplored primary document even if it were composed of the countess's original prayers and meditations alone. In addition to these materials, however, the countess's "Loose Papers" also include two brief essays on marriage and widowhood that may have stronger inherent interest for twentieth-century readers than her religious writings.

Occasioned by no event known to or recoverable by us, such as a domestic squabble or her husband's serious illness, and presumably an attempt to clarify her thoughts for herself alone, these two exercises are fairly unique private reflections by a woman on two of the roles that bulked large in the experience of the seventeenth-century Englishwoman. They constitute a female counterpart to the abundance of sixteenth- and seventeenth-century prescriptive works by men concerning the family, which describe the roles of each of its members. Differing in degree, rather than in kind, these prescriptive tracts by Protestant reformers and Roman Catholic humanists reinforced Renaissance patriarchy, perhaps inadvertently opening the way to greater independence for women, but consciously positing the subjection of the wife to the husband.[24] Egerton's essays are both fascinating and instructive in showing us how a contemporary woman might internalize their dicta. Both discuss basic tenets concerning marriage and they therefore are discussed here in tandem.

"Considerations concerning Marriage" begins by acknowledging that "Some account of marriage as an unhappy life, by reason there is an obedience must belong from the wife to the Husband" (78). Such a statement is in itself a miracle of perspective in this period; it addresses a female complaint, not through admonishment from on high but from the point of view of the person who is expected to give obedience; it would be difficult to define the pronoun "some" as referring to anyone but a female. What is particularly interesting, and perhaps difficult to understand for the twentieth-century reader, is the fact that the countess has accepted the subordination contingent on her sex without apparent difficulty. That she has done so is perhaps the greatest tribute that she could render to her husband's sensitivity to her—which we later find suggested in his epitaph.

The foundation of the countess's prescription for a happy marriage is

her acceptance of the subordination of the wife to the husband "since we are commanded, by those that are above our capacity of reason, by God himselfe" (78–79). This is no more than the official doctrine of the church, although the countess dispenses with such traditional props to female subjection as the reminders of the fall of Eve which pepper the writings of her male contemporaries. Furthermore, she introduces a new, highly personal, experiential perspective to her consideration of the commandment to "obedience." "I think that person unhappy," she states, and, again, the reference seems exclusively to women, "that will not esteeme of Matrimony, so as to take that tye into consideration, to inquire with themselves, whether or no they could esteeme of such a person so as to value his Judgment, and in matter of consequence, to yeild to his councell" (79–80). This remark is qualified and clarified by the comments that follow. The writers of the domestic tracts expended a great deal of energy in idyllic descriptions of companionate marriage, but the simplicity of the countess's discussion has a charm, which perhaps emanates from its revelation of her actual experience.

For example, the countess would not have a wife "be in such awe of him [her husband], as a servant of his Master, as not to speake, to contradict the least word he saith, but to have an affection, and love to him, as to a friend, and so to speake their mind, and opinion freely to him, yet not value him the lesse" (ibid.). Although she describes a hierarchical situation that is somewhat mediated by gentleness, there is no doubt that the countess places the heaviest burden for domestic harmony on the wife or that her objectives and prescriptions are different from those of the twentieth-century West:

> if he be hasty, tis fitt she should be silent, giving him no cause to be angry, and then his anger cannot last long; if he be fickle and various, not caring much to be with his wife at home, then thus may the wife make her owne happinesse, for then she may give her selfe up to prayer, which St. Paul speakes as if a marryed person could not; and thus, in his absence, she is as much Gods, as a virgine, and if she have a loving discreet Husband, . . . he will doubtlesse not hinder her duty to God . . . and there is no doubt, but where both these parties do perfectly agree, with passionate and sincere affection, but tis the happyest condition, a friendship never to be broke, as the words of Matrimony say, till death them depart. (81–83)

After noting these instances in which the countess counsels a wife to espouse what we might consider extreme meekness, and in which she recommends religious consolation to the unhappily married woman, we are perhaps less surprised to find a similar instance of conservative thinking in her second essay, "Of Marriage, and of Widdowes." Beginning with the assertion, "I would never have married if I had thought I

could not serve God & obay man" (84), the countess "proves" the value of marriage by citing such evidence of Christ's high esteem for matrimony as his presence at Cana, an example that was also the staple of marriage manuals, sermons, and domestic conduct books: "he it was that allowed of Marriage, and decreed it to be so . . . he knew we might serve him, though he commanded us to obay a Husband, for God is never unjust, to sett us a taske which we cannot performe" (85). Again she is thinking of the woman's part, considering the institution of marriage from the female point of view, but considering it most fundamentally as an adjunct to religious duty.

It is a little surprising, however, to find that she disapproves of the remarriage of widows: "but for widdowes I am in the opinion of St. Paul, not for them to marry, having beene once one man's wife" (86–87). Was it beyond the countess, secure in her marriage to a husband who apparently idolized her, to empathize with less fortunate women? Or could she have suspected a censor who might have been upset to learn that she approved of remarriage? Or had she internalized traditional male discomfort about the widow?[25]

Like other questions about MS Egerton 607, this point is unanswerable. Egerton's writings provide us with many suggestive insights, but while we may enjoy that speech we can coax from them, we cannot totally break the enforced silences that may have initially shaped them and that have hidden them from view until our time. For while the "Loose Papers" of Elizabeth, countess of Bridgewater, may be largely lacking in those qualities that characterize the highest literature and certainly do not fit neatly into traditional literary slots, they nevertheless are far more than "*his* wife's prayers and meditations, with *his* autograph note, 'Examined by J. Bridgewater' " (Espinasse). Previous descriptions of MS Egerton 607, such as Espinasse's, are necessary but not sufficient. The manuscript is much more than the pious effusions of Egerton's wife. If, for reasons that have been made clear, the association of John Egerton with this manuscript cannot be ignored, and if, even more generally, the associations of women with the men in their lives cannot be ignored in considering their work, it is equally clear that Egerton and his ilk cannot adequately serve as a primary focus for a reading of Elizabeth Egerton's writings, or of her sisters'.

Notes

Following a first reference, sources are referred to parenthetically in the text of the essay.

1. Particularly telling parries are those of G. R. Elton, "History According to St. Joan," *American Scholar* 54 (Autumn 1985): 549–55; Joan Kelly, "Did Women Have a

THE PRIVATE WOMAN

Renaissance?" in *Women, History & Theory: The Essays of Joan Kelly*, ed. Catharine Stimpson (Chicago: University of Chicago Press, 1985), 19–50; Lois G. Schwoerer, "Seventeenth-Century English Women Engraved in Stone?" *Albion* 16, (Winter 1984): 389–403.

2. For examples of literary reevaluation, see the essays by Judith Gardiner, "On Female Identity and Writing by Women," and Elaine Showalter, "Feminist Criticism in the Wilderness," in *Writing and Sexual Difference*, ed. Elizabeth Abel (Chicago: University of Chicago Press, 1982), 177–90 and 9–36; and Mary G. Mason, "The Other Voice: Autobiographies of Women Writers," in *Autobiography: Essays Theoretical and Critical*, ed. James Olney (Princeton: Princeton University Press, 1980), 207–35. For an example of historical reevaluation, see Carole Levin, "Lady Jane Grey: Protestant Queen and Martyr," in *Silent But for the Word*, ed. Margaret Hannay (Kent, Ohio: Kent State University Press, 1985), 92–106.

See Sara Heller Mendelson, "Stuart Women's diaries and occasional memoirs," in *Women in English Society 1500–1800*, ed. Mary Prior (London: Methuen, 1985), 180–210, which discusses writings like Egerton's and refers glancingly to Egerton's manuscript.

I thank the British Library for allowing me to quote portions of BL MS Egerton 607 here.

3. Among them are George Ballard, *Memoirs of Several Ladies* . . . (1752); reprint, Detroit, 1985); Francis Bickley, *The Cavendish Family* (1914); Henry Chauncey, *The Historical Antiquities of Hertfordshire* (1700); Robert Clutterbuck, *History and Antiquities of the County of Hertfordshire* (1815); Francis Espinasse, "Egerton, John, second Earl of Bridgewater (1622–1686)," *DNB* 6: 574–75; Henry John Todd, ed. *Poetical Works of John Milton* . . . (1852); Horace Walpole, *Catalogue of Royal and Notable Authors* . . . (1806); Thomas Warton, ed. [Milton's] *Poems upon Several Occasions* . . . (1791); and Jane Williams, *Literary Women of England* . . . (1861).

4. The only exception to this tradition seems to be Bernard Falk, *The Bridgewater Millions: A Candid Family History* (London: Hutchinson and Co., 1942), which is an account that hangs upon Falk's ability to build scandal from straw. Available depictions of the couple confirm the impression of their good rapport, including the appended Diepenbeek print, reproduced by Falk with the caption, "Happy Egerton Couple," which shows the two seated together in altogether conventional fashion, the countess modestly avoiding her husband's eye while he speaks eagerly to her. Another appended print including the Egertons, as well as other offspring of the duke of Newcastle, appears in the 1743 edition of the duke's *Methode* (see n. 10), *A General System of Horsemanship In all it's {sic} Branches*.

Both these depictions are after a drawing by the Flemish artist Abraham van Diepenbeek, who was in England, at the command of the king, to work on some commissions for Cavendish. I thank Diane Russell of the Department of Prints and Engravings at the National Gallery of Art for this information about the two depictions.

5. Elizabeth Basset was the only daughter and heir of William Basset, Esquire, of Blore in Staffordshire. At the time of her marriage to Sir William in 1618 or 1619 she was the widow of Henry Howard, third son of Thomas Earl of Suffolk, and the mother of a young daughter. She proved an exemplary wife to Cavendish, bearing him eight children (Arthur Collins, *The Peerage of England* . . . [London, 1812], 3: 154).

6. Ibid., 1: 318; and Charles Harding Firth, "Cavendish, William, Duke of Newcastle (1592–1676)," *DNB* 3: 1273–78.

7. Margaret Cavendish, *Life of the First Duke of Newcastle* (1656; reprint, New York: J. M. Dent and Sons, 193?), 96. Her "portion was £12,000 the moiety whereof was paid

in gold on the day of her marriage, and the rest soon after," according to her stepmother (96). The lavish celebration of the nuptials included a vocal recital in which Elizabeth Egerton's new sister-in-law, Lady Alice Egerton of *Comus* fame, was joined by Henry Lawes, the musician (Falk 65). According to Warton, Lawes set music for a poem by John Birkenhead entitled "Anniversary on the Nuptials of John, earl of Bridgewater, Jul. 22, 1642" (130).

8. The terms, of course, are Lawrence Stone's (*The Family, Sex and Marriage in England 1500–1800* [New York: Harper and Row, 1977]), defined by him on 3–10.

9. In our own time, Margaret Cavendish has been the object of a great deal of interest. For recent studies, see Mary Beth Rose, "Gender, Genre, and History: Seventeenth-Century English Women and the Art of Autobiography," in *Women in the Middle Ages and the Renaissance*, ed. Mary Beth Rose (Syracuse: Syracuse University Press, 1986), 245–78); also Mason.

10. Sir William Cavendish, *La Methode et Invention Nouvelle de dresser les Chevaux* (Antwerp, 1657); *A New Method and Extraordinary Invention to Dress Horses, and Work them, according to Nature; as also to Perfect Nature by the Subtlety of Art; which was never found out but by the thrice noble, high, and puissant Prince, William Cavendish . . .* (London, 1677). Sir William claimed that the 1677 book was a new work (*DNB* 3: 1276–77).

Sir William was not the only member of Egerton's natal family to write; her older sister, Lady Jane, who married Charles Cheyne (Cheiny), Esquire, later Viscount Newhaven, composed an unpublished work of "devout reflections" (Williams 83).

11. In the quotations from the manuscript in the text, conventional abbreviations are silently expanded.

12. Their names and known dates are: John (November 9, 1646–March 19, 1700/01); Sir William (August 15, 1649–December, 1691); Thomas (March 16, 1651–November 2, 1685); Elizabeth (August 24, 1653–1709); Charles (March 12, 1654–January 30, 1712); Henry (June 2, 1656–June 29, 1656); Stewart (March 8, 1660–1678); Frances and Katherine, whose birth and death dates are unrecorded and who died early (Clutterbuck 392). The only information on these infants that I have been able to secure is the following statement, which is taken from her epitaph: "of which Children three, viz. Mr. *Henry Egerton* her fifth Son, Mrs. *Frances* her eldest, the Lady *Katherine Egerton* her third Daughter lye here interred, dying in their Infancy" (Chauncey 488). One assumes that a tenth, nameless child died with Elizabeth Egerton, "in childbed," on June 14, 1663 (Espinasse 575), although there is no record in the Clutterbuck pedigree.

13. Suzanne Hull, *Chaste, Silent and Obedient* (San Marino, Calif.: Huntington Library, 1982).

14. On the difficulties of interpreting manuscripts like the countess's, which may have been edited, see Margo Culley, *A Day at a Time* (New York: Feminist Press, 1985), 15–17. I thank Virginia W. Beauchamp for her reference to Culley during a valuable conversation about this essay.

15. Jean Starobinski, "The Style of Autobiography," in *Literary Style: A Symposium*, ed. Seymour Chatman (New York: Oxford University Press, 1971), 285.

16. James Olney, "Autobiography and the Critical Moment," in Olney 12.

17. See Joan Webber, *The Eloquent 'I' . . .* (Madison: University of Wisconsin Press, 1968).

18. Rose discusses Margaret Cavendish, Egerton's stepmother; Anne, Lady Halkett; Ann, Lady Fanshawe; and Alice Thornton. Mendelson discusses twenty-three Stuart women and appends a valuable listing of their published and unpublished "diaries and occasional memoirs"; Betty Travitsky provides excerpts from the published diaries of

Margaret Hoby and Anne Clifford, as well as from intimate writings addressed by several seventeenth-century women to their husbands and children (*Paradise of Women* [Westport, Conn.: Greenwood Press, 1981], chap. 2).

19. Sandra Findley and Elaine Hobby, "Seventeenth-Century Women's Autobiography," in *1642: Literature and Power,* ed. Francis Barker et al. (Colchester: University of Essex Press, 1981), 13.

20. See especially Percival Willoughby, *Observations in Midwifery* [first printed and edited by Henry Blenkinsop] (1863); reprinted with intro. by John L. Thornton (Yorkshire: S. R. Publishers, 1972), esp. 11–12, 31–34, and 273–75. See also Hilda Smith, "Ideology and Gynecology in Seventeenth-Century England," in *Liberating Women's History,* ed. Berenice Carroll (Urbana: University of Illinois Press, 1976), 97–115.

21. If anything, the reverse may have been true. See Dorothy McLaren, "Marital Fertility and Lactation 1570–1720," in Prior 22–53; and Ralph Houlbrooke, *The English Family, 1450–1700* (New York: Longman, 1984), esp. 127–33.

22. For an instructive discussion of these stages and their expression in Renaissance poetry of mourning, see G. W. Pigman, *Grief and the English Renaissance Elegy* (Cambridge: Cambridge University Press, 1985).

23. Among those who have contested the point are Houlbrooke (esp. 134–40) and Schwoerer.

24. Chilton Powell provides a sound introduction to these materials in *English Domestic Relations 1487–1653* (New York: Columbia University Press, 1917). For a balanced discussion of the effects on women of the Protestant and Catholic faiths, see Natalie Davis, "City Women and Religious Change," in *Society and Culture in Early Modern France,* ed. Natalie Davis (Stanford: Stanford University Press, 1975), 65–95.

25. Charles Carlton, "The Widow's Tale: Male Myths and Female Reality in 16th and 17th Century England," *Albion* 10 (Summer 1978): 118–29.

Works Consulted

Primary

Bentley, Thomas. *The Monument of Matrones: conteining seven severall Lamps of Virginitie, or distinct treatises.* . . . London, 1582. A massive storehouse of religious materials by and for Renaissance women; the sole repository of many otherwise unrecorded pieces; and a valuable clue to the expectations of the period for women.

Cavendish, Margaret. *Life of the 1st Duke of Newcastle.* 1656. Reprint. New York: J. M. Dent and Sons, 193?. An account as fascinating as it is true to the character of the eccentric Margaret Cavendish; useful primarily for information on the duke and herself.

Clinton, Elizabeth. *The Countesse of Lincolnes Nurserie.* 1622. The only known writing of the period by an Englishwoman on the experience of breast-feeding; a valuable testimony to the efficacy of the exhortations to breast-feed addressed to contemporary women by the humanist and Protestant reformers.

Egerton, Elizabeth, Countess of Bridgewater. BL MS Egerton 607. A manuscript that is perhaps best described as a "periodic life record," in Margo Culley's phrase.

Joceline, Elizabeth. *The Mothers Legacie to her unborn childe.* 1624. A poignant book of instruction written by a young mother-to-be to the unborn child she did not live to see.

Willoughby, Percival. *Observations in Midwifery.* [First printed and edited from MS by Henry Blenkinsop (1863)]; Reprinted with introduction by John L. Thornton.

Yorkshire: S. R. Publishers, 1972. A fascinating journal recording the experiences of a prominent Renaissance physician who specialized in treating difficult deliveries.

Secondary: Theory, Mainly Feminist

Abel, Elizabeth, ed. *Writing and Sexual Difference.* Chicago: University of Chicago Press, 1982. Useful anthology of essays on writing by women. See especially Gardiner and Showalter, below.

Culley, Margo. *A Day at a Time.* New York: Feminist Press, 1985. The introductory remarks are useful for a consideration of various types of journals as literary forms favored by women.

De Mause, Lloyd, ed. *The History of Childhood.* New York: Psychohistory Press, 1974. An attempt to reconceptualize the history of childhood. See Illick, below.

Elton, G. R. "History According to St. Joan." *American Scholar* 54 (Autumn 1985): 549–55. A ferocious posthumous attack on Joan Kelly's work and on women's history, generally.

Findley, Sandra, and Elaine Hobby. "Seventeenth-Century Women's Autobiography." In *1642: Literature and Power in the Seventeenth Century,* edited by Francis Barker et al., 11–36. Colchester: University of Essex Press, 1981. A somewhat labored attempt to analyze female autobiography in conformity with Marxist thinking about women.

Gardiner, Judith Kegan. "On Female Identity and Writing by Women." In Abel, *Writing and Sexual Difference,* 177–90. An important effort to identify the essential qualities of writing by women.

Kelly, Joan. *Women, History & Theory: The Essays of Joan Kelly.* Edited by Catharine R. Stimpson. Chicago: University of Chicago Press, 1985. A posthumous collection of the thought-provoking essays on Renaissance historiography by this pioneering figure in Renaissance women's studies.

Mason, Mary G. "The Other Voice: Autobiographies of Women Writers." In Olney, *Autobiography,* 207–35. A pioneering study of female autobiography, with attention to several early women writers.

Olney, James. "Autobiography and the Critical Moment: A Thematic, Historical, and Bibliographical Introduction." In Olney, *Autobiography,* 3–27. A valuable history of the development of the study of autobiography and a valuable evaluation of work in the field.

——, ed. *Autobiography: Essays Theoretical and Critical.* Princeton: Princeton University Press, 1980. An important collection. See Mason and Olney, above.

Pigman, G. W., III. *Grief and the English Renaissance Elegy.* Cambridge: Cambridge University Press, 1985. An examination of the elegies of Surrey, Spenser, Jonson, King, and Milton in the context of twentieth-century perspectives on the mourning process and of Renaissance beliefs about death and mourning.

Quilligan, Maureen. "Feminine Endings: The Sexuality of Spenser's Rhyming," Spenser Society Meeting, MLA Convention, New York, December 29, 1986. A fresh analysis of Spenser's use of rhyme to reinforce patriarchal truisms. See her essay in this volume for a related study.

Schwoerer, Lois G. "Seventeenth-Century English Women Engraved in Stone?" *Albion* 16 (Winter 1984): 389–403. A trenchant attack on Lawrence Stone's paradigm for family development and on his analyses of issues relating particularly to women.

Showalter, Elaine. "Feminist Criticism in the Wilderness." In Abel, *Writing and Sexual Difference,* 9–36. A valuable introduction to the varieties of feminist criticism.

Starobinski, Jean. "The Style of Autobiography." In *Literary Style: A Symposium,* edited by Seymour Chatman, 285–94. New York: Oxford University Press, 1971. A definition of the genre on the basis of style.

Waller, Gary. "The Interpellation of the Reader in Renaissance Poetical and Rhetorical Theory," Special Session, MLA Convention, New York, December 28, 1986. An effort to introduce reader-response theory to the study of Renaissance texts. See his essay in this volume for an application to Mary Herbert's writings.

Webber, Joan. *The Eloquent "I": Style and Self in Seventeenth Century Prose.* Madison: University of Wisconsin Press, 1968. Originative study of self-presentation in seventeenth-century prose.

Secondary: Renaissance Women

Ballard, George. *Memoirs of Several Ladies of Great Britain.* . . . 1752. Reprint. Edited by Ruth Perry. Detroit: Wayne State University Press, 1985. Exceedingly painstaking and valuable work on many obscure figures, some discussed only here. The scholarly apparatus provided by Perry offers a useful beginning for the investigator.

Biographium faemineum. The female worthies or, Memoirs of the most illustrious ladies of all ages and nations. . . . London: Printed for S. Crowder, 1766. Too general for the needs of today's scholar, this collection of biographical material is nevertheless noteworthy as one of very few early compilations.

Carlton, Charles. "The Widow's Tale: Male Myths and Female Reality in 16th and 17th Century England." *Albion* 10 (Summer 1978): 118–29. A thought-provoking reexamination of the truisms about the high status of the widow in Renaissance England.

Carroll, Berenice, ed. *Liberating Women's History: Theoretical and Critical Essays.* Urbana: University of Illinois Press, 1976. A useful early collection. See Smith, below.

Davis, Natalie. "City Women and Religious Change." In *Society and Culture in Early Modern France,* edited by Natalie Davis, 65–95. Stanford: Stanford University Press, 1975. An originative essay on the effects of religious change on women of different denominations, examining early modern religious change through a feminist perspective.

Gagen, Jean. *The New Woman: Her Emergence in English Drama, 1600–1730.* New York: Twayne, 1954. A pioneering and still useful study of the emergence of a new type of female character in seventeenth-century drama and an interesting study of Margaret Cavendish as woman and playwright.

Hannay, Margaret P., ed. *Silent But for the Word: Tudor Women as Patrons, Translators, and Writers of Religious Works.* Kent, Ohio: Kent State University Press, 1985. A useful collection of essays on the religious writings of Renaissance Englishwomen. See Levin, below.

Hull, Suzanne W. *Chaste, Silent and Obedient: English Books for Women 1475–1640.* San Marino, Calif.: Huntington Library, 1982. An extremely useful bibliography of conduct books addressed to women in Renaissance England.

Illick, Joseph. "Child-Rearing in Seventeenth-Century England and America." In De Mause, *History of Childhood,* 303–50. A study of childbirth and child rearing in the period.

Levin, Carole. "Lady Jane Grey: Protestant Queen and Martyr." In Hannay, *Silent But For the Word,* 92–106. A nontraditional analysis of the life and writings of the nine-days queen.

———. "Queens and Claimants: Political Insecurity in Sixteenth-Century England." In *Gender, Ideology, and Action: Historical Perspectives on Women's Public Lives,* edited by Janet Sharistanian, 41–66. Westport, Conn.: Greenwood Press, 1986. A nontraditional analysis of women's insecure rule in Renaissance England.

McLaren, Dorothy. "Marital Fertility and lactation 1570–1720." In Prior, *Women in English Society,* 22–53. An analysis of the demographic effects of breast-feeding on different classes of Renaissance Englishwomen.

Mendelson, Sara Heller. "Stuart Women's Diaries and occasional memoirs." In Prior, *Women in English Society*, 180–210. An important, intriguing study of the private writings of several Renaissance women, with a useful apparatus for further study.

Rose, Mary Beth. "Gender, Genre, and History: Seventeenth-Century English Women and the Art of Autobiography." In *Women in the Middle Ages and the Renaissance: Literary and Historical Perspectives*, edited by Mary Beth Rose, 245–78. Syracuse: Syracuse University Press, 1986. A useful examination of the development of autobiography by four seventeenth-century women.

Smith, Hilda. "Ideology and Gynecology in Seventeenth-Century England." In Carroll, *Liberating Women's History*, 97–115. An examination of seventeenth-century obstetrical and gynecological theories and their impact on women.

Travitsky, Betty. *Paradise of Women: Writings by Englishwomen of the Renaissance*. Westport, Conn.: Greenwood Press, 1981. A sampling of writings by Renaissance Englishwomen, 1500–1640.

Williams, Jane. *Literary Women of England. . . .* London: Saunders, Otley and Co., 1861. An early effort to record the writings of English women. The entries occasionally yield information not preserved elsewhere.

Secondary: Renaissance Society

Bridenbaugh, Carl. *Vexed and Troubled Englishmen, 1590–1642*. New York: Oxford University Press, 1968. A fresh, useful, incisive study of unrest in Renaissance England, perhaps somewhat superseded by the recent onslaught of quantitative social history.

Collins, Arthur. *The Peerage of England . . . Augmented by Sir Egerton Brydges*. 9 vols. London, 1812. Standard guide to the family histories of the English nobility.

Hill, Christopher. "Sex, Marriage and the Family in England." *Economic History Review: Essays in Bibliography and Criticism* 31, no. 3 (1978): 450–63. A balanced analysis of Stone's *Family, Sex and Marriage in England*.

Houlbrooke, Ralph A. *The English Family, 1450–1700*. New York: Longman, 1984. A solid social history of Renaissance England.

Macfarlane, Alan. "The Family, Sex and Marriage in England 1500–1800: Review Essay." *History and Theory: Studies in the Philosophy of History* 18, no. 1 (1979): 103–26. An early attack on many of the points in Stone's work which are now generally considered to be weaknesses.

Powell, Chilton. *English Domestic Relations 1487–1653*. New York: Columbia University Press, 1917. A still unsurpassed study of literature about the family in Renaissance-Reformation England. Powell's discussion of the domestic conduct book is particularly valuable.

Prior, Mary, ed. *Women in English Society 1500–1800*. London: Methuen, 1985. Varied and valuable essays. See McLaren and Mendelson for material related to this essay, and the essay by Crawford for valuable bibliographic material on seventeenth-century women's writings.

Stone, Lawrence. *The Crisis of the Aristocracy 1558–1641*. Oxford: Clarendon Press, 1965. Seminal work on the problems and decline of the English aristocracy, 1550–1641.

———. *The Family, Sex and Marriage in England 1500–1800*. New York: Harper and Row, 1977. An ambitious effort to chart the development of the nuclear family through various phases; valuable, but severely criticized, also. See Hill, Macfarlane, Schwoerer.

Walpole, Horace. *Catalogue of the Royal and Noble Authors of England, Scotland, and Ireland . . . enlarged and continued by Thomas Park*. London: Printed for John Scott,

1806. An important early effort to list often obscure writings, including many by women.

Wrightson, Keith. *English Society, 1580–1680*. London: Hutchinson, 1982. A good introduction to English Renaissance social history.

Wrigley, E. A. "Family Limitation in Pre-Industrial England." *Economic History Review* 19 (1966): 82–109. A technical demographic study of population control in early modern England.

Secondary: The Cavendish Family

Bickley, Francis. *The Cavendish Family*. Boston: Houghton Mifflin, 1914. A solid, if slightly old-fashioned, study of the family.

Blaydes, Sophia. "The Poetry of the Duchess of Newcastle: A Pyramid of Praise." *Bulletin of the West Virginia Association of College English Teachers* 6, no. 1–2 (1981): 26–34. A perhaps overly ambitious attempt to characterize Cavendish's poetry as unified in its treatment of the duchess's heroic ideals. Perpetuates some errors such as the belief that the duchess was "the first woman in the English tradition to write for publication" (33).

Chauncey, Henry. *The Historical Antiquities of Hertfordshire*. London, 1700. An antiquarian's mass of information on the shire, including some useful information on the Egertons.

Clutterbuck, Robert. *History and Antiquities of the County of Hertfordshire*. London, 1815. Another massive antiquarian guide to the shire.

Espinasse, Francis. "Egerton, John, second Earl of Bridgewater (1622–1686)." *DNB* 6: 574–75. A standard account of the life of John Egerton which neglects and partially distorts the influence of his wife and the nature of her writings.

Falk, Bernard. *The Bridgewater Millions: A Candid Family History*. London: Hutchinson and Company, 1942. A sensationalized and probably inaccurate account of the history of the Bridgewater family.

Firth, Charles Harding. "Cavendish, William, Duke of Newcastle (1592–1676)." *DNB* 3: 1273–78. A useful summary of Cavendish's life, though it lacks some information important to the student of women's history, such as the name of his first wife.

Paloma, Dolores. "Margaret Cavendish: Defining the Female Self." *Women's Studies* 7, no. 1–2 (1980): 55–66. A moving consideration of the unusual, often eccentric creations of female selves by Cavendish. A discussion of the gender boundaries that Cavendish appears to have found restrictive and to have violated intentionally in her writings.

Todd, Henry John, ed. *Poetical Works of John Milton*. . . . 5th ed. 4 vols. London: Rivingtons, 1852. Vol. 4, esp. 38–46. A dated study, valuable occasionally for details about the Egerton family, particularly in connection with *Comus*.

Warton, Thomas, ed. *Poems upon Several Occasions . . . by John Milton, with notes*. 2d ed. London: For G.G.J. and J. Robinson, 1791. The notes occasionally contain details of interest about the Egerton family.

V

Women and the Sidneian Tradition

BETH WYNNE FISKEN

"To the Angell spirit . . ."
Mary Sidney's Entry into the "World of Words"

"To the Angell spirit . . ." is one of just four known original poems by Mary Sidney.[1] The bulk of her writing fell within the parameters of translation and religious paraphrase which were considered culturally acceptable literary activities for women during her time. However, her verse-paraphrases of Psalms 44–150, which completed a project initially conceived and begun by her brother Philip Sidney would be more rightly termed "imitations" in the classical sense, as they surpass the literalism of her translations of Robert Garnier's *Antonie* and Philippe de Mornay's *Discourse of Life and Death*. In Mary Sidney's verse-translations of the Psalms, she conflated the voice of the psalmist with her own by adding original comparisons and elaborations which reconstructed the matter of the Psalms in a style and context that would illuminate the issues of her contemporary society as well as have personal application to her own spiritual welfare. For her imagery she drew from her public experiences as a woman of responsibility, influence, and power (first as daughter to Henry Sidney, lord deputy of Ireland, and as a youthful lady-in-waiting at Elizabeth's court, and then as wife to the earl of Pembroke). She also drew upon her private perceptions as a woman and a mother to transform her paraphrases of the Psalms into individual exercises in meditation.[2]

Nevertheless, in these verse-translations of the Psalms, despite the inventiveness of portions of her writing, Mary Sidney was still working within the limits of literary ambition observed by such scholarly predecessors as Margaret Beaufort, Margaret Roper and Mary Bassett, Anna (Cooke) Bacon and Elizabeth (Cooke) Russell, and Queens Mary Tudor and Elizabeth, who undertook religious translations, as well as Queen Catherine Parr and Anne Wheathill, who wrote original prayers and meditations.[3] Even the more liberal sixteenth-century humanist attitudes toward women's aspirations as scholars and writers (exemplified in Richard Hyrde's popular translation of Juan Luis Vives's conduct book, *The Instruction of a Christian Woman*) recommended private classical and religious instruction to keep women occupied and focused on the chaste and virtuous life, but cautioned women not to undertake any

The young Philip and Robert Sidney at Penshurst Place. Reprinted from H. R. Fox Bourne, *Philip Sidney* (London: Putnam & Co., Ltd.). Every effort has been made to locate the photographer of this picture.

public displays of learning (including original writing) because their supposed innate moral instability might lead others astray. A woman was encouraged, rather, to copy the moral sentiments of male writers or perhaps to translate such passages from English to Latin, but not to add to or evaluate what she wrote.[4] Such a plan of exercises would inevitably lead women to internalize these prescribed limits and restrict themselves to translation of male religious writing as the appropriate outlet for their learning. As Mary Ellen Lamb explains, to do otherwise "was to risk the charge, perhaps even by their own consciences, of being foolish, indiscreet, vain, and even irreligious, all attributes of loose women" (115).

To go beyond these tacit and internalized boundaries to write original verse on nonreligious subjects, to enter the lists of declared poets, had been attempted by few women previous to Mary Sidney.[5] It is scarcely surprising, then, that her four known original poems were rooted in what Margaret Hannay calls "the usual feminine genres of dedications and epitaphs" (149), which emphasized her temporal subordination to Elizabeth and her creative and emotional obligation to the memory of her brother Philip. To dare to write poetry at all was an act of unprecedented boldness that could only be excused by the guise of humility necessitated by the conventions of her subject matter.

Of these four poems, her finest and most ambitious effort was "To the Angell spirit of the most excellent Sir Phillip Sidney," an elegiac lament dedicated to her brother's memory, which was appended to a scribal manuscript of their verse-translations of the Psalms. As Margaret Hannay suggests, the conjunction of this poem with the admonitory dedication, "To the Thrice Sacred Queen Elizabeth," contained a strong partisan religious and political statement concealed under the conventional humility *topos,* both poems contributing to an ongoing campaign, the canonization of Philip Sidney as a type of martyred Protestant saint. In this way, Mary Sidney covertly reminded the queen (without directly challenging or criticizing her) of the central role she should play in the establishment of Protestantism in Europe as well as in England (149–65). Yet this poem also simultaneously reveals and conceals Mary Sidney's intense personal ambitions as a poet as well as these public aspirations as a political mediator. That such ambition is not shown directly but rather is deflected by the conventional stances of apology and humility is a reflection of her internalization of cultural strictures against women speaking and writing in public modes, which were assumed to be, morally, exclusively masculine domains. As such, "To the Angell spirit . . ." is quietly subversive on a private as well as a public level.

As Mary Ellen Lamb describes them, epitaphs generally "provided non-threatening outlets for their author's learning and poetic skills" (120) because they reinforced the writer's central womanly functions of devotion and dependence as defined by her culture. In *The Triumph of Death* Gary Waller has described "To the Angell spirit . . ." as an intensely personal expression of grief, in particular focusing on Mary Sidney's exaggerated Neoplatonic terms of praise, agitated syntax, and the use of the cryptic phrase "strange passions" as indications of her neurotic attachment to her brother's memory (50–53). Indeed, all of Mary Sidney's literary endeavor centered on her brother's example, whether it was editing his work, translating a play in the classical tradition he approved, penning a translation of a work by de Mornay, his personal friend (perhaps as a companion piece to his own incomplete translation, *Of the Trewnes of the Christian Religion*), finishing his verse-translations of the Psalms, or composing poetry in his memory.[6] Since Mary Sidney's writing was a daunting act of courage for a woman of her time, however, it is readily understandable why she would anchor her efforts in her brother's example; as Waller himself points out, she had available in the successive stages of her brother's work a literary model from which she could teach herself how to write. By first editing Philip's works and translating those of others and by then revising the final irregular stanzas of some of Philip's psalms, Mary Sidney taught herself the art of composition and the discipline of revision (as is apparent in her own heavily emended manuscripts), which eventually enabled her to develop the skill to experiment with an astonishing variety of stanzaic and metrical forms as well as the self-confidence to create a poetic voice distinct from that of her brother. Perhaps, in part, the fervent devotion voiced in "To the Angell spirit . . ." is a reaction to the combination of gratitude and discomfort she felt at having used his example to find her own means of expression. It is not surprising that in this ambitious poem, which resembles the best passages of her *Psalmes*, Mary Sidney found it necessary to camouflage the assertiveness of her style with the self-abnegation of her subject matter. That her theme of humility and dedication to her brother's memory seems overstated is a measure, perhaps, of the giddiness she felt at the height of her own aspiration, the shame at her own "presumption too too bold," and her sincere and intense gratitude for her brother's model of excellence that enabled her to write as herself.[7] Although this bold and elaborately constructed tribute focused on her artistic and emotional dependence on her brother, in the act of writing it she most completely realized her independence from his influence. In "To the Angell spirit . . ." the disjunction between Mary Sidney's internalized definitions of her role as a woman and her burgeoning ambitions as a writer is most apparent.

THIS DISJUNCTION between the assertiveness of her form and the humility of her tone is most evident in Mary Sidney's audacious breach in stanzaic integrity between stanzas 5 and 6:

> And sithe it hath no further scope to goe,
> nor other purpose but to honor thee,
> Thee in thy workes where all the Graces bee,
> As little streames with all their all doe flowe
> to their great sea, due tribute's gratefull fee:
> so press my thoughts my burthened thoughtes in mee,
> To pay the debt of Infinits I owe
>
> To thy great worth; exceeding Nature's store,
> wonder of men, sole borne perfection's kinde,
> Phoenix thou wert, so rare thy fairest minde
> Heav'nly adorned . . . (Ll. 29–39)

This stanzaic rupture reenacts the bold leap of her imagination in an attempt to fuse her efforts with her brother's divine inspiration to complete his work and thereby honor his memory. However, this break in stanza only serves to underscore her central theme of humility as it records her failure to scale the wall of "Infinits." She is left mourning in the mutable world of debts and burdens, unable to either achieve or adequately express even a dim reflection of her brother's worth, "sole borne perfection's kinde." Piling superlative upon superlative does not adequately convey her wonder, as the subsequent defensive insistence that these epithets are not exaggerated indicates:

> . . . Earth justlye might adore,
> where truthfull praise in highest glorie shin'de:
> For there alone was praise to truth confin'de;
> And where but there, to live for evermore? (Ll. 39–42)

Her separation from her brother is absolute and irrevocable and she is left groping in the darkness of her own grief and failure: "Where thou art fixt among thy fellow lights: / my day put out, my life in darkenes cast" (ll. 57–58).

This daring breach of stanzaic integrity as well as the use of stellar imagery in this poem prefigured Ben Jonson's Pindaric ode to Cary and Morison, in which he separated his name between two stanzas to demonstrate his own attempt to re-create "that full joy" known by Morison, who "leap'd the present age, / Possest with holy rage, / To see that bright eternall Day."[8] Jonson also used astronomical metaphors to describe the division between the two friends:

> In this bright *Asterisme:*
> Where it were friendships schisme,

(Were not his *Lucius* long with us to tarry)
To separate these twi-
Lights, the *Dioscuri;*
And keepe the one halfe from his *Harry.*
But fate doth so alternate the designe,
Whilst that in heav'n, this light on earth must shine. (Ll. 89–96)

The brief separation of "twi-/Lights" repeats the major break between "*Ben/Jonson*" (ll. 84–85), reinforcing the theme of "friendships schisme." Stellar imagery in elegiac verse was not uncommon during Mary Sidney's time. In fact, those who eulogized her also included this strain of imagery, perhaps in emulation of her tribute to her brother, as is seen in this example from the "Extra Sonnets of Henry Lok":

Whereby you equall honor do attain,
To that extinguisht lamp of heavenly light,
Who now no doubt doth shine midst angels bright,
While your faire starre makes clear our darkened sky.[9]

Although this type of imagery was not original, Ben Jonson and Mary Sidney were allied in their sophisticated development of variations on the conventions. Mary Sidney tested one vocabulary against another; she was alternately awkward and eloquent, simple and ornate, in an attempt to bridge earth and heaven, much as Jonson's style was, at turns, joking and poignant, proverbial and obscure. That Jonson was familiar with Mary Sidney's verse-paraphrases of the Psalms is demonstrated by the fact that he reminded Drummond of Hawthornden that some of them were written by Philip. Whether he knew or was influenced by "To the Angell spirit . . ." remains an intriguing but unanswered question.

IF DURING the early portion of her career Mary Sidney used her brother's writing as a model for her revisions, it is clear from a comparison of an earlier version of "To the Angell spirit . . ." with the final one that she used the example of her own *Psalmes* to help her improve that piece. Gradually during the process of writing her *Psalmes,* she developed a distinctive style that mirrored the internal conflicts of the psalmist, the fits and starts of anxiety, despair, and renewed hope, the successive stages of doubt and reaffirmation. In order to capture the intensity of the speaker's dilemma, she used a complicated conversational syntax, studded with questions, interruptions, parenthetical interjections and exclamations. (Psalm 51, 34–35; Psalm 62, 19–20; Psalm 85, 212–13; and Psalm 102, 34–36 are just a few striking examples of this characteristic syntax.) To generate a similar illusion of spontaneity in "To the Angell spirit . . ." she added parenthetical

interjections to stanzas 4 and 8 when she revised. In stanza 4 the change from "Behold! O that thou were now to behold, / This finisht long perfections part begun" (ll. 36–37)[10] to "Yet here behold (oh wert thou to behold!) / this finish't now, thy matchlesse Muse begunne" (ll. 22–23) strengthens the overall rhetorical strategy of the poem which is conceived as a direct address to her dead brother, both as a commemoration of his genius and as an apology for her contributions. She seems to be thinking out loud, visualizing her brother standing before her, and as a result the poem seems less formal, more sincerely personal and immediate. In stanza 8, with the addition of "Truth I invoke (who scorne else where to move / or here in ought my blood should partialize)" (ll. 50–51), the illusion created is that of the speaker correcting herself, anxious to speak the truth as well as invoke it. She changed stanza 11 which originally read:

> Had divers so spar'd that life (but life) to frame
> The rest: alas such losse the world hath nought
> Can equall it, nor O more grievance brought
> Yet what remaines must ever crowne thy name (Ll. 67–70)

to:

> Had Heav'n so spar'd the life of life to frame
> the rest? But ah! such losse hath this world ought
> can equall it? or which like greevance brought?
> Yet there will live thy ever praised name. (Ll. 74–77)

Her alteration of syntax to the exclamatory and interrogative modes recreates her agitation at the memory of her brother's death. The return to the declarative mode in the last line serves as a reconfirmation of her faith in the immortality of his fame, enabling her to regain self-possession.

In addition to these changes in syntax, Mary Sidney's other revisions demonstrate an increased self-confidence as a poet, a new willingness to take risks with more elaborate imagery, as is seen in her extension of the comparison of Philip's works with "goodly buildings" that become "Immortall Monuments" of his fame (ll. 64–75) and the baroque comparison of the ink in which her psalms are written with the "bleeding veines of never dying love," the lines of verse becoming "wounding lynes of smart / sadd Characters indeed of simple love" (ll. 80–82). Her experience with patterns of alliteration in her *Psalmes* enabled her to conceive the felicitous phrase: "Nor can enough in world of words unfold" (l. 28).

Although this "world of words" is a fallen one, inadequate to express

the "strange passions" of her heart, her "sences striken dumbe" (ll. 45–46), still it has seized her imagination. It was her brother who first gave her the key to unlock that masculine world:

> To thee pure sprite, to thee alone's addres't
> this coupled worke, by double int'rest thine:
> First rais'de by thy blest hand, and what is mine
> inspird by thee, thy secrett power imprest. (Ll. 1–4)

And it is her gratitude for the possibility of the poem itself that joins with her grief to fuel the intensity of her praise, a praise that will foster his fame, just as his example nurtured her as the maker of that praise.

THE INTERLOCKING rhyme scheme employed within the stanzas composed of seven iambic pentameter lines seems admirably suited to the subject matter of the poem. Each stanza has only two end rhymes, one of which forms double couplets in lines 2 and 3 and lines 5 and 6, mirroring the joint undertaking of Mary and Philip in their verse-translations of the psalms:

> this coupled worke, by double int'rest thine:
> First rais'de by thy blest hand, and what is mine (Ll. 2–3)

and Mary's avowal of absolute devotion to her brother:

> if love and zeale such error ill-become
> 'tis zealous love, Love which hath never done. (Ll. 26–27)

The other rhyme is delayed and separated by these couplets, however, occupying lines 1, 4, and 7 of the stanza, reflecting the ultimate separation of the two:

> I can no more: Deare Soule I take my leave;
> Sorrowe still strives, would mount thy highest sphere
> presuming so just cause might meet thee there,
> Oh happie chaunge! could I so take my leave. (Ll. 88–91)

The return to the exact rhyme "leave" after the couplet resembles the tolling of a bell, recalling Mary from her futile attempt at spiritual reunion with her brother. There is a pivotal irony to the word "leave," as it represents both her farewell to Philip and her anticipated death that will enable her to rejoin him eventually.

In combination with her interlocking rhyme, Mary Sidney constructed a latticework of interlacing allegiances throughout the poem. Her acknowledgment of her brother's inspiration is expressed in words traditionally reserved for God:

> So dar'd my Muse with thine it selfe combine,
> as mortall stuffe with that which is divine,
> Thy lightning beames give lustre to the rest. (Ll. 5–7)

Just as her brother was both a creation and a reflection of God's perfect will, so her brother's poetry was analogous to divine creation: "Thee in thy workes where all the Graces bee." Therefore, in paying tribute to her brother she was also paying tribute to her God because Philip embodied his "Maker's praise" (stanzas 5, 9). Likewise, the ambition that fired the two of them to write their *Psalmes* was not arrogant, but worshipful, sanctioned by God:

> That heaven's King may daigne his owne transform'd
> in substance no, but superficiall tire
> by thee put on; to praise, not to aspire
> To, those high Tons, so in themselves adorn'd,
> which Angells sing in their caelestiall Quire. (Ll. 8–12)[11]

The uneasy defensiveness of these lines has a double origin. First, Mary Sidney must clear herself from the charge of blasphemy for daring to undertake this sacred task of paraphrasing the Psalms, despite Paul's injunction: "But I suffer not a woman to teach, nor to usurp authority over the man, but to be in silence."[12] Not only did Mary Sidney choose not to be silent (although she limited her public voice to passing her manuscript around among a select audience rather than publishing it to reach a larger one), but she also chose to speak on a level with her brother. Therefore, second, she must defend herself not only from being thought presumptuous for translating the Psalms, but also for finishing her brother's work:

> Pardon (oh blest soule) presumption too too bold:
> if love and zeale such error ill-become
> 'tis zealous love, Love which hath never done,
> Nor can enough in world of words unfold. (Ll. 25–28)

To escape such criticism she fashioned an elaborate Chinese box of obligations, placing herself as the last, the smallest, and the least significant in the series. Mary Sidney was inspired by her brother, who emulated David, "thy Kinglie Prophet," in re-creating the "high Tons . . . which Angells sing in their caelestiall Quire" in praise of "heaven's King" (ll. 14, 11, 8). The traditional religious hierarchy in which the woman takes the lowest seat is invoked in this poem to re-create a lineage of poetic inspiration with Mary Sidney the apologetic inheritor. Her confirmation of subordination and inferiority, however, is also a statement of affirmation and poetic purpose. As a woman she must

sit at the end of the footstool when worshipping her God, but still she is claiming her place in this "world of words."

Two disparate vocabularies jostle each other in this poem, the mundane terminology of business and the ornate manner of the miraculous. The contrast between these two levels of diction measures the distance between Mary Sidney imprisoned on an imperfect earth and her brother enshrined in heaven. What was hers was loaned, "imprest" by him and by "double int'rest" his (ll. 2, 4). She owed him "due tribute's grateful fee," a "debt of Infinits," and she was left bereft and counting ". . . this cast upp Summe, / This Reckoning made, this Audit of my woe" (ll. 33, 35, 43–44). Underscoring this language of calculation are constant reminders of incompletion that refer to her contributions: "this half maim'd peece," "the rest but peec't," "in ought my blood should partialize," "passing peece," and "meanest part" (ll. 18, 24, 51, 73, 84). By contrast, her brother was a "Phoenix," a "wonder" beyond "Nature's store" (l. 36), and upon weeping for him, "not eie but hart teares fall" (l. 20), a baroque religious metaphor that emphasizes once again the conjunction of her "zealous love" for both Philip and her God—her mentor on earth and her Master in heaven. This contrast between worldly incompletion and spiritual perfection is deepened by an oscillation in the poem between awkward, convoluted questions and qualifications (as previously noted in stanzas 4, 7, 8, and 11) and simple, eloquent grief: "sadd characters indeed of simple love." This contrast in tone reflects Mary Sidney's insecurity, yearning to be worthy of Philip's "perfection," yet impeded by her own "mortall stuffe," her inadequacy before the "secrett power" of the universe (ll. 4–6), terms that apply equally to her spiritual condition and her poetic aspirations.

ALTHOUGH Mary Sidney ended "To the Angell spirit . . ." with a confession of her failure to achieve union with her brother in either spirit or creative endeavor, the achievement of the poem itself belies the humble and discouraged tone of its final stanzas. Through her writing Mary Sidney forged a bond with her brother that his death could not sever, and through that writing she gave meaning and purpose to her life after his death, dedicating herself to continuing his political Protestantism as well as his poetic idealism by finishing his verse-translations of the Psalms. Yet, the crowning result of her labor was the formation of a style uniquely her own, first seen in her paraphrases of the Psalms and most evident in this tribute to her brother's memory. If the theme of "To the Angell spirit . . ." is her unworthiness, the style in which that unworthiness is expressed is an affirmation of both her ambition and her talent. She paid to her brother "the debt of Infinits I owe," but by

following him, learned to find her own way. The legacy he left her was not only his memory and his work, but the inspiration that impelled *her* to work as well, and the justification for her to do so; in honoring him she created herself. The irreconcilable separation between her spirit and his, bemoaned at the end of "To the Angell spirit . . . ," made possible the achievement of that poem.

Notes

1. "To the Angell spirit of the most excellent Sir Philip Sidney" is appended to J, a copy of A, the Penshurst manuscript of the Sidney *Psalmes*, which was transcribed by John Davies of Hereford. J is in the possession of Dr. B. E. Juel-Jensen and is dated 1599. The other poems are "The Dolefull Lay of Clorinda," c. 1588, first published in *Colin Clouts Come Home Again* (1595); "A Dialogue between two shepheards, Thenot and Piers, in praise of Astrea," c. 1599, published in Francis Davison's *Poetical Rhapsody*, 1602; and "Even now that Care," dated 1599, also appended to this copy of the Penshurst manuscript. See Gary F. Waller, *The Triumph of Death*, 10, 44–64. Although I disagree with Coburn Freer's assessment of Mary Sidney's poetic ability, I am indebted for the title of my essay to his "Countess of Pembroke in a World of Words."

2. Mary Ellen Lamb, in "The Art of Dying," makes a case for the "intellectual self-assertion" of Mary Sidney's translations of Mornay's *Discours*, Garnier's *Antonie*, and Petrarch's *Triumph of Death*, contrasting Sidney's ambitious scholarship with these works' underlying theme of passive womanly heroism expressed through stoical "self-effacement."

See also my essay, "Mary Sidney's *Psalmes:* Education and Wisdom," which discusses Sidney's formation of an original poetic style through her verse-translations of the Psalms.

3. See Travitsky for a history of women writers before Mary Sidney.

4. See Wayne; see also Lamb, "The Cooke Sisters," and Kelso for further discussion of the education of women in the sixteenth century.

5. Anne, Jane, and Margaret Seymour had written Latin distichs commemorating the death of Margaret of Navarre, pub. 1550. Isabella Whitney had published *The Copy of a Letter . . . to her unconstant Lover* (1567) and *A Sweet Nosegay* (1573). Elizabeth Cooke Hoby had written several epitaphs in Latin, Greek, and English for both of her husbands, as well as for her brother, sister, son, and daughter. Katherine Cooke Killegrew wrote a Latin epitaph in preparation for her own death. Mildred Cooke Cecil's daughter, Anne, published four epitaphs on the death of her son in 1584.

6. Mary Sidney edited both his *Arcadia* and *Astrophil and Stella* after her brother's death. Her dual translation of *Antonie*, a faithful rendition of Robert Garnier's *Marc Antoine*, and of *A Discourse of Life and Death*, taken from the original by Philippe de Mornay, was published in 1592. She wrote and revised her verse-translations of the Psalms from the time of her brother's death in 1586 until 1599, when the presentation copy was readied for a projected visit from Queen Elizabeth.

7. Line 25. All references from the final version of "To the Angell spirit . . ." will come from J.C.A. Rathmell, ed., *The Psalms of Sir Philip Sidney and the Countess of Pembroke*, xxxv–xxxviii.

8. Ben Jonson, "To the Immortall Memorie, and Friendship of That Noble Paire, Sir Lucius Cary, and Sir H. Morison," in *The Complete Poetry of Ben Jonson*, ed. William B.

WOMEN AND THE SIDNEIAN TRADITION

Hunter, Jr. (New York: Norton, 1963), 226 (ll. 87, 79–81). All other references will come from this edition.

9. Quoted in Young 193.

10. These lines come from stanza 6 in the early version of "To the Angell spirit . . ." that was mistakenly published in the collected works of Samuel Daniel in 1623 and is reproduced in Waller's *Triumph of Death,* 190–92. All references to the earlier version of this poem will come from this source.

11. The metaphor of Sidney as an angel in a "caelestiall Quire" is, of course, borrowed from her own, earlier, "Dolefull Lay of Clorinda," ll. 61–64.

12. 1 Timothy 2:11–12 (King James version).

Works Consulted

Bornstein, Diane. "The Style of the Countess of Pembroke's Translation of Philippe de Mornay's *Discours de la Vie et de la Mort.*" In Hannay, *Silent But for the Word,* 126–34. Discusses the graceful concision and metaphorical additions of Mary Sidney's translation.

Fisken, Beth Wynne. "Mary Sidney's *Psalmes:* Education and Wisdom." In Hannay, *Silent But for the Word,* 166–83. Discusses the verse-paraphrases of the Psalms as meditative exercises in self-education, poetic and spiritual, for which Mary Sidney drew upon her own experiences in her expanded metaphors and applications.

Freer, Coburn. "The Countess of Pembroke in a World of Words." *Style* 5, no. 1 (1971): 37–56. Some valuable commentary on Mary Sidney's characteristic style in her verse-translations of the Psalms, although Freer's general characterization of her poetic voice as "narrow" seems unwarranted.

Hannay, Margaret P. " 'Doo What Men May Sing': Mary Sidney and the Tradition of Admonitory Dedication." In Hannay, *Silent But for the Word,* 151–65. A convincing argument demonstrating that "Even now that Care" and "To the Angell spirit . . . ," the two dedicatory poems appended to the 1599 Juel-Jensen manuscript of the Sidnean Psalter, couple a lament for Philip Sidney with a disguised political recommendation to Queen Elizabeth that she further his dedication to the Protestant cause in Europe.

———. ed. *Silent But for the Word: Tudor Women as Patrons, Translators, and Writers of Religious Works.* Kent, Ohio: Kent State University Press, 1985. This collection of essays explores the contributions of Renaissance women to the dissemination of partisan religious works, as well as the ways in which these women subtly changed their texts to reflect personal and political perspectives.

Kelso, Ruth. *Doctrine for the Lady of the Renaissance.* 1956. Reprint. Urbana: University of Illinois Press, 1978. Discusses Renaissance ideals and recommendations for the proper education and conduct defining the role of the "lady."

Lamb, Mary Ellen. "The Art of Dying." In *Women in the Middle Ages and the Renaissance,* edited by Mary Beth Rose, 207–26. Syracuse: Syracuse University Press, 1986. Hypothesizes that Mary Sidney's choice of works to translate presents a model of stoic self-denial consistent with patriarchal values but at odds with Sidney's own aggressive scholarship.

———. "The Cooke Sisters: Attitudes toward Learned Women in the Renaissance." In Hannay, *Silent But for the Word,* 107–25. Discusses how the Cooke sisters' internalization of patriarchal strictures led them to limit their work to religious translations, personal letters, and epitaphs.

Rathmell, J. C. A., ed. *The Psalms of Sir Philip Sidney and the Countess of Pembroke.* New York: New York University Press, 1963. The standard text of the final versions of the Sidneian psalter, which is introduced by a ground-breaking essay on the style of Mary Sidney's verse-translations of Psalms 44 through 150.

Travitsky, Betty, ed. *The Paradise of Women: Writings by Englishwomen of the Renaissance.* Westport, Conn.: Greenwood Press, 1981. An anthology of Renaissance women's writing with biographical and critical introductions to individual writers.

Waller, G. F. *Mary Sidney, Countess of Pembroke: A Critical Study of Her Writings and Milieu.* Salzburg: Salzburg University Press, 1979. The first full-length biographical-critical study of Mary Sidney since Frances Young's.

———. "The Text and Ms. Variants of the Countess of Pembroke's Psalms." *Review of English Studies* 26 (1975): 6–18. A valuable reconstruction of Mary Sidney's process of self-education as a poet through analysis of her revisions.

———. "'This Matching of Contraries': Calvinism and Courtly Philosophy in the Sidney Psalms." *English Studies* 55, no. 1 (1974): 22–31. Contrasts two themes, Calvinism and courtly Neoplatonism, in the style of the Sidney psalter.

———, ed. *The Triumph of Death and Other Unpublished and Uncollected Poems by Mary Sidney, Countess of Pembroke (1561–1621).* Salzburg: Salzburg University Press, 1977. Includes previously unpublished variant versions of some of the psalms, as well as an earlier version of "To the Angell spirit. . . ."

Wayne, Valerie. "Some Sad Sentence: Vives' *Instruction of a Christian Woman.*" In Hannay, *Silent But for the Word,* 15–29. Discusses the restrictive influence of Juan Luis Vives' popular conduct book on Renaissance women's intellectual lives.

Young, Frances Campbell. *Mary Sidney, Countess of Pembroke.* London: David Nutt, 1912. The first biographical study of Mary Sidney's life, works and influence as a patron. Includes several of Sidney's letters as well as *The Triumph of Death* as an appendix.

MARGARET ANNE MCLAREN

An Unknown Continent

Lady Mary Wroth's Forgotten Pastoral Drama, "Loves Victorie"

LADY MARY WROTH was a member of the famous Sidney family who set a stamp on Elizabethan and early Jacobean society in the fields of courtesy, literature, and politics. The Sidneys retain an aura of mystique and glamour even (perhaps especially) today in a different, nuclear age. Unlike her uncle Sir Philip Sidney and, later, her aunt the countess of Pembroke, Lady Wroth remained obscure both as a woman and as a writer, in part because she dared to write fiction that dealt with such matters as love and sex, rather than confining herself like her aunt to religious and moral works and to translation. "Worke oth' workes leave idle bookes alone / for wise and worthyer women have writte none," snarled a contemporary satirist of the first and only work by Lady Wroth to appear in print during her lifetime, in 1621.[1]

That book constituted the first part of a prose romance by Lady Mary Wroth, which she dedicated to her best friend Susan Vere (first wife of Philip Herbert, earl of Montgomery, younger brother to William Herbert, earl of Pembroke) and entitled *The Countesse of Mountgomeries Urania*, or, *Urania* (1621). The work, however, was suppressed soon after it was published, on the grounds that it was a roman à clef which caricatured prominent members of the court of James I. Whether Lady Wroth ever intended to have her work published remains in doubt, but there is no question about her seriousness as an author (Witten-Hannah [McLaren] 66–107). Apart from the printed first half of *Urania* (1621), four of her holograph manuscripts survive, a sequence, "Songs and sonnets beginning with poems from Pamphilia to Amphilanthus" (a version of the poems appearing in the published part of *Urania*), a second half of the romance called "The first and second books of the secound part of the Countess of Montgomerys Urania" ("Urania, Part Two"), and an almost completely unknown pastoral drama called "Loves Victorie," which exists in two copies.[2]

Lady Wroth's work, which belonged for so long to what Adrienne Rich calls the "Great Silence" surrounding women's art and history (70), is gradually being rescued from oblivion. The present chapter focuses attention on the play "Loves Victorie," the least known of her productions. Although the following remarks must be partial because access to

"Loves Victorie," f. 1. Huntington MS HM 600. By permission of the Huntington Library, San Marino, California.

only one of the manuscript versions is possible at present, study of this text contributes to our understanding of Lady Wroth's oeuvre as a whole and to our appreciation of the particular contribution made by women to the development of English literature.

Lady Wroth's obscurity, like her father's, was due to unflattering comparison of her work with that of Sir Philip Sidney and the countess of Pembroke, as well as to the lack of significance generally attached to works of art below the first rank. In *Signs Taken for Wonders,* Franco Moretti has recently highlighted the shortsightedness of such an exclusive view of literature. Taking issue with the Annales school of French literary criticism, Moretti objects to the idea that "'normal literature' . . . has no place in criticism. The result is that, at present, our knowledge of literary history closely resembles the maps of Africa of a century and a half ago: the coastal strips are familiar but an entire continent is unknown. Dazzled by the great estuaries of mythical rivers, when it comes to pinpointing the source we still trust too often to bizarre hypotheses or even to legends" (15).

Moretti claims that literary historiography has for too long comprised an *"histoire evenementielle,* where the 'events' are great works or great individuals." He argues instead for the study of literary genres as a whole, including "low" or "mass literatures," and an examination of the "norm" that produces meanings that he believes are far from "predictable" or "banal" (13, 15).

Lady Wroth was exceptional as a Sidney (so she believed) and as a female author who ventured into areas that few of her sex dared to enter, but her work—especially "Loves Victorie"—is genre bound and owes important debts to both earlier and contemporary models. Examining the play in the light of Moretti's theories offers special rewards when it is studied in relation to the literary and social norms prevailing in Lady Wroth's lifetime. "Loves Victorie" is predictable in its surface direction, that of conventional Renaissance pastoral. Its theme could be summed up in the words of a courtier-turned-shepherd in "Urania, Part Two" who complains that he and his fellows "are forced to serve an other master . . . which is the most tirannicall thing called love, heere wee whine, heere wee cry, sigh, lament, write cruell harsh, and unsufferable complaining, and groaning lamentations . . ." (bk. 2, fol. 3bv).

Although both "Loves Victorie" and "Urania, Part Two" are constructed along similarly stereotyped ideological lines, the drama notably lacks the irony underlying the mock shepherd's satirical plaint. In "Loves Victorie," dislocations that arise from the interaction of writer and milieu are typically expressed in silence.

G. F. Waller in *English Poetry of the Sixteenth Century* emphasizes the

significance of ideology in Renaissance literature, a term he glosses as "the system of images, attitudes, feelings, myths, and gestures which are peculiar to a society, which the members who make up that society habitually take for granted" (9). The thrust of his analysis is to examine the pressure of history on texts and thus to apply the tools of structuralism and poststructuralism to Renaissance literature in a manner that usefully complements Moretti's ideas. Waller considers the effect of "oppositional voices," among different writers on the one hand and within a single text on the other (10), while Moretti refers to the "non-univocal" and even "self-contradictory" text (21). Moretti does not exclude univocal analyses but talks of the need to approach the text "not as if it were a vector pointing neatly in one direction, but as if it were a light-source radiating in several directions or a field of forces in relatively stable equilibrium" (22).

Critics like Moretti and Waller thus provide models to show how a "normal" work like "Loves Victorie," a manuscript that seems totally conventional and one that is almost wholly forgotten by literary history, can be seen as a complex, rich text if we approach it as an intersection of discourses, an example of give and take between literary and social structures, and as a field of tensions, contradictions, and absences. Studied in this manner, "Loves Victorie" offers a view of the court and its disguises and obsessions from a point of view that has seldom been considered: the view of a woman author whose images usually link with social norms but sometimes betray significant evidence of nonlinkage, whose writing is marked by conspicuous gaps and even by silence.

Terry Eagleton's comments on Pierre Macherey's Marxist notions concerning "decentred" form are pertinent here:

> For Macherey, a work is tied to ideology not so much by what it says as by what it does not say. It is in the significant *silences* of a text, in its gaps and absences, that the presence of ideology can be most positively felt. It is these silences which the critic must make 'speak'. The text is . . . ideologically forbidden to say certain things; . . . it is always *incomplete.* Far from constituting a rounded, coherent whole, it displays a conflict and contradiction of meanings; and the significance of the work lies in the difference rather than unity between these meanings. (34–35)

In some ways the self-contradictions (more obvious in the case of the complete "Urania") that mark Lady Wroth's productions reflect the peculiar dualism of the times in which she lived. As Moretti puts it in a second essay, the Jacobean court was, despite the much celebrated formal decorum of its public demeanor, "the exemplary site of an unrestrained conflict of private interests" (72). Waller's theory of the

pressure of history on writers insists that the literary text is not a simple reflection of the social text. The social structure interacts with the literary structures as a field of forces we can usefully map. Lady Wroth's particular contribution derives from the pressure that gender exerts on this interaction. The results can be surprisingly unconventional, even in her pastoral drama where she does her best to tailor the social textures of the play to fit literary prototypes.

Drawing on a variety of commentators, Waller makes an observation, which is apt in this connection:

> The text's detours, silences, omissions, absences, faults, and symptomatic dislocations are all part of what we focus on in addition to, and even at times in preference to, its surface. We look for the different languages, literary and social that hover in the vicinity of the text, trying to master and muffle it; in particular we focus on places where the seemingly unified surface of a work is contradicted or undermined, where the text "momentarily misses a beat, thins out or loses intensity, or makes a false move—where the scars show, in the face of stress." (12)

The aim of the present chapter is to examine several different languages that make up "Loves Victorie": the language of the court with its predictable and ideologically conventional use of Petrarchan and Neoplatonic images and philosophy, the language of comedy with its use of anti-Petrarchan elements and satire, and the language of myth and ritual with its references to spring, the gods, and associated rites of love. Less obviously, but no less strikingly, "Loves Victorie" also makes use of a special language of avoidance, where the author chooses to emphasize the festive and positive aspects of her story in keeping with the public nature of her chosen medium (courtly drama) in preference to the potentially dark and despairing possibilities inherent in the plot and lurking at every twist and turn.

The language of avoidance which mutes the text from time to time can be seen as the device of a Renaissance or, more particularly, a Jacobean woman. It derives from a complex disjunction between the discourse of courtship and the context in which it is used. It serves to stress the frustration and helplessness of women characters caught in the age-old dichotomy between the image of woman in popular mythology—queen, goddess, all-powerful mistress—and her everyday subordination imposed in the name of love. The play, which determinedly avoids the contentious issues more openly addressed in the complete "Urania," is a text whose stability is only relative. There is a disturbing vacuum beneath the surface, an absence that amounts to a muffling of the text (quite apart from the fact that the Huntington manuscript is unfinished), that calls for detailed analysis.

Lady Wroth's work, however indirectly in "Loves Victorie" where the ambiguities and dislocations of her theme of sexual love erupt less obviously than in her prose or lyrics, reflects the increasing powerlessness of women and new limitations affecting them. The changing idea of the lady at the Jacobean court contrasts sharply with that obtaining in Elizabethan times. Humanist values regarding the importance of education for women—upper-class women at least—were giving way to a new emphasis on woman's traditional domestic role. Hence the political overview of the world evident in a Jonson or a Shakespeare is less central to the world of a Lady Wroth who inhabited a milieu only too ready to berate her as a woman meddling in matters beyond her sphere. The device of avoidance serves to limit the scope of the dramatic action in "Loves Victorie" and to shift the focus from macrocosm to microcosm.

It is a commonplace of literary criticism to point to the tensions and unfulfilled ambitions informing the courtly poetry of writers like Wyatt, Ralegh, or Sir Robert Sidney. The mistress of many a sixteenth-century poem represented Queen Elizabeth: her lover's pleas voiced demands for material favors in the form of perquisites or office at court. In a similar way, Jacobean masque constructed an ideal Platonic realm intended to embody the political claims promulgated by the Stuart monarchy. Lady Wroth's characters, on the other hand, are more likely to reflect homely realities than political concerns. Her themes are highly personal and her work less open to allegorical interpretation than much of the prose and poetry of her male contemporaries. "Loves Victorie" resembles her other works in picturing not an exterior, outward world, but an interior, inward realm that begins and ends with the experience of human rather than divine love and sifts the ever-shifting quicksands of the relationships between men and women.

The plot of the Huntington version of "Loves Victorie" can be summarized as follows:

> Somewhere in an unnamed country in the environs of Arcadia, twelve shepherds and shepherdesses wander the fields and valleys looking after their sheep. The men are called Philisses, Lissius, Rustick, Lacon, Arcas (or Argas), and Forester. The women are named Musella, Simena, Dalina, Fillis, Climena, and Silvesta. The buffoon Rustick, who is richer than the others, looks after cattle as well. Much of the action revolves around the difficulties the characters experience in conveying their feelings of love to the partners of their choice, and the women are faced with a special dilemma because the consensus is that they should not take an active role in courtship. A variety of love relationships is presented, ranging from the comic, one sided, and earthy longings of Rustick, to the mutual, passionate, and virtuous feelings of Philisses and Musella, which join love with reason. Another type of love is seen in the relationship between Silvesta and Forester, where the nymph

eschews human love and Forester agrees (reluctantly) to commit himself to a sexless compromise in the manner of the courtly or Neoplatonic lover.

Two mythological characters, Venus and Cupid, provide a framework for the play and an internal commentary on the action. When Philisses's best friend Lissius scorns the power of love, Venus, enraged, orders Cupid to wreak havoc among the pastoral troup. Jealousy, suspicion, and gossip infect the lovers. The play comes to a climax when Musella reveals to Philisses that her father has betrothed her to Rustick in his will, and that, although he is dead, her mother feels obliged to fulfill her husband's promise. The play breaks off at the point when Musella and Philisses pledge their undying love and agree to visit the temple to seek an unknown solution.

Following the fashion for tragicomic drama, which reached its apogee in the seventeenth century, Lady Wroth has constructed a five-act play that concludes each of its first four acts (the fifth is incomplete in the Huntington manuscript) with the appearance of the goddess Venus— although at the end of act 3 the speech heading "Venus" is followed by a blank page, the speech not having been copied out. In three of her four appearances Venus is accompanied by her son Cupid. Lady Wroth rigorously eschews contemporary allegory, and the two mythological figures function as a structural device not unlike the diversions, played one by one in each of the first four acts, which range from storytelling to the reading of prophetic rhymes and the telling of riddles.[3] In a play that sees little action and whose characters seem at times to resemble the "talking heads" of modern television drama, these games serve as focus for the psychological drama that constitutes the real heart of "Loves Victorie."

Each diversion offers the opportunity for the aims of Venus and Cupid as spelled out at the end of act 1 to be realized. The mythological figures do not interact with the other characters in the play (except for a reference to a meeting with Venus in one of the shepherds' songs, and some awareness on Dalina's part of what the gods are up to). However, like Andrea and Revenge in *The Spanish Tragedy,* Venus and Cupid act as chorus, so that when Lissius protests with humor that his friend Philisses has fallen in love—"this is the humor makes our sheapheards rave / I'le non of this, I'le souner seeke my grave" (LVH, IV, ll. 19–20) and several of his companions seem less than deeply involved in their love affairs, Venus protests, speaking to Cupid,

> Fy this is nothing, what is this your care
> that among ten the haulf of them you spare
> I would have all to wayle, and all to weepe
> will you att such a time as this goe sleepe
> awake your forces, and make Lissius find
> Cupid can cruell bee as well as kind. (LVH, 4v, ll. 33–38)

The following discussion spells out the meaning of the play's title. "Loves Victorie" is not merely intended to suggest that in the end true love will win out. Very simply the title means power: the power of Venus and Cupid to humble everyone in the play, even those who seem most immune to love. Cupid assures Venus,

> they shall both cry, and waile, and weepe
> and for our mercy shall most humbly creepe
> love hath most glory when as greatest sprites
> hee downward throwse unto his owne delights
> then take noe care loves victory shall shine
> when as your honor shall bee raisd by mine. (LVH, 5r, ll. 5–10)

The disturbances just perceptible beneath the surface of the play are embodied in Venus, with her malevolence, her power to wreak havoc, and her association with lust. These are characteristics that Shakespeare was very careful to exclude in *The Tempest* (c. 1611) by banning "Mars's hot minion" from the betrothal masque for Miranda and Ferdinand (4.1.91–101). Jonson retains but subdues them when he produces Venus in *The Haddington Masque* (1608) at the side of her husband, Vulcan. Yoking passionate love to matrimony, the goddess vows, "My lamp shall burn / With pure and chastest fire" (Orgel 117). Likewise in Samuel Daniel's *Vision of Twelve Goddesses* (1604), Venus appears with "mild aspect," carrying a scarf of amity designed "T'ingird strange Nations with affections true" (Grosart 3:200).

Classical gods and goddesses have played a part in pastoral poetry and drama from the earliest times, and Venus and Cupid were always favorite motifs in Lady Wroth's work: the first sonnet of *Pamphilia to Amphilanthus* opens with an account of a dream in which both mother and son appear (*Urania* [1621], sig. 4Ar). Lady Wroth would have been familiar with the use made of mythological figures by Tasso in his *Aminta*, by Daniel in his tragicomedy, *Hymen's Triumph* (1614), and by Jonson in a play like *Cynthia's Revels* and masques such as *Love Freed from Ignorance and Folly*, performed in 1611 (Greg 15, 156; Roberts 54–55). But the bitter and recurrent despair, which marks her songs and sonnets (in both printed and manuscript versions) and "Urania, Part Two," conveys a sense of personal pain in relation to the theme of love which is quite lacking in the complacent depiction by her male contemporaries of Venus *Domestica*.

Of course pastoral is traditionally cast in the comic mode. The despair of the lyrics is largely absent in "Loves Victorie" where difficulties in love, while not entirely ignored, are (more or less) resolved in keeping with convention. The death of the heart, a major theme in Lady Wroth's other work, is downplayed in the drama. Although the Huntington

manuscript breaks off, and although there are oppositional voices affecting the comic discourse, the play points toward closure and foreshadows a "happy ending." It can be compared with an episode in "Urania, Part Two" where ten shepherds and shepherdesses led by a brother and sister appear in a similarly lighthearted situation (bk. 2, fols. 3av–5bv). Names are duplicated—Arcas, Rustick, Magdalina (Dalina in the dramatic version)—although roles vary somewhat: Musella of "Loves Victorie" is a more central character than her counterpart who is named in the play as Philisses's sister Simena; the Venus and Cupid of "Urania, Part Two" appear only in the imagery of courtly love employed by Arcas and Rustick, while the Cupid of "Loves Victorie" has more in common with the mischievous god of Jonson's *Cynthia's Revels*, whose dual identity as Eros and "loves enemie" Anteros, causes division and maximum confusion (Herford and Simpson 4:167). This is a device that Jonson uses again in 1613 in *A Challenge at Tilt* (Orgel 198–99).

In "Loves Victorie," Cupid introduces difficulties into the lives of the rustics in order to demonstrate the overwhelming power of Venus. The portrayal of the troubling goddess herself probably owes most to an earlier entertainment, *The Lady of May*, devised by Lady Wroth's uncle Sir Philip Sidney. This divertissement was written for Robert Dudley, earl of Leicester, Sidney's uncle, on the occasion of a visit by Queen Elizabeth to his country mansion at Wanstead in 1578 or 1579. Queen Elizabeth, like Lady Wroth's Venus, provides a frame for the playlet. A summary follows:

> The queen is walking in Wanstead gardens when she is addressed by a countrywoman who explains that her daughter, the lady of May, is being sought in marriage by two suitors: one a lively and generous (but poor and bad-tempered) forester called Therion, the other a rich and kindly (but quiet and meditative) shepherd called Espilus. The lady appears, pulled this way and that by opposing parties of foresters and shepherds, while a pedantic schoolmaster named Rombus tries unsuccessfully to separate them. The May lady, who affects not to recognize the queen nevertheless bows to her superior beauty and asks her to choose a husband on her behalf. The two rivals engage in a singing competition, and their supporters, the old shepherd Dorcas and the young forester Rixus, continue the argument. Finally, Queen Elizabeth delivers her judgment and chooses the shepherd Espilus. The lady of May concludes with the conceit that she hopes the flourishing of May will long represent the life and reign of the queen.

Like Lady Wroth's Venus, Sidney's Elizabeth is as all-powerful in this spring world as she is elsewhere. The May lady recognizes the queen's intrinsic superiority and quickly yields preeminence to her (Duncan-Jones and Van Dorsten 24). Spring functions, in both Sidney's and Lady

Wroth's plays, as a resonant metaphor opposed to a picture of winter, death, and decay. The effect of Queen Elizabeth's "gay apparel" covered in flowers either real or embroidered, remarked on by the May lady, is to create a rival Queen of May. So too in "Loves Victorie," Venus appears in the guise of Flora—or a May lady—and, like Elizabeth, is described in terms of a *locus amoenus*. The shepherd Lacon sings:

> By a pleasant rivers side
> hart and hopes on pleasures tide
> might I see within a bower
> proudly drest with every floure
> which the spring can to us lend
> Venus, and her loving freind. (LVH, 4r, ll. 47–52)

Each lady is the epitome of beauty in her world, and each personifies the idea of love. Lady Wroth's choice of Venus as the presiding genius in her play can be construed as a delicate compliment to the part played by Elizabeth in Sidney's work. Like Elizabeth, who represents the outsider solicited to resolve difficulties within the drama, Venus is part of the story but exists outside it as well: she not only initiates action but also brings it to a successful conclusion.

More strikingly, the goddess Venus serves Lady Wroth as an analogue of female power, whereas for Sidney's generation the strongest feminine symbol was the Virgin Queen (as Spenser's *Faerie Queene* resoundingly testifies). Queen Elizabeth's essential strength derived from her single status which meant that she was not under the power of any man and could keep suitors vying for her favors even when the game had become little more than a sham. Elizabethan writers associated her with the moon goddess Diana (Artemis, Cynthia) who represents married and unmarried chastity but herself remains woman alone, virgin huntress, possessed by no man, although as goddess of childbirth she assists the fruitfulness of others. In Petrarchan terms, the queen represented beauty and a love forever unattainable. "Thus, by a paradox, sex, having created a problem, itself solved it, and the reign was turned into an idyll, a fine but artificial comedy of young men—and old men—in love" (Neale 70).

By the time Lady Wroth came to write her play about forty years later, there was no compelling living female image on which to focus as representative of the power of the feminine principle such as Elizabeth had provided in the previous era. What power Queen Anne possessed derived solely from her relational position as wife of a monarch and mother of the kingdom's heirs. A reaction had set in concerning the question of women's independence and education. In Lady Wroth's

fictional world the kind of supremacy that Elizabeth had wielded over her domain, including the area of personal relationships and marriage, could only be paralleled by a mythological figure with power over love, in whose name, supposedly, women were to subject themselves more stringently to the rule of men.

Clearly virginity no longer conveyed the same sense of vigor and authority in the Jacobean age that it had in the Elizabethan. Sex is important to Lady Wroth as a theme in her work. Nevertheless it is interesting to note that the lover of Venus in "Loves Victorie" is not named. The name of the goddess of love traditionally signifies diverse meanings—sometimes she is linked to sexual passion and adultery, sometimes to marriage. Lady Wroth's Venus is her own woman, her anonymous lover strictly incidental to the symbol she represents.

This symbol does not go completely unchallenged in "Loves Victorie." There are oppositional voices apparent in the drama which provide evidence of the kind of symptomatic dislocation making minor texts as revealing in their way as more important works of the same period. The first woman character to appear in "Loves Victorie," apart from Venus in the privately owned copy of the play (Roberts 67), is the erstwhile shepherdess Silvesta who, because she has been rejected by Philisses, has become a nymph of Diana and vowed herself to celibacy:

> for thanks to heaven, and to the Gods above
> I have wunn chastity in place of love;
> now love's as farr from mee as never knowne,
> then bacely tied, now freely ame mine owne;
> slavery and bondage with mourning care
> was then my living sighs, and teares my feare,
> butt all these gon now live I joyfully
> free, and untouch'd of thought but chastitye. (LVH, 2r, ll. 15–22)

Silvesta functions as an antithesis to Musella who is passionately and deeply in love with Philisses, the same man the nymph once loved herself. Musella's love acts as a contrast to the earthy, possessive, and fickle passions of Rustick and Dalina. Musella's role provides an instance of the intersection of discourses characteristic of Lady Wroth's work. Silvesta's new independence, for instance, suggests an attractive alternative to the suffering that friends like Musella continue to endure. The reiterated stress on the "freedom" experienced by those no longer in love strikes a plangent note which echoes oddly in the context of a play that promises at several points that the ending will be a happy one *with all the lovers restored to suitable partners.* "I see thou'rt bound who most have made unfree," observes Silvesta addressing Musella in act 3 (LVH, 11r,

l. 30), the line recalling sonnet 14 in the first section of *Pamphilia to Amphilanthus* in which the speaker laments that love "captive leads me prisoner bound, unfree" (*Urania* [1621], sig. 4A4v). The opposition of love and freedom betrays a sense of the author's despair, which is otherwise largely banished from the text of the play.

Although Silvesta's unorthodox decision about the place of love in her own life is not the dominant view of the play, from a structural point of view her ideas are given prominence. She appears near the start of acts 1 and 2 where she expresses herself at length. She gives the opening speech in act 3, and her name is mentioned by Musella in the first line of act 4. While Silvesta is absent from the fragmentary act 5 in the Huntington version, Musella's despair at the prospect of losing Philisses (because her parents have betrothed her to Rustick) neatly illustrates the kind of dilemma the nymph is able to side-step as a result of her dedication to virginity and the goddess Diana:

> Chastity my pleasure is
> folly fled
> from hence now I seeke my blis
> cross love dead. (LVH, 11r, ll. 9–12).

Silvesta henceforth avoids the difficulties inherent in human loving, much in the same way that Lady Wroth avoids spelling out the implications of the presence of oppositional voices such as those of Silvesta, Musella, or the fickle Dalina. The note of irony sounded from time to time when Lissius scoffs at love is muted in the overall pattern of the play, which is more commonly marked by a reiteration of the significance of the ideal of heterosexual love. Silvesta nevertheless speaks a language that is very different from that of Musella and Philisses: her experience of love and her conclusions reveal the tension beneath the surface of the work—"where the scars show, in the face of stress."

Venus makes a crucial statement at the end of act 2, written on a quarto leaf appended to the text, possibly a later addition. She directly addresses the audience, almost certainly envisaged by Lady Wroth as a courtly one: "harts obay to Cupids sway / prinses non of you say nay" (LVH, 10r, ll. 16–17). The goddess warns,

> lett your songs bee still of love
> write noe satirs which may prove
> least offensive to his name. (LVH, 10r, ll. 22–24)

Her image is not only appropriate to the pastoral setting but in addition strikes a vulnerable note. If her listeners ignore her injunction concerning satires,

> . . . you will butt frame
> words against your selves, and lines
> wher his good, and your ill shines
> like him who doth sett a snare
> for a poore betrayed hare
> and that thing hee best doth love
> lucklesly the snare doth prove. (LVH, 10r–v, ll. 25–29, 1–2)

The comparison of the writer who satirizes love with a hunter who accidentally kills the thing he loves best is a telling one by which Lady Wroth reveals a great deal about her own aims as an author. Not for her the satiric portrait that Jonson paints in *The Christmas Masque* (1616) of Venus as a deaf tirewoman, speaking in the manner of a poor old woman from Pudding Lane, while the lord of Misrule is played by "Tom of Bosoms Inn" (Orgel 236–37, 240). The earthy or risqué element favored by several writers of pastoral dramas and sometimes masques is almost wholly absent from "Loves Victorie." With the possible exception of a few remarks by Forester about his difficulties in viewing Silvesta in a wholly platonic light, Lady Wroth avoids the titillating elements that inform the work of her male contemporaries.

She also avoids the extremes of either panegyric or violence characteristic of their productions. For instance, Forester and Silvesta's relationship may owe something to the example set by Clorin in Fletcher's *Faithful Shepherdess* (1608), who dedicates herself to the memory of her dead lover (Bowers 3:501–2). Clorin is courted in the meantime by the shepherd Thenot, and when she tests his sincerity by offering herself to him, thereby breaking her vows, he rejects her, having built his love on the expectation that she is unobtainable (564).

The self-protective ambiguity informing Clorin's offer and the roughness of Thenot's repudiation are aspects that Lady Wroth avoids in favor of a gentle and disarming use of humor. She employs instead the anti-Petrarchan imagery used by Sidney in the *Arcadia* to describe the rustic Mopsa in her depiction of Rustick's love for Musella. The buffoon celebrates his beloved as "whiter then lambs wull"; he says her eyes "do play / like goats with hay" and that her cheeks are as red "as okar spred / On a fatted sheeps back"; and, finally, that her breasts "are found / as aples round" (LVH, 4r, ll. 25, 29–30, 36–37, 39–40). Lady Wroth's nonviolent pastoral images, however much they poke fun at the language of courtly love, bear little relation to the savage irony informing Fletcher's play. In another example from *The Faithful Shepherdess*, the shepherdess Amoret is twice wounded to death by her lover Perigot as the result of a misunderstanding, stuffed down a well and left for dead

by a different rustic, the lascivious Sullen Shepherd (Bowers 3:542–43, 560).

"Loves Victorie" eschews the aggressive sexuality of incidents such as the foregoing or the Sullen Shepherd's expression of regret that he failed to rape Amoret, or Chloe's and Amarillis's frustrated efforts to find themselves sexual partners (Bowers 3:535, 514–15, 540).[4] Likewise, whatever Lady Wroth may owe to *Hymen's Triumph* (1614),[5] she avoids the frankness shown by Daniel's Silvia. A shepherdess disguised as a boy and stabbed nearly to death by a jealous forester called Montanus who mistakes him (her) for a rival, Silvia tells the audience that the reason for her alias as Clarindo is to avoid premarital sexual relations with her lover (Grosart 3:367).

In "Loves Victorie" Lady Wroth employs the language of avoidance not only in regard to the cruder physical manifestations of "love," but extends it also to the political, social, and courtly dimensions with which in "Urania, Part Two" she invests a troup of seeming rustics, almost identical with those of the drama. The world of "Urania, Part Two" is in turmoil; a group of young princes and princesses have been abducted, and the sophy of Persia has put Asia to the sword. Here, the shepherds and shepherdesses described by Arcas as suffering for love are really disguised courtiers awaiting their opportunity to end the enchantment in which the lost princes and princesses are trapped. Arcas himself is the courtier Amicles and Rustick turns out to be a young Morean knight called Folietto.

Whereas the conventional fields and woods of "Loves Victorie" echo only to the sounds of silence (even Philisses's pipe is hushed), in "Urania, Part Two" they are resonant with drumbeats from other wider worlds. Much play is made early in the manuscript on Folietto's color—he is black—but the issues this raises and the uncomfortable experiences he undergoes as a raw recruit called to the problematic and frustrating search for the lost princes (bk. 1, fol. 11ar–v), which recall Ariel's tormenting of Stephano and Trinculo in *The Tempest*, are entirely omitted in the drama. So too is the notion expounded by Rustick (Folietto) that his and his friends' sufferings for love are largely a fiction designed as a cover for their true mission, a notion which makes the ironies of Lady Wroth's use of pastoral elements in "Urania, Part Two" explicit.

In "Loves Victorie" the rustics are real. Their world stops at the edge of field and forest and there is no mention of court or courtiers. The names of major characters like Philisses and Musella may owe their origins to the court, perhaps to specific examples like Philip Sidney who was sometimes nicknamed Philisides, the shepherd knight, and Stella

(Penelope Rich), the muse of Sidney's Sonnets. Their language may be couched in the ideologies of courtly and Neoplatonic love. Nevertheless, the connection ends on this surface level. Philisses and Musella are locals fixed, however improbably, in their rural setting. They and their companions (at least in the Huntington manuscript) do not turn out to be the disguised sons and daughters of kings and queens. They are confined by their author to the never-never world of the pastoral.

This world does however include consideration of the proper roles of men and women in courtship. A curious sexist element rears its head in the course of the play which reflects the prejudices of the age and exemplifies the particular reaction of a woman writer to the implications of those prejudices in regard to the relationship between the sexes. In act 2, Lissius, an avowed enemy of Cupid, cynically describes what he regards as men's characteristic relation to women, who are imaged in terms of animals from the pastoral realm:

> for wee should woemen love butt as our sheepe,
> who beeing kind, and gentle gives us ease,
> butt cross, or strayning, stuborne, or unmeeke
> shun'd as the woulf which most our flocks disease. (LVH, 6v, ll. 31–34)

The effect of such an attitude on the meaning of the play as a whole is less simple than it seems when we come to such instances as Arcas chiding Dalina a few pages later for being overbold in claiming her turn in the riddling game immediately after Musella. One woman has spoken already, he says. Now a *man* should follow (LVH, 8r, l. 2). More disturbingly, Lissius rounds on Climena in act 3 and berates her for making advances toward him: "fy, I doe blush for you, a woman woo, / the most unfittest, shamfullst thing to doo" (LVH, 14r, ll. 28–29).

Musella, the ideal of pastoral womanhood in the play, is only too well aware of the prohibition on women's assertiveness in love: "some times I faine would speake then straite forbeare / knowing itt most unfitt; this woe I beare." Silvesta agrees: "indeed a woman to make love is ill" (LVH, 11v, ll. 33–36).

The result is that when on Silvesta's advice Musella gets up early to meet Philisses in the woods (where he wanders bewailing his love), she pretends she is there by chance. Moreover, she feels that she cannot act directly to comfort her lover and is constrained to wait until he takes the initiative: "I faine would comfort him, and yett I know / nott if from mee 't'will comfort bee or noe" (LVH, 15v, ll. 47–48). Careful not to court Philisses overtly, Musella can only respond to his bleak and generalized remarks with the timid suggestion, "tell mee who 't'is you love, and I will give / my word I'le win her if she may bee wunn" (LVH,

16r, ll. 19–20). The reader senses the pressure of what remains unspoken—Musella's longing to express herself without restraint and of her own free will.

Such muffling of the main issue—the treatment of women as second-class citizens—is not allowed to pass entirely without comment in the play. Dalina, a woman who has chosen her own way (although not entirely happily), makes the point in the middle of the drama that she has never taken love particularly seriously:

> this is the reason men ar growne soe coy
> when they parseave wee make their smiles our joy
> lett them alone, and they will seeke, and sue,
> butt yeeld to them, they will with scorne poursue;
> hold awhile of they'll kneele, nay follow you,
> and vowe, and sweare, yett all their othes untrue.
>
> (LVH, 13v, ll. 30–35)

Such straight speaking is unusual in "Loves Victorie." In the main, the relationship between the sexes is approached obliquely, tentatively; there is a hesitancy on the part of the author to bring the difficulties lying just beneath the surface of her story to open view. Literary and social norms are nevertheless implicitly questioned again and again by allusions to the inadequacy of the received ideologies to account for women's particular experiences and points of view. But this questioning remains implicit in "Loves Victorie." Inconstancy, as in the case of Lissius and Simena, is merely a matter for unfounded rumor or the experience of minor and ridiculous characters such as Dalina and Climena. Major roles such as Philisses and Musella are unaffected by character weaknesses like fickleness. The threat to their love is external as in the case of Romeo and Juliet. The contrast to the tragic on-again, off-again relationship of Queen Pamphilia and Emperor Amphilanthus in the complete "Urania" (the emperor is always susceptible to a pretty face) could hardly be greater.

Whether Lady Wroth's avoidance of issues with which she was preoccupied in her prose fiction and her other poetry constitutes self-restraint or a new direction in her work is debatable. The play *may* have been written in the aftermath of the bitter criticism of the freedom Lady Wroth was alleged to have displayed in describing the private lives of her fellow courtiers in *Urania* (1621). The prospect of public performance may also have had a significant effect on her choice of tone, and certainly the style is more in keeping with the Platonic ideals of the masque than with the darker realities of the rest of her fiction.

Finally, it remains true that the oppositions of love and death and of

summer and winter, reiterated throughout "Loves Victorie," function as sign posts to the real obsessions characterizing Lady Wroth's work. Musella may present the sun in the parlance of Neoplatonism but she is followed always by her "shadowe" (Rustick). As the buffoon hastily follows in the shepherdess's wake when she exits at the end of act 4, Philisses acerbically remarks,

> noe follow; shadowes never absent bee
> when sunn shines, in which blessing you may see
> your shadow'de self, who nothing in truth are
> butt the reflection of her too great care. (LVH, 20r, ll. 26–29)

Philisses may not realize it, but in Rustick he sees a copy of the "shadow'de self" that he, like all of us, reflects. Where love exists, the possibility of "joy's decay" is also present (LVH, 17v, l. 19). The image is the last symptomatic dislocation to be referred to here. The Huntington manuscript breaks off on a note of uncertainty. Flying in the face of the wishes of Musella's parents, the shepherdess and Philisses express their undying love for one another. Philisses offers Musella his life and she replies on an ominous note,

> that I will aske, and yours requite with mine
> for mine can nott bee if nott joined to thine,
> goe with mee to the temple, and ther wee
> will bind our lives, or els our lives make free. (LVH, 21v, ll. 41–44)

While they agree, finally, not to do away with themselves, the reader's impression is that from beginning to end Lady Wroth continually avoids the more dangerous rift zones of the human heart. Simena, in the last line of the Huntington version, remains unclear as to whether or not the two lovers plan to fulfill a suicide pact: "butt what will you tow doe / both dy, and mee poure maiden quite undoe" (LVH, 21v, ll. 62–63). The question remains unanswered in the Huntington version. Throughout the play Venus has promised the audience a happy ending. This seems likely to be fulfilled, but love remains "shadow'de."

At first sight Lady Wroth's "Loves Victorie" may seem to follow the mainstream of late sixteenth-century and seventeenth-century pastoral drama, but a close examination reveals the many different ways in which her imagery and choice of language—especially her silences—reflect the special experience of a woman writing in Jacobean England. Beneath the soothing assurances that all will be well lies a "labourinth of woe, and care" (LVH, 16r, l. 23). Lady Wroth's insights, her achievements, and especially her failures in "Loves Victorie" contribute usefully to our understanding of Renaissance literature in general and to our appreciation of the experience of women in an earlier age in particular. "Let him

not dy," Silvesta pleads with Musella, speaking on behalf of the despairing Philisses (LVH, 12r, l. 6). It is important that we as a modern audience do not allow an almost forgotten but unexpectedly revealing manuscript like "Loves Victorie" to die.

Notes

ABBREVIATIONS

Urania (1621) *The Countesse of Mountgomeries Urania*. London: John Marriott and John Grismand, 1621. *STC²*: 26051

"Urania, Part Two" The first and second books of the secound part of the Countess of Montgomerys Urania. Newberry Library. Chicago. Shelf Mark Case MS fY 1565. W 95

LVH Loves Victorie. Huntington Library. San Marino, Calif. Shelf Mark HM 600 (Note: Line references include act and speech headings. Punctuation at the end of quotations is silently emended.)

Complete "Urania" Refers to both the first and second parts of the prose romance (*Urania* [1621] and "Urania, Part Two")

The following spellings are modernized and regularized in all quotations: wt/with; wch/which.

1. The poem, which Lady Wroth believed was written by Lord Edward Denny, baron of Waltham, is included with a vituperative correspondence between the two, copies of which are held at the University Library of Nottingham, reference number CI LM 85/1–4.

2. A second version of "Loves Victorie" is privately owned and is due to appear shortly in photofacsimile edited by Michael G. Brenan of the University of Leeds (kindly communicated by him). Thanks is also owing to M. A. Halls, Archivist, King's College Library, Cambridge, for information and to Fiona McLaren for inquiries made on my behalf.

3. Similar games are played by the courtiers in Jonson's play *Cynthia's Revels*, acted in 1600 and published in 1616 (Herford and Simpson 4: 110).

4. The motif of rape recurs in Jonson's *Sad Shepherd* where Lorel is advised by his mother, the witch Maudlin, to rape the nymph Earine (Herford and Simpson 7:30). Jonson's lost pastoral "The May Lord" (in which Lady Wroth was assigned a part) may also have had an influence on "Loves Victorie" (Harrison 17).

5. The betrothal of Musella has similarities to that of Silvia in *Hymen's Triumph* (Grosart 3: 388).

Works Cited

Bowers, Fredson, gen. ed. *The Dramatic Works in the Beaumont and Fletcher Canon*. 6 vols. London: Cambridge University Press, 1966.

Duncan-Jones, Katherine, and Jan van Dorsten. *Miscellaneous Prose of Sir Philip Sidney*. London: Clarendon Press, 1973.

Eagleton, Terry. *Marxism and Literary Criticism*. 1976. Reprint. London: Methuen and Co., 1985. Thoughtful and provocative. Encourages divergent thinking.

Greg, W. W. *Pastoral Poetry and Pastoral Drama*. New York: Russell and Russell, 1959. A wonderful background work. Wide-ranging knowledge.

Grosart, Alexander B., ed. *The Complete Works in Verse and Prose of Samuel Daniel*. 5 vols. [c. 1885] Reprint. New York: Russell and Russell, 1963.
Harrison, G. B., ed. Ben Jonson. *Timber, Discoveries* (1614); *Conversations with Drummond of Hawthornden* (1619). 1923. Reprint. Edinburgh: Edinburgh University Press, 1966.
Herford, C. H., and Percy Simpson, eds. *Ben Jonson*. 8 vols. Oxford: Clarendon Press, 1925–38.
Moretti, Franco. "The Soul and the Harpy," trans. David Forgacs; and "The Great Eclipse: Tragic Form as the Deconsecration of Sovereignty," trans. David Miller. In *Signs Taken for Wonders*. London: Verso editions and *NLB*, 1983. Stimulates new ways of thinking about popular literature.
Neale, J. E. *Queen Elizabeth I*. 1934. Reprint. Harmondsworth: Penguin, 1967.
Orgel, Stephen, ed. *Ben Jonson, The Complete Masques*. New Haven: Yale University Press, 1969.
Rich, Adrienne. *Of Woman Born*. 1976. Reprint. New York: W. W. Norton and Co., 1977.
Roberts, Josephine A. *The Poems of Lady Mary Wroth*. Baton Rouge: Louisiana State University Press, 1983. An excellent and thoughtful text.
Waller, G. F. *English Poetry of the Sixteenth Century*. London: Longman, 1986. The attention paid to women's contribution to Renaissance literature is welcome and overdue.
Witten-Hannah, Margaret A. (now McLaren). "Lady Wroth's *Urania:* The Work and the Tradition." Ph.D. diss., University of Auckland, 1978.
Wroth, Lady Mary (nee Sidney). Correspondence with Lord Edward Denny, Baron of Waltham. University of Nottingham Library. Nottingham. Reference number CI LM 85 / 1–4.
———. *The Countesse of Mountgomeries Urania*. London: John Marriott and John Grismand, 1621. STC[2]: 26051.
———. The first and second books of the secound part of the Countess of Montgomerys Urania. Newberry Library. Chicago. Shelf Mark: Case MS FY 1565. W 95.
———. Loves Victorie. Huntington Library. San Marino, Calif. Shelf Mark: HM 600.
———. Songs and sonnets beginning with poems from Pamphilia to Amphilanthus. Folger Shakespeare Library. Washington. Shelf Mark: V a 104.

NAOMI J. MILLER

Rewriting Lyric Fictions
The Role of the Lady in Lady Mary Wroth's *Pamphilia to Amphilanthus*

NEAR THE END of *Pamphilia to Amphilanthus*, Lady Mary Wroth's poet-speaker contrasts the "true forme of love" in her thoughts with those "ancient fictions" that conjure shapes from the stars.[1] During the English Renaissance, male sonneteers wove discursive fictions around the lady as the object of love, often following the example of Astrophil's addresses to his Stella. Even as Wroth makes deliberate reference to "olde fictions" of Arcadia in her prose romance, *Urania*, in order to differentiate her narrative from that of her uncle, Sir Philip Sidney,[2] so she rewrites the "ancient fictions" of her Sidney forebears when giving voice to the "true forme" of love in her poetry.

Appended to *Urania* in 1621, Wroth's *Pamphilia to Amphilanthus* is the first sonnet sequence published by a woman in the English Renaissance. Furthermore, beyond the historical significance of the publication as such, Wroth establishes herself as the first English writer to reverse the traditional gender roles of lover and beloved in a complete sonnet collection.[3] While Wroth derives some of the principal terms of her discourse from the lyric sequences of her uncle and of her father, Robert Sidney, she writes against tradition in restructuring certain conventions of the genre to assert a feminine perspective on love.[4] Wroth's poems inscribe at once her heritage and her legacy as a Sidney and as a lady of the Renaissance, a lover and a poet.

Recently, Gary Waller has noted some of the rhetorical difficulties confronting Renaissance women who attempted to write within genres structured by male categories and dominated by masculine discourse ("Struggling into Discourse," 238–56).[5] In the ongoing controversy about women in the first half of the seventeenth century, many of the feminist pamphlets take a defensive stance in seeking to refute the stereotypes presented by misogynistic treatises.[6] Wroth's creation of a literary work rather than a political pamphlet allows her to take the offensive, so to speak, by modifying generic conventions to reflect a feminine emphasis, re-viewing as well as revising male-authored conceptions of "the lady" in the Renaissance.[7] While Wroth's aunt, the countess of Pembroke, provides positive female models by depicting

heroic women in her translations of Petrarch and Garnier, her characters have been described by one recent critic as "models of negation" because of their definition according to male perspectives (Lamb 222). Encouraged by the example of her aunt but not limited by the constraints of translation, Wroth creates a model of affirmation in the figure of Pamphilia, a sonneteer whose female voice re-forms previously male claims to love. Although Waller suggests that the writings of Renaissance women call attention to gender-specific concerns primarily through the silences and absences in their texts ("Struggling into Discourse," 246–47), I will argue that Wroth counterpoises speech and silence, absence and presence, in such a way as to decenter the authority of the male beloved, so that it is the lady who commands the balance of the discourse.

The role of the lady in the sonnet sequences of Wroth's precursors in the genre reflects male Renaissance fictions concerning the distant and often unattainable female beloved.[8] While the recipient of voluble praise from the sonneteer, the sonnet lady often remains voiceless herself within the poems, her description serving more to indicate the exclusive nature of the sonneteer's passion and ingenuity in love than to reveal her own character. By contrast, Wroth gives the speaker's voice in her sonnet sequence to the woman, thus silencing the man and simultaneously undermining the stricture of female silence so emphasized in Renaissance directives for women.[9] Furthermore, while male sonneteers periodically blame their personal trials in love upon the harshness of their ladies, Wroth's speaker moves beyond blame or self-pity to celebrate the "true forme of love" apart from the caprice of her male beloved. In structuring her sequence around a woman's voice, Wroth does more than simply reverse the conventional relationship of male lover and female beloved.[10] Pamphilia speaks not solely as a lover focused upon the beloved but as a woman cognizant of the shared female experience of suffering for love. In her acknowledgment of the embracing rather than the exclusive nature of her passion, Pamphilia at the same time encodes her refusal to be relegated to the margins of discourse as an isolated woman in love. Writing within but against the patriarchy, Wroth uses not the egocentrism of masculine rhetoric but Pamphilia's feminine awareness of mutuality to empower her lyric voice.

The role of the lady in Wroth's sequence can be viewed in special relation to the Sidney family tradition, as both Philip and Robert Sidney produced lyric sequences in which the lady, albeit briefly, is given a voice.[11] In the eighth song of *Astrophil and Stella* and the sixth song of Robert Sidney's sequence, the lady speaks her love within a third-person narrative frame that places both lover and beloved at one remove from

Portrait of Lady Mary Wroth. From the collection of Viscount De L'Isle, V.C., K.G., at Penshurst Place, Tonbridge, Kent. With the kind permission of Viscount De L'Isle.

the first-person frame of the larger sequence. The lady's voice in each case heralds or reflects a further separation from the lover, leaving the sonneteer's song "broken."[12] While drawing from the examples of her father and her uncle, Wroth transforms the role of the lady in her own sequence from a breaker into a maker of songs. In *Pamphilia to Amphilanthus,* the woman appears not as an object of adoration but as a lover, not as a muse but as a poet. When the "sonnet lady" of the generic tradition becomes the sonneteer, the conventional rhetoric of the lyrics serves unexpectedly as a discourse of sexual difference.

Early critics of Wroth's sequence tended to dismiss her work as derivative, worthy of note only because of her gender.[13] More recently, critics such as Josephine Roberts and Elaine Beilin have reappraised the literary value of Wroth's poetry.[14] Such recent studies assess the nature of love in the sequence by stressing the faithlessness of the male lover and the ideal constancy of the woman, whereas my essay focuses more specifically upon the role of the lady as a maker of songs. In the absence of any detailed study of the influence of the other Sidneys upon Wroth,[15] my essay offers a comparative consideration of the models provided by Wroth's uncle and father, in order to evaluate the individuality of Wroth's poetic achievement.

Pamphilia to Amphilanthus opens with a dream vision in the first sonnet which establishes the central characters in the drama. Venus and Cupid succeed in "martiring" the dreamer's heart so that Pamphilia awakens as a "lover" (P 1). Because the male beloved is absent except for the presence of his name in the title, Wroth from the first places the emphasis directly upon the voice of the female lover.[16] The evolving dynamic among the central characters soon differentiates Wroth's perspective from that of her male predecessors in the genre. In particular, the speaker's relation to Cupid shifts when the sonneteer is a lady. For example, whereas Philip Sidney presents the figure of Cupid as both ally and rival to Astrophil in the pursuit of the female beloved (AS 11), Wroth's Cupid becomes the female poet's suitor. Thus Pamphilia finds herself in the position of denying Cupid's suit while affirming her constancy toward her male beloved (P 8).[17]

At the same time, Wroth delineates the altered relation of her poet-speaker to Cupid in order to revise the conventional metaphor of battle. Both Philip and Robert Sidney regularly represent the lover's predicament in martial terms, outlining the speaker's attempts on the one hand to conquer the beloved's heart (AS 61, 69; RS 7) or on the other hand to resist captivity himself, when faced with his beloved's arsenal of beauty (AS 53; RS 15, 18, 33). Wroth shifts the focus of the strife, so that her speaker's conflict is with Cupid rather than with her beloved (P 16).

Furthermore, while the male sonneteers emphasize the strength of their efforts, surrendering only when "no power is left to strive" (RS 18), Wroth's female speaker demonstrates her passion without the masculine emphasis on aggression. All the "powre" and aggressive strife is left to Cupid, while the lady admonishes him that "'tis cowardise, to strive wher none resist" (P 8). By displacing the focus of the conflict, Pamphilia maintains the prerogative of choosing her beloved willingly. And by acknowledging rather than resisting her passion, she is enabled to reject the authority of Cupid's "boyship" once she has directed her love toward Amphilanthus (P 8). Both as a lover and as a poet, Wroth's lady prefers to take the initiative in offering her affections through song directly to her beloved rather than prolonging a martial engagement with Cupid.

In several of her sonnets Wroth uses imagery standard to the genre, only to re-present that same imagery with a new twist later in the sequence, manipulating the conventional discourse of the sonnet tradition toward her own ends. Wroth draws upon the traditional alternation of day and night in the expression of grief, for example, in one sonnet that opens with the question: "Which should I better like of, day, or night" and concludes with the lament: "Darke to joy by day, light in night oprest / Leave both, and end, thes butt each other spill" (P 20). This common pairing appears with some variation in the verse of her Sidney predecessors as well. Philip Sidney intensifies the traditional dichotomy in his sequence, alternating his images until the two states are superimposed in one experience of heightened suffering: "While no night is more darke then is my day, / Nor no day hath lesse quiet then my night" (AS 89). Robert Sidney, in a fashion characteristic of the tone of his sequence, emphasizes the suffering of his speaker with metaphors of physical pain.[18] Thus one sonnet portrays the lover as a galley slave "who on the oar doth stretch / His limbs all day, all night his wounds doth bind," and ends with the speaker's complaint that no day is so long that new wounds are not received, "Nor longest night is long enough for me / To tell my wounds, which restless bleeding be" (RS 19).

When Wroth's sonnets upon the relative merits of day and night are viewed as a larger group, it becomes apparent that instead of maintaining the dichotomy insisted upon by her father and uncle, she more often moves beyond that dichotomy to a choice. One sonnet that begins with the day/night alternation becomes a comparison of the speaker and "Night" as female companions in grief. After a litany of parallels—"my thoughts are sad; her face as sad doth seeme"—Wroth's lady concludes: "Then wellcome Night, and farwell flattring day" (P 13). A subsequent sonnet opens with that same welcome—"Truly poore Night thou well-

come art to mee"—and proceeds to delineate Pamphilia's reasons for loving this companion who gives quiet "to uss, and mee among the rest oprest" (P 17). Rather than focusing upon the exclusivity of her pain in love, as do many of the male speakers in the genre, Wroth's lady perceives herself as part of a larger community of "oprest" lovers and embraces the character of "Night" as a female friend in a shared time of trouble. Wroth even contrasts this view of "Night" on the part of her speaker with that of "some mens phant'sies" (P 17), emphasizing the female perspective of her speaker. While Philip Sidney compares "night" and "thought" in terms of their aesthetic similarities (AS 96), Wroth embraces the triple companionship of "silence," "grief," and "Night" in personal terms (P 43) that stress her awareness of a shared female bond of suffering and decenter the role of the male beloved, relegating him in effect to the margins of this "freindship."

The influence of both Philip and Robert Sidney upon Wroth can be measured in a crown of sonnets at the very center of Wroth's sequence. In the *Old Arcadia,* Philip Sidney presents one of the first instances of the *corona* in English, in the form of ten linked dizains (OA 72). Robert Sidney follows his brother's example, including an incomplete crown of four sonnets in his sequence, while Wroth expands upon her father's effort by completing her own crown of fourteen sonnets in *Pamphilia to Amphilanthus.* Yet even where Wroth's debt to the male Sidneys is most marked, she fashions her *corona* to reveal the central concerns of her sequence as a whole, distinguishing her perspective from those of her uncle and father.[19] The crown in Wroth's sonnet sequence becomes a crown for the sonneteer, a triumph of individual expression for the voice of the lady in affirming a love-centered rather than a self-centered perspective.

In the opening sonnet of her crown, Wroth introduces the image of a "strang labourinth" which Pamphilia can only navigate by taking "the thread of love" (P 77). As the final line of each sonnet is repeated in the first line of the successive sonnet, Pamphilia's voice itself becomes her thread of love expressed, revealing her chosen path through a maze of fluctuating behavior on the part of her beloved. Early in the *corona,* Wroth highlights the issue of constancy from a female point of view. In the third sonnet, the speaker describes the testing ground of true love:

> Heere are affections, tri'de by loves just might
> As gold by fire, and black desernd by white,
> Error by truthe, and darknes knowne by light,
> Wher faith is vallwed for love to requite. (P 79)

In the trial of affections, faith is valued and true love proves "constant as fate" (P 79). The series of similes, from "gold by fire" to "darknes

knowne by light," suggests the intensity of the speaker's dedication to love, a dedication admitting of no compromise or inconstancy. For eight lines of her monorhymed sonnet, Wroth chooses two of the same ending words—"might" and "light"—as Philip Sidney uses for his monorhymed sonnet in the *Old Arcadia*. Sidney's sonnet, however, is attributed to Gynecia, who is tormented by her selfish desire to betray her marriage for adulterous love of Pyrocles. In that sonnet, Gynecia invites "clowdie feares" to close her sight (*OA* 42), while in Wroth's sonnet, Pamphilia declares that "noe clowde can apeere" to dim the light of true love (P 79). The deliberate echoes of the earlier sonnet only highlight the contrast between Sidney's inconstant Gynecia and Wroth's constant Pamphilia, revealing Wroth's determination to give a new voice to the lady in love.

The third sonnet of Wroth's crown also recalls and reverses the third sonnet of Robert Sidney's crown, in which the speaker professes his faith to his beloved yet admits that he has loved others before her. In excuse of his behavior, he argues that "Love gave me not to them, he did but lend" (RS 13), and offers a justification in the following sonnet: "Ah let not me for changing blame endure, / Who only changed, by change to find the best:" (RS 14). Wroth demonstrates her awareness of that particular justification of change in her own depiction of the relationship between lover and beloved, yet in her case she attributes that position to Amphilanthus. When Pamphilia remarks upon her beloved's inconstancy in *Urania,* he replies that "none can bee accused . . . for their change, if it bee but till they know the best, therefore little fault hath yet been in me: but now I know the best, change shall no more know me."[20] Pamphilia's response is simply that "every change brings this thought." Within the *corona,* Pamphilia emphasizes not a self-centered quest for "the best" as a justification for change but rather a dedication to love as a justification for constancy. In place of patriarchal Renaissance conceptions of constancy as rare in women and optional for men, Wroth's lady represents constancy as required of all true lovers. Pamphilia's voice in the third sonnet of the crown thus becomes Wroth's vehicle for differentiating her particularly female perspective on the "true forme of love" from the views expressed or implied in related sonnets by her father and uncle.

Elsewhere in her crown, Wroth revises central metaphors from the verse of her Sidney predecessors while heightening their individual significance in her own sequence. The metaphor of poet-lover as painter, for example, which recurs in the sequences of the male Sidneys, reappears with a different emphasis in the seventh sonnet of Wroth's *corona,* in an address to all true lovers:

> Love will a painter make you, such, as you
> Shall able bee to drawe your only deere

301

> More lively, parfett, lasting, and more true
> Then rarest woorkman, and to you more neere. (P 83)

According to Wroth's conception, the lover is enabled to paint the truest image of the beloved. The double meaning of "true," alluding not only to the accuracy of the likeness but also to the desired constancy of the subject, is underscored by the final phrase, "and to you more neere." Speaking with the authority engendered by her own lyric discourse, Pamphilia connects the power of representation with successful passion. Her focus, characteristically, is on how love directs the lover's talents outward, toward the beloved, rather than inward, upon the lover's own plight. The success Pamphilia attributes to the lover-as-painter contrasts with the failure of art bemoaned by the male sonneteers.

The first sonnet of Robert Sidney's crown, for example, reveals the lover's painterly skills turned impotently upon himself, as the speaker laments: "I labour shall in vain / To paint in words the deadly wounds the dart / Of your fair eyes doth give" (RS 11). Similarly, the first sonnet of *Astrophil and Stella* finds the speaker seeking "fit words to paint the blackest face of woe"—to paint, that is, his own face of woe, in order to win Stella's pity. Near the center of the sequence, Philip Sidney calls further attention to the failure of the speaker's art, with Astrophil's complaint that "Stella oft sees the verie face of wo / Painted in my beclowded stormie face: / But cannot skill to pitie my disgrace" (*AS* 45). After noting that Stella is moved by "a fable," Astrophil beseeches her to think "that you in me do reed / Of Lover's ruine some sad Tragedie," concluding: "I am not I, pitie the tale of me" (*AS* 45). In Philip Sidney's sequence, love makes Astrophil a painter of his own plight, a fabler of his own sad tale. His seeming self-denial—"I am not I"—actually advances an assertion of self encoded in a fiction—"pitie the tale of me." The representational circularity of such egocentrism results most commonly for the male sonneteers, as noted above, in confessions of impotence, which contribute to their "ancient fictions."

Although Wroth, like her uncle, shows her speaker seeking "pitty" after having been made a "stage of woe" (P 48), Pamphilia more consistently appeals for the favor of her beloved by advancing her depiction of his image rather than her own. Thus one typical sonnet concludes with Pamphilia's request that her beloved "Pitty my loving, nay of conscience give / Reward to mee in whom thy self doth live" (P 24). Although seemingly an example of the self-abnegation expected of a Renaissance lady, Pamphilia's stance asserts not the impotence but rather the authority of her song. The seventh sonnet in the crown reinforces the centrality of this perspective to the sequence, as Pamphilia celebrates the representational power of the female lover as poet.

Wroth translates other metaphors common to the sequences of her uncle and father in terms that reveal her lady endeavoring increasingly not only to give voice to her own particular plight but also to acknowledge the shared female experience of suffering for love. For example, Philip Sidney uses metaphors of pregnancy and childbirth to convey Astrophil's fertile desire to express his love—"thus great with child to speake" (AS 1)—even if Astrophil's words at times do not survive his labor: "I cannot chuse but write my mind, / And cannot chuse but put out what I write, / While those poore babes their death in birth do find:" (AS 50). For Wroth, metaphors of pregnancy and childbirth become a vehicle to convey the falsehood of male lovers, who disguise their lust with the name of love in order to "begett / This childe for love" without shame (P 85). Pamphilia removes the prerogative of claiming love's pregnancy from men concerned with lust, restoring it instead only to those lovers who "wantones, and all those errors shun" (P 86). Again, instead of centering her lyric discourse upon her own person, Wroth's speaker proves herself a maker of songs that embrace truth in love beyond purely individual circumstances.

Robert Sidney frequently uses garden imagery in his sequence to convey his speaker's personal experience of love. In one sonnet, the speaker compares himself with "Gardens, which once in thousand colours dressed / Showed nature's pride, now in dead sticks abound" (RS 31), while in a later song he depicts his heart as a deserted garden where "nettles of grief" and "briars of care" have replaced the "flowers of hope" (RS Song 22). Wroth echoes the darkness of her father's imagery in the eleventh sonnet of her crown (P 87), but redeems that imagery in the twelfth sonnet (P 88). Instead of celebrating a personal triumph in love, Pamphilia looks forward to the future glory of all those formerly "oprest" lovers of whom she is one, comparing them to "those blossooms fayre / Which fall for good, and lose theyr coulers bright / Yett dy nott, butt with fruite theyr loss repaire" (P 88). Pamphilia's words take account of the genuine suffering of lovers whose flowers of hope "fall for good," while at the same time affirming love's promise of "fruite" even from loss. The continuing music of the larger sequence, even in the face of suffering, likewise represents the fruit of Pamphilia's own love in song.[21]

Wroth's *corona* circles back upon itself with the questioning couplet of the fourteenth sonnet: "Soe though in Love I fervently doe burne, / In this strange labourinth how shall I turne?" (P 90). The question in the fourteenth line of the fourteenth sonnet echoes the question in the first line of the first sonnet, completing the circle only to continue it.[22] Philip Sidney goes beyond his circle in order to end it, attaching a four-line tag after the tenth dizain in which Strephon calls explicitly for "an

303

ende" (*OA* 72). Robert Sidney breaks his circle without ending it, cutting off the fifth sonnet of his crown after one quatrain. Wroth differentiates her crown from those of her uncle and father by maintaining a true circularity of form, which reflects the continuing rather than the conclusive nature of her speaker's experiences in love.

Interestingly enough, however, the circular continuity of Wroth's crown actually echoes and encompasses the essential circularity embedded in the larger sequences of her father and uncle. While the broken fifth sonnet of Robert Sidney's crown, which would have been the fifteenth sonnet of his sequence, interrupts the inner circle of the *corona*, the actual fifteenth sonnet of the sequence only reiterates the continuing nature of the speaker's plight, ending with his query "what way to fly?" (RS 15). The final sonnet of Philip Sidney's sequence suggests the continuing cycle of Astrophil's experience with a circular couplet—"That in my woes for thee thou art my joy, / And in my joyes for thee my only annoy" (*AS* 108)—which echoes the circular plaint of Strephon and Klaius in Philip Sidney's *corona*: "I joye in griefe, and doo detest all joyes" (*OA* 72). The ending of Wroth's *corona* thus recalls the apparently endless trials of love expressed in the larger sequences of her Sidney forebears. At the same time, in her own larger sequence, Wroth moves beyond the circularity of her *corona* with the final utterances of her poet-lady.

Pamphilia to Amphilanthus closes with a sonnet conveying the speaker's conscious decision to complete her music: "My muse now hapy, lay thy self to rest, / Sleepe in the quiett of a faithfull love" (P 103). Pamphilia directs her muse to "Leave the discource of Venus, and her sunn / To young beeginers," concluding: "And thus leave off, what's past showes you can love, / Now lett your constancy your honor prove" (P 103). Just as the sequence opened with a dream vision of Venus and Cupid from which the speaker first wakes to love, the sequence closes with a call to sleep. However it is now the lady, no longer a helpless dreamer, who directs her muse to sleep. As both lover and poet, Wroth's lady has moved beyond the arbitrary power of Venus and Cupid, tracing her thread of passion from the margins through the heart of the "labourinth," until her experience enables her to command her own rhetoric of love. Likewise Wroth demonstrates that she has moved beyond the influence of her father and uncle in tracing her thread of song from the margins of the Sidney family tradition to the central achievement of her own lyric sequence, whose existence re-forms the tradition.

Relinquishing the fictive "discource" of Venus and Cupid, Pamphilia turns from writing to living, from singing her love to living out her song. The silence of Pamphilia's muse in this final sonnet is a silence not

of lack but of completion.[23] As she designates the point of closure for her lyric sequence, Pamphilia characteristically makes reference to the necessary continuation of that discourse in the hands of other lovers, whose presence in her sequence through her acknowledgment of the shared nature of female suffering has decentered the absence of her own beloved. Both Philip and Robert Sidney end their sequences with assertions of continuing love as well as frustration, in which their speakers lament their personal plights. Pamphilia has no greater personal success in love than Astrophil or Rosis, yet her voice celebrates the music of love not only through but also beyond the personal trials of the lover.

For male sonneteers like Philip and Robert Sidney, although the lady may be the object of affection, the speaker's "tale of me," or fiction of himself, is the true subject of the sequence. For Wroth, on the other hand, the lady's subject of true love takes precedence over the enfabling of her experiences. When the lady speaks, in the eighth song of *Astrophil and Stella* or in the sixth song of Robert Sidney's sequence, the music of the male sonneteers is at least temporarily broken, because their "ancient fictions" are predicated upon their definitions of the lady as listener rather than voice. Wroth's speaker maintains that the "true forme of love" lives within the lady, beyond the changing whims of male response, spoken or unspoken, so that no male beloved can fracture her lady's song. The silence at the end of *Pamphilia to Amphilanthus* thus represents not the defeat of the singer but the culmination of the song.

As a lady of the Renaissance, Wroth herself was no breaker of songs, as can be gathered from the many poems written in her honor.[24] Furthermore, she is honored by other poets not just as a lady but as a maker of songs in her own right—most notably by Ben Jonson's assertion that since copying her sonnets he became "A better lover, and much better poet."[25] Even as Wroth proves herself, in *Pamphilia to Amphilanthus*, a rightful heir to the lyric achievements of the Sidney family, she leaves her own legacy as a Sidney whose poems not only give a voice to the lady, but also give a new and female voice to love within the sonnet tradition.

Notes

1. *Pamphilia to Amphilanthus*, #100, in *The Poems of Lady Mary Wroth*, ed. Josephine Roberts. Hereafter cited in the text as P, according to Roberts's numbering scheme.

2. Upon encountering a new landscape, one of the characters in *Urania* observes that poets "in their olde fictions do most strangely rave on the desarts, and rarenesses of the pleasant Arcadia, butt to mee this seemes as pleasing, rare, and farr more delightfull

because more richly stored with Varieties" (unpublished second part of *Urania* [Newberry Library, Case MS fY 1565.W 95], book 2, fol. 3v).

3. Earlier continental examples of women poets who reversed or revised gender roles include the French women troubadours of the twelfth and thirteenth centuries, as well as the sixteenth-century poets Pernette du Guillet (*Les Rymes,* 1545), Louise Labé (*Sonnets,* 1555), and Veronica Franco (*Terze rime,* 1575).

4. Discussing the responses of sixteenth-century women poets to male conventions, Ann Rosalind Jones remarks that Pernette du Guillet and Louise Labé "wrote within but against the center of the traditions that surrounded them, using Neoplatonic and Petrarchan discourse in revisionary and interrogatory ways" ("Assimilation with a Difference," 135).

5. See also Waller's essay in this collection.

6. For more discussion of the feminist pamphlets, see Henderson and McManus, esp. 47–98. Linda Woodbridge traces the influence of the "formal controversy" about women upon the popular literature of the period (114–36).

7. For a comprehensive survey of Renaissance conceptions of the role of "the lady," see Ruth Kelso's landmark study, *Doctrine for the Lady of the Renaissance.*

8. For historical background on such fictions, see Kelso, esp. 208–9; Dunn 15–38; Jardine 169–98; Henderson and McManus, 99–130.

9. Hull provides examples of such directives.

10. Jones assesses the importance of such role reversal in the poetry of Louise Labé ("Assimilation with a Difference," 148). See also Jones, "City Women and Their Audiences."

11. Joan Kelly observes that many feminist writers "were the sisters, daughters, and nieces of humanists and teachers and were educated by them" ("Early Feminist Theory and the *Querelle des Femmes,* 1400–1789," in her *Women, History and Theory,* 70).

12. Astrophil resumes his first-person voice to lament: "With what she had done and spoken / . . . therewith my song is broken" (eighth song of *Astrophil and Stella,* from *The Poems of Sir Philip Sidney,* ed. William A. Ringler, Jr. [Oxford: Clarendon Press, 1962]). In Robert Sidney's poem, the lady's expression of love is an epitaph (sixth song of Robert Sidney's sequence, from *The Poems of Robert Sidney,* ed. P. J. Croft [Oxford: Clarendon Press, 1984]). The poems of Philip and Robert Sidney will hereafter be cited from the Oxford editions, by number in the text (*Astrophil and Stella* as AS, *Old Arcadia* poems as OA, and Robert Sidney's sequence as RS).

13. See Kohler 218–20; Parry 57–58. Even so recent a critic as Simon Shepherd inaccurately refers to *Urania* as "a collection of poems" (32).

14. Roberts's studies include the introduction to her edition of Wroth's poems, as well as "Lady Mary Wroth's Sonnets" and "The Biographical Problem of *Pamphilia to Amphilanthus.*" See also Beilin, " 'The Onely Perfect Vertue' " and Beilin, "Heroic Virtue: Mary Wroth's *Urania* and *Pamphilia to Amphilanthus,*" in her *Redeeming Eve: Women Writers of the Renaissance,* esp. 232–43.

15. Roberts suggests a thematic comparison of the verse of father and daughter based upon the "attitude of somber introspection" which she identifies in both sequences, in the introduction to her edition of *Poems* (47–48), while Waller emphasizes the importance of the family connection, in "Struggling into Discourse," 248.

16. Beilin explains Amphilanthus's exclusion by suggesting that "he has no place within the scheme of constancy, because he represents change" (" 'The Onely Perfect Vertue,' " 240).

17. See Roberts, introduction to *Poems,* 325, and Beilin, " 'The Onely Perfect Vertue,' " 233–34, for two separate considerations of the "dual" image of Cupid in Wroth's sequence.

18. Croft suggests that Robert Sidney can be viewed as "the author of a collection of 'war poems' " (3-4), which depict a continual process of suffering and dying.
19. For another view of Wroth's crown, see Beilin, who maintains that the *corona* is not representative of but rather is "set off" from the rest of her sequence by tone, imagery, and diction (" 'The Onely Perfect Vertue,' " 236).
20. *The Countesse of Mountgomeries Urania* (London, 1621), STC 26051, book 1, p. 138.
21. Retha M. Warnicke demonstrates a common critical view of Wroth in failing to differentiate between her "disillusionment" with the male beloved and her affirmation of the female lover's capabilities as a poet (194).
22. Beilin interprets the repetition of the question in spiritual terms (" 'The Onely Perfect Vertue,' " 239).
23. On this point I differ from Waller, who maintains in "Struggling into Discourse" that "Pamphilia projects Amphilanthus as presence, herself only as absence—as lack, incompleteness, and finally, as silence waiting to be completed" (249).
24. For examples, see Roberts, introduction to *Poems,* 15-22.
25. Ben Jonson, "A Sonnet to the Noble Lady, the Lady Mary Worth [sic]," *Underwood* 28, in *Poems,* ed. Ian Donaldson (Oxford: Oxford University Press, 1975), 175.

Works Consulted

Abel, Elizabeth, ed. *Writing and Sexual Difference.* Chicago: University of Chicago Press, 1982. Collection of essays on writing and gender difference, with special attention to issues concerning female identity.

Beilin, Elaine V. " 'The Onely Perfect Vertue': Constancy in Mary Wroth's *Pamphilia to Amphilanthus.*" *Spenser Studies* 2 (1981): 229-45. Examines Wroth's sonnets as an exploration of the particularly feminine virtue of constancy; concludes that the essence of Pamphilia's virtue is divine.

———. *Redeeming Eve: Women Writers of the English Renaissance.* Princeton: Princeton University Press, 1987. Comprehensive study of Renaissance women writers; argues that they responded to negative conceptions of feminine identity by glorifying feminine virtues and regenerating the image of woman in the familiar terms of their own culture.

Bogin, Meg. *The Women Troubadours.* New York: W. W. Norton, 1980. Traces the tradition of French women troubadours of the twelfth and thirteenth centuries, considering their treatment of love in the context of their historical and cultural background; includes dual-language text of the poems.

Carney, Jo Eldridge. "Female Friendship in Elizabethan Literature." Ph.D. diss., University of Iowa, 1983. Introductory chapters on male friendship in Renaissance literature and actual female friendships of Elizabethan women followed by discussion of literary representations of female friendship, with particular attention to Shakespeare's plays.

Chodorow, Nancy. *The Reproduction of Mothering: Psychoanalysis and the Sociology of Gender.* Berkeley: University of California Press, 1978. Draws on psychoanalytic account of female and male personality development to demonstrate sexual asymmetries in the social organization of gender generated by women's mothering.

Croft, P. J. Introduction to *The Poems of Robert Sidney,* edited by P. J. Croft. Oxford: Clarendon Press, 1984. Places Robert Sidney's poems in literary and historical contexts, while highlighting specific themes and techniques.

Dunn, Catherine M. "The Changing Image of Women in Renaissance Society and

Literature." In *What Manner of Woman: Essays on English and American Life and Literature*, edited by Marlene Springer, 15–38. New York: New York University Press, 1977. Argues that what distinguished the Renaissance gentlewoman from her predecessors was her learning.

Gilligan, Carol. *In a Different Voice: Psychological Theory and Women's Development*. Cambridge: Harvard University Press, 1982. Contrasts male and female voices in order to highlight different modes of thinking about relationships, with particular reference to psychological and literary texts.

Goreau, Angeline, ed. *The Whole Duty of a Woman: Female Writers in Seventeenth-Century England*. Garden City, N.Y.: Doubleday, 1984. Collection of writings documenting education, social background, and circumstances under which seventeenth-century women wrote and indicating contradictory attitudes toward publication.

Henderson, Katherine Usher, and Barbara F. McManus. *Half Humankind: Contexts and Texts of the Controversy about Women in England, 1540–1640*. Urbana: University of Illinois Press, 1985. First portion surveys the Renaissance debate about women with reference to social and literary contexts; second portion includes excerpts from relevant primary texts.

Homans, Margaret. *Women Writers and Poetic Identity*. Princeton: Princeton University Press, 1980. Addresses the question of how the consciousness of being a woman affects the workings of the poetic imagination, with reference to three representative nineteenth-century women poets (Dorothy Wordsworth, Emily Brontë, Emily Dickinson).

Hull, Suzanne W. *Chaste, Silent and Obedient: English Books for Women, 1475–1640*. San Marino, Calif.: Huntington Library, 1982. Examination of printed books directed toward an English-speaking female audience from 1475 to 1640.

Jardine, Lisa. *Still Harping on Daughters: Women and Drama in the Age of Shakespeare*. Sussex: Harvester Press, 1983. Concentrates on representations of women in the drama of the early modern period, suggesting ways in which "femaleness" was significant in a network of possibilities for categorizing and discriminating experience.

Jones, Ann Rosalind. "Assimilation with a Difference: Renaissance Women Poets and Literary Influence." *Yale French Studies* 62 (1981): 135–53. Considers the reception of lyric conventions in the poetry of Pernette du Guillet and Louise Labé, in order to evaluate sixteenth-century women's response to their social and literary context.

———. "City Women and Their Audiences: Louise Labé and Veronica Franco." In *Rewriting the Renaissance: The Discourses of Sexual Difference in Early Modern Europe*, edited by Margaret W. Ferguson, Maureen Quilligan, and Nancy J. Vickers, 299–316. Chicago: University of Chicago Press, 1986. Explores how urban settings and ambiguous class positions influenced two women poets in appropriating previously masculine rhetorics of love poetry.

Kelly, Joan. *Women, History and Theory*. Chicago: University of Chicago Press, 1984. Collection of essays on women and history which calls into question accepted schemes of periodization and treats sex as a category of social thought.

Kelso, Ruth. *Doctrine for the Lady of the Renaissance*. Urbana: University of Illinois Press, 1978. Study of western European writers on women, 1400–1600, which surveys Renaissance ideals of education and conduct.

Kohler, Charlotte. "The Elizabethan Woman of Letters: The Extent of Her Literary Activities." Ph.D. diss., University of Virginia, 1936. Includes section on Lady Mary Wroth which identifies her prime importance in historical rather than literary terms.

Lamb, Mary Ellen. "The Countess of Pembroke and the Art of Dying." In *Women in the*

Middle Ages and the Renaissance: Literary and Historical Perspectives, edited by Mary Beth Rose, 207–26. Syracuse: Syracuse University Press, 1986. Argues that the countess's translations of Mornay, Garnier, and Petrarch embody a female literary strategy through which women could be represented as heroic without challenging the patriarchal conceptions of Elizabethan culture.

Parry, Graham. "Lady Mary Wroth's *Urania*." *Proceedings of the Leeds Philosophical & Literary Society, Literary & Historical Section* 16, Part 4 (1975): 51–60. Defines *Urania* as a product of the courtly-chivalric ethos prevalent in late sixteenth- and early seventeenth-century England, emphasizing its derivation from the example of Sidney's *Arcadia*.

Paulissen, May Nelson. *The Love Sonnets of Lady Mary Wroth: A Critical Introduction*. Salzburg: Institut fur Anglistik und Amerikanstik, University of Salzburg, 1982. Views Wroth's sonnets as combining classical, metaphysical, and courtly strains in representing the struggle between love and lust.

Roberts, Josephine A. "The Biographical Problem of *Pamphilia to Amphilanthus*." *Tulsa Studies in Women's Literature* 1 (1982): 43–53. Indicates link between Wroth and William Herbert, third earl of Pembroke, which may underlie Wroth's representation of the bond between Pamphilia and Amphilanthus; concludes that Wroth limited the degree of personal reference in her sequence, concentrating instead on expressing a universal response to disappointment in love.

———. "Lady Mary Wroth's Sonnets: A Labyrinth of the Mind." *Journal of Women's Studies in Literature* 1 (1979): 319–29. Argues that Wroth uses her sequence to analyze love's most dangerous effects for women, such as subjugation, frustration, and loss of self; concludes that Wroth's persona comes to accept pain as a necessary complement to joy in love and to recognize the unpredictability of human emotions.

———. Introduction to *The Poems of Lady Mary Wroth*. Edited by Josephine A. Roberts. Baton Rouge: Louisiana State University Press, 1983. Outlines Wroth's life and the historical circumstances surrounding her publication of her work and provides some analysis of the poems themselves.

Shepherd, Simon. *Amazons and Warrior Women: Varieties of Feminism in Seventeeth-Century Drama*. Sussex: Harvester Press, 1981. Includes discussion of Shakespeare's comic heroines as a separate female group with its own ideas and standards.

Showalter, Elaine, ed. *The New Feminist Criticism: Essays on Women, Literature, and Theory*. New York: Pantheon Books, 1985. Collection of essays using gender as a fundamental category of literary analysis with the aim of achieving a radical rethinking of the conceptual ground of literary study.

Smith, Hilda L. *Reason's Disciples: Seventeenth-Century English Feminists*. Urbana: University of Illinois Press, 1982. Study of English feminists primarily in the second half of the seventeenth century.

Stone, Lawrence. *The Family, Sex, and Marriage in England, 1500–1800*. New York: Harper and Row, 1977. Includes analysis of the role of women in the changing family structures of the late sixteenth and early seventeenth centuries.

Swift, Carolyn Ruth. "Feminine Identity in Lady Mary Wroth's Romance *Urania*." *English Literary Renaissance* 14 (1984): 328–46. Argues that Wroth reveals the loss of identity that women experience in a society that victimizes them, concluding that contradictions in *Urania* indicate limitations upon the ability of Renaissance women to fashion themselves as they wished.

Travitsky, Betty, ed. *The Paradise of Women: Writings by Englishwomen of the Renaissance*. Westport, Conn.: Greenwood Press, 1981. Anthology of writings by Renaissance Englishwomen, including excerpts from the published *Urania*.

Waller, Gary. "The 'Sad Pilgrim': The Poetry of Robert Sidney." *Dalhousie Review* 55 (1975–76): 689–705. Connects the tone of melancholy and disillusionment in Robert Sidney's poems with the political and personal frustrations of his career.

———. "Struggling into Discourse: The Emergence of Renaissance Women's Writing." In *Silent But for the Word: Tudor Women as Patrons, Translators and Writers of Religious Works,* edited by Margaret P. Hannay, 238–56. Kent, Ohio: Kent State University Press, 1985. Considers the status of women within the dominant rhetorics of Renaissance poetry and maintains that the writings of Renaissance women call attention to gender-specific items through the gaps and silences in their texts.

Warnicke, Retha M. *Women of the English Renaissance and Reformation.* Westport, Conn.: Greenwood Press, 1983. Study of prominent figures in four generations of English women humanists and scholars in the Renaissance and Reformation.

Witten-Hannah, Margaret Anne. "Lady Mary Wroth's *Urania:* The Work and the Tradition." Ph.D. diss., University of Auckland, New Zealand, 1978. Examines prominent themes and techniques in *Urania* with reference to literary and historical contexts; includes discussion of the relationship between the published and unpublished parts of Wroth's romance. See her essay [McLaren] in this volume.

Woodbridge, Linda. *Women and the English Renaissance: Literature and the Nature of Womankind, 1540–1620.* Urbana: University of Illinois Press, 1984. Discusses the formal and transvestite controversies over women and their effect on literary conventions.

MAUREEN QUILLIGAN

Feminine Endings
The Sexual Politics of Sidney's and Spenser's Rhyming

RECENT STUDIES of both contemporary and Renaissance rhetorical practice, especially the excavation of the relationship between rules for language use and modes of social control, have much to teach feminist theory. Although Frank Whigham's argument in *Ambition and Privilege: The Social Tropes of Elizabethan Courtesy Theory* does not take up the question of gender, it does demonstrate the relevance of rhetorical theory to a whole mode of organizing social mobility in the Renaissance. More recently Patricia Parker has pointed to the gendered nature of many exempla in the rhetorical handbooks themselves, arguing that they share the same discursive goal of controlling female behavior as that more explicitly expressed in female conduct books (97–125). If even so innocent seeming a practice as rhetorical exemplification can carry a gendered message, aimed at social control, it may not be illogical to ask whether the technical vocabulary of poetics during the Renaissance was part of the same discursive package, serving similar social aims.

The distinction in English between "feminine" and "masculine" rhymes neatly appropriates sexual difference to make its categories. Masculine rhymes end on the stressed, or hard, syllable, whereas feminine rhymes conclude on the soft, unstressed ending. Such a distinction seems motivated by the most direct appeal to the physical differences between male and female bodies; poetics here seems immediately grounded on a mimetic biologism that is innocent of larger, social constructions. Rhyme in English, however, was not always named by these "natural" terms, and the terms "masculine" and "feminine" represent a specific cultural borrowing during the Renaissance, as well as a set of self-conscious English cultural constructions that left a distinct mark on Elizabethan poetry in particular.

A central text that takes up the question of rhyming—itself an embattled issue during the time of experimentation with imitation of classical meter—is Sir Philip Sidney's *Apology for Poetry*.[1] In *Apology* Sidney has this to say of feminine and masculine rhymes:

> Now for the rhyme, though we [English] do not observe quantity, yet we observe the accent very precisely, which other languages either cannot do, or

will not do so absolutely. That caesura, or breathing place in the midst of the verse, neither Italian nor Spanish have, the French and we never almost fail of. Lastly, even the very rhyme itself the Italian cannot put in the last syllable, by the French named the masculine rhyme, but still in the next to the last, which the French call the female, or the next before that, which the Italians term *sdrucciola*. The example of the former is *buono : suono*, of the *sdrucciola, femina : semina*. The French, on the other side, hath both the male, as *bon : son*, and the female, as *plaise : taise*, but the *sdrucciola* he hath not: where the English hath all three, as *due : true, father : rather, motion : potion;* with much more which might be said, but that I find already the triflingness of this discourse is much too enlarged. (141)

Even Sidney thinks the question is unimportant. But, as his very examples make clear, the technicality of the rhymes bespeaks a much larger social system than mere poetic technique. "Good sound" in French is male (*bon : son*), a "silence" rhyming with that which "pleases" is female (*plaise : taise*); the masculine rhyme in English speaks of duty and truth (*due : true*). The sliding rhyme in Italian posits "woman" in relation to "semen" or "seed" (*femina : semina*); in English the *sdrucciola*, following an odd example of the feminine rhyme, *father : rather*, is *motion : potion* (a potion may well serve as the agent of motion— particularly appropriate in romance when one needs to get a father out of the way). Gender difference in rhyme, at least in the small narrative inscribed by Sidney's examples here, tells the story of sexual difference specifically in terms of the patriarchy. The remarkably close, nearly causal, connection between the nature of the examples and the notion of masculine and feminine in the vocabulary of poetic technique marks Sidney's own practice and, after him, Spenser's. To spend time noticing where Elizabethan poets consciously choose to use feminine rhyme may tell us something about the complex interrelations between the politics of poetry and sexuality in the English Renaissance.

But before we take up English practice, we need to place it in its continental context. As Sidney makes explicitly clear in *An Apology*, the naming of the terms for rhyme comes from the French. Apparently the practice began with the "grande rhetoriqueurs" of the fifteenth and early sixteenth centuries.[2] It was picked up by the Pleiade poets, specifically Marot and Ronsard: Marot used regular alternations of masculine and feminine rhymes in his translations of the Psalms, while Ronsard achieved a regular alternation specifically in couplet poems. Developed in the 1550s, the technique was regularized throughout the decade (Weber 153–54). In the *Abbregé de l'Art Poétique François* (1565), Ronsard explains that "rhyme is no other thing than a consonance and cadence of syllables, falling at the end of the verse; and I hope you will observe as many in the masculine as in the feminine, either of two whole and

perfect syllables, or at the least of the one masculine, so that the verse might be resonant and of an entire and perfect sound."[3] The feminine rhyme in French, it must be noted, has purely to do with the sounding of the *e muet* in both nouns and various verb forms. Ronsard's examples of both are as interesting as Sidney's; first, examples of the feminine: "France, Esperance, despense, negligence, familiere, fourmiliere, premiere, chere, mere." Second, of the masculine: "surmounter, monter, douter, sauter, Juppiter" (8). On the distaff side we have an allegorical France and hope (both capitalized), a neglectful spending of money, familial relations, the primary dear mother and a bizarre intrusion of an insect, the piss-ant. On the masculine side, we have intellectual doubt, and verbs of leaping, climbing, and conquest, as well as the name of the Latin father God. Psychoanalyzing the free associations of patriarchy is alluringly facile in both languages.[4]

In his edition of Sidney's poetry, William Ringler argues that Sidney's "great innovation was to bring feminine rhyme back into English verse and to make it a formal structural element in the shaping of his stanzas" (lvi). In this Sidney had a "companion in Spenser," whose practice, however, according to Ringler, contrasted with Sidney's because he did not make feminine rhymes a structural element in stanzaic organization—whereas Sidney did—and because, moreover, Spenser appears to have avoided the device itself in the first installment of *The Faerie Queene*. There are remarkably few feminine end rhymes in the first three books of Spenser's epic, but those that are there are telling, because they tell a very interesting story about sexual difference and, indeed, sexuality. Ringler is quite right that there are a far greater number in the second installment—and we might do well to ask why there was this strange increase in feminine rhymes—from none in the first six cantos of Book 1, to five in a single stanza of the Mutability Cantos. Might they not mark some essential change of purpose in the text of the epic?

Sidney's practice in *Old Arcadia*—the metrical experimentation there would probably have had the greatest impact on Spenser—uses feminine rhyme to articulate the patriarchal chaos at the heart of the plot.[5] Sidney's most spectacular use of feminine rhyme is in the virtuoso double sestina given to Strephon and Klaius in their lament for the absence of Urania at the opening of the eclogues to Book 4. Basilius is dead, murdered, it is suspected, by the cross- and down-dressed princes. The shepherds' lament for the absent Urania is their private version of the public debacle (not native to Arcadia, they do not feel the loss of the king as keenly):

Strephon. Ye goat-herd gods, that love the grassy mountains,
Ye nymphs, which haunt the springs and pleasant valleys,
Ye satyrs, joyed with free and quiet forests,

> Vouchsafe your silent ears to plaining music
> Which to my woes gives still an early morning,
> And dawns the dolor on till weary evening. (285)

This set piece does not immediately call internal attention to the political "garboils"—as the narrator terms them—surrounding the eclogues of the fourth book, but it does amply demonstrate Sidney's stanzaic use of feminine rhyme. Further lamentations in the eclogues do, however, turn to the loss of Basilius, especially Agelastus's sestina, which uses feminine rhyme:

> Orphans indeed, deprived of father's might;
> For he our father was in all affection,
> In our well doing placing all his pleasure,
> Still studying how to us to be a light.
> As well he was in peace a safest treasure;
> In war his wit and word was our direction.
> Whence, whence alas, shall we seek our direction
> When that we fear our hateful neighbour's might,
> Who long have gaped to get Arcadian's treasure?
> Shall we now find a guide of such affection,
> Who for our sakes will think all travail light,
> And makes his pains to keep us safe his pleasure? (303)

Lest the feminine rhymes seem an accident of sestina practice and so therefore not tied to the politics of the plot, it is useful to note that the first sestina in the text is Agelastus's immediate response to Basilius's death:

> Since wayling is a bud of causeful sorrowe,
> Since sorrow is the follower of evill fortune,
> Since no evill fortune equalls publique damage:
> Now Prince's losse hath made our damage publique,
> Sorrow pay we unto the rights of Nature
> And inward griefe seal up with outward wailing. (246)

More significant still, the first poem to use feminine rhymes *entirely* is one spoken by Basilius in praise of his supposed night with "Cleophila" (that is, the cross-dressed Pyrocles).

> O night, the ease of care, the pledge of pleasure,
> Desire's best mean, harvest of hearts affected,
> The seat of peace, the throne which is erected
> Of human life to be the quiet measure. (238)

Basilius, of course, has not slept with Cleophila (Pyrocles), but with his own wife Gynecia (who had been awaiting Pyrocles). Both king and

queen, besotted in their lust for the cross-dressed prince, are caught out by his double trick and confront each other. Unfortunately, the king insists upon drinking the potion intended for the young lover and "rather" than increasing his sexual performance, the "father" of Arcadia, not too "true" himself, appears to die, "due" to the too great "motion" of that magic "potion."

Although there are feminine rhymes elsewhere in the poems scattered through the text of the romance, the marked consistency of feminine endings in the poems surrounding the catastrophe of the plot (Basilius's supposed death) would seem to suggest that the proper prosody for political upset is feminine rhyming.[6]

Spenser's practice in the second installment of *The Faerie Queene* would seem to suggest that he understood Sidney's political program in his use of feminine rhyme. To take an example not entirely at random: Spenser rhymes *daughter* with *slaughter* in Book 5 of his epic; the stanza in which this feminine rhyme appears bears full quotation because it exemplifies the remarkable explicitness of the feminine and profoundly political context in which the technical tactic functions. The stanza describes Artegall's rescue of Terpin and his attack on Radigund:

> Whom when as Artegall in that distresse
> By chance beheld, he left the bloudy *slaughter,*
> In which he swam, and ranne to his redresse.
> There her assayling fiercely fresh, he *raught her*
> Such an huge stroke, that it of sence *distraught her:*
> And had she not it warded warily,
> It had depriv'd her *mother* of a *daughter.*
> Natheless for all the powre she did apply,
> It made her stagger oft, and stare with ghastly eye. (5.4.41)

The internal rhyme on *mother : daughter* insists with grisly humor on the insubordinate mother-daughter matriarchy Radigund represents as Amazon warrior queen, a power specifically inimical to the patriarchy Britomart reasserts after she, rather than Artegall, finally hacks off Radigund's head: strange to say, it is Britomart who assumes the throne of this former Amazonian land, but she does so with a difference that somehow de-female-izes her own rule:

> During which space she there as Princess rained,
> And changing all that forme of common weale,
> The liberty of women did repeale,
> Which they had long usurpt; and them *restoring*
> To mens subjection, did true Justice deale:
> That all they as a Goddesse her *adoring,*
> Her wisedome did admire, and hearkned to her *loring.* (5.7.42)

The final feminine rhyme exonerates femininity, now restored by a deified female to its proper subjection to human masculine authority.

Having deprived Radigund's mother of a daughter, Britomart becomes a goddess and is honored in that "nonpolitical" status shared by so many other female figures of authority in the epic. Similarly, when Scudamour comes to the temple of Venus in Book 4, canto 10, he comes to a place of essential femininity:

> The temple of great Venus, that is hight
> The Queene of beautie, and of love the *mother,*
> There worshipped of every living wight;
> Whose goodly workmanship farre past all *other*
> That ever were on earth, all were they set *together.* (4.10.29)

As the principle of generation, of natural sexuality, of motherhood, femaleness is authoritative and acceptable.

In a similar vein, another potentially rebellious daughter is put in her place by one who is no less than her mother. The instability threatened by Mutability's challenge to what is, in essence, the patriarchal authority represented (however comically) by the pagan pantheon, comes spoken in subtly appropriate feminine rhymes: Mutability's quest arrives at Diana's sphere:

> Thence, to the Circle of the Moone she clambe,
> Where Cynthia raignes in everlasting *glory,*
> To whose bright shining palace straight she came,
> All fairely deckt with heavens goodly *story:*
> Whose silver gates (by which there sate an *hory*
> Old aged Sire, with hower-glasse in hand,
> Hight Tyme) she entred, were he liefe or *sory:*
> Ne staide till shee the highest stage had scand,
> Where Cynthia did sit, that never still did stand. (7.6.8)

The punning on *sto, stare, stasis* in this stanza anticipates the terms in which Nature will reduce Mutability's claim to nothing, for all things their *states* maintain; the punning on "still" in the stanza about time itself complicates motion and stasis, reflected later in the grand calendar of testimony that proves Mutability wrong. Mutability has come to Nature herself because she is a great goddess:

> Who Right to all dost deale indifferently,
> Damning all Wrong and tortious Injurie,
> Which any of thy creatures doe to *other*
> (Oppressing them with power, unequally)
> Sith of them all thou art the equall *mother,*
> And knittest each t'each, as brother unto *brother.* (7.7.14)

Mutability's very language here, as elsewhere, undercuts her claims: *mother* rhymes with *brother;* Great lady Nature, androgynous herself like Britomart, cannot help reasserting the privileges of patriarchal rule: motherhood officially functions in relation to brotherhood, not matriarchal daughterhood. If *mother* characteristically rhymes with *brother* in *The Faerie Queene,* it should not surprise us that, despite Sidney, *father* never appears as a rhyme word in the poem.[7] It would, of course, make a most inappropriate feminine rhyme.

More surprisingly, in a poem about such chivalric virtues as glory and honor, these two words appear only once apiece in rhyming positions; the example of *glory* we have already seen—Cynthia reigns in "everlasting glory" and so will in her very feminine, moonish instability undercut Mutability's claim to rule beyond patriarchal power. The single appearance of *honor* as an end rhyme must be compared to 101 other appearances within the line. Again, it is in a quasi-comic context that gently mocks the confusions into which Britomart and Amoret are thrown when Amoret assumes that Britomart is a male and Britomart does not think to disabuse her of the notion:

> His will she feared; for him she surely thought
> To be a man, such as indeed he seemed,
> And much the more, by that he lately wrought,
> When her from deadly thralldome he redeemed,
> For which no service she too much esteemed;
> Yet dread of shame, and doubt of fowle *dishonor*
> Made her not yeeld so much, as due she deemed.
> Yet Britomart attended duly *on her,*
> As well became a knight, and did to her all *honor.* (4.1.8)

This weird set of rhymes, amounting almost to a pun (on her/honor), speaks to the rewrite of the ending of Book 3, the excision of the androgynous embrace between Scudamour and Amoret, and the urgent insistence that Amoret and Scudamour were already married in Book 3—all attempts by Spenser to evade, some have guessed, the censure of that bad Burleigh-like reader who cannot judge of love because he does not feel kindly flame.[8] The *dishonor : on her : honor* rhyme is an early set of feminine endings in the second installment—and, as Ringler has accurately noted, there are many more in the second installment than in the first.

But we do the first installment a disservice if we ignore the significance of feminine rhyming that is there. One word in particular has great force in the first installment as a rhyming term. The word is *power;* with Spenser's peculiar spelling, the word may be both a two- and a one-syllable word, and therefore may make both masculine and feminine

rhymes. Duessa's power in Book 1 is essentially seductive and feminine and often appears in the stressed position at the end of the line.

> The Lady when she saw her champion fall,
> Like the old ruines of a broken *towre,*
> Staid not to waile his woefull funerall,
> But from him fled away with all her *powre;*
> Who after her as hastily gan *scowre,*
> Bidding the Dwarfe with him to bring away
> The Sarazins shield. (1.2.20)

Duessa cleverly covers her power, here a masculine monosyllable, by calling hers the Redcrosse Knight's own (2.2.22); in Book 1 *power* in the rhyming position is always Duessa's and must be contrasted to Fidelia's, who has it only at the distinctly feminine caesura, where it is power properly borrowed from a masculine authority:

> And eke huge mountaines from their native seat
> She would command, themselves to beare away,
> And throw in raging sea with roaring threat.
> Almightie God her gave such *power,* and puissance great. (1.10.20)

When Prince Arthur fights in Book 2 with Pyrochles and also with the sensuous forces attacking Alma's castle, he fights with characters whose power is placed in the rhyming position (2.8.35 and 48). Alma's castle is built with *power,* like a *tower,* or a *bowre,* by God; here a masculine authority has created the process of generative creation, the human body, which comes in both sexes; its power can be feminine in the end because male in the beginning.

But one purely feminine power is seen as purely good in the first installment of *The Faerie Queene.* At the end of the faery chronicles, Guyon finds a description of the reign of Tanaquill:

> Fairer and nobler liveth none this *howre,*
> Ne like in grace, ne like in learned skill:
> Therefore they 'Glorian' call that glorious *flowre,*
> Long mayst thou Glorian live, in glory and great *powre.* (2.10.76)[9]

The conclusion that Spenser consciously chose feminine rhymes for specific feminine contexts is inescapable. The rhyme here is, of course, forced into a masculine sound—a legitimation of Gloriana's power that, at the same time, may share a disturbingly androgynous monstrosity with Duessa's. The only thing Gloriana's flower/power has in common with Artegall's daughter/slaughter is the reference to feminine figures; that both these instances have to do directly with female authority, specifically with Queen Elizabeth's female authority, may suggest, of

course, the further propriety of feminine rhyme in an epic titled *The Faerie Queene*.

In the Proem to Book 4, Spenser had specifically described the queen's ideal reading of his text with feminine rhymes. No longer addressing her directly, as in the Proems to the first three books, Spenser takes the more circuitous route of asking Cupid to inspire her to read:

> Do thou dread infant, Venus dearling dove,
> From her high spirit chase imperious care,
> And use of awfull Majestie remove:
> Deawd with ambrosiall kisses, by thee *gotten*
> From thy sweet smyling mother from above,
> Sprinkle her heart, and haughtie courage *soften*,
> That she may hearke to love, and reade this lesson *often*. (4.Proem.5)

One final example will show how specific and yet how generally significant is Spenser's practice of feminine rhyme. It probably does not surprise anyone to learn that the faery chronicle which Guyon reads quite rightly has a feminine ending, however masculinized, in the reign of Gloriana, and also in the stanza that brings its reading to a close. It is a bit of a surprise, however, to realize that another large text comes to a very strange and distinctly feminine finale. The text of *The Faerie Queene* itself, as it stood in Spenser's lifetime, has a feminine ending. But before we can appreciate just how bizarre this ending is, we need to glance very briefly at the words that make up the rhyme scheme of its final stanza. The word *pleasure* ought, ideally, to have some connection to sexuality— and it does in the last three books of the epic. In Book 4, after ransacking Poeana's father's castle, Britomart and Arthur rest to give "solace in soft *pleasure*" to the weaker ladies (4.9.12). Paridell's and Blandamour's weak and inconstant love is a thing of *leisure*, out of *measure*, with no particular lady a special *treasure* (4.9.21). When Scudamour comes to the Temple of Venus he wants to stay in its delicious garden forever, which seemed a second paradise of all *pleasure*, filled with nature's *treasure* (4.10.23), an attitude that might remind the moralistic reader of the lover in the *Roman de la Rose* mistaking two very different gardens for each other. When, finally in Book 6, the cannibals eye the naked Serena with remarkably salacious appetite, we may begin to suspect the *pleasure* that exceeds due *measure:*

> Those daintie parts, the dearlings of delight,
> Which mote not be prophan'd of common eyes,
> Those villeins vew'd with loose lascivious sight,
> And closely tempted with their craftie spyes;
> And some of them gan mongst themselves devise,

Thereof by force to take their beastly *pleasure*.
But them the Priest rebuking, did advize
To dare not to pollute so sacred *threasure*,
Vow'd to the gods: religion held even theeves in *measure*. (6.8.43)[10]

Weak, illicit, suspect, such pleasure mistakes the real measure of true treasure.

Then, in the final stanza of the sixth book of *The Faerie Queene* Spenser writes an envoy to his epic, a book he fears will be cannibalistically torn by the teeth of the Blatant Beast:

Ne may this homely verse, of many *meanest*,
Hope to escape his venomous despite,
More than my former writs, all were they *clearest*
From blamefull blot, and free from all that wite,
With which some wicked tongues did it backebite,
And bring into a mighty Peres *displeasure*,
That never so deserved to endite.
Therefore do you my rimes keep better *measure*,
And seeke to please, that now is counted wisemens *threasure*. (6.12.41)

Remarkable for the sad and bitter tone of defeat, this stanza is also notable because it has not one but two feminine rhymes: *meanest : clearest* as well as *displeasure : measure : treasure*. Where the faery chronicle could end on a glorious celebration of feminine power, *The Faerie Queene* itself ends weakly, in despair, presumably betrayed by the feminine power who would not protect it from the displeasure of a mighty Peer. In the Proem to Book 4 Spenser had answered the rugged statesman who had blamed his "looser" rhymes, magnifying the dear debates of love. There Spenser had specifically said his rhymes were not intended for such a reader, defending his chosen subject of love in distinctly feminine rhymes:

. . . who so list looke back to former *ages*,
And call to count the things that then were donne,
Shall find, that all the workes of those wise *sages*,
And brave exploits which great Heroes wonne,
In love were either ended or begunne. (4.Proem.3)

Now, however, at the end of the second installment, that program has ended in defeat. The satire of the wise men who wish merely to be pleased by servile romance rather than instructed by the treasure of allegory is only matched by the self-lacerating despair of the poet's telling his text to keep better measure in a feminine rhyme.

We might well ask what impact this programmatic cultural gendering of rhyme could have had on actual women. The beginning of an

answer to such a question might usefully begin with the poetic practice of Lady Mary Wroth, who was not only Sidney's niece but was also the first woman to publish in English both a work of prose fiction and a sonnet cycle. In *The Countesse of Mountgomerie's Urania*, Wroth recasts her uncle's arcadian romance and rewrites key episodes of *The Faerie Queene*. Her rewriting of the scene of Amoret's torture in Book 3 is particularly interesting because its engagement of a fascinating set of reversals includes a subtle reorchestration of masculine and feminine rhyme in a quatrain that is otherwise a comparatively poor poetic production for Wroth.

Toward the end of the first printed part of *Urania,* the heroine Pamphilia comes upon a "crown of Stones" in her search for her beloved hero Amphilanthus, whom she continues to love, however faithless he might be. Pamphilia descends into an underworld and comes across a scene in which Amphilanthus is being tortured. Thus, Wroth's version of the torture scene reverses the genders: the victim is male and the (plural) torturers are female. The largest difference, however, is that Pamphilia is ultimately not successful in her rescue, while, of course, Britomart is.

> Pamphilia adventured, and pulling hard at a ring of iron which appeared, opned the great stone, when a doore shewed entrance, but within she might see a place like a Hell of flames, and fire, and as if many walking and throwing pieces of men and women up and downe the flames, partly burnt, and they still stirring the fire . . . the longer she looked, the more she discernd, yet all as in the hell of deceit, at last she saw Musalina sitting in a Chaire of Gold, a Crowne on her head, and Lucenia holding a sword, which Musalina took in her hand, and before them Amphilanthus was standing, with his heart ript open, and "Pamphilia" written in it, Musalina ready with the point of the sword to conclude all, by razing that name out, and so his heart as the wound to perish. (1.4.494)

Wroth re-scripts Spenser's already literalized set of conceits and makes the written name "Pamphilia" visible on Amphilanthus's fleshly heart while Spenser's Busyrane is merely busy with his pen, writing spells (possibly with her heart's blood) that will "remove" Amoret's heart. The appearance of the letters, of course, is a further literalization, doubtless authorized by Spenser's own practice in the first poem of his *Amoretti,* where his beloved reader is asked to read what is written by tears in "heart's close bleeding book." The dismembering tradition of the Petrarchan blason may also be literalized in the bits and pieces of lovers' flesh being tossed about in the flames—a tradition that Spenser himself mocks in the episode with Serena and the cannibals in Book 6. What is most striking about Wroth's revision of Spenser's scene, however, is that

Title page of *The Countesse of Mountgomery's Urania* (1621). By permission of the Huntington Library, San Marino, California.

the moral values are completely reversed. Pamphilia tries vainly to come to Amphilanthus's rescue but she is unable to, not because she may be implicated, like Scudamour, some way in the torture, nor because she has no powers of aggression (like Britomart's magic lance), but because only false lovers are able to enter such an arena. She is too true and constant (read "chaste") to have an impact.

> so with as firm, and as hot flames as those she saw, and more bravely and truly burning, she ran into the fire, but presently she was throwne out again in a swound, and the doore shut; when she came to her selfe, cursing her destinie, meaning to attempt again, shee saw the stone whole, and where the way into it was, there were these words written:
>
> Faithfull lovers keep from hence
> None but false ones here can *enter:*
> This conclusion hath from whence
> Falsehood flowes, and such may *venter.* (1.4.494)

The alternation of the masculine and feminine rhymes is perfectly acceptable Renaissance practice: false lovers are given the lines that end with the feminine "weak" stress: Only false lovers may *venture* to *enter* such a place. The association of feminine rhyme with falsity runs counter to Wroth's usual emphasis throughout the romance. The entire pressure of the narrative of *Urania* insists upon the moral virtue of constancy; it is a virtue, moreover, that is specific to women. Pamphilia is heroine because she is the truest, most constant lover, the most all-loving, that is "Pam-philia." The hero is named for the principle of falsity, "Amphilanthus," "lover of two." Wroth's huge romance, then, rewrites Spenser's satirical Squire of Dames dilemma as well as the constancy test of the Argalus and Parthenia episode in the *Arcadia.* Wroth recasts these narratives, moreover, by self-consciously reversing the moral positions of the differently gendered principals. Thus, for instance, Veralinda wryly comments to Musalina—a woman with whom the fickle Amphilanthus has had a passing attachment and who becomes his torturer in the torture scene—on the gender dichotomy: in opposition to women, men are absolutely inconstant: "take heed brave Lady, trust not too much; for believe it, the kindest, lovingest, passionatest, worthiest, loveliest, valiantest, sweetest, and best man, will, and must change, not that he, it may bee, doth it purposely, but tis their natural infirmitie, and cannot be helped" (1.3.375). Veralinda is aware that such counsel comprises a neat reversal of former gender categories. She ironically explains how it is a real change from earlier tradition: "It was laid to our charge in times passed to bee false, and changing, but they who excell us in all perfections, would not for their honours sake, let us surpass them

in any one thing, though that, and now are much more perfect, and excellent in that then wee, there is nothing left us, that they excell us not in, although in our greatest fault" (1.3.375).

Given such self-consciousness on the part of the romance generally about the neat reversal of traditional gender categories, the emphatic tagging with feminine rhyme of the verses about falsity cannot be pure accident—especially because this episode, so conspicuously recast from Spenser, is the climax of the printed segment of text. If she uses feminine rhyme as a traditional signal of the moral weakness of those who are false in love, at the same time Wroth's signal sets up an ironic counterpoint: the "weaker" position of falsity belies Pamphilia's "weakness" in her failure to save Amphilanthus. She cannot save him, not because she is weak but because she is too strong, too constant in love. Her weakness in such a context of falsity is due to a (formerly masculine) strength. Wroth rewrites Spenser's scene with a thoroughgoing ironic regendering of moral virtue.

We can, of course, never be certain that Wroth was fully conscious of how her rhyme reemphasizes the gender reversals she points to directly in other parts of her text. Lacking any study of her rhyming practice we are not yet in a position to say what else Wroth does with gender patterns in rhyming. However, we can say that she appears to have noticed the gender dichotomy in rhyme, as well as the specificity of Spenser's and Sidney's use of it to emphasize the femaleness of the contexts in which it appears. Rhyme thus may well have been part of the discursive control exercised over women; but also it therefore may have provided a tool by which women could open up a discourse of their own.

Notes

1. For the defense of rhyming itself as a native English practice, see Samuel Daniel, *The Defense of Rhyme* (1603).

2. See Langlois 270; I am indebted to Lance K. Donaldson-Evans for this and other references.

3. "La ryme n'est autre chose qu'une consonance & cadence de syllabes, tombantes sur la fin des verses laquelle ie veux que tu observes tant auz masculins qu'aux foeminins, de deux entiere & parfaites syllabes ou pour le moins d'une aux masculins, pourueu quelle soit resonante, d'un son entier & parfaict" (Ronsard 7–8). I am indebted to Nancy Vickers for this reference.

4. Italian discussions of rhyme do not appear to divide them in terms of gender. Bembo, for instance, in *Prose della Volgar Lingua* (1505) elevates the Tuscan language because it has both masculine and feminine family names, but he does not use masculine and feminine as technical terms for distinguishing rhymes. Rhymes please the Italian ear more by the variety of their closeness to and distance from each other than by a codified patterning. I am indebted to Victoria Kirkham for this reference.

5. Although scholarship will never be certain of the chronology, it appears that

1579 is the pivotal year for Sidney's and Spenser's early court careers and the year in which Spenser had most access to the Sidney circle at Wilton (where Sidney rusticated because of the royal displeasure his letter to the queen had occasioned). The metrical experimentation of which Spenser writes to Harvey appears most fully in Sidney's *Old Arcadia*—done in "loose sheets" for his sister at Wilton; doubtless the issue of feminine rhyme came up during the discussion of meter, just as Sidney's mention of feminine rhyme in *Apology* is associated with quantitative measure. Both men—members of the Leicester faction—were under a political cloud, denied the royal, female, favor.

6. The shared lament of Lalus and Dorus in the first eclogues necessarily uses feminine-looking rhyme, but it is probably Sidney's attempt at *sdrucciola,* or, as Ringler calls it, "trisyllabic rhyme" (572).

7. See C. G. Osgood, *Concordance to the Poems of Edmund Spenser* (Washington, D.C., 1915). Cambina's mother, in a rhyming position, has taught her daughter magic arts so that, should it ever be necessary, she would be able to heal her brother, also in the rhyming position (4.3.40).

8. The actual explanation that Amoret and Scudamour were married all along in Book 3 comes in the third stanza of the first canto of Book 4, a stanza in which seven out of the nine rhymes are feminine endings:

For that same vile Enchauntour Busyran,
The very selfe same day that she was wedded,
Amidst the bridale feast, whilest every man
Surcharg'd with wine, were heedlesse and ill hedded,
All bent to mirth before the bride was bedded,
Brought in that mask of love which late was showen:
And there the Ladie ill of friends bestedded,
By way of sport, as oft in maskes is knowen,
Conveyed quite away to living wight unknowen.

9. Compare Gwendolyn, wife to Locrin in the British Chronicle:

In her owne hand the crowne she kept in store,
Till ryper years he raught, and stronger stay:
During which time her power she did display
Through all this realme, the glories of her sex,
And first taught men a woman to obay:
But when her sonne to mans estate did wex,
She it surrendered, ne her selfe would lenger vex. (2.10.20)

Gwendolyn also butchered her daughter Serena—a good mother in the patriarchy.

It is also possible that Spenser's use of *powre* as a rhyming word in the first installment is in fact a masculine rhyme, its special spelling (distinct from the usual *power*) indicating that it is a single-syllable term. The point is that even as a single-syllable term, *powre* as a rhyme word in the first installment is always associated with female potency.

10. So too, the Brigand Captain must protect Pastorella from rape by thieves and refuses to sell her to the highest bidder, but keeps her for himself:

At last when all the rest them offred were,
And prises to them placed at their pleasure,
They all refused in regard of her,
Ne ought would buy, how ever prised with measure,

Withouten her, whose worth above all threasure
They did esteeme, and offered store of gold.
But then the Captain fraught with more displeasure,
Bad them be still, his love should not be sold:
The rest take if they would, he her to him would hold. (6.11.14)

Works Cited

Parker, Patricia. "Motivated Rhetorics: Gender, Order, Rule." In *Literary Fat Ladies* 99–125. London: Methuen, 1988. A study of the relationship between rhetorical tropes for controlling language and methods for controlling (among other things) the excesses of gender; a reading of rhetorical handbooks in conjunction with female conduct books. The book also studies travel narratives, Spenser, Milton, romantic poetry, nineteenth-century novels, and Freud's theory of sexuality.

Ringler, William A., Jr., ed. *The Poems of Sir Philip Sidney.* Oxford: Clarendon Press, 1962. The standard edition of Sidney's poetry.

Ronsard, Pierre de. *Abbregé de l'Art Poétique François.* 1565. Reprint. Geneva: Slatkine Reprints, 1972. Ronsard's brief argument about proper French poetic techniques.

Sidney, Sir Philip. *An Apology for Poetry.* Edited by Geoffrey Shepherd. London: Thomas Nelson, 1965. An argument about the importance of poetry as an undertaking worthy of English aristocrats, which includes a survey of genres and strictures about decorum as well as a discussion of rhyme in English.

———. *The Countess of Pembroke's Arcadia (the Old Arcadia).* Edited by Katherine Duncan-Jones. 1973. Reprint. Oxford: Oxford University Press, 1985. The first version of *Arcadia* probably written while Sidney was visiting his sister at Wilton in 1579; never published until the twentieth century, the text would have been accessible to Wroth as a close family member.

Spenser, Edmund. *The Faerie Queene.* Edited by J. C. Smith. 2 vols. Oxford: Oxford University Press, 1966. The first three books were published in 1590. A second edition of six books plus a fragmentary seventh was published in 1596.

Weber, Henri. *La Création Poétique au Seizième Siècle en France.* Paris, 1955. A study of poetic form in sixteenth-century French literature.

Whigham, Frank. *Ambition and Privilege: The Social Tropes of Elizabethan Courtesy Theory.* Berkeley: University of California Press, 1984. A study of courtesy handbooks and rhetorical manuals, arguing for a close relationship between rhetorical tropes and "tropes" of social behavior that authorized specific procedures for social advancement in sixteenth-century court life.

Wroth, Lady Mary. *The Countess of Mountgomerie's Urania.* London: John Marriott and John Grismand, 1621. The first romance published by a woman in English; the volume included 558 pages of prose text, plus a sonnet cycle, *Pamphilia to Amphilanthus.*

GARY F. WALLER

The Countess of Pembroke and Gendered Reading

You study what you desire or what you fear.
—Roland Barthes

THE DISCUSSIONS of "femmeninism," of men reading "as a woman," between Elaine Showalter and Jonathan Culler, Stephen Heath, Peggy Kamuf, Paul Smith, and others have focused on the questions of *whether* and, if so, *how* men can read women's writing outside the seemingly gender-neutral but (in fact) predominantly masculinist discourse of traditional criticism and scholarship.[1] There seems to be no commonsense reason why male readers cannot ask the same questions of a text as a female reader ("How do I respond?" "What are the effects of this text on me?" "Which of its textual strategies are especially powerful?"). Yet, one can counter, are those questions really the "same"? Are they asked from the "same" position—that defined by being the-body-of-a-woman, and of having distinctive demands made on and for that body? What gendered *reading* (as opposed to *textual*) strategies, in short, are operative in any particular reading situation, in the "matching of repertoires" that occurs whenever we read? That "we," of course, is a large part of the problem. Can men—today, at all—have the "grain of the voice," the "intonation" or "syntax" that would otherwise distinguish a woman's expression of the same concepts and discourses? (Ross 87).[2] If, as Foucault has taught us, to exercise power is to configurate "the real" in the details of discourse, then is it crucial that women readers not only stake out their "own" distinctive place of power but even exclude men from standing with them? And is such a move particularly crucial when dealing with women *writers?* These are hard questions—not just intellectually but also experientially difficult. For those of us who are men, they challenge us to rethink many of the practices we have comfortably taken for granted most of our professional (and, longer, our personal) lives. At the very least, the extent to which readings of women writers have in the past been (and are now being) affected by gender-specific factors is a crucial question in the contemporary critical climate.

The rediscovery of Mary Sidney's work this century—from Frances Berkeley Young onward—has been shared by both men and women scholars, but until very recently the terms in which this rediscovery has

been set out were innocent (or, more accurately, ignorant) of any self-conscious consideration of gender except in the most obvious terms. Seen within the history of criticism, its terms were predominantly formalist-historicist; it was concerned primarily with reviewing Mary Sidney's work for its "own" intrinsic interests or as part of gaining a fuller picture of her historical setting. As the area of gender studies has gained more prominence, her life and work have also been seen in terms of her status as a woman writer. But until recently such a consideration has existed mainly on the level of the commonplace. If we examine the critical context in which Mary Sidney's work has been largely put—if, in short, we analyze the general and literary repertoires of the critics—we find a blindness to the gender-related particulars of both her writings and (even more interestingly) their own situatedness.

This is not to say that there have not been scholars and critics who have focused on the countess as a *woman* as well as a *writer*. Young's biographical study (1912) was unquestionably one such pioneering work. But her critical stance, while acknowledging (obviously) that the countess's roles as daughter, sister, wife, and mother were not without interest, never treats them as occupying socially constructed gender roles. Her approach is not only belletrist and impressionistic, but also coyly sentimental. In discussing the countess's marriage, for instance, Young conjures up the specter of a lustful ogre, the middle-aged Henry Herbert, second earl of Pembroke, and invites her reader to imagine "the probable emotions" of a pious maiden ravaged by "a man more than twenty-five years older than herself and infinitely more experienced, for good and evil, in worldly affairs" (34). In the same tradition, equally sentimental though more overtly salacious, was Rudolf Holzapfel's *Shakespeare's Secret* (1961), which has the "vivacious Mary Sidney" shortly after her marriage becoming (of all people!) Shakespeare's mistress, and then (as a consequence) the mother of his illegitimate son, William Herbert, third earl of Pembroke—to whom Shakespeare's sonnets are supposedly addressed. Holzapfel admits (undoubtedly correctly): "I may be ridiculed by layman and expert," but nonetheless goes indefatigably on: "yet I must tell you: William Herbert, third Earl of Pembroke, poet, courtier, Knight of the Garter and Lord Chamberlain . . . was Shakespeare's own son" (xi). Shakespeare's sonnets are then interpreted in terms of this supposed relationship.

On the whole, especially since J.C.A. Rathmell's pioneering edition of *Psalms* (1963), traditional historicist scholars and critics who have focused on the countess as a *writer* rather than as a *woman* have produced the more interesting work. Yet, as we have learned in the past two decades, such a stance of gender neutrality is deceptive. To focus on merely "literary" questions and values is to be blind to such aspects of a

text's, a writer's, or a reader's repertoire as gender or class—in short, it is to be blind to the historical situatedness from which any reading is made. Hence, to acknowledge (as Young did) that Mary Sidney was a woman, and therefore of interest to modern readers, may in fact establish a useful basis for a new consideration of her work. But unless what it is to be a woman reader is problematized for both the writer *and* the critic, then such criticism remains within a paradigm that is inherently limiting, whether it is written by a woman or (as Culler would argue) a man reading "as a woman." Likewise, unless a male critic—or a woman reading "as a man"—problematizes what it is to read Mary Sidney's work as a man, he (or she) takes both her work and its reading out of history. In such cases, the result is a reification of a culturally archaic fall-back position in which reading strategies are simply allowed to be written by the dominant masculinist scholarly discourse, one that assumes that a text is, in a simplistic way, a "reflection" or (contradictorily) an "expression" of its author or its society (Belsey, chap. 1). In such a paradigm, the situatedness of the historian or critic is not seen as problematic, since it is assumed that it is the reader's role to be as "objective" as possible and to let the text speak "for itself." Surveying the work on the countess of Pembroke before the 1980s (including my 1977 edition of her poetry and my 1979 critical study of her "life and milieu"), this is largely what I now observe—a general blindness to the received, seemingly gender-independent criteria of traditional scholarship and criticism in which we were all working. The countess and her work were interesting to us because she was a woman, certainly; but we had not gone on to problematize the gender-specific categories within which we read her life and works. The "we" here is a gender-blind collective voice, a dehistoricized masculinist discourse that has tried to embrace both men and women.

Increasingly in the past decade, criticism has become sensitive to the fact that a reader must be accountable for and implicated in his or her own readings. Just as texts are produced in history, increasingly it is realized, so too are readers. Every reader brings a different set of experiences, concerns, knowledge, and expectations to bear on a text. No reader can pretend to be neutral or universal in his or her questions. We (a different collective voice here) acknowledge that, in Althusserian terms, no reading is innocent: we are required only to say what reading we are guilty of. Until recently, however, such acknowledgments, and the criticism they imply, have remained marginal to the dominant formalist critical models built ultimately on the Cartesian distinction of subject and object and the positivistic assumption that language is a neutral, value-free tool. Yet over the past twenty years such a model of the reading situation has been radically challenged. Just as texts are

inextricably connected with the age in which they were written, so readers, too, are implicated in the particular sociocultural formations in which they live; they are produced by their society's ideology, both literary and general. Like a text, every reader operates within a particular literary and general repertoire. Different readings arise in part because different readers bring to their reading different repertoires—a set of culturally conditioned expressions, beliefs, knowledge, expectations, literary preferences, and life-styles. That is not to say that a particular society will produce a standardized and agreed upon reading. Within any society, quite different reading formations can be observed. But the dominant ideology of any period makes some beliefs more plausible than others, while marginalizing still others (McCormick, Waller, and Flower 10).

When a text is read, therefore, quite diverse matchings of repertoires can occur between text and reader. The text invariably tries to privilege a particular range of readings, offering clues by which readers are encouraged to construct readings. But the process of reading is affected equally strongly by the distinctive cognitive styles and the overdetermined enculturation of the text's readers: reading is not something that occurs either independent of the ordinary processes of cognition or outside the distinctive constraints of a culture. "Gender" itself is, of course, a culture-specific category: there may be still some argument about biologism, whether there are inherent or "natural" categories distinctive to each gender, but such arguments smack of an essentialism that most feminist (and other literary) theorists are today trying to avoid, except (and admittedly this is not a trivial exception) as a political stance or tactic. The fundamental and, let us hope, uncontroversial point is that the practice of reading is not something we do outside a historically and culturally created situation. All readings are made from and on behalf of particular positions; a strong reading makes these positions as explicit as possible. Patriarchal society has tended to marginalize certain kinds of readings, and as gender awareness and feminism in particular have decentered men's dominate place in discourse, we (this we is "men" or "male critics") have had to learn the implications of our gendered assumptions—and, clearly, not only about reading, although "reading" broadly considered is certainly central to that process of learning.

2

Such a theorization of the reading situation provides the basis for explaining what occurs when a male critic reads the texts of a woman writer. I want next to exemplify some of these theoretical concerns in

relation to the readings of the countess of Pembroke—including some of my own previous relatively untheorized readings, however (always, of course, the exploiter's plea) well intentioned they may have been. As Stephen Heath puts it, "Men have a necessary relation to feminism— the point after all is that it should change them too" (1). This essay is record of such (if as yet partial) change.

There is always the excuse of tradition. Such is the weight of the residual paradigm in which the countess's work has been put, that it can be traced as far back as her own time. Given the general history of women's writing and its readers, that is not a surprising observation, but the particular terms in which the countess has been praised from her own time to ours are especially revealing. As Mary Ellen Lamb has shown, the place of the woman-as-reader is carefully proscribed in Renaissance texts. Women are written as potential readers into texts by a dominant male discourse. A woman is interpellated to fulfill a limited number of roles: as a skilled humanist pupil, subservient to the text; as a Protestant, subservient to the male god of theology; or as the gentlewoman reader, flirted with, frivolous, but still essentially under male authority.[3] This process of proscription in which, as a woman, the countess was simultaneously lavishly praised and given strictly delimited roles, all subservient to a dominant male discourse, can be seen from those works in which she is directly addressed. In works by Nicholas Breton, Thomas Moffett, Edmund Spenser, Nathaniel Baxter, and Abraham Fraunce, the countess plays a major role. As well, there is a host of incidental references, such as the famous epitaph by William Browne of Tavistock. From these works, a symbolic system emerges by which the countess, as a socially powerful woman, is positioned and controlled as a reader by her male followers and poets. If humans acquire individuality only as a condition of being inserted into the "réel" which governs and defines what it is to be human (Jameson 384), a woman— whether as writer or reader—is traditionally outside the symbolic in this sense, and it has been the role of masculinist critical discourse to define under what conditions she may be afforded such a place. Mary Sidney was not silenced, but in her lifetime and after she was awarded a place within discourse only as an object of representation or on condition of her subservience. She is primarily, in Browne's words, "Sidney's Sister, Pembroke's Mother," not just as the subject of biological and legal discourses, but as a reading and writing subject. Just as for Browne she is defined by her roles in relation to her brother and son, so too for Spenser she is "sister unto Astrofell," and for Nashe "the Fayre sister of Phoebus." She is thereby accorded power—but it is the power of the pedestal. She is free to move only by standing still. In such works,

Portrait of Mary Herbert, countess of Pembroke. Reprinted from Carroll Camden, *The Elizabethan Woman* (New York: Elsevier, 1952). By permission of Paul P. Appel, publisher.

insofar as Mary Sidney is a writer or a reader, her role is that of the apprentice, the pupil, and the approving patron, and her language is given to her by her masters.[4]

The most substantial texts in which the countess is addressed are those by two of her proteges, Nicholas Breton and Abraham Fraunce. Fraunce's *Countesse of Pembrokes Ivychurch* (1591), in which a hunt in Tasso's tale of Amyntas is freely adapted—complete with a gratuitous (and fortuitous) bear who obliges by being slain by "Pembrokiana"— gives us a view of how Fraunce saw the countess presiding, as "the Matchless Lady regent," over what Breton called her "little court" at Wilton. As the "brave Lady Regent of these woods," Pembrokiana is depicted as being in control of the pastimes and the "solempne great hunting," but the terms in which she is described are a revealing mixture of worship and fixity. Her role is to preside, to bless (by her presence and presumably her purse) the activities of her followers— especially her poets. She is the inspiring monarch, but she lacks a monarch's power. More revealingly, in *The Pilgrimage to Paradise* (1592), a work by Nicholas Breton, we can start to see something of the ideological contradictions by which she was positioned. Breton compares the countess at Wilton with Elizabeth Gonzaga at Urbino, describing her role and thereby interpellating her as the subject of a contradictory discourse that is at once courtly, autonomous, and beneficent and at the same time fixes her as powerless to move except within the role of patroness and the unmoving inspiration to her male writers. She is a "right noble Lady, whose rare vertues, the wise no lesse honour, then the learned admire, and the honest serve." He is "the abject of fortune" where she is the "object of honour." Knowing her is an inspiration to write for her followers, servants, and those who fall "at the feete of" her favor, offering to celebrate her with their own writing. Despite the fact that by 1592 the countess had completed the bulk of her own writing—a play, a prose translation, nearly two hundred psalms and some of her incidental verses, including the translation of one of Petrarch's *Trionfi*, Breton describes her not as a writer but as a reader. She is the "favourer of learning" and "the mainteiner of Arte," whereas he is "your poore unworthy named poet."[5]

Positioned thus primarily as a woman and a reader (rather than as a writer), the countess can be denied the activity of a subject position in the discourse of poetry. Her writing career, of course, reflects such a placing of her and her work: she is autonomous only to the extent that she encourages and rewards her (male) poets. In her own work, that autonomy is denied. The extensive and increasingly confident experiments in verse form, meter, and stanzaic pattern that distinguish her versions of the psalms were made with her brother's translations before

her. They were probably started shortly after his death in 1586 and when finally completed and assembled, the collection was dedicated to his memory. She completed the translation of her brother's friend Philippe de Mornay's *Discours de la Vie et de La Mort* before 1590 (it was published that year), and about the same time she completed another translation in accord with her brother's principles of drama, the *Marc-Antoine* by Robert Garnier. In her other incidental writings too, the presence of her brother is paramount.

Such observations are by now commonplace enough: Mary Sidney was a widely admired patroness and a highly competent, even original, translator of her brother's and other (men's) works. But such a reading of Mary Sidney and her work as that I am attempting, stressing both the gender-specific production of her writings and the gender-specific bias of her readers, involves a greatly expanded range of questions and issues from that assumed by traditional formalist or historicist observations. It involves, first, reading her work in relation to the general and literary ideology of her time, focusing on the particular repertoires appropriated by her work and articulated in it. It involves in particular focusing on the powerful ideological absences of work—many of which are, indeed, gender specific. But as well, second, it involves becoming conscious of the different reading formations in which her work has been and can be read subsequently: it thus focuses on the general and literary repertoires of her readers, which are in turn appropriations from the general and literary ideology of their society. Both text and readers are situated within history, products of different social formations. As Tony Bennett puts it, reading "takes place not within texts but between texts, and between texts and readers: not some ideal, disembodied reader, but historically concrete readers whose act of reading is conditioned, in part by the text it is true, but also by the whole ensemble of ideological relationships which bear upon the incessant production and reproduction of texts" (174–75).

3

I wish now to exemplify some of these theoretical principles in more detail. Piety, literary fashion, and subservience to her brother certainly consciously motivated most of Mary Sidney's writings. Three poems are direct tributes to her brother Philip: the so-called Doleful Lay of Clorinda, included in Spenser's *Colin Clout* and described by the countess as her "certain idle passion"; a dedicatory poem to Queen Elizabeth; and "To the Angell Spirit of the most excellent Sir Phillip Sidney," both the latter found in one of the manuscripts of her *Psalms*.[6] The last is

especially interesting in its direct statement of the countess's motive for writing, which is to express her grief at her brother's death and her desire to dedicate her own poetical skills to his memory: It has, she says, "no further scope" but to "honor" him, to "pay the debt of infinits" she owes to his memory.

The poem is conventional enough, typical of the praises a generation of fellow poets gave to Sidney—apart from a few highly personalized lines. Sidney is not only her poetic inspiration—"what is mine / inspired by thee, thy secret power imprest"—and the embodiment of heaven's grace, but something more personal and disturbing that is hinted at when she writes of the "so strange passions" that strike her heart when she thinks of him. Is the tone of adulation in such phrases something more than conventional? Is there something in (or, more accurately, in the vicinity of) this poem that could provoke comments like those of Ben Jonson on Donne's "Anniversary" poems as "profane and full of blasphemies . . . if it had been written of the Virgin Mary it had been something." Is the countess describing the "idea" of Sidney, not (as Donne replied to Jonson when accused of blasphemously idealizing a mere mortal woman) "as he was." Here a manuscript revision may be revealing. The line "my thoughts, whence so strange passions flowe" is not found in an earlier, rough draft of the poem that was printed mistakenly in the 1623 edition of the works of Samuel Daniel: it was added in a later revision, as if an affirmation beyond the hopes of idealization was trying to force itself through (Waller, *Triumph of Death*, 97–102).

When I first published and commented on these two versions of the countess's poem ten years ago, I, perhaps no less than Mary Sidney herself, was reaching for some way of articulating my unease with the strange feeling many readers sense lie behind those lines. Indeed there is perhaps not a little prurience in the remarks about what I perceived as a missed beat, a tremor, in the poem—a moment at which something more than I could then articulate needed to be said. There was, of course, an existing discourse into which my remarks fitted. It was the male-created discourse of the gaze, spying on and anatomizing women as objects and so placing them under male control. More than half a century after her death, John Aubrey had remarked of Mary Sidney that "there was so great love between" Sidney "and his faire sister that I have heard old gentlemen say that they lay together."[7] My response in the late 1970s was to fit comfortably and unselfconsciously into the same mode of discourse and to draw (or, rather, pretend *not* to draw) an analogy between Mary Sidney and Dorothy Wordsworth. It was, it might be said again, well intentioned—even though intentions do not count for much

in such matters. Yet, unbeknown perhaps, it was not an entirely inappropriate analogy, since in the past decade we have learned to understand Dorothy Wordsworth, Fanny Brawne—and, for that matter, Mary Sidney—much better as gendered subjects, positioned within ideology, and so we can place Aubrey's remark in a tradition of men constituting women by the gaze or of controlling their sexuality by marginalizing it as salacious or improper. We have also been faced by larger questions of how women struggle to constitute themselves as writing or sexual subjects. Instead of focusing on what I then rejected as "the perils of historical psychoanalysis" (Waller, *Mary Sidney*, 100) we can now focus powerfully on revealing the cultural unconscious of a text like "To the Angell Spirit." We can note the systematic subordination of the countess to her roles as wife, mother, sister, and writer, and so to a number of masculinist discourses. We can also note the masochism with which she embodied her permission to speak, verbally and bodily, in the "spirit" of her dead brother. We can speculate on how much of her experience, given to her by her culture and gender both, must have been "other" to her. In Lacan's terms, she can be seen as restricted to the Oedipal "wave of passivity," which traditionally is alone "capable of introducing the subject to the ideals of his or her sex" (Mitchell and Rose 109). We can also speculate on how much her subjection enables her to achieve a measure of autonomy and agency.

The family, of course—and informing that, a powerfully interconnecting set of myths of patriarchy, political power, and lineage—helped to determine both the ways Mary Sidney was subjected to powerful discourses outside her control, how she struggled as a gendered subject to make her mark on the world, and therefore the extent to which she was able to challenge these myths. The Sidney family—especially in the century before the Civil War—was not merely a collection of individual men and women linked by kinship, but also a major site of contradictory cultural forces, a discursive formation in miniature in which the broader conflicts of the age were being enacted. We cannot talk about the Sidney family "itself" any more than we can talk about Mary Sidney "herself" or the texts she wrote in "themselves." Both Mary Sidney and her writing are fascinatingly dense transfer points for the operation of power in a wider cultural framework.

Even more, we can use what we have learned about the psychological structure of early modern family relations, especially in relation to the production of gender roles, to elucidate Mary Sidney's significance—and our own places in relation to it. Even studying the records of an Elizabethan family, one can identify a whole series of double binds, relationship traps that arose from the interacting strains of class, gender,

and social roles within the family structure produced by patriarchal culture. Mary Sidney was the daughter of an ambitious, nervous, upwardly mobile father, the devoted sister of two powerful brothers, Philip (who died young but whose influence and power over her increased after his death) and Robert, and she was the mother of one of the most brilliant, aggressive womanizers in the Jacobean Court, William Herbert, third earl of Pembroke. In addition, if almost incidental to her literary life, her husband the second earl was a remote, elderly figure whose economic (if not intellectual) power over her was not to be discounted, even if (as traditionally has been argued) her position as countess of Pembroke gave her the scope to preside over Wilton House and Baynard Castle, the London home of the earl of Pembroke, which was shared with the Sidneys.

The most powerful of these male influences over her was undoubtedly that of her brother (her relationship with her son will be the focus of part of a further, full-length study on which I am presently working). Her *Psalms,* which constitute the countess's greatest claim to sustained poetical achievement, were written under her brother's (absent) tutelage. They were the works by the countess that were best known to her contemporaries and they upheld her reputation as a writer for fifty years after her death, by which time John Aubrey (once again) inaccurately but revealingly mentioned "a translation of the whole book of Psalms, in English verse, by Sir Philip Sidney, writt curiously, and bound in crimson velvet and gilt."[8] The "Sidnean Psalmes," as Donne called them, were in fact mainly composed by the countess, not by her brother. They remained unpublished until 1823 and were never fully published with all their variants until J.C.A. Rathmell published his "semipopular edition" in 1963 and I supplemented his edition in 1977 (*Triumph of Death*). The sixteen manuscripts of the Psalms show that Mary Sidney spent over twenty years on these poems. She was, in William Ringler's term, an "inveterate tinkerer," a phrase that I quoted in my earlier work on her without seeing its dismissive connotations.[9] The countess saw her repeated working on the psalms as a continuation of her brother's playful yet pious experimentation with meter, stanza, and trope in the forty-three psalms he completed. I say "playful" because the countess's "tinkering" might be seen more interestingly and fairly than as merely the nervous tic of a literary dilettante. The evidence from the Psalms manuscripts shows her continually shifting epithets, altering rhymes, translating psalms into a variety of English verse forms. She made quite different versions of a number of psalms. Psalms 120–27, for example, exist in quantitative verse forms as well as in simpler ballad stanzas, and there are two and sometimes three quite distinct versions of

a number of psalms. In a sense, the countess had no "final" version of the work. In 1599 she had a copy made by the scribe John Davies of Hereford for presentation to the queen on a visit to Wilton House, but even as it was being copied, she was making changes. In all there are over 150 distinguishable psalms in her collection, plus many substantive and minor variants. She expressed her dedication in Psalm 111, a poem in which the first letters of the lines spell out the alphabet:

> At home, abroud most willingly I will
> Bestow on God my praises utmost skill.

But more revealing, when we consider the manner in which she revised her work, are four lines in Psalm 104:

> As for my self, my seely self, in me
> while life shall last, his worth in song to show
> I framed have a resolute decree.
> And thankfull be, till being I forgoe.

The pronouns are significant here, in particular the contrast between the devalued self of the poet and the "worth" of the male authority figure. For twenty and more years, Mary Sidney worked over her brother's manuscript, learning from not only God's but her brother's "worth," his continuing example and guidance. She kept two working copies of the psalms, one at Wilton House and one at Baynard Castle, in London. Often discrete changes were copied from one working copy to the other; sometimes, quite distinct versions of the same psalm were developed independently. The additions and independent versions provide us with glimpses in the interstices of translation into something of her strategies as a writer—as well as into the ideological repertoire she brought into her work. To some she added a distinctively courtly note as if wanting to move the original into the more playful realm of the courtly lyric; to others she added a stern Calvinist emphasis, thus reinforcing their religious impact; and most interestingly, some psalms mix Calvinist and courtly elements in what I have elsewhere termed, using Arthur Golding's translation of a phrase of Calvin's, a "matching of contraries."[10] It is these last psalms where the contradictory discourses that produced the countess as a woman and a writer are most evident. She was caught amongst conflicts over which she had little control and in which she struggled to "own" a voice.

I summarize Mary Sidney's method of working on the psalms because, it seems to me, we should see it in the light of what Lacan terms woman's "supplementary jouissance." His phrase, as Jacqueline Rose notes, points to a recognition of woman's "'something more,' the 'more than *jouissance*,'" which Lacan locates in the Freudian notion of repeti-

tion—"what escapes or is left over from the phallic function, and exceeds it" (Mitchell and Rose 51). Like the traditional Western female subject, Mary Sidney's writing embodies (largely) a question not an assertion, the question of her own (that is her repressed) gender-specific *jouissance*. Her "tinkerings" represent what her culture would have approved of, a subordination to a male, since the originals are after all, psalms to God, and to a doubly authoritative transcendental paternalistic ideology. Yet by their very obsessive repetitiveness, her writing makes gestures toward a supplementary, what might become in a later cultural conjunction, an *owned, jouissance*. Elaine Showalter notes that because the woman writer "has no alternative" to the dominant discourse, she can "inscribe her disaffection only through a deliberate mimicry" (138).

There is, says Lacan, a "*jouissance* proper to" woman, "to this 'her' which does not exist and which signifies nothing. There is a *jouissance* proper to her and of which she herself may know nothing, except that she experiences it—that much she does know" (quoted in Mitchell and Rose 51). Here Lacan is trying to avoid the essentialism of speaking of *the* feminine, or of "woman": undoubtedly, the best way of avoidance is to historicize how particular women were spoken and read by the dominant discourses of particular ages. The countess's "tinkerings" in the psalms are at once evidence for her being written by the masculinist patriarchal/fratriarchal discourse of her age; yet at the same time they show the glimmerings of a "disaffection" as she struggled to encode her own *jouissance*. Something similar can be observed in the work of her niece, Lady Mary Wroth, where a constant sense of "molestation" is at once a helpless cry against patriarchy and a smothered assertion of a counter-discursive sexuality (Waller, "Struggling into Discourse," 248).

We should briefly observe the same pattern in the countess of Pembroke's other writings. *The Tragedie of Antonie* and *A Discourse of Life and Death* were both written under the shadow of both Sidney and God, the same potent combination that had "authorized" the Psalms. By the late 1580s no dramatist had taken up Sidney's call for the "notable morallitie" and "stately speeches" of the French neo-Senecan closet drama, so the countess's sense of literary vocation directed her to take on that task as well.[11] Her translations initiated a series of English closet dramas, the most notable of which are Daniel's *Tragedy of Cleopatra* (1594) and Greville's *Mustapha* (1599) and *Alaham* (1601). The distinctively favorable view Garnier took of Cleopatra may well have appealed to the countess's own sense of being a woman, just as Philippe de Mornay's *Discours de la Vie et de La Mort* undoubtedly appealed to her because of its subject—and because its author had been a friend of her dead brother. In translating *Discours*, Mary Sidney must have been only too deeply

aware of the force of the commonplaces of *ars moriendi:* her daughter Katherine died in 1584, her father and mother, as well as Philip, died in 1586. Around her the golden age of the Elizabethan court was breaking up, and although Wilton House, the "little court," must have seemed a safe and tranquil haven, the omnipresence of death was clearly a subject on which the countess had personal as well as intellectual conviction.

The most interesting of the countess of Pembroke's works outside the Psalms is the translation of Petrarch's "Triumph of Death." Not fully published until my edition of her works in 1977, the countess's translation is a triumph of technical mastery, formal ingenuity, and vigorous language.[12] It is also intriguing because of its subject—the dead Laura, idealized by the poet, farewelling him and setting him free to praise her while he waits, in the world, for the day they will be joined in heaven:

> Ladie (quoth I) your words most sweetie kinde
> Have easie made, what ever erst I bare,
> But what is left of you to live behinde.
>
> Therefore to know this, my onelie care,
> If sloe or swift shall com our meeting—day.
> She parting saide, As my conjectures are,
>
> Thow without me long time on earth shalt staie. (78–79)

Why did the countess choose this particular *trionfo* to translate? Did the combination of idealized but intense love and death have an unusual personal attraction for her? What seems to be equally important to note is that, unlike Petrarch, the countess found her forbidden love's death a liberation into autonomy, into being more than a passive reader of the significance of her brother's life. Instead, even within the restrictive practices of her society, she became a writer, and the overdetermination of her gendered role, an act of "hommage" (Schor 98) which opened up—in absence if not visibly in her texts—emergent struggles that would surface later in our history.

4

I want, finally, to retheorize something of the approach I am taking in this paper—an approach that I believe has important implications for historical scholarship generally. The goal of a symptomatic history such as I am attempting is to read back into the texts of the past the ideological contradictions that their rhetorical and structural devices were designed to exclude. We can usefully categorize these exclusions as "silences" and "absences." "Silences" occur where a text deliberately does not speak of issues and pressures that were contemporary with its

production but that were only, as it were, in the vicinity of the text, that helped, silently, to produce it as it appeared. "Absences" are the ruptures in a text where it could not, was unable to, speak—because the language or the social practices that would enable it to do so were not yet available. Historical criticism's traditional task has been to make the silences of a text speak: to bring the political, religious, material practices of a culture that, as it is conventionally put, "influenced" that text to bear on our reading of it. What recent theory has legitimized are ways of reading absences *into* a text, reading it for the broader cultural patterns into which later readers may see it fit but that were not present or even perhaps possible at the time. Such absences show where texts reach a point beyond which there can be only gaps and puzzlements, where the writing contradicts itself, or comes to a premature close— often because as yet, historically, no language is available or adequate to fill out the absences. We all live within systems of representations that both enable and limit our articulations as living (and writing or reading) subjects; the absences of our particular historical conjunctions can often be articulated only by later readers who see them precisely as absences, as signs perhaps of a preemergent break with the epistemic limits of a particular society, class, gender, or family, and who link that "absence" with a (by-now) more visible preoccupation within their own society.

With Mary Sidney, issues of gender point clearly to such a major set of absences. I have presented her as a woman "written" by men—in particular by God and by her brother, with the two sometimes not easily distinguished. She occupied the classic position of woman as mediatrix: her body—as daughter, sister, wife, and mother—the site of struggle for men and their language. As Rosi Braidotti puts it, "it's on the woman's body—on her absence, her silence, her disqualification—that phallocentric discourse rests" (235). In making the argument, of course, I am also making her a subject of my own uneasily gender-conscious discourse, using her words as traces (which they often, indeed, literally are) of contradictory discursive practices. Many of these—the dominant ones—are the discourses of predominantly masculinist scholarship and criticism. The most notable counterdiscourse is, of course, that evoked today by her gender. Does it matter that I acknowledge the importance of this counterdiscourse as a man? Or can I, as Culler would argue (and as I would like in more complacent moments to assume) read "as a woman"? (43–64).

Behind the phrase are a number of unfortunate assumptions. Two in particular need to be teased out. The first is *gender* essentialism—that there are, indeed, "universal" or "natural" ways by which men and women read rather than that there are prior historically produced discourses within which men and women are subjected. Yet to read "as a

man" may involve very different assumptions today, for me, than it did for Sidney or Daniel or Jonson over four hundred years ago, or even than it did for me a decade ago. We are all historical subjects, written not only by contradictory but (partly *because* contradictory) by changing discourses. The second is *textual* essentialism—the assumption that it might be appropriate to read (or to try to read) as a woman because the countess of Pembroke was one and therefore reading as a woman will somehow get us closer to the "truth" of her writing, to its "essential" meaning. Behind Culler's well-intentioned concession to feminism is, therefore, an older paradigm of both reading and writing—that these are essential truths and that they reside somehow "in" texts, waiting for appropriately educated readers to extract them.

But readings are always made from and on behalf of positions. Those positions are not absolute or authoritative: they do not valorize meanings any more than texts can do so. Meanings are neither "in" the reader nor "in" the text; they are always interactive and, as such, always historically situated. When a reader starts to become self-conscious about how (like the text being read) he or she is situated, then it is possible to start to construct a model for reading that is neither essentialist nor blind to gender. Each reader has a characteristic repertoire of literary assumptions and reading strategies which is the product of education, class, and other factors—including gender. No text makes sense "in itself": it wants, always, to be read.

Rereading my own early work, like many critics trained in the contradictory conjunction of formalism and old historicism, a combination that still dominates so much of our discipline, I am only gradually becoming aware of many of the ideological assumptions buried deep in the language that writes me. According to the culturally rooted interactive theory of reading from which I have worked throughout this essay, a reader should always strive to problematize her or (in this case, his) reading situation. But such an effort should not simply turn into a personality profile: an individual reader is always subject to wider cultural forces than is usually compassed within simplistic notions of subjectivity or being an "individual." For any reader to acknowledge that he or she has acquired "natural" assumptions about reading is to become aware not only of cognitive style but also, more specifically, of cultural situatedness. We can acquire, from our wider culture, a variety of reading strategies that may (some would say "must") include an awareness of gender issues. Such an awareness of the cognitive processes of reading involves an exploration of factors underlying our responses, but it needs to be complemented by an acknowledgment of the cultural imperatives underlying cognitive style.

Increasing our cognitive and cultural awareness of the ways we read

texts includes, therefore, starting to understand how, as readers, we are produced not as neutral but as gendered subjects, asking gender-specific questions, from a particular though changing cultural conjunction. We need always to foreground this process of situating ourselves. We can thus avoid the essentialism of reading "as a man" or "as a woman" while acknowledging that gender, and thus our wider culture and history, has produced what we are as readers. We might—perhaps should—then choose to offer ourselves as allies in learning to read as men-in-relation-to-feminism and to women, but perhaps only if we realize that as Stephen Heath puts it, "we," as men, are the "point of departure" for such a shift in criticism (27). Elaine Showalter remarks that "the way into feminist criticism" for the male critic "must involve a confrontation with what might be implied by reading as a man, and with a questioning or surrender of paternal privileges" (143).

To read the countess of Pembroke, then, four hundred years after she took up her pen, thereby transgressing against an encultured male autonomy in ways she may have felt (and certainly wrote about) only obscurely, is to read with an awareness that there are no fixed meanings of "her" text, but that her writing, her cultural situatedness, her role as a woman written by men, can be explicated in gender-sensitive terms without being limited by them. It is on the one hand to acknowledge that in every reading situation, it is not something we have reified as the self that speaks but language along with the other material practices of a culture that language attempts to name. But, on the other hand, it is also to acknowledge that language contains emphases and demands that come to readers and writers alike from a culture that has tried, for hundreds of years and more, to be blind to gender. A text may try to privilege a certain reading—and, as the countess's writings show, that reading may be deeply offensive to the writer's own gender or class interests, though not to her situatedness. She was a woman, written by men. Today, she can be—and it is the responsibility of the critic to ensure that this is so—a woman read by men and women, sensitive to their own as well as her subjection to history. As Tony Bennett puts it, a text is never "the issuing source of meaning" but rather "a site on which the production of meaning" takes place (174–75). It becomes the responsibility of today's readers, men and women, to articulate and acknowledge their parts in that struggle and above all to acknowledge that such a struggle is not just a literary one.

Notes

1. On this point, this essay has also benefited from comments from members of my graduate seminar on the Sidneys at Carnegie Mellon, notably by John Timmons and

Craig Dionne, and from comments by and conversations with Naomi Miller and Janice Holm.

2. The term "matching of repertoires" comes from Waller, McCormick, and Fowler 5–15, and from McCormick, Waller, and Flower 19–27.

3. Mary Ellen Lamb, "The Countess of Pembroke's Readers," forthcoming. I am grateful to Mary Lamb for allowing me to read her essay and to cite her on this point.

4. Waller, *Mary Sidney*, 2. For further references by contemporaries to the countess's patronage and reputation, see also 67–73. The revisionist views of Mary Ellen Lamb provide, however, a useful corrective in that, clearly, not all those who commented on the countess's bounty or talent were members of her circle. See Lamb, "The Countess of Pembroke's Patronage," *English Literary Renaissance* 12 (1982): 162–79, and "The Myth of the Countess of Pembroke," *YES* 11 (1981): 194–202.

5. Abraham Fraunce, *The Countesse of Pembrokes Ivychurch* (London, 1591), sigs. B2v, E1v, E2v; Nicholas Breton, *The Pilgrimage to Paradise* (Oxford, 1592), 18.

6. The texts may be found in Waller, *Triumph of Death*, 87–95, 176–79.

7. John Aubrey, *Brief Lives*, ed. O. L. Dick (Harmondsworth: Penguin, 1948), 220.

8. John Aubrey, *The Naturall History of Wiltshire*, ed. John Britton (London, 1847), 86.

9. William A. Ringler, ed., *The Poems of Sir Philip Sidney* (Oxford: Clarendon, 1962), 502; Waller, *Triumph of Death*.

10. *The Psalms of David with Calvin's Commentaries*, trans. Arthur Golding (London, 1571), Psalm 8. See the discussions in Waller, *English Poetry of the Sixteenth Century*, 144, and " 'This matching of Contraries': The Influence of Calvin and Bruno on the Sidney Circle," *Neophilologus* 56 (1972): 331–43.

11. Sir Philip Sidney, *A Defence of Poetry*, in *Miscellaneous Prose of Sir Philip Sidney*, ed. Katherine Duncan and Jan van Dorsten (Oxford: Oxford University Press, 1973), 113.

12. Quotations are taken from Waller, *Triumph of Death*, 66–79.

Works Cited

Belsey, Catherine. *Critical Practice*. London: Methuen, 1979. Combines Althusserian Marxism and feminism to raise, among others, the question of the gendered subject.

Bennett, Tony. *Formalism and Marxism*. London: Methuen, 1980. Invaluable for raising the issue of the "reading formation" by which critics and readers construct readings of earlier texts.

Braidotti, Rosi. "Envy: or With Your Brains and My Looks." In Jardine and Smith, *Men in Feminism*, 233–42.

Culler, Jonathan. *On Deconstruction*. Ithaca, N.Y.: Cornell University Press, 1982. In his chapter "Reading as a Woman" (43–64), Culler raises the important question of how women readers are culturally and linguistically constructed.

Hannay, Margaret P., ed. *Silent But for the Word*. Kent, Ohio: Kent State University Press, 1985. Contains a series of valuable essays on Renaissance women writers.

Heath, Stephen. "Male Feminism." In Jardine and Smith, *Men in Feminism*, 1–32.

Holzapfel, Rudolf. *Shakespeare's Secret*. Dublin: Dolmen Press, 1961. Argues, melodramatically and unpersuasively, for Shakespeare as the countess of Pembroke's lover.

Jameson, Fredric. "Marxism, Psychoanalytic Criticism, and the Problem of the Subject." *Yale French Studies* 55–56 (1977): 338–95. An important attempt to reconcile the Marxist theory of the subject with psychoanalysis.

Jardine, Alice, and Paul Smith, eds. *Men in Feminism*. London: Methuen, 1987. A series of provocative essays raising the question of the place of men in feminist criticism.

Kamuf, Peggy. "A Double Life (Femmeninism II)." In Jardine and Smith, *Men in Feminism*, 93–97.

———. "Femmeninism." In Jardine and Smith, *Men in Feminism*, 78–84.

McCormick, Kathleen, Gary Waller, and Linda Flower. *Reading Texts*. Lexington, Mass.: D. C. Heath, 1987. Attempts to combine reader-centered cognitive with cultural criticism, making a space for the construction of gendered readings of Renaissance and other texts.

Mitchell, Juliet, and Jacqueline Rose, eds. *Feminine Sexuality: Jacques Lacan and the Ecole Freudienne*. New York: Norton, 1985. A major introduction to the work of Lacan in relation to gender.

Rathmell, J.C.A., ed. *The Psalms of Sir Philip Sidney and the Countess of Pembroke*. Oxford: Oxford University Press, 1962. The first modern edition of the Sidney Psalms. Needs to be supplemented by Waller, *The Triumph of Death*.

Ross, Andrew. "No Question of Silence." In Jardine and Smith, *Men and Feminism*, 85–92.

Schor, Naomi. "Dreaming Dissymmetry: Barthes, Foucault, and Sexual Difference." In Jardine and Smith, *Men in Feminism*, 98–110.

Showalter, Elaine. "Critical Cross Dressing: Male Feminists and the Woman of the Year." *Raritan* 3, no. 2 (Fall 1983): 130–49.

Smith, Paul. "Men in Feminism: Men and Feminist Theory." In Jardine and Smith, *Men in Feminism*, 33–40.

Waller, Gary. *English Poetry of the Sixteenth Century*. London: Longman, 1986. A "revisionist" historicist reading of the sixteenth century. It includes a consideration of gender within Petrarchanism, a chapter on the Sidneys, including the countess of Pembroke, and concluding remarks on how the question of gender has opened the canon of the period.

———. *Mary Sidney Countess of Pembroke*. Salzburg: Institut für Anglistik und Amerikanistik, 1979. A biographical and critical study, focusing on the countess's writing and her circle.

———. "Struggling into Discourse: The Emergence of Renaissance Women's Writing." In Hannay, *Silent But for the Word*, 238–56.

———, ed. *Pamphilia to Amphilanthus by Lady Mary Wroth*. Salzburg: Institut für Anglistik und Amerikanistik, 1977. An edition of the poems attached to *Urania*, with variants from the Folger MS. The introduction focuses on the court's power over Mary Wroth.

———, ed. *The Triumph of Death and Other Unpublished and Uncollected Poems by Mary Sidney, Countess of Pembroke*. Salzburg: Institut für Anglistik und Amerikanistik, 1977. Prints all the known variants of the countess's Psalms, miscellaneous poems, and the first complete edition of "The Triumph of Death."

Waller, Gary, Kathleen McCormick, and Lois Fowler, eds. *The Lexington Introduction to Literature*. Lexington, Mass.: D. C. Heath, 1986. Sets out, mainly for students, the possibilities of gender-aware readings of older texts.

Young, Frances Berkeley. *Mary Sidney, Countess of Pembroke*. London, David Nutt, 1912.

ELAINE V. BEILIN

Current Bibliography of English Women Writers, 1500–1640

THIS BIBLIOGRAPHY lists works by women printed between 1500 and 1640. Many of these writers belonged to religious, literary, political, and social circles which ensured the publication of their works during a time not generally favorable to women's public endeavors. Very few women were published writers, but they nevertheless contributed a number of significant works for all English readers, particularly on religious topics; they also produced texts specifically aimed at women readers. This annotated list is intended to aid further definition and evaluation of a field that will keep growing as texts continue to be rediscovered and reprinted.

The bibliography is organized under three main headings: Prose, Verse, and Drama. Under subheadings, writers are listed chronologically; however, chronology is broken in order to keep works by one writer together. Some related works in manuscript, some modern editions, and a list of anthologies have been entered separately at the end. For further modern editions of some of these works, the reader is referred to Elizabeth H. Hageman, "Recent Studies in Women Writers of Tudor England: Part I: Women Writers, 1485–1603," and Josephine Roberts, "Part II: Mary Sidney, Countess of Pembroke," *English Literary Renaissance* 14 (1984): 409–25 and 426–39; and Elizabeth H. Hageman, "Recent Studies in Seventeenth-Century Women Writers," ibid. 18 (1987): 138–67. Place of publication is London unless otherwise noted.

I. Prose

1. Autobiography

Moved by piety, suffering, and indomitable will to tell their stories and express their beliefs, these two remarkable women appear to have initiated English autobiography.

Kempe, Margery. . . . *a shorte treatyse of contemplacyon taught by our lorde Jhesu cryste or taken out of the boke of Margerie Kempe of lynn.* [1501]. Reprinted with alterations, 1521. This is a very brief excerpt of Kempe's spiritual conversations with Christ.

Askew, Anne. *The first examinacyon of Anne Askewe, lately martyred in Smythfelde, by the Romysh popes upholders, with the Elucydacyon of Johan Bale.* Wesel, 1546. [1547? 1548? c. 1550, c. 1560? 1585?].

347

———. *The lattre examinacion of the worthye servaunt of God mastres Anne Askewe.* Wesel, 1547. [1547? 1548? c. 1550, c. 1560?]. Both examinations are reprinted in Foxe, *Actes and Monuments*, 1563 (see Anthologies). (See also Cattley edition, 1838; reprint, 1965; vol. 5, 537–50). Also in *Select Works of John Bale*, edited by Henry Christmas. Parker Society, 1849; reprint. 1968; and in *Writings of Edward the Sixth, William Hugh, Queen Catherine Parr, Anne Askew, Lady Jane Grey, Hamilton, and Balnaves.* Philadelphia, n.d. Selection in *Paradise of Women*, 173–86 (see Anthologies). The dramatic first-person account of a Reformer's questioning by civil and ecclesiastical officials is both Askew's spiritual autobiography and an indictment of male authority. Four editions include an "elucidation" by John Bale which shows Askew's importance for the Protestant cause.

2. Translation

Translation, very much a mainstream activity for Renaissance writers, was both an opportunity and a limitation for women. As translators, women could demonstrate their learning and interest in such subjects as Scripture and religious doctrine; however, translation did not ordinarily prepare women for further literary development. The notable exception is Mary Sidney, countess of Pembroke.

Beaufort, Margaret, countess of Richmond and Derby. *A full devoute and gostely treatyse of the Imytacyon and folowynge the blessed lyfe of our moste mercyfull savyour cryste.* Books 1–3 of the Latin by John Gerson were commissioned by Lady Margaret and translated by William Atkinson; Book 4 was "In prynted at the commaundement of the most excellent princes Margarete: moder unto our sovereine lorde: kinge Henry. the. vii. Countes of Rychemount and Derby. And by the same pryncess it was translated out of frenche into Englysshe . . ." 1504.

———. *The mirroure of golde for* (to) *the synfull soule.* [1506?], 1522, 1526. Lady Margaret translated from French to English an originally Latin text teaching contempt for the world, the pains of hell, and the joys of paradise.

Roper, Margaret More. *A devout treatise upon the Pater Noster.* [1526?], [1531?]. Reprinted in *Moreana* 7 (1965): 9–64. Roper's excellent translation of Erasmus's commentary on the Lord's Prayer indicates her accomplishments in Latin and English prose and her participation in the work of the Catholic humanist circle. The 1524 preface by Richard Hyrde advocates women's education, praising Roper as the ideal learned and virtuous woman.

Elizabeth I. *A godly medytacyon of the christen sowle concerninge a love towarde God and hys Christe . . . Translated by Elyzabeth doughter to our late soverayne kynge Henri the .viii.* Edited by John Bale. Wesel, 1548. 1590. With additions by J. Cancellar, [1568?], [1580?]. Reprinted in *Monument of Matrones*, Second Lamp, 1–34 (see Anthologies). See *The Mirror of the Sinful Soul.* Facsimile edition of 1544 MS Bodleian. Introduction by Percy Ames. 1897. Eleven-year-old Elizabeth gave her prose translation of Marguerite de Navarre's *Miroir de l'Ame pécheresse* to Catherine Parr as a New Year's gift. It was

published by the Protestant press to signal Elizabeth's piety and importance as a leader for the Reformed church.

Bacon, Anne Cooke. *Sermons* [five] *of Barnardine Ochine of Sena.* 1548. Reprint. [1551?]. *Fourtene Sermons of Barnardine Ochyne, concernying the predestinacion and eleccion of god: very expediente to the settynge forth of hys glorye among hys creatures. Translated out of Italian in to oure natyve tounge by A.C.* [1551?]. Reprint. [1551?], [1570?]. One of the learned Cooke sisters, Bacon translated the work of an important Reformist leader, indicating her early determination to serve the Protestant cause. She dedicated the work to her mother, who guided her to religious study.

———. *An Apologie or answere in defence of the Churche of Englande with a briefe and plaine declaration of the true Religion professed and used in the same.* 1564, 1600, 1635. Reprint. *An apology of the Church of England by John Jewel.* Edited by John Booty. Folger Library. Charlottesville: University Press of Virginia, 1963. Through her excellent translation of Jewel's Latin defense of the English church, Bacon rendered a valuable, much appreciated service to the newly established church.

Basset, Mary Roper Clarke. "An Exposition of a part of the passion made in Latine by Sir Thomas More, knight (while he was prisoner in the tower of London) and translated into englyshe by Maystres Mary Basset." In *Works of Sir Thomas More.* 1557. Pages 1351–1404. Reprint. *St. Thomas More's History of the Passion.* Edited by P. E. Hallett. London: Burns Oates & Washbourne, Ltd., 1941. Margaret Roper's daughter translated her grandfather's work from Latin.

Locke, Anne Vaughan [Dering; Prowse]. *Sermons of John Calvin, upon the songe that Ezechias made after he had bene sicke, and afflicted by the hand of God.* 1560, 1574. A close friend of John Knox, Locke translated Calvin to aid the establishment of the Reformed church in England.

———. *Of the markes of the children of God, and of their afflictions. To the faithfull of the Low Countrie. By John Taffin.* 1590, 1591, 1597, 1599, 1608, 1609, 1615, 1634.

Martin, Dorcas. "An instruction for Christians . . . translated out of French into English." In *Monument of Matrones,* Second Lamp, 221–31 (see Anthologies). Martin provides an English translation of Psalm verses and the Ten Commandments.

Tyler, Margaret. *The Mirrour of Princely Deeds and Knighthood.* 1578, [1580?], [1599?]. Dedication and Epistle reprinted in *First Feminists,* 50–57 (see Anthologies). Tyler prefaces her translation of a Spanish romance—an unconventional choice for a woman—with an argument supporting women as secular authors free to choose material from fiction, medicine, law, and government, as well as from divine writings.

Sidney, Mary, countess of Pembroke. *A Discourse of Life and Death. Written in French by Ph. Mornay.* 1592, 1600, 1606, 1607, 1608. Reprint. *The Countess of Pembroke's Translation of Philippe de Mornay's Discourse of Life and Death.* Edited by Diane Bornstein. Detroit: Michigan Consortium for Medieval and Early Modern Studies, 1983. This translation of De Mornay, the prominent

Huguenot and friend of Philip Sidney, indicates Mary Sidney's study of Protestant doctrine on the Fall, worldliness, and death and demonstrates her considerable abilities as a prose stylist.

Russell, Elizabeth Cooke. *A Way of Reconciliation of a good and learned man.* 1605. One of the Cooke sisters, Russell translated this treatise on transubstantiation from French, apologizing for its publication, yet seriously concerned to publish religious "truth," and dedicating it to her daughter as a spiritual guide.

Cary, Elizabeth. *The Reply of the Cardinall of Perron to the Answeare of the Most Excellent King of Great Britain.* Douay, 1630. As a mark of her devotion to the cause of Catholicism in England, Cary translated, reportedly in a month, this lengthy part of the debate between James I, who claimed the universal title "Catholic," and his continental opponents.

Gray, Alexia. *The rule of the most blissed father Saint Benedict Patriarke of all Munkes.* Gant [1632]. Gray dedicates her work to the abbess of the English Benedictine monastery at Gant, making available for her fellow countrywomen Benedict's rules for prayer, the organization of the convent, and good works.

Duvergerre, Susan. *Admirable Events: Selected out of foure bookes, Written in French by the Right Reverend John Peter Camus, Bishop of Belley. Together with morall Relations, written by the same Author.* 1639. (The *morall Relations* may be translated by "T.B." whose initials follow the preface of the Translator to the Reader in the second part.) Duvergerre dedicates her work to Queen Henrietta Maria, offering her translation of Camus's narratives for the benefit of virtuous minds. She may have been moved by Camus's wish to provide alternatives for lustful, filthy, and immoral romances by writers like Boccaccio and by his concluding each story with a moral explaining how evil is punished and good rewarded.

3. Pious treatises and prayers

Parr, Catherine. *Prayers stirryng the mynd unto heavenlye medytacions.* 1545 (3), 1546, 1547, [1548?], [c. 1550] (3), [1556], [1559], 1561, [1574?], 1640. Reprinted in *Monument of Matrones,* Second Lamp, 80–98 (see Anthologies). Parr collected her material from Thomas à Kempis's *Imitation of Christ,* providing a nonsectarian, pious, and popular Christian guide.

———. *The Lamentacion of a Sinner.* 1547, 1548, (1563). Reprinted in *Monument of Matrones,* Second Lamp, 37–79 (see Anthologies). Published after Henry VIII's death, this work is more overtly Reformist, particularly in its criticism of Catholic doctrine. Parr adopts the voice of the sinner whose spiritual journey moves from grief to vision.

Grey, Jane (Jane Dudley). "An epistle of the ladye Jane to a learned man of late falne from the truth of Gods word." [1554?]. See Foxe, *Actes and Monuments,* 920–22 (see Anthologies), and *The Life, Death and Actions of the Most Chast, learned, and Religious Lady, the Lady Jane Grey, Daughter to the Duke of Suffolk.* 1615 (1629, 1636). A2v–B3 (editorial additions). By age thirteen, Jane Grey was an accomplished linguist and scriptural scholar and was totally

committed to the Reformers; in this work urging the apostate John Harding to return, she argues fervently and skillfully for the truth of the Reformed church.

―――. "A certaine effectuall praier." [1554?]. In Foxe, *Actes and Monuments,* 919–20, and in *Monument of Matrones,* 98–100 (see Anthologies). In her prayer Grey moves from doubt to an intense expression of faith, finally imaging herself as the Christian soldier.

―――. "An exhortation . . . to her sister the Ladie Katherine." [1554?]. See Foxe, *Actes and Monuments,* 918–19; *The Monument of Matrones,* 100–102 (see Anthologies); *The Life, Death, and Actions.* C2v–C3. Grey asserts her profound faith in Scripture and instructs her sister in the Christian way of death.

Tyrwhit[t], Elizabeth. "Morning and evening praiers, with divers psalmes himnes and meditations." (1574). Reprinted with alterations in *Monument of Matrones,* 103–38 (see Anthologies). Prose meditations and doctrinal verses attest to Tyrwhitt's Reformist piety if not to her poetic skill.

Aburgavennie, Frances. "The Praiers made by the right Honourable Ladie Frances Aburgavennie." In *Monument of Matrones,* 139–213 (see Anthologies). Prayers in prose and verse for many occasions and different times of the day, dedicated on her deathbed to her daughter.

Wheathill, Anne. *A handfull of holesome (though homelie) hearbs, gathered out of the goodlie garden of Gods most holie word.* 1584. The standard apology for a woman's weakness and ignorance precedes an unexceptionable guide to Puritan devotion, notable perhaps for the equal guilt apportioned to Adam and Eve.

Audeley, Eleanor (Eleanor Douglas). *A warning to the dragon and all his Angels.* 1625. Dedicated to Charles I, the first of Audeley's prophecies professes to interpret the visions of Daniel which she sees as fiercely Protestant, anti-Catholic, and apocalyptic. Audeley was thought to be mad by some and dangerous by others (Charles imprisoned her); her voluminous writings spanned the next quarter-century. See also *All the kings of the earth shall prayse thee* (Amsterdam, 1633) and *Woe to the house* (Amsterdam, 1633).

Livingston, Helen, countess of Linlitgow. *The confession and conversion of the right honorable, most illustrious and elect lady, my lady C of L.* Edinburgh, 1629. Having converted from Catholicism, Livingston provides a point-by-point acknowledgment of Puritan doctrine and a vilification of all Catholic practices.

Owen, Jane. *An antidote against purgatory, or Discourse, wherein is shewed that Good-Workes, and Almes-deeds, performed in the Name of Christ, are a chiefe meanes for the preventing, or mitigating the Torments of Purgatory.* 1634. Addressed to English Catholics, this long substantial work combines translation from Cardinal Bellarmine's *De Gemitu Columbae* on the pains of purgatory with advice on how to avoid the pains by doing good works, many of which Owen lists.

Sutcliffe, Alice. *Meditations of mans mortalitie or, a way to true Blessednesse. Written by Mrs. Alice Sutcliffe wife of John Sutcliffe Esquire. Groome of his Maiesties most Honourable Privie Chamber. The Second Edition, Enlarged.* 1634. Dedicating her

work to the sisters Katherine, duchess of Buckingham, and Susanna, countess of Denbeigh, Sutcliffe asks for protection from detractors of women's writing; she then delivers a substantial treatise on Christian living, concluding with a long verse account of the coming of death into the world with the hope of redemption. Ben Jonson and George Wither wrote admiring commendatory verses.

4. *Defenses of women*
Around the turn of the century, women were beginning to participate in the ancient debates on the "woman question." Entering the battle called for new female personae and an argumentative language hitherto rarely seen in women's works.

Anger, Jane [pseud.?]. *Jane Anger her Protection for Women.* 1589. Selection in *First Feminists* (see Anthologies). Responding to a pamphlet attack on women by a "late Surfeiting Lover," Jane Anger was apparently the first woman to write a defense of women. This is a spirited, witty, though conventional, attack on men who malign women and a rehabilitation of woman's character.

Munda, Constantia [pseud]. *The Worming of a mad Dogge: Or, A Soppe for Cerberus the Jaylor of Hell.* 1617. Selection in *Half Humankind*, 244–63 (see Anthologies). Dedicating the work to her mother, "Lady Prudentia," the author attacks Joseph Swetnam's *Araignment of Women* in vigorous, angry language, while yet defending the traditional feminine virtues.

Sowernam, Ester [pseud.]. *Ester hath hang'd Haman: or an Answere to a lewd Pamphlet, entituled, The Arraignment of Women.* 1617. Selections in *Half Humankind*, 217–43, and in *First Feminists*, 74–79 (see Anthologies). Also responding to Joseph Swetnam's *Araignment of Women*, the author dedicates her work to all women and cites examples of women's history as evidence of their virtue and value, concluding with an arraignment of Swetnam and a condemnation of man as the root of all evil.

Speght, Rachel. *A Mouzell for Melastomus, The Cynical Bayter of and foule mouthed Barker against Evahs Sex.* 1617. A response to Joseph Swetnam's *Araignment of Women*, this work vigorously attacks Swetnam and then goes on to reclaim women's characters, using Eve and other scriptural examples.

5. *Mother's Advice*
This uniquely feminine genre became popular early in the seventeenth century; notably, many of the mother-authors speak from their deathbeds.

Grymeston, Elizabeth. *Miscelanea, Meditations, Memoratives.* 1604. Augmented. [1606?], [1608?], [1618?]. Selection in *Paradise of Women*, 52–55 (see Anthologies). Assured of her own imminent death, Grymeston compiles and reworks contemporary poetry, prayers, and classical texts to make a guidebook to life for her only son.

Leigh, Dorothy. *The Mothers Blessing: Or, The godly Counsaile of a Gentle-woman.* 1616, 1617, 1618 (2), 1621, 1627, 1629, 1630, 1633, 1634, 1636, 1640. Writing just before her death, Leigh offers many reasons to justify the

publication of her work. While she is ostensibly advising her young sons in such matters as choosing good wives, naming their children, and praying, her treatise also gives extended attention to women's chastity.

Clinton, Elizabeth, countess of Lincoln. *The Countess of Lincolnes Nurserie.* Oxford, 1622. Selection in *Paradise of Women,* 57–60 (see Anthologies). Addressing her daughter-in-law Briget, the countess strongly advocates that mothers breast-feed their own children as part of their divinely ordained role and as most expressive of their feminine virtue.

Jocelin, Elizabeth. *The Mothers Legacie to her unborn Childe.* 1624. Selection in *Paradise of Women,* 60–63 (see Anthologies). In a fascinating preface, Jocelin expresses her ambivalence about female learning and authorship, but her own learning and piety flower in her treatise of advice on godly living.

M.R. *The Mothers Counsell, or, Live within Compasse.* Ent. 1623; published 163[0?]. Another last will to a daughter, this work advises women to preserve chastity, temperance, beauty, and humility. It probably responds to *Keepe within Compasse or, The worthy Legacie of a wise father to his beloved Sonne.* M.R.'s sentences are interspersed with didactic verses from contemporary poets.

6. Romance

Wroth, Mary. Mary Sidney Wroth chose genres already identified with the Sidney family, the prose romance and the sonnet sequence. *The Countesse of Montgomeries Urania,* 1621, resembles in numerous ways her Uncle Philip's *Countess of Pembroke's Arcadia.* The published portion follows the adventures in love and war of a vast cast of characters, but focuses particularly on Pamphilia, a new kind of female hero who is both queen and poet; her cousin Urania; and her inconstant lover, Amphilanthus. The book was withdrawn in the year of publication after Wroth was accused of slander, a move supporting the probability that additional characters are based on contemporary portraits. A manuscript continuation, *The Second Part of the Countesse of Montgomerys Urania,* in the Newberry Library is being edited by Josephine Roberts for publication by the Renaissance English Text Society in 1990–91.

II. Verse

Askew, Anne. "The Balade whych Anne Askewe made and sange whan she was in Newgate." Appended to *The lattre examinacion of the worthye servaunt of God mastres Anne Askewe.* Wesel, 1547. [1624?]. See Askew entry above under Prose: Autobiography. Imaging herself in the scriptural armor of faith, Askew creates vivid metaphors of her battle against authorities of church and state.

Seymour, Anne, Margaret, and Jane. *Le tombeau de Marguerite de Valois Royne de Navarre.* Paris, 1551. The three young daughters of Lord Protector Somerset eulogize Marguerite de Navarre in 104 Latin distichs, idealizing her as the supremely virtuous bride of Christ.

CURRENT BIBLIOGRAPHY

Whitney, Isabella. *The Copy of a letter, lately written in meeter by a yonge Gentilwoman: to her unconstant Lover.* [1567?]. Selection in *Paradise of Women*, 118–20 (see Anthologies). In this early poem by a woman about love, Whitney rehearses many classical examples of men betraying women and admonishes women to guard their chastity, piety, and constancy.

―――. *A sweet nosegay or pleasant posye. Contayning a hundred and ten Phylosophicall flowers.* 1573. Reprinted in *The Floures of Philosophy (1572) by Hugh Plat and A Sweet Nosegay (1573) and The Copy of a Letter (1567) by Isabella Whitney*. Facsimile. Edited by Richard J. Panofsky. New York, 1982. See Betty Travitsky, ed., Whitney's "The 'Wyll and Testament' of Isabella Whitney," reprinted in *English Literary Renaissance* 10 (1980): 76–94. In the first part of her work, Whitney turns Hugh Plat's sentences into didactic verse urging godly living; in the second part, letters by the author and her friends detail the vicissitudes of daily life in a mutable world; in the climactic third part, a last will and testament, Whitney's work deepens and improves poetically as she envisions London, the teeming and profligate earthly city, from a perspective initially involved but finally detached.

Dowriche, Anne. *The French Historie: A Lamentable Discourse of three of the chiefe, and most famous bloodie broiles that have happened in France for the Gospell of Jesus Christ.* 1589. Dowriche writes a self-conscious preface about her calling as a woman writer and then adopts a male narrator to tell her completely partisan verse account of recent Huguenot history. The Catholics are evil, the Protestants are heroic, but sometimes the narrative is gripping and the poetry dramatic.

Elizabeth I. "The doubt of future foes." In George Puttenham, *The Arte of English Poesie.* London, 1589. Book 3, chap. 20, p. 208. Puttenham claims the poem refers to the queen's problems with Mary Queen of Scots and prints it as a perfect example of *exargasia* or the gorgeous.

Sidney, Mary, countess of Pembroke. "The Doleful Lay of Clorinda." In Edmund Spenser, *Colin Clout's Come Home Again.* 1595. Reprinted in *The Triumph of Death and Other Unpublished and Uncollected Poems by Mary Sidney, Countess of Pembroke.* Edited by G[ary] F. Waller. Salzburg: Institut für Anglistik und Amerikanistik, 1977, 176–79. Mary Sidney's contribution to Spenser's collection of elegies for Philip Sidney is a pastoral contrasting the earthly landscape bereft of Astrophel with the landscape of paradise where he resides.

―――. "A Dialogue betweene two shepheards, Thenot, and Piers, in praise of Astrea." In [Francis Davison] *A Poetical Rapsody.* 1602. See *Triumph of Death*, 181–83. Sidney's praise of Elizabeth is also a dialogue about the insufficiency of fallen language to express truth.

Melville, Elizabeth (Elizabeth Melville Colville). *Ane Godlie Dreame, Compylit in Scottish Meter be M. M.* [Mistress Melville] *Gentlewoman in Culros, at the requeist of her freindes.* Edinburgh, 1603. *A Godlie Dreame, Compyled by Elizabeth Melvill, Ladie Culros yonger at the request of a friend.* (English version, 1604? 1606, 1620). Scottish version reprinted in *Early Popular Poetry of Scotland and the Northern Border*, edited by David Laing, LL.D., in 1822 and

1826. Rearranged and Revised with Additions and a Glossary by W. Carew Hazlitt. 1895. Vol. 2, 279–91. The strongly pious Melville creates her dream vision of a journey to the heavenly city in vivid images, concluding with an exhortation to the godly to prepare for death.

Lanyer, Aemilia. *Salve Deus Rex Judaeorum.* 1611. Reprinted in *The Poems of Shakespeare's Dark Lady,* edited by A. L. Rowse. New York: Clarkson N. Potter, 1979. In this powerful three-part poem, Lanyer dedicates her work to prominent women, particularly the countess of Cumberland, her own early patron; writes a Passion narrative in which women figure as central supporters of Christianity; and concludes with a fine topographical elegy, "The Description of Cookham."

Speght, Rachel. *Mortalities Memorandum, with a Dreame Prefix'd, imaginarie in manner: reall in matter.* 1621. Speght's "Dream," an intense and moving poem, is an allegory of her search for learning, concluding in "Erudition's garden," which contains untainted knowledge. The second part, inspired by the death of Speght's mother, follows the course of Death in the world since Eden, but affirms resurrection and immortality.

Wroth, Mary. *Pamphilia to Amphilanthus.* 1621. Printed with *Urania.* Reprinted in *The Poems of Lady Mary Wroth.* Edited by Josephine Roberts. Baton Rouge: Louisiana State University Press, 1983. See also *Pamphilia to Amphilanthus.* Edited by Gary F. Waller. Salzburg: Institut für Anglistik und Amerikanistik, 1977. Wroth's sonnet sequence recalls both Philip Sidney's *Astrophel and Stella* and Robert Sidney's unnamed sequence, but it also innovates as the first sequence with a female sonneteer. The emotional and spiritual climax occurs in a unique Crown of fourteen sonnets dedicated to Love.

Primrose, Diana. *A Chaine of Pearle. Or a Memoriall of the peerles Graces, and Heroick Vertues of Queene Elizabeth, of Glorious Memory.* 1630. Dedicated to all noble ladies and gentlewomen, these verses memorialize Elizabeth's ten public and private attributes, from her religion and chastity, to her clemency and justice, to her science, patience, and bounty.

Fage, Mary. *Fames roule: or, the names of our dread soverayne Lord King Charles, his Royall Queen Mary, and his most hopefull posterity . . . Anagrammatiz'd and expressed by acrosticke lines on their names.* 1637. In her almost incredibly sustained, obsessive exercise in anagrams and acrostics, Fage writes verses on all the members of the royal family, their foreign allies, and a large sampling of the aristocracy and upper gentry. In her 420 entries, there are, however, no women outside the royals.

III. Drama

1. Original

Cary, Elizabeth, Lady Falkland. *The Tragedie of Mariam, The Faire Queene of Jewry.* 1613. Reprint. Malone Society, 1914. The first play written in English by a woman is a verse-drama portraying the conflict between the virtuous and introspective Mariam; her husband, Herod the Great; and her

vigorously wicked sister-in-law, Salome. The play bears a striking relation to Cary's life as recorded in her daughter's biography, *The Lady Falkland: Her Life* (c. 1655). Valerie Lucas is preparing an edition of *Mariam* for Nottingham University Drama Texts.

2. *Translation*
Sidney, Mary, countess of Pembroke. *Antonius. A Tragoedie written also in French by Ro. Garnier*. 1592. Printed with her translation of De Mornay. Reprinted with alterations, 1595. The verse translation of Garnier's *Marc Antonie* reflects a primarily moral, didactic version of the Antony and Cleopatra story; Cleopatra's final speeches of love for Antony show Sidney's skill in depicting poetic passion.

Some Works Printed or Entered for Printing, Now Lost

Fane, Elizabeth. *Certaine Psalmes in Number 21, with 102 Proverbs*. 1550.
Knollys, Katherine. *A heavenly Recreation or comfort to the sowle*. Ent. July 1569–July 1570.
Harvey, Urania. *An Antidote against sinne*. 1637.

Doubtful Works

De Vere, Anne Cecil, countess of Oxford. "Four Epitaphes made by the Countes of Oxenford after the death of her young Sonne, the Lord Bulbecke." In *PANDORA, the Musyque of the beautie, of his Mistresse Diana*. Composed by John Soowthern. 1584. Sigs. Ciiiv–Civ. Including these epitaphs, all the sonnets in *Pandora* have the same rhyme scheme and the same eleven-syllable line, suggesting the possibilities that Soowthern wrote them; that he edited them; or that the countess exactly followed his models. The verses are not skillful, but they are intense and affecting expressions of a mother's love and loss.

Elizabeth I. "Epitaphe, made by the Queenes Maiestie, at the death of the Princesse of Espinoye." In *PANDORA, the Musyque of the beautie, of his Mistresse Diana*. Composed by John Soowthern. 1584. Sig. Di. The same questions about Soowthern's role arise here. The poem is a conventional, somewhat stilted sonnet in which Cupid flies around the princess's tomb weeping at the loss of her eyes, where he once lived.

Ez. W. *The answere of a mother unto hir seduced sonnes letter*. 1627. The Catholic son writes to his mother from Douay, signing himself "I. MADD," and the grieved mother writes back urging him to free himself from slavery and return to Protestantism. That the letters between mother and son are a useful fiction is further suggested when the work becomes a dialogue between the son and mother and between the seducing "harlot"-church and the mother. The work is not necessarily by a woman.

Tattlewell, Mary [pseud.]. *The women's sharpe revenge: Or an answer to Sir Seldome Sober that writ those railing Pamphelets called the Juniper and the Crab-tree Lectures,*

etc. Being a sound Reply and a full confutation of those Bookes: with an Apology in this case for the defence of us women. Performed by Mary Tattle-well, and Joane Hit-him-home. Spinsters. 1640. See *Women's Sharp Revenge,* 160–93 (see Anthologies below). In response to accusations of women's incontinence, scolding, drinking, lying, and gossiping in the named pamphlets, the authors arraign the slanderers, catalog men's inhuman acts through history, decry parental curbs on girls, deny women's subordination, and praise their virtue and chastity. Drunkenness is one of their main targets, as they draw out detailed descriptions of male drinking habits and pranks. The question is whether John Taylor wrote both the attacks and the defense, a well-established practice in the woman question debates.

Works in Manuscript before 1640, Now in Modern Editions

1. Diaries

These books record home life, pious occupations, and glimpses of family relationships.

Mildmay, Grace. *The Journal of Lady Mildmay,* circa 1570–1617. Extracts in Rachel Wiegall, "An Elizabethan Gentlewoman," *Quarterly Review* 215 (1911): 119–38. Mildmay approvingly recalls her domestic, pious life far from the court frequented by her husband: she read divinity, studied her "Herball," cared for the sick, drew, and did needlework.

Hoby, Margaret. *The Diary of Lady Hoby.* Edited by Dorothy M. Meads. Boston: Houghton Mifflin, 1930. For the years from 1599 to 1605, the Puritan Lady Hoby recorded an essentially private country life of prayer, Bible reading, spiritual self-examination, housekeeping, and family visits. Meads transcribed British Museum MS Egerton 2614.

Clifford, Anne. *The Diary of the Lady Anne Clifford.* Edited by V. Sackville-West. London: Heinemann, 1923. These excerpts from a few scattered years (1603; 1616–1619) give some sense of Clifford's strong personality; her close relationship with her mother, the countess of Cumberland; her reading; her life at court; and her difficult marriage to the earl of Dorset. This edition is based on an eighteenth-century transcription of a diary no longer extant.

2. Poetry

Sidney, Mary, countess of Pembroke, translator. *"The Triumphe of Death" Translated out of Italian by the Countess of Pembroke.* Edited by Frances B. Young. *PMLA* 27 (1912): 47–75. Also *Triumph of Death,* 66–79. Sidney retains the terza rima of Petrarch's *Trionfo della Morte* in her beautiful rendition of Laura's appearance and instruction to the poet.

———. "Even now that Care that on thy Crown attends." In Bent Juel-Jensen, *Two Poems by the Countess of Pembroke.* Oxford: Oxford University Press, 1962. Reprinted in *Triumph of Death,* 88–91, and in *The Female Spectator,* 66–69 (see Anthologies). Mary Sidney dedicates her English version of the Psalms to Elizabeth whom she compares to King David. The poem makes specific Elizabeth's spiritual and political significance as the female ruler of England, the new Israel.

CURRENT BIBLIOGRAPHY

———. *The Psalms of Sir Philip Sidney and the Countess of Pembroke.* Edited by J.C.A. Rathmell. New York: New York University Press, 1963. After Philip Sidney's death, Mary Sidney edited the first forty-three psalms that he had written, and composed the rest of the 150 over the following dozen years. There are seventeen extant manuscripts of this extraordinary work, which provided an English version of the Psalms in a dazzling variety of verse forms. Rathmell includes "To the Angell spirit of . . . Sir Phillip Sidney," Mary Sidney's glorious dedication of the Psalms to her dead brother, in which she expresses her strong feeling for him, her faith, and her own commitment to divine poetry.

Elizabeth I. *The Poems of Queen Elizabeth I.* Edited by Leicester Bradner. Providence, R.I.: Brown University Press, 1964. Includes Elizabeth's translations of Petrarch's "Triumph of Eternity"; the second Chorus of Seneca's *Hercules Oetaeus;* the metres of Boethius's *Consolation of Philosophy* (1593); Plutarch's "On Curiosity" (1598); and Horace's *Art of Poetry,* ll. 1–178 (1598). Bradner also prints "On Monsieur's departure," noting that his copy text (Bodleian Tanner 76, p. 162) places the poem among papers connected to the earl of Essex, circa 1600; however, the two other manuscripts connect it to the duc d'Anjou's departure in 1582.

3. Drama

Lumley, Joanna [Jane], translator. *Iphigenia at Aulis Translated by Lady Lumley.* [154?]. Edited by Harold H. Child. Malone Society, 1909. This partial translation, probably based on Erasmus's Latin version, focuses on Iphigenia's self-sacrifice for her country and has numerous Christian echoes.

Wroth, Mary. *Love's Victorie.* Josephine Roberts suggests that this pastoral play in five acts was written about the same time as the continuation of *Urania,* since the two works share characters and plot. (See *The Poems of Lady Mary Wroth.* Edited by Josephine Roberts, 37–38. Baton Rouge: Louisiana State University Press, 1983). The manuscript is being edited by Michael Brennan. See Margaret Anne McLaren's essay in this volume.

Works in Manuscript before 1640

For a valuable account of works in manuscript, including letters, see Ruth Hughey, "Cultural Interests of Women in England from 1524 to 1640. Indicated in the Writings of the Women. A Survey." Diss. Cornell University, 1932.

Cary, Elizabeth. *The History of the Life, Reign, and Death of Edward II . . . Written by E[lizabeth] F[alkland] in the year 1627.* 1680. Attribution has been controversial. See Tina Krontiris, "Style and Gender in Elizabeth Cary's *Edward II,*" in this volume. If Krontiris's persuasive arguments about Cary's authorship are correct, this substantial piece of historical characterization is an important, probably unique, addition to the list of women's works.

Egerton, Elizabeth, countess of Bridgewater. British Library MS Egerton 607. See Betty Travitsky, "His wife's prayers and meditations," in this volume.

Anthologies

A number of works have been preserved and kept continuously before the reading public because they were collected in anthologies. Some have been edited, but the problems of an altered text may well be outweighed by the benefits of its continued existence.

Foxe, John. *Actes and Monuments of these Latter and Perillous Dayes.* 1563. Seven editions 1563–1632. See *The Acts and Monuments of John Foxe.* Edited by Reverend Stephen Reed Cattley. London: R. B. Seeley and W. Burnside, 1837–41. Foxe includes texts by Askew and Grey; he records the martyrdoms of many women Reformers and the lives of Protestant luminaries like Catherine Parr and Elizabeth I.

The Monument of Matrones: conteining seven severall Lamps of Virginitie, or distinct treatises . . . compiled . . . by Thomas Bentley of Graies Inne Student. 1582. Bentley gathers texts relevant to women's piety, ranging from the words of women in the Bible to the works of contemporary women to Queen Elizabeth's psalmlike dialogue with God. The Second Lamp reprints works by Elizabeth, Catherine Parr, Jane Grey, Elizabeth Tyrwhitt, Frances Aburgavennie, Dorcas Martin, and various other contributors, named and anonymous, to Protestant pious writing.

Ballard, George. *Memoirs of Severall Ladies of Great Britain, Who Have Been Celebrated for Their Writings or Skill in the Learned Languages, Arts and Sciences.* Oxford, 1752. Reprint. Edited by Ruth Perry. Detroit: Wayne State University Press, 1985. Ballard gives bibliographical references, contemporary references, and some examples of women's works in his biographical and historical accounts, as for example, Elizabeth's Tilbury speech.

Specimens of British poetesses; selected and chronologically arranged by the Rev. Alexander Dyce. London, 1825, 1827, 1828. Askew, Elizabeth I, and Anne, countess of Oxford are represented.

The British female poets: with biographical and critical notices by George W. Bethune. Philadelphia, 1848. Reprint. 1972. Includes Parr, Aburgavennie, Elizabeth I, and Sidney.

The female poets of Great Britain, chronologically arranged: with copious selections and critical remarks by Frederic Rowton. London, 1848, 185? American edition with additions, Philadelphia, 1849, 1854, 1856. *Cyclopaedia of female poets.* Philadelphia [185?], 1874, n.d. *Cyclopaedia of female poets.* Dayton, 1883. *Facsimile of the 1853 edition with a critical introduction and bibliographical appendices by Marilyn L. Williamson.* Detroit: Wayne State University Press, 1981. Rowton includes brief excerpts from Askew, Elizabeth I, Sidney, Melville, Cary, Wroth, Primrose, and Fage.

The Female Spectator: English Women Writers before 1800. Edited by Mary R. Mahl and Helene Koon. Bloomington: Indiana University Press and Old Westbury, N.Y.: The Feminist Press, 1977. The volume includes excerpts from Kempe, Parr, Elizabeth I, Grymeston, Sidney, Lanyer, Clinton, and Cary.

The Paradise of Women: Writings by Englishwomen of the Renaissance. Edited by Betty Travitsky. Westport, Conn.: Greenwood Press, 1981. The breadth of the field is well indicated by excerpts from a wide range of writers.

CURRENT BIBLIOGRAPHY

First Feminists: British Women Writers 1578–1799. Edited by Moira Ferguson. Bloomington: Indiana University Press and Old Westbury, N.Y.: The Feminist Press, 1985. This anthology includes excerpts from Tyler, Anger, and Sowernam.

Half Humankind: Contexts and Texts of the Controversy about Women in England, 1540–1640. Edited by Katherine Usher Henderson and Barbara F. McManus. Urbana: University of Illinois Press, 1985. The editors provide selections from Anger, Sowernam, Munda, and Tattlewell.

The Women's Sharp Revenge: Five Women's Pamphlets from the Renaissance 1580–1640. Edited by Simon Shepherd. New York: St. Martin's Press, 1985. Shepherd edits and annotates Anger, Speght, Sowernam, Munda, and Tattlewell and argues that the last is actually by John Taylor, author of the "Juniper lectures," an antifeminist diatribe.

Notes on Contributors

ELAINE V. BEILIN is the author of *Redeeming Eve: Women Writers of the English Renaissance* and has published articles on Elizabeth Cary, Mary Wroth, and Anne Askew. Her dissertation, *The Uses of Mythology in Elizabethan Prose Romance,* has just been published. She has taught at Mount Holyoke College and Boston University and is associate professor of English at Framingham State College. Currently, she is working on Elizabeth Cary and collaborating with Helen Heineman on the topic of dialogue in women's writing.

ABBE BLUM is assistant professor of English at Swarthmore College. Her essay "The author's authority: *Areopagitica* and the labor of licensing" appeared in *Re-membering Milton: Essays on the Text and Traditions* (1987). Like her book-in-progress, *Composing the Author: Milton's Writing in Its Social Context,* the essay deals with gender politics, particularly in divorce tracts.

JUDITH BRONFMAN earned her doctorate in English at New York University. She has taught at the School of Visual Arts and now serves as director of Governmental and Community Affairs at John Jay College of Criminal Justice, the City University of New York. She has published articles on the Griselda story and on the teaching of the Sir Gawain legend. Her current research interest is in illustrations for the Griselda story and in the interpretations of the story contained in them.

IRA CLARK is professor of English at the University of Florida (Gainesville). He has published widely across English Renaissance literature, primarily criticism based in historical contexts and relying on stylistics. His major publications, which have focused on sacred literature, include *Christ Revealed: The History of the Neotypical Lyric in the English Renaissance* (1982). He is now considering the plays of the Caroline professionals—Massinger, Ford, Shirley, and Brome—as reflections and commentaries on their privileged audience's political, economic, social, and personal situation.

BETH WYNNE FISKEN received her doctorate from Rutgers University where she currently teaches in the English department. Her essay "Mary Sidney's *Psalmes:* Education and Wisdom" appeared in *Silent But for the Word* (1985), and she has published essays on Mary Wilkins Freeman. She is presently at work on a study of the influence of *Astrophil and Stella* on Mary Sidney's *Psalmes.*

ANNE M. HASELKORN currently serves as associate professor of English at York College, the City University of New York. She has lectured on women in Renaissance literature and is author of *Prostitution in Elizabethan and Jacobean Comedy* (1983). Her current research interests include the collaborative preparation of a critical edition of Juan Luis Vives's *Instruction of a Christen Woman* with other members of the Folger Colloquium on Women of the Renaissance.

NOTES ON CONTRIBUTORS

ANN ROSALIND JONES, associate professor of comparative literature at Smith College, has published articles on Thomas Nashe, Philip Sidney, and women love poets of the Renaissance. She has recently completed a full-length study, *Negotiating Eros: Women's Love Lyric in France, Italy, England, 1545–1620,* for Indiana University Press.

CONSTANCE JORDAN is associate professor of English at the Claremont Graduate School. She is the author of *Pulci's Morgante: Poetry and History in Fifteenth-Century Florence* (1987) and of various articles and reviews on Montaigne, Spenser, and women in Renaissance literature in such journals as *Renaissance Quarterly* and *Studies in Philology*. She is currently completing a study of Renaissance defenses of women.

CLARE KINNEY was educated at Cambridge and Yale where she completed her doctorate in 1984. She currently serves as assistant professor at the University of Virginia, where she teaches Renaissance literature and genre courses on romance. Her article on Beowulf appeared in *Studies in Philology* in 1985, and she is now considering the metamorphoses of desire in the epic-romances of Sidney and Spenser.

TINA KRONTIRIS, Ph.D., University of Sussex, has carried out extensive research on the secular writings of Renaissance Englishwomen. Her work has focused on the interrelation of gender, culture, and style. She has been involved in various socialist and feminist groups in America and England. She is currently Lecturer in English literature at Aristotle University in northern Greece.

R. VALERIE LUCAS is completing her Ph.D. on Puritan domestic ideology and Jacobean drama at the University of Essex, where she was convenor of a graduate reading group on Freud and feminism. She has published in the area of Amerasian literature and is presently with the Department of Theatre Studies, University College Cardiff, and is editing *Swetnam the Woman-hater* and Elizabeth Cary's *Tragedie of Mariam the Faire Queene of Jewry* for Nottingham University Drama Texts.

MARGARET ANNE MCLAREN has lectured in Renaissance literature at Auckland University. Her particular interests are in Renaissance drama and African writing. She has worked extensively with both the published and the manuscript writings of Lady Mary Wroth. She is currently at work on an edition of Wroth's "Love's Victorie" and is teaching English and drama.

NAOMI J. MILLER is assistant professor of English at the University of Arizona. Her research centers on representations of women in Renaissance romance. She has published on Lady Mary Wroth and is currently working on a book on Wroth's works viewed in their literary and cultural contexts.

MAUREEN QUILLIGAN currently serves as associate professor of English at the University of Pennsylvania. She is the author of many articles on Renaissance literature and coeditor of *Rewriting the Renaissance* (1986). Her major studies include *The Language of Allegory: Defining the Genre* (1979) and *Milton's Spenser: The Politics of Reading* (1983). She is now at work on a study of female sovereignty in the sixteenth century.

GAIL REITENBACH recently received her Ph.D. from Boston College. She is

NOTES ON CONTRIBUTORS

a visiting assistant professor of American literature at the University of Wyoming and is working on a book about contemporary American international novels.

JOSEPHINE A. ROBERTS is professor of English at Louisiana State University. Her publications include a book on Sir Philip Sidney's *Arcadia* (1978), an edition of the poems of Lady Mary Wroth (1983), and essays on Renaissance poets in a variety of journals, including *English Literary Renaissance, Huntington Library Quarterly,* and *Comparative Literature.* She is preparing an edition of the Newberry Library manuscript of Lady Mary Wroth's *Urania* for the Renaissance English Text Society.

BETTY S. TRAVITSKY has taught at Brooklyn College, Touro College, and the Jerusalem College for Women. She has held a summer fellowship at the Folger Shakespeare Library and a Mellon Postdoctoral Fellowship at the University of Pennsylvania. Her publications include *The Paradise of Women: Writings by Englishwomen of the Renaissance* (1981; reprint, 1989) and essays on Renaissance literature. Her current research projects include a study of portrayals of the female villain in Renaissance drama.

GARY F. WALLER is professor of literary studies and head of the Department of English at Carnegie Mellon University. His books include editions of the countess of Pembroke and Mary Wroth, and studies of the countess, Sidney, Joyce Carol Oates, and Shakespeare. His most recent book is *English Poetry of the Sixteenth Century* and he has a study of Mary Wroth's relationship with William Herbert in progress. He wishes he had time to complete his second volume of poetry.